W9-CBC-751

History of
COLOR IN PAINTING

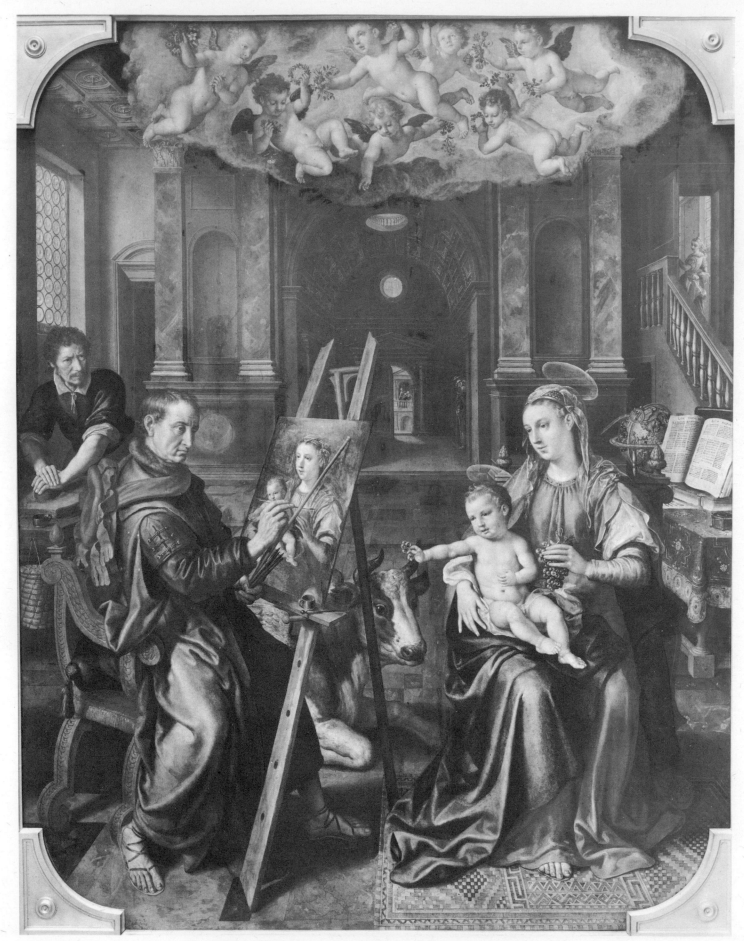

ST. LUKE PAINTING THE PORTRAIT OF THE VIRGIN.

Marten de Vos (1531-1603). (Courtesy of Royal Museum of Fine Arts, Antwerp.)

History of
COLOR IN PAINTING

Faber Birren

 VAN NOSTRAND REINHOLD COMPANY
NEW YORK CINCINNATI TORONTO LONDON MELBOURNE

Van Nostrand Reinhold Company
New York Cincinnati Toronto London Melbourne

Copyright © 1965 by Litton Educational Publishing, Inc.
Library of Congress Catalog Card Number 64–22424
ISBN 0-442-11118-5

Designed by Myron Hall III

Published by Van Nostrand Reinhold Company
135 West 50th Street, New York, N. Y. 10020

16 15 14 13 12 11 10 9 8 7 6 5 4 3

Contents

PART II. THE HISTORICAL REFERENCES

The Illustrations

This book includes over 550 halftone and line engravings, plus a special color chart with 83 mounted color chips. The legends for these illustrations tell a story of their own, and are supplemented by over 150,000 words of accompanying text.

Because color is the chief theme, emphasis is on it and on the palettes and color expression of great painters. Some 80 such portraits—artists and their palettes—are shown. The author has surveyed the western world of art, and, following an international search for related subjects, he has gathered together close to 300 appropriate examples. In addition to the 80 in this book, the others are maintained in a special collection at the Art Library of Yale University in New Haven, Connecticut and may there be consulted.

Foreword

This book is concerned with color expression in the art of painting, rather than with the mechanics of painting or *how* to paint. It deals with the broad field of vision and perception — how artists of the past *thought* and *felt* about colors, how they achieved unusual color effects, how they organized their palettes, what science contributed to the art of color, and what modern inquiry and creativity promise for the future.

In the mid-sixteenth century, Giorgio Vasari, the great Italian architect, painter and art historian, wrote, "Unity in painting is produced when a variety of different colors are harmonized together." The colors "must be painted with sweetness and harmony, because he who throws them into discord makes that picture look like a colored carpet or a handful of playing cards, rather than blended flesh or soft clothing or other things that are light, delicate and sweet."

Yet, according to Vasari, the artist was to show discretion: "As the too fiery mars the design; so the dim, sallow, flat, and overdelicate makes a thing appear quenched, old, and smoke-dried; but the concord that is established between the fiery and the flat tone is perfect and delights the eye just as harmonious and subtle music delights the ear."

Good color may not assure great art. But the best of paintings in form, composition and technique become mediocre if the color expression is poor. Although Ruskin believed in his day that "color is less important than form," he quite willingly admitted that "to color perfectly is the rarest and most precious power an artist can possess."

When one begins at the beginning, it is quite certain that drawing came first and color later. There was delineation of man himself, the natural world that surrounded him, and the environment he created. This could be done in line and perspective, with depth and dimension cleverly simulated. Indeed, the Renaissance artist followed this course, adding color as subsequent raiment over his form.

The idea that color might be pursued for its own sake, that it might supersede or at least rank equally with form, did not come until later. With Turner and Impressionism, then Kandinsky and Abstract Expressionism, complete release was achieved and — at times — color and color alone was dominant.

I believe that the art of color has witnessed two great epochs, and that a third is in the offing. The first epoch was the Renaissance in the fifteenth and sixteenth centuries which saw the development of the chiaroscuro style by da Vinci. This was based on dramatic modeling with light and shadow, on a restrained and very special control of color to be described later in this book, and on a recognition of aerial perspective.

The second great development in the art of color occurred in the nineteenth century when the Impressionists revealed and exploited the glories of human vision. Then the artist used his pigments as if they were spectral light itself.

1. THE ARTIST. J. L. Meissonier. 1886. There must be absorption, dedication, and self-expression. (Picture Collection, New York Public Library.)

2. THE CRITIC. J. L. Meissonier. 1886. Although art is personal, it also must stand critical appraisal. (Picture Collection, New York Public Library.)

Form was manifest in color, and space itself was filled with vibrations to be mixed in the retina of the eye.

With the emergence of Fauvism, Orphism, Expressionism, and Abstract Art in the twentieth century, a third epoch might well have been presented to the world had the artists of these movements shown more resourcefulness and originality. As it happened, however, the painter suddenly abandoned discipline, knowledge, and training for impulse and intuition — and progress in the art of color stopped dead in its tracks.

The art of color in painting has now gotten to its feet again and is headed toward a new frontier — perception — as will be told in Chapters 6, 7, and 8.

Art must be a thing of spirit and not mere fidelity. It must pay homage to the glory of man, not mere obeisance to nature. It must be free, yet profound. If the artists of the Renaissance were better craftsmen than creators, the action painters of modern times, for all their ferment, appear somehow inept. Van Gogh, who was a competent craftsman although erratic in temperament, had this excellent advice: "It is not only by yielding to one's impulses that one achieves greatness, but also by patiently filing away the steel wall that separates what one feels from what one is capable of doing."

One holds pity for so many eager painters with majestic visions before them, who have no time for filing and hence are incapable of doing. They are like musicians with broken fingers.

The time for the third great epoch in the art of color is now. The road has been surveyed, the directions marked, the early explorations set forth and recorded. If only a new generation of painters will leave the haunts of the past — Montmartre, Greenwich Village — and get out where the air is fresh and the sights are new, there will be a third epoch as different from the Impressionist period as this period was from the Renaissance.

I confess that this work of mine is prejudiced. As Manet pointed out, there are no lines in nature — only colors and areas of color. Drawing may have come first in the history of art, but color comes first in human consciousness!

The color art of tomorrow will very likely de-

rive from an unfolding of the mysteries of seeing. If the Renaissance marked a time of great technical skill, if Impressionism was dedicated to the phenomenal in vision, the epoch of the future will be one that blossoms from the whole of perception — not just the eye, but the brain itself. Things will not take place merely on a canvas; they will happen in human consciousness. Men who are witness to art will not only view what is before them; they will participate in the feeling of the artist and add something of their own feeling as well.

The Gestalt psychologist, David Katz, once wrote, "Color, rather than shape, is more closely related to emotion." In other words, color comes *before* drawing. To demonstrate this, Katz arranged a series of simple forms (triangles, circles, squares) in primary hues (red, yellow, blue) and asked young children to put similar things together.

3. THE ATTRIBUTES OF THE ARTS. Jean Baptiste Siméon Chardin. 1776. This engaging painting was made for Catherine II of Russia. One sees the tools of the architect, painter, and sculptor, along with a medal, and gold and silver coins. The palette has glints of white, red, blue, yellow ocher, brown, and black. A duplicate painting is at The Hermitage, Leningrad. (Courtesy of The Minneapolis Institute of Arts, Dunwoody Fund.)

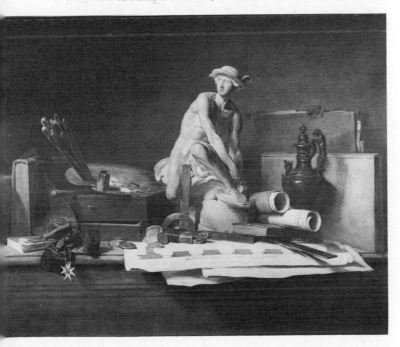

4. IN THE STUDIO. F. Beda. There is the artist of opulence, the man patronized by kings and princes, wealthy men and beautiful women. (Picture Collection, New York Public Library.)

He found "as a rule, younger children chose a form of similar colors rather than similar shape This finding confirms the primacy of color in creating form." Thus, if color is emotionally more elemental than form, it is also true, in the words of Katz, that "color is more important than shape in the creation of forms."

It is neither specious nor unjust to put color right beside drawing or form as a fundamental element in the art of painting. Color is not secondary; it is primary. According to Maria Rickers-Ovsiankina, "Color experience, when it occurs, is thus a much more immediate and direct sense datum than the experience of form. Form perception is usually accompanied by a detached, objective attitude in the subject. Whereas the experience of color, being more immediate, is likely to contain personal, affectively toned notes."

A new psychology of color built upon research in perception will be described in this book. Man lives in a psychological age, beset by moods of loneliness, frustration, fear. It has not been more than a dozen years that color has come to be identified with these modern symptoms

For example, in the clinical study of human mind and emotion, the taking of what are known as hallucinogenic drugs (hallucinogens) will induce odd psychological effects. Quite noticeable is an immediate heightening of sensation to

5. AN ARTIST'S STUDIO IN SAN FRANCISCO. Edwin Deakin. 1876. There is the impecunious painter, sacrificing comfort for the realization of his dreams. (Courtesy of M. H. De Young Memorial Museum, San Francisco.)

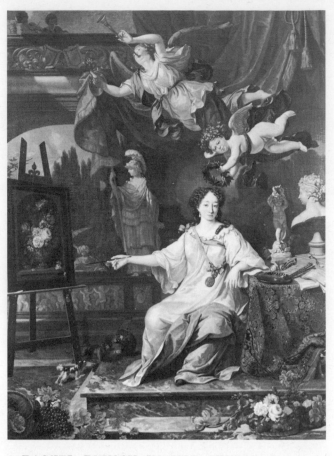

6. RACHEL RUYSCH IN HER STUDIO. Constantin Netscher (Dutch, 1668-1723). In this fanciful, allegorical painting, the artist is blessed by angels with trumpets and wreaths of laurel. (Courtesy of North Carolina Museum of Art, Raleigh.)

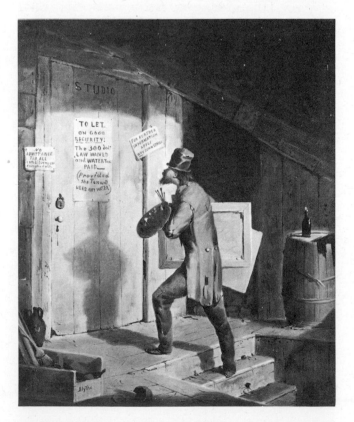

7. ART VERSUS LAW. David Blythe (American, 1815-1865). The artist is forlorn. He is belabored with trials and tribulations that only a man of genius could endure. (Courtesy of The Brooklyn Museum.)

color, brightness and luminosity. There may be sights and visions of free-flowing hues, or familiar things may take on fantastic luster. As described by Dr. Sidney Cohen of the University of California School of Medicine, the effect is "as though a translucent membrane had been peeled from one's eyes for the first time." Everything becomes more chromatic, clearer, brighter, sharper, endowed with dimensions and qualities never before noticed.

With the deepening of the drug's effects, the subject may experience active illusions. These may come and go: crystalline landscapes, jewel-encrusted mountains of gold, geometrical patterns, flowers, birds, butterflies, fountains of color. These, in turn, may give way to actual scenes, animals, objects, people, voices from an earlier time.

There is much in color that is inexplicable, illusory, and yet profoundly basic to man's conscious and unconscious existence. Color is not a casual, or superficial experience. However, I have no intention of dealing with color in abstruse

terms. Color perception as defined in this book refers to the curious ways in which the eye and brain interpret what is seen — and how the painter can, through a knowledge of visual processes, create effects not before achieved in the history of color expression. Chapter 7 discusses one of the newest fields of research in perception — color induction. Here the findings have been quite startling and revolutionary, And they have yet to be fully converted into art expression.

It is quite likely that as the years go by, color expression in art will improve in technical execution (hopefully, the flinging of paint has had its day) and in greater and more sensitive use of color. Realism may come and go in cycles, and so may the strictly abstract. The naturalistic painter may use color abstractly — i.e., blue horses — and the abstract painter may now and then create non-objective effects that resemble a sunset. Regardless, the profound and elementary nature of color in human experience, so recently divulged in studies of perception, is sure to give color greater significance today than in any other time.

This might not come too easily. Shortly before the advent of Impressionism, Delacroix wrote, "The elements of color theory have been neither analyzed nor taught in our schools of art, because in France it is considered superfluous to study the laws of color, according to the saying 'Draftsmen may be made, but colorists are born.' Secrets of color theory? Why call those principles secrets which all artists must know and all should have been taught?"

The Impressionists took this advice, and for a number of years — through Neo-Impressionism and Post-Impressionism — there was considerable application of the "science" of color.

In the midst of the twentieth century, however, the artist turned his inquisitiveness inward upon himself and the art of color atrophied. Now the truant son has returned and seems willing to go back to school and continue where his education had left off.

Perceptual factors in color expression were reviewed by the writer in 1938 in a book *Monument To Color* which contained 16 color plates, some printed in 10 colors. In 1948 an exhibit of color studies in oil assembled by the writer were shown at the National Arts Club in New York,

the Art Institute of Chicago, and the Kansas City Art Institute. In 1961 the newer principles of color were expressed in the book *Creative Color.*

The present book, *History of Color In Painting*, represents a summation of the author's efforts in the field of color expression. The first part concerns "The Practical Methods" in the artist's quest for color expression. The material here represents a working handbook of color theory and organization, detailed reviews of palettes, techniques, modes of expression, plus a full account of modern inquiries into the wonders of perception.

The second part, "The Historical References," supplements the first part and offers a brief but pointed account of color expression from the Renaissance to the present as found in great works of art and the views of great painters and schools of painting. These chapters are optional reading for those seeking a thorough grounding in color tradition and achievement from the Renaissance to the present.

All in all, this present work is perhaps the first one ever devoted exclusively to color expression in art. I trust it will serve to enlighten those artists who, like myself (and with far larger talent), would strive to establish new precedents for color in art.

Finally, let me add a few words on the all-important illustrations which accompany the text. The black and white examples have been prepared for the book or secured from the sources credited. I am profoundly grateful for the help and cooperation extended to me. A special feature will be found in the many portraits and self-portraits which show artists with their palettes. To my knowledge, this collection is unique; it has been drawn from museums around the world through personal contacts and lengthy correspondence.

PART I. THE PRACTICAL METHODS

Chapter 1

The Quest for Method and Order

A brief review of the theoretical and scientific aspects of color development will provide a necessary background to understanding the various palettes and techniques used by painters of the past and present. The scientific viewpoint will again be explored in later chapters devoted to recent studies of human perception.

While a good sense of color may be innate in many artistic individuals, far more than this is required for an artist to be truly capable. Admittedly the Old Masters were blessed men who through inspiration and profound application did prodigious things with color. Yet perhaps there was more trial and error than deliberation in their achievements. Certainly they did not consort with scientists, for at the time they painted, science was in its infancy.

The fashions of the Old Masters were not to last forever. When the school of Impressionism arose in the latter part of the nineteenth century, the scientists had much to do with the revolution and joined hands with the artist to effect one of the most complete breakthroughs in the long history of art.

In any study of early color expression, one is struck by a curious but obvious fact. If the ancients of Egypt, Greece, Asia Minor, the Orient had skill, talent and good taste, they were by no means *creative* in the sense of the word today. Virtually everything they did related to history and mythology. They may have abstracted their forms, but not their ideas. Their job was to portray what others directed. Their decorations had meaning. They were illustrators of history and mysti-

cism who drew both inspiration and instruction from pharaohs, priests and philosophers. They dwelt in the midst of life as artisans. Unlike their later counterpart, these artists claimed no special insights or emotions, nor did they attempt, in an egoistical way, to pose as interpreters of social and moral unrest. They were one with other men, not apart from them.

The simplicity and strictness of the palettes of the ancients, and a discussion of the classical tradition of color in art will be found in Chapters 9 and 10. It is quite clear that formal order was the rule and that color was used literally or symbolically rather than imaginatively. There was little if any effort on the part of the artists to let their fancies run wild. Color had significance, or the vestiges of it, that required much skill but little if any originality.

To proceed with the theme of method in color, the ancients probably took pride in the ability to make pigments in the first place. This required great skill. Once they had developed their palettes they apparently had little interest in the physical nature of light itself. They devoted thought to the meaning or symbolism of color, recognizing that the cosmos was somehow tied in with the hues of the rainbow.

The ancients related color to their gods, to the elements, the quarters of the earth, the planets, to healing and medicine, and to all that dominated their cultures. The architecture, wall decorations, monuments, sculpture were charts or codes as far as color was concerned. Each hue was a distinct token.

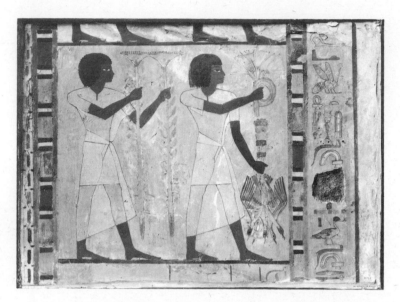

1-1. OFFERING BEARERS. Wall painting from the Tomb of Sebek-hotpe, Thebes. XVIII Dynasty. Tempera on mud plaster. The palette of the ancient Egyptian painter was a simple one and was applied according to strict ritual. (Courtesy of The Metropolitan Museum of Art. Rogers Fund.)

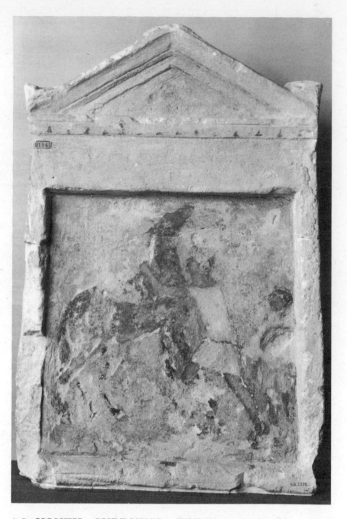

1-2. YOUTH SUBDUING HORSE. Gravestone with painted decoration from Hadra, near Alexandria. Ca. 200-300 B.C. Marble panel. Colors in decoration, sculpture, and architecture were usually bold and not essentially realistic. (Courtesy of The Metropolitan Museum of Art. Darius Ogden Mills, 1904.)

Ancient Viewpoints

One of the earliest attempts to theorize about the nature of color occurs in the Hindu *Upanishads* dating back to the seventh or eighth century B.C. It reads, "Whatever they thought looked red, they knew was the color of fire. Whatever they thought looked white, they knew was the color of water. Whatever they thought looked black, they knew was the color of earth. Whatever they thought was altogether unknown, they knew was some combination of these three beings."

The Greeks added air as an element, and the concept remained intact for many centuries. Indeed, Pythagoras related colors and forms to the elements, reserving the sphere as a symbol of the supreme deity. Much of this symbolic meaning of color is a story in itself and has been outlined in previous books by the author.

That color had more than spiritual or symbolic significance begins to show itself in the writings of Aristotle. He begins his treatise, *De Coloribus*, as follows. "Simple colors are the proper colors of the elements, i.e., of fire, air, water, and earth. ... Verifications from experience and observation of similarities are necessary, if we are to arrive at clear conclusions about the origin of different colors, and the chief ground of similarities is the common origin of nearly all colors in blends of different strengths of sunlight and firelight, and of air and water." Aristotle knew that "darkness is due to privation of light." Hence where darkness and light met, the colors of the world were created. Thus "black mixed with sunlight or firelight turns crimson," but "violet is obtained from a blend of feeble sunlight with a thin dusky white."

A theory like this prevailed for a number of centuries and was even defended by Goethe some 2000 years later, despite incontrovertible evidence to the contrary.

Aristotle wrote of white, black, gray, yellow, gold, crimson, pink, brown, violet, dark blue. He dealt with practically all color phenomena in

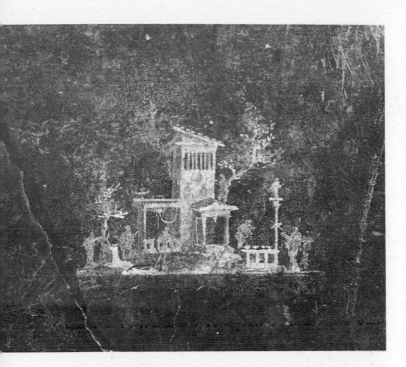

1-3. AEDICULA WITH SMALL LANDSCAPE. Detail of wall painting on black ground from a villa at Boscotrecase, on the south slope of Vesuvius. Ca. 31 B.C.-50 A.D. Colors were bright and primary. (Courtesy of The Metropolitan Museum of Art. Rogers Fund, 1920.)

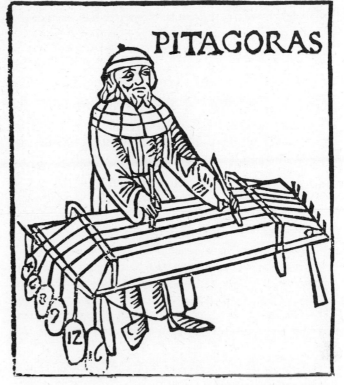

1-4. PYTHAGORAS. Engraving. 1492. He described the shapes of the elements, related them to colors, and invented the diatonic scale in music. (Picture Collection, New York Public Library.)

nature, often reaching odd conclusions: "Hair is never crimson or violet or green or any other color of that kind, because all such colors arise only by mixture with the rays of the sun, and further because in all hairs which contain moisture the changes take place beneath the skin and so they admit of no admixture." He ended by stating, "From what has been set forth in this treatise one may best understand the scientific theory of colors."

The nature of color, of course, was not as simple as Aristotle presumed. Yet his views were respected, almost as laws, up to the time of Robert Boyle and Isaac Newton — some 18 centuries later.

To add to the confusion, the Roman scholar, Pliny, following the lead of Aristotle, wrote:

I remark that the following are the three principal colors; the red, that of kermes, for instance, which, beginning in the tints of the rose, reflects, when

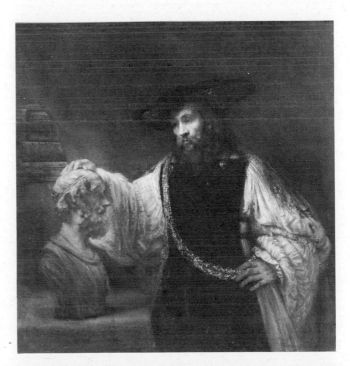

1-5. ARISTOTLE CONTEMPLATING THE BUST OF HOMER. Rembrandt van Rijn. Aristotle was one of the first great writers on color and Rembrandt was one of the greatest color technicians. (Courtesy of The Metropolitan Museum of Art. Purchase, 1961.)

viewed sideways and held up to the light, the shades that are found in the Tyrian purple; . . . the amethystine color, which is borrowed from the violet; . . . and a third, properly known as the "conchyliated" color, but which comprehends a variety of shades, such, for instance, as the tints of the heliotropium, and others of a deeper color, the hues of the mallow, inclining to a full purple, and the colors of the late violet.

This would mean that the "principal" colors were a red, a purple, and a violet. It may be that the conclusion bothered Pliny. Even omitting green and blue, some mention would have to be made of yellow. So to allow for yellow, Pliny indulged in a curious bit of reasoning:

> I find it stated that, in the most ancient times, yellow was held in the highest esteem, but was reserved exclusively for the nuptial veils of females; for which reason it is perhaps that we do not find it included among the principal colors, these being used in common by males and females: indeed it is the circumstance of their being used by both sexes in common that gives them their rank as principal colors.

Da Vinci

With a fair start in Greece and Rome, method and science in color lay dormant through the Middle Ages. Some interest arose during the fifteenth century with the invention of oil painting.

Leonardo da Vinci, the universal man of the Renaissance, was interested in practically all of the human knowledge of his day. Being a capable and inventive painter — as well as a philosopher, and engineer, his talents were directed to all aspects of color.

It was da Vinci's genius to recognize objective and subjective factors in color and to be at once artist, scientist, and psychologist. In his *Treatise on Painting*, this remarkable statement is found:

> The first of all simple colors is white, though philosophers will not acknowledge either white or black to be colors; because the first is the cause, or the receiver of colors, and the other totally deprived of them. But as painters cannot do without either, we shall place them among the others; and according to this order of things, white will be the first, yellow the second, green the third, blue the fourth, red the fifth, and black the sixth. We shall set down white for the representative of light, without which no color can be seen; yellow for the earth; green for water; blue for air; red for fire; and black for total darkness.

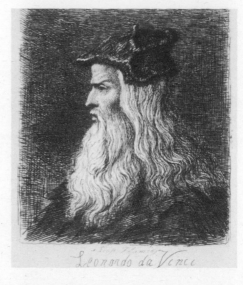

1-6. PORTRAIT OF LEONARDO DA VINCI. Old engraving. Da Vinci made one of the first true statements of the nature of color in human perception. (Picture Collection, New York Public Library.)

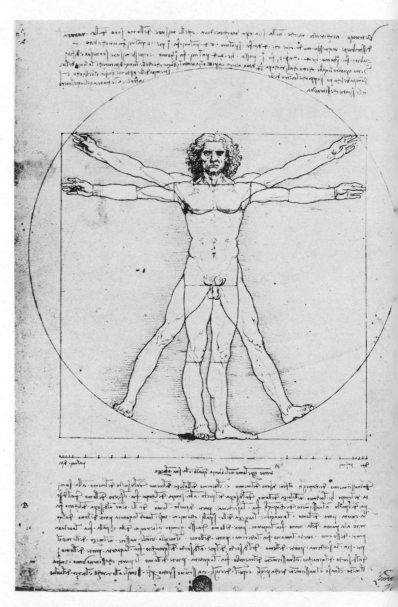

1-7. MAN OF PERFECT PROPORTIONS. Leonardo da Vinci. Here is da Vinci's ideally proportioned man, created by God in divine symmetry. (From original drawing at Academy of Fine Arts, Venice.)

18

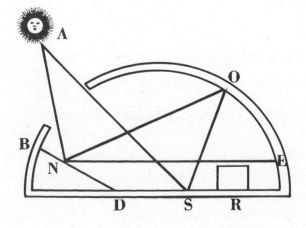

1-8. DA VINCI'S DIAGRAMS RELATING TO COLOR AND LIGHT. According to record, these drawings were made by the Italian architect Alberti, from da Vinci's notes. (From *A Treatise on Painting*, 1877.)

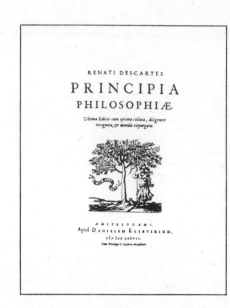

1-9. TITLE PAGE, *Principia Philosophiae* by René Descartes. 1677. In this treatise, Descartes wrote of light, color, and "ether."

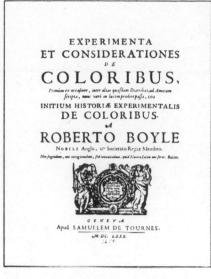

1-10. TITLE PAGE, *Experimenta et Considerationes de Coloribus* by Robert Boyle. 1680. Boyle's treatise on color was published during his lifetime in the universal language of science—Latin.

1-11. TITLE PAGE. *Opticks* by Isaac Newton. 1706. This Latin edition of Newton's work revolutionized scientific thought and made him recognized as one of the greatest geniuses of all time.

Psychologists would later come to recognize da Vinci's simple colors — red, yellow, green, blue, white and black — as primary in sensation, thus confirming and paying tribute to the painter's remarkable insight.

Da Vinci was the best of painters, developing the chiaroscuro style which is one of the foremost accomplishments in the art of painting. He had perhaps the best "scientific" understanding of color of any man of his time. And he was unusually aware of the strange workings of human vision, pointing out a number of phenomena, the study of which, in modern times, has opened up the most fertile of all fields of color inquiry — perception.

Descartes and Boyle

With the exception of da Vinci, the Renaissance painters and philosophers did not attempt to develop their empirical knowledge of color into anything resembling method or order. This remained for the coming of the scientific age in the seventeenth century when the nature of light was brilliantly and thoroughly investigated.

But first the ghost of Aristotle had to be banished. Indeed, it hovered over the halls of learning for a good many centuries. Before the time of Newton, for example, Aristotle's teachings were actually supported by the church, and any criticism of them was next to heresy. The Italian philosopher, Bruno, who visited Oxford in 1583, wrote, "Masters and Bachelors who did not follow Aristotle faithfully were liable to a fine of five shillings for each divergence."

René Descartes (1596-1650) was one of the first to break away from the mistaken notion that colors were blends of light and shade (a theory which Goethe later refused to abandon). To Descartes, all space was pervaded by the ether — the "plenum." Light was essentially a pressure transmitted through a dense mass of invisible particles. The "diversities of color and light" were due to different ways in which the matter moved. Various hues had different rotary speeds, rapid for red, slow for blue.

With Robert Boyle (1627-1691), the English physicist and chemist, the shade of Aristotle was further dissolved. His book, *Experiments and Considerations Touching Colours*, published in 1670, was dedicated to an artist friend: "I have

seen you so passionately dedicated, *Prophilus*, to the delightful Art of Limning and Painting, that I cannot but think myself obliged to acquaint you with some of the things that have occurred to me concerning the changes of Colours." Few scientific works have so bowed to art.

In the beginning of his thesis he wrote, "I have not found that by any Mixture of White and True Black . . . there can be a Blew, or Yellow, or a Red, to name no other colour." Color theory would see the last of Aristotle. Boyle assumed the existence of ether. Light had to travel in or upon something. All hues were contained in white light, and this light was distorted by substances to form hues. "The Beams of Light, Modify'd by the Bodies whence they are sent (Reflected or Refracted) to the eye, produce there that Kind of Sensation Men commonly call Colours."

Boyle wrote of atmospheric colors and structural colors, a point that was forgotten for many years but was revived by modern psychologists in terms of film colors and surface colors. (The two forms of color differ, one being related to light and the other to surface. Film colors are essentially "clean" and space-filling, while surface colors usually contain black and are localized in objects.)

Finally, Boyle paid respect to human elements in the perception of colors. Indeed, colors could not be the inherent property of things, for "An apparition of them may be produc'd from within." Somewhat ahead of Newton, he came to the conclusion that colors were "produc'd by the Impulses made upon the Organs of Sight, by certain extremely Minute and solid Globules I think we may probably enough conceive in general that the Eye may be Variously affected, not only by the Entire Beams of Light that fall upon it as they are such, but by the Order, and by the degree of Swiftness, and in a word by the Manner according to which the Particles that compose each particular Beam arrive at the Sensory." This was very close to order in color.

Isaac Newton

With Sir Isaac Newton (1642-1727) a big jump on firm ground would be made. It is important to understand, however, that physical explanations of color may be remote from visual, emotional, and psychological phenomena. As will be discussed in Chapter 7, color as physical energy and color as sensation may be two different things. The two aspects seem to grow wider apart with time. Investigators of this generation have emphasized and clarified the role of perception and in so doing have opened up a wholly new era for color expression in art.

In the development of method and order in color, Newton stands as a patriarch, for he was the first man ever to conceive an organized color circle. The world knows today that Newton proved that all colors — in the physical sense — are contained in white light. His theory is among the great scientific achievements of all times.

Briefly, Newton, while trying to make improvements in the telescope, observed that a beam of white light in passing through a prism was spread out and converted into the colors of the spectrum. White light was not as simple as had been supposed; it was a mixture or bundle of rays which the prism was able to separate. Being an atomist at heart, he posited a theory of light corpuscles. He assumed that light was generated by an emission of particles which spun about and moved forward in a straight line.

There were primary atoms for seven hues. These colors were red, orange, yellow, green, blue indigo, and violet. If Newton was an atomist, he also was something of a mystic for the choice of seven colors was rather arbitrary and allied to the seven notes of the diatonic scale in music and to the seven heavenly spheres or planets. Red particles were large and violet particles small. "Do not several sorts of rays make vibrations of several bignesses, which according to their bigness excite sensations of several colours, much after the manner that the vibrations of air, according to several bignesses excite sensations of several sounds?" In Newton's view, note C was red, D was orange, E was yellow, F was green, G was blue, A was indigo, and B was violet.

Newton's emission theory was later disputed in favor of a wave theory; today both concepts are blended into one.

Illustration 1-12 shows Newton's color circle. While the spectrum extends from red, through orange, yellow, green, blue, indigo, into violet, he noted that the two extremes (red and violet) bore visual resemblance: "If red and violet be mingled, there will be generated according to their various

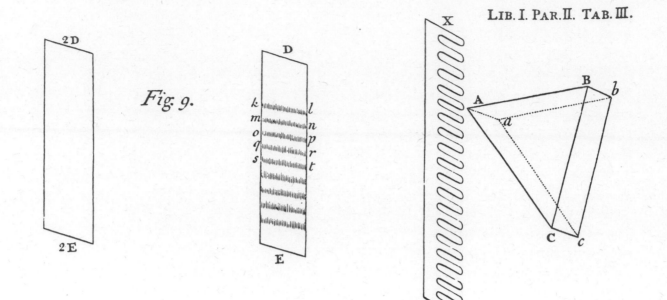

Fig. 9.

Fig. 10.

Fig. 11.

Fig. 12.

1-12. NEWTON'S COLOR CIRCLE AND OTHER DIAGRAMS. Newton's color circle was the first one ever devised. Also shown are diagrams of his experiments in the refraction of light. (From *Opticks* by Isaac Newton, 1706.)

Proportions, various Purples, such as are not like in appearance to the Colour of any homogeneal Light." Thus the straight band of the spectrum could be twisted in a circle and made continuous. The result was the first of all color circles. As to the connecting link, purple, "The Colour compounded shall not be any of the prismatick Colours, but a purple inclining to red and violet."

Although he was objective and scientific in his analysis of light and color, Newton did not overlook subjective phenomena. "I speak here of Colours so far as they arise from Light. For they appear sometimes by other Causes, as when by the power of Phantasy we see Colours in a Dream, or a Mad-man sees things before him which are not there; or when we see Fire by striking the Eye, or see Colours like the Eye of a Peacock's Feather, by pressing our Eyes in either corner whilst we look the other way."

Voltaire

Newton gained world-wide fame during his lifetime. His discoveries, not only in color and light but also in mathematics and physics, gave science the strongest and most enduring push that had ever been exerted by one man. He was immediately praised — and attacked. As greatness attracts greatness, two of the most renowned men of the eighteenth century became a friend and an enemy.

The friend was Voltaire. He had met Newton in London, read the English scientist's works avidly, and declared, "There is in this world a devil of a Newton who has found out how much the sun weighs, and of what colors the rays are that compose light. This strange man has turned my head."

This tribute was by no means a superficial one. Voltaire's admiration for Newton, "the greatest man that ever lived," was shared equally by the Frenchman's beloved Emilie, Marquise du Chatelet. The two of them set up a laboratory at Cirey and put aside literary work for scientific. Here Voltaire labored among microscopes, prisms, air pumps and furnaces. When asked what might be gained from all this, he replied, "We must have all imaginable modes of life, open all the doors of our souls to the sciences and all the sentiments."

A tremendously prolific man, Voltaire managed to keep writing plays, poems, essays and dia-

tribes while composing a book on Newton. Accused of pagan profanity for some of his writings, and in threat of arrest by French authorities, he went to Amsterdam. "I live like a philosopher. I study much. I see little company. I try to understand Newton; I try to make him understood."

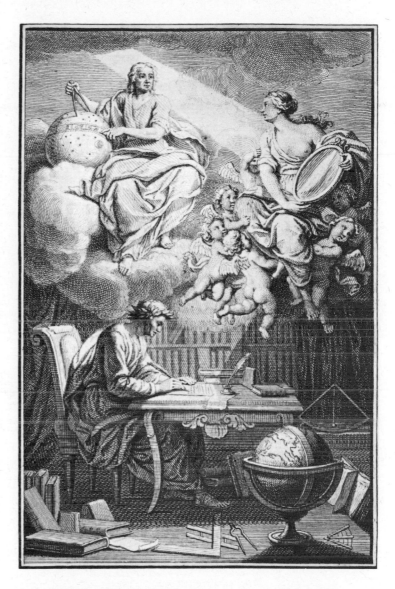

1-13. TITLE ENGRAVING, *Elemens de la Philosophie de Newton* by Voltaire. 1738. The great French dramatist and philosopher added further glory and luster to Newton's fame.

Finally the finished work was denied publication in France for what was mistaken as impiety and was left with a Dutch printer. There it lay as Voltaire went on to other endeavors.

The Dutch printer, however, knowing of the eminence of Voltaire, had an incompetent writer put the manuscript in shape and published it in 1738, *Elemens de la Philosophie de Newton*. This all came as a shock to Voltaire who raved of imbeciles and charlatans, but to no avail.

Goethe

One of Newton's chief enemies was Johann Wolfgang von Goethe. Although both Newton and Voltaire were dead when Goethe's *Farbenlehre* was published in 1810, controversy over Newton's amazing discoveries was very much alive. While Goethe is a very important man in the story of color, one wonders at his blind prejudice, unfairness, and acrimony toward Newton's work. He minces no words when he writes, "We compare the Newtonian theory of colors to an old castle, which was at first constructed by its architect with youthful precipitation; it was, however, gradually enlarged and equipped by him according to the exigencies of time and circumstances, and moreover was still further fortified and secured in consequency of feuds and hostile demonstrations." Not satisfied with this, Goethe goes on, "We find this eighth wonder of the world already nodding to its fall as a deserted piece of antiquity, and begin at once, without further ceremony, to dismantle it from gable and roof downwards; that the sun may at last shine into the old nest of rats and owls."

These are bitter words, and hardly justified, even in Goethe's time. What bothered the poet? One can read between the following lines: "Should we succeed, by a cheerful application of all possible agility and dexterity, in razing this Bastille, and in gaining a free space, it is thus by no means intended at once to cover the site again and to encumber it with a new structure; we propose rather to make use of this area for the purpose of passing in review a pleasing and varied series of illustrative figures."

The world knows today that Goethe was largely wrong and that Newton was nearly right. The poet tried his best to revive Aristotle's belief that colors were a manisfestation of light and dark. Indeed, the two fundamental colors were yellow and blue. "Next to the light, a color appears which is called yellow; and another appears next to the darkness, which we name blue." As to a third primary, red, it was produced when the two extremes of yellow and blue were united. "With these three ... colors, which may be conveniently included in a circle, the elementary doctrine of colors is alone concerned." He was the artist who rebelled violently against what seemed final and sure of itself. He loathed facts,

1-14. PRISM USED BY GOETHE. In his experiments with color and light, Goethe used this prism. (From *Beiträge zur Optik* by Johann Wolfgang von Goethe, 1791.)

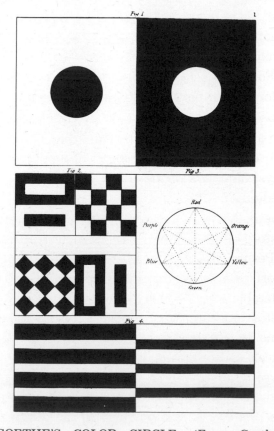

1-15. GOETHE'S COLOR CIRCLE. (From *Goethe's Theory of Colours* translated by Charles Lock Eastlake, 1840.)

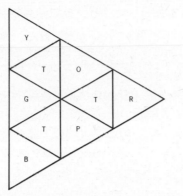

1-16. GOETHE'S COLOR TRIANGLE. Primary red, yellow, and blue were on the angles, with secondary orange, green, and purple between. The T's represent tertiaries—dull yellow, dull red, and dull blue. (Adapted from *Art Through the Ages* by Helen Gardner, 1959.)

mathematics, scientific method, and all that ran counter to the current of his feelings.

To his credit, he insisted that the eye took an active rather than passive part in the act of seeing. He spoke of afterimages and the colors of shadows, and expressed personal views about color which delighted the artist, if not the scientist. The trouble, of course, was that the men of his day confused radiant energy, wave lengths and light frequencies with color as human experience. The two aspects are quite different. Had Goethe realized this, he could have circled around Newton and proceeded to those parts of his *Farbenlehre* which deal with feeling and emotion and which still are pertinent to the art of color (as will be noted in Chapter 4).

For example, he rightly spoke of physiological colors: "We have called them physiological because they belong to the eye in a healthy state." He also spoke of pathological colors which were due to "morbid phenomena," and chemical and physical colors "produced by certain material mediums." All this was quite discerning and made Goethe one of the most remarkable giants in the history of color theory.

Perhaps he was sensitive to the fiasco of his efforts and angry about it. He wrote, with considerable despair and quite contrary to what history remembers of him, "As for what I have done as a poet, I take no pride in it whatever. Excellent poets have lived at the same time with myself; more excellent poets have lived before me, and will come after me. But that in my century I am the only person who knows the truth in the difficult science of colors — of that, I say, I am not a little proud."

J. C. Le Blon

Newton's color circle was developed in the latter part of the seventeenth century and shown in an illustrated book in 1704. It referred (in black and white) to seven colors. While Newton discussed the intermixture of spectral lights, he quite presumably did little or nothing with pigments. The two mediums were not alike.

It may be surprising to learn that the discovery of red, yellow and blue as primary in the mixture of pigments did not occur until several decades later. Da Vinci had come close when he wrote, "Green is composed of a simple and a mixed color, being produced by blue and yellow." But how about red and yellow forming orange, and red and blue forming violet? Apparently to most earlier scientists and artists, colors were entities in themselves, and while they might be mixed with each other, a basic palette was overlooked.

The primary nature of red, yellow and blue was set forth by J. C. Le Blon in a treatise on color published some time before 1731. An early English reference of this date was contained in a monograph written by one Cromwell Mortimer: "Mr. *Le Blon* published, some Years ago, an ingenious Book on the Subject, intituled, *Coloritto*, or, *The Harmony of Colouring in Painting*." Not only was Le Blon the first to establish red, yellow and blue as primaries, but he also distinguished between additive and subtractive color mixtures. His statement was widely acclaimed in Europe and Great Britain. Mortimer declared, "That invention has been well approv'd thro'out Europe, tho' at first it was thought impossible."

Illustration 1-17 shows the title page from a rare little book, *L'Art D'Imprimer les Tableaux*,

1-17. TITLE PAGE, *L'Art D'Imprimer Les Tableaux* by J. C. Le Blon. 1756. Le Blon's treatise set forth the use of primary colors in printing, weaving, and painting.

printed in Paris, in 1756. Illustration 1-18 shows a spread; here in both French and English, Le Blon's statement is given simply and clearly. What he had discovered was promptly applied, not only to the art of painting, but to printing and engraving, and to the weaving of tapestries and brocades. With some pride Le Blon wrote, "But for my part, I freely own, that most of the modern Authors and Painters who I have consulted on the Subject in all my Travels, have declar'd there were never any certain or sure Rules for the Coloritto; many of 'em have believ'd it cannot be reduc'd to certain Rules of Art."

28 TRACT OF COLOURING.	TRAITÉ DU COLORIS. 29
PAINTING can *reprefent* all *vifible Objeƈts* , with three *Colours* , Yellow , Red , and Blue ; *fort* all other *Colours* can be *compos'd* of *thefe* Three , *which I call* Primitive ; *for Example*.	La Peinture peut repréfenter tous les Objets vifibles avec trois Couleurs , fçavoir le *Jaune* , le *Rouge* & le *Bleu* ; car toutes les autres Couleurs fe peuvent compofer de ces trois, que je nomme Couleurs primitives. Par exemple ,
Yellow and } *make an* Orange *Colour.* Red	Le *Jaune* & } font l'*Orangé.* Le *Rouge*
Red and } *make a* Purple *and* Violet Blue } Colour.	Le *Rouge* & } font le *Pourpre* & le Le *Bleu* } *Violet.*
Blue and } *make a* Green *Colour.* Yellow	Le *Bleu* & } font le *Verd.* Le *Jaune*
And a Mixture *of thofe* Three *Original* Colours *makes a* Black , *and all other* Colours *whatfoever* ; *as I have demonftrated by my* Invention *of* Printing *Piƈtures and* Figures *with their natural* Colours.	Et le mélange de ces trois Couleurs primitives enfemble produit le Noir & toutes les autres Couleurs, comme je l'ai fait voir dans la Pratique de mon Invention d'imprimer tous les Objets avec leurs couleurs naturelles.

1-18. LE BLON'S STATEMENT OF PRIMARY COLORS. This is the first printed statement of the fundamental nature of red, yellow, and blue. (From *L'Art D'Imprimer Les Tableaux* by J. C. Le Blon, 1756.)

Moses Harris

Le Blon illustrated his principles with palettes, but he apparently did not think through to a well-organized color circle. This remained for Moses Harris, an Englishman, who about 1766 published *The Natural System of Colours*.

This is perhaps the rarest of all known works in the literature of color, and only two or three copies probably have survived. The book was dedicated to Sir Joshua Reynolds. It contains the first recorded examples of a color circle illustrated in full hue (Ill. 1-21). The volume is thin but handsome, and contains two key charts which Harris engraved himself. These were then tinted by hand.

Harris wanted order and systematic knowledge because the subject, he wrote, "in general hath been so dark and occult." He noted a natural succession of hues which "gave the hint that they should be placed in a circular form." His "Prismatic" colors were formed by intermixtures of the "primitive" colors, red, yellow, and blue. His "compound" colors were formed by intermixtures of the "mediates," orange, green, and purple. He arranged everything in terms of complements and wrote of afterimages and colored shadows.

The system of Harris featured 660 colors, shades and tones, all presented in neat sequence on two plates. It holds distinction as a monumental achievement in the art of color, and set a pattern for all future effort at color organization. Though it was scarce until recently, many references to it have been found in other writings on color and art. A facsimile edition sponsored by this writer was published in 1963 by the Whitney Library of Design.

Harris, who was an entomologist, in 1776 published a book on English insects and showed his famous color circle in another form, including with it a system for the codification of colors of value to the naturalist (Ill. 1-22). Despite this, the work of Harris, while referred to again and again by other scholars, remained rare.

Color Theory

Red, yellow, and blue in the mixture of pigments are primary in theory only. Harris was aware of this and suggested that the artist feel free to introduce other hues. He gave examples. "Suppose an orange colour was wanted, red and yellow will effect it . . . but red orange and yellow orange mixed will do much better." "So with respect to composing a green, blue and yellow will make one . . . but yellow and blue green will make a far brighter color." (An ideal basic color palette is described in Chapter 7 of this book.)

After Harris, red-yellow-blue color circles and charts were created by the score. A beautiful, pictorial one was designed by Schiffermuller and published at Vienna in 1772 (Ill. 1-23). George Field, a famous English colorist of his day, wrote

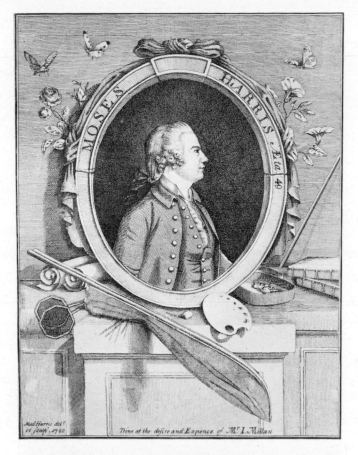

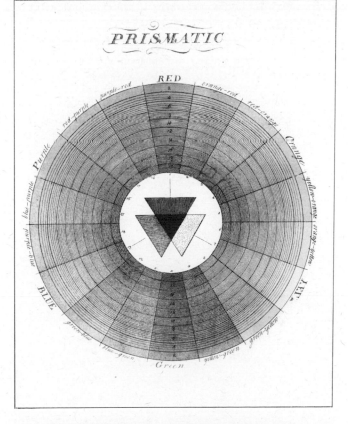

1-19. PORTRAIT OF MOSES HARRIS. Note the palette and butterfly nets. Harris was fairly eminent in his day, but his original work in color was neglected for many years. (From *An Exposition of English Insects* by Moses Harris, 1776.)

THE NATURAL

SYSTEM of COLOURS,

Wherein is displayed the regular and beautiful **Order** and Arrangement,

Arising from the Three Premitives, *Red*, *Blue*, and *Yellow*,

The manner in which each Colour is formed, and its Composition,

The dependance they have on each other, and by their

HARMONIOUS CONNECTIONS

Are produced the Teints, or Colours, of every Object in the Creation,

And those Teints, tho' so numerous as 660, are all comprised in Thirty Three Terms, only

By MOSES HARRIS,

AUTHOR of the AURELIAN, &c. &c.

Printed at LAIDLER's OFFICE, Princes-street, Licester-Fields.

1-20. TITLE PAGE, *The Natural System of Colours* by Moses Harris. 1766. The book was dedicated to Sir Joshua Reynolds.

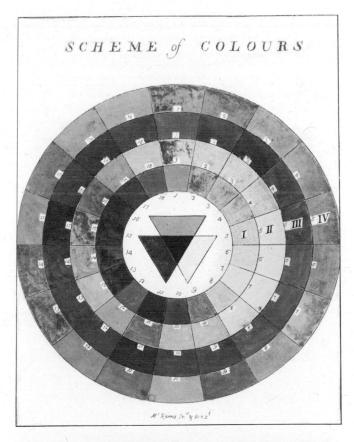

1-21. COLOR CIRCLE BY MOSES HARRIS. This is the first color circle published in full color. Harris' organization and terminology are still pertinent today. (From *The Natural System of Colours* by Moses Harris, 1766.)

1-22. COLOR ORGANIZATION BY MOSES HARRIS. With this version of his color circle, Harris devised what was perhaps the first system for the identification, description, and standardization of colors. (From *An Exposition of English Insects* by Moses Harris, 1776.)

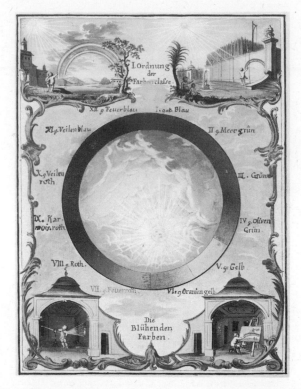

FIELD'S COLOR CIRCLE

1-23. COLOR CIRCLE BY IGNAZ SCHIFFERMUL-LER. This romantically designed color circle was published in Vienna in 1772. (From *Versuch eines Farbensystems* by Ignaz Schiffermuller.)

1-24. COLOR CIRCLE BY GEORGE FIELD. Field disputed Newton and followed conventions set by Le Blon and Harris. (From *Chromatics, or the Analogy, Harmony and Philosophy of Colors* by George Field, 1845.)

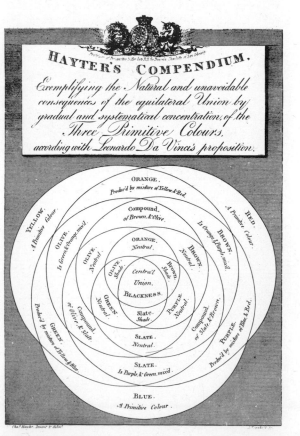

1-25. FRONTISPIECE, *Compendium* by Charles Hayter. 1826. Hayter credited Leonardo da Vinci with concepts that should have been attributed to Newton, Le Blon, and Harris.

1-26. CHEVREUL'S COLOR CIRCLE. Chevreul's red-yellow-blue color circle still dominates art education. (From *De la Loi du Contraste Simultané des Couleurs* by M. E. Chevreul, 1839.)

(1817), "Le Blon is followed by Harris in a similar tract, entitled *The Natural System of Colours*, in which he taught nearly the same doctrine." Field was opposed to Newton. His red-yellow-blue color circle (Ill. 1-24), though beautifully designed, had already become conventional. However, he conceived a number of amusing analogies between colors and sounds.

In 1826, Charles Hayter, an eminent writer on perspective, published *A New Practical Treatise on the Three Primitive Colours*. It seems odd that despite Le Blon, Harris, Field, and Goethe — all earlier than Hayter and all devotees of the red-yellow-blue doctrine — the book mentioned no one but da Vinci, Newton, and Young. As it happened, however, Hayter felt obliged to write in the preface of his work:

> . . . the principles on which my *Painter's Compasses* are *here* enlarged on, were thoroughly formed in my mind in the year 1813, the date of my first edition, as clearly evinced by my diagrams . . . and explanations . . . when a work by Moses Harris *(which I had never before seen or heard of)* was brought to me, to dash my claim to the originality of my diagrams. But although we have accidentally thought somewhat alike, with regard to the method of displaying the circular union and expansion of colours, and granting him upon my own principles to be *so far* right, I still found, and (my book being then published) must confess, that at the time I felt no undue degree of triumph over my proffered antagonist.

David Brewster

Goethe (among a number of others) also subscribed to the red-yellow-blue doctrine in his *Farbenlehre* (1810). So, too, did the eminent M. E. Chevreul of France, and Denman Ross, Arthur Pope, Walter Sargeant, and Herbert Ives of the United States. However, the system has been best known as the Brewsterian, in honor of Sir David Brewster who, in 1831, gave the primaries his blessing in *A Treatise on Optics*.

At that time there was quite a controversy over the matter; certain physicists insisted that the true primaries were not red, yellow and blue, but red, green and blue-violet. Brewster, who was an authority in the field of optics, declared, "I conclude that the solar spectrum consists of three spectra of equal lengths, viz. a *red* spectrum, a *yellow* spectrum, and a *blue* spectrum." Despite

1-27. LIGHT MIXTURES. In the mixture of lights, the primary colors are red, green, and blue-violet. They combine to form magenta red, yellow, and turquoise blue.

1-28. PIGMENT MIXTURES. In the mixture of average pigments, the primary colors are magenta red, yellow, and turquoise blue. These combine to form orange, green, and violet (or purple).

1-29. MUNSELL'S COLOR CIRCLE. Munsell chose five "principal" colors and worked his system out on a decimal basis. (From *A Color Notation* by Albert H. Munsell, 1936.)

1-30. OSTWALD'S COLOR CIRCLE. Ostwald's circle is concerned chiefly with vision, not lights, or pigments. The primary colors are red, yellow, green (sea green), and blue. (From *Color Science* by Wilhelm Ostwald, 1931.)

the fact that he was quite wrong in this, many rallied to his defense.

The truth, of course, is that there are not one, nor two, but *three* sets of primary colors, one set for lights, one for pigments, and one for human vision, as will be explained. Where the mixture

of spectral light is concerned, red, green, and blue-violet will form all other pure hues. This fact was established by Wünch in 1792. Thomas Young took over these primaries and passed them on to James Clerk Maxwell and Hermann von Helmholtz — and subsequently to A. H. Church and R. A. Houstoun of England, Wilhelm von Bezold of Germany, and Ogden Ross, Michael Jacobs, and (to some extent only) Albert Munsell in America.

As an interesting commentary, in process color reproduction, the light primaries of the physicist and the pigment primaries of the chemist are brought together. The plate to print yellow is photographed through a blue-violet filter. The plate to print red (magenta) is photographed through a green filter. The plate to print blue (turquoise) is photographed through a red filter. And in color television, red, green, and blue-violet fluorescent dots result in the perception of red, yellow, and blue colors where they overlap and mix together. The red, green and blue-violet

primaries of the physicist are *additive*, and all three combine to form white. The red, yellow and blue pigment primaries are *subtractive* and combine to form a black or near-black (Ill. 1-31).

Ewald Hering

The third set of primaries — those of vision — was championed by Ewald Hering, an outstanding German psychologist who was interested in color.

In vision — and precisely as da Vinci stated centuries ago — the human eye sees uniqueness in red, yellow, green, blue — plus white and black. Combinations of these, *in visual mixture*, will form all other colors. The best expression of this doctrine is found in the color system of Wilhelm Ostwald.

Because of the vital significance of the visual and psychological aspects of color, Chapters 6, 7 and 8 will be devoted to them, Chapter 6 will deal with color solids and color systems in which color circles play an important part.

A

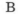

B

C

1-31. LIGHT, PIGMENT, AND VISUAL MIXTURES. Mixtures of light are additive, as in A. Mixtures of pigments are subtractive and form deeper values, as in B. Visual mixtures are medial and tend to strike averages in value, as in C.

Chapter 2
Old Palettes and Techniques

Now that the development of color theory has been outlined, the basic color choices, palettes, and techniques of famous painters from the time of the Renaissance through the eighteenth century will be examined. Palettes recommended in handbooks on painting will also be described. Because this book is devoted to color expression and color vision, technical information on the chemistry of paint and the mechanical problems of the craft will be avoided. The reader who wishes to pursue these subjects may consult the excellent works by Hilaire Hiler, Max Doerner, Ralph Mayer, and others in this field.

The art of painting as understood today began in the fifteenth century, particularly with the invention of oil as a vehicle. Previously the artist had been handicapped by his materials; what he did can hardly serve as proof of what he had in mind or what he might have done, had he not been so restricted. With the discovery of oil painting, however, he became a free man, and this release is beautifully revealed in the versatile quality of his achievements during the Renaissance and after.

While the previous chapter referred briefly to ancient color theory before the Renaissance, this chapter begins with one Cennino Cennini of Florence who in the middle of the fifteenth century put together what has become known as *The Craftsman's Handbook*. Practically every book on the history of art written since that time refers to Cennini's work which was printed in many editions and in several languages.

He is a key figure, the first to relate in charming detail how the Old Masters painted, what

materials they used, from where they derived their pigments, how such pigments were applied, and the whole substance of the artists' craft.

Cennini gave this practical advice to young painters: "You . . .who with lofty spirit . . . are about to enter the profession, begin by decking yourselves with this attire: Enthusiasm, Reverence, Obedience, and Constancy." The artist was to be honest and was to use only the best of materials. "Your standing will be so good for using good colors that if a master is getting one ducat for a figure, you will be offered two . . . As the old saying goes, good work, good pay."

Cennini wrote before the perfection of the oil painting technique. Although he stated. "I will teach you to work with oil on wall or panel, as the Germans are given to do," he knew little of the medium and concentrated instead on tempera and fresco. He made extensive reference to colors, pigments, vehicles, glues, gesso (a plaster compound used for underpainting). "Know that there are seven natural colors, or rather, four actually mineral in character, namely black, red, yellow, and green; three are natural colors, but need to be helped artificially, as lime white, blues — ultramarine, azurite-giallorino." Thus the palette consisted of black and white, red, yellow, green and blue — colors which da Vinci would later accept as primary.

Some pigments were available from apothecaries. Cennini advised caution: "Always buy vermilion unbroken, and not pounded or ground. The reason? Because it is generally adulterated, either with red lead or with pounded brick."

With oil paints, colors could be mixed and

blended on a palette; however the Renaissance artist working in tempera or fresco had to put up with flatter tones and limited modeling of form. It is quite apparent that pigments and variations of them were prepared in advance. Cennini described the painting of a red drapery as follows: the artist was to "get three little dishes." Then he was to "take some cinabrese and a little lime white; and let this be one color.... Make one of the other two colors light, putting a great deal of lime white into it. Now take some of the first dish and some of this light, and make an intermediate color." Such method led to mediocre color effects which da Vinci corrected in the development of chiaroscuro. Cennini's pale tint which should have been purest in red, was weakest, and his deepest tint, which should have been soft, was rich — an inversion of visual fact in the perception of a folded red cloth.

If Cennini's advice was followed, the artist left the painting of faces to the last. "When you have done the draperies, trees, buildings, and mountains, and got them painted, you must come to the painting of faces." Then follows this amusing bit of counsel regarding egg yolk as a vehicle for tempera. The artist was to prepare a base flesh tone or "couch." Now country egg yolks (as a vehicle) were good, "because of their richness, for tempering flesh colors for aged and swarthy persons." On the contrary, "...for the faces of young people with cool flesh color, this couch should be tempered ... with the yolk of a town hen's egg, because those are whiter yolks than the ones which country or farm eggs produce."

David V. Thompson, Jr., in, *The Materials of Medieval Painting* points out that many early paintings have deteriorated, tending to become darker, particularly where varnishes had been applied. Yet the early painter was a craftsman at heart. As Thompson points out, if craftsmanship "does not add to the esthetic value of a fine object," it may contribute a certain nobility to works of art that otherwise "would be plain rubbish."

2-1. EARLY WOODCUTS AND ENGRAVINGS. Fifteenth and sixteenth centuries. Dutch, Flemish, and German. These all show artists at work. The palettes were small in size and had few pigments. A lot of color mixing was done on the panel itself. (Picture Collection, New York Public Library.)

According to Thompson, the medieval artist was not a free man. He labored in service to others and was expected to do works of permanence and quality. He writes, "I sometimes think that modern painting...suffers a little for its freedom, bears its freedom less gracefully than medieval painting bore its servitude." Incidentally, this was written in 1936, before the advent of action painting and Abstract Expressionism.

The Matter of Grounds

The painting techniques of the Renaissance are fairly well known. Excellent sources for reference are Vasari, Sir Charles Lock Eastlake, Jacques Maroger, and others. Early writers, such as Vasari, wrote from first-hand knowledge. Modern writers like Maroger have had the benefit of scientific analysis. The discussions that follow are necessarily brief but cover points of direct concern to the subject of this book — color expression.

Da Vinci, for example, wrote that "the mixture of colors may be extended to an infinite variety." He went on to state, "After black and white come blue and yellow, then green and tawny or umber, and then purple and red. These colors are all that Nature produces. With these I begin my mixtures, first black and white, black and yellow, black and red; then yellow and red...Black is the most beautiful in the shades; white in the strongest light; blue and green in the half-tint; yellow and red in the principal light; gold in the reflexes; and lake in the half-tint."

First of all, it was common practice to work on colored grounds or panels. Cennini mentioned tinting papers in green, violet, blue, gray, pink, flesh tone. According to Hilaire Hilcr, da Vinci did underpainting in a brownish wash, as did van Eyck. The vehicle may have been a form of bitumen which tended not to dry and eventually deadened all other hues. The Venetian painters also liked dark grounds in brown, red, and gray. These might be covered with an opaque impasto in parts and then washed with glazes. Titian is said to have exclaimed, "Svelature, trenta o quaranta!" (Glazes thirty or forty!) Max Doerner relates that Goethe once remarked on the Venetian system. Where a glaze had been applied to a dark ground, the painting tended to deepen through the years. Yet where glazes had been

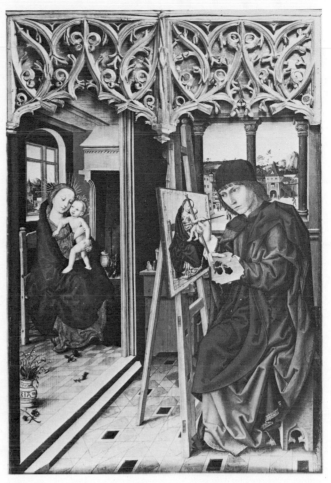

2-2. ST. LUKE PAINTING THE VIRGIN AND CHILD. Rueland Frueauf, the Younger. This dates to the early sixteenth century and is one of the earliest known paintings of an artist with his palette. (Courtesy of German National Museum, Nürnberg.)

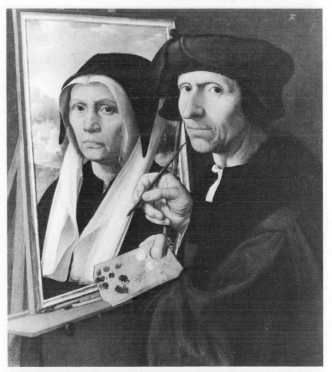

2-3. THE ARTIST WITH A PORTRAIT OF HIS WIFE. Jacob Cornelisz van Oostsaanen. Ca. 1530. The colors on the palette are red (three shades), burnt sienna, brown, black, and flesh tones. There is no green or blue. (Courtesy of The Toledo Museum of Art.)

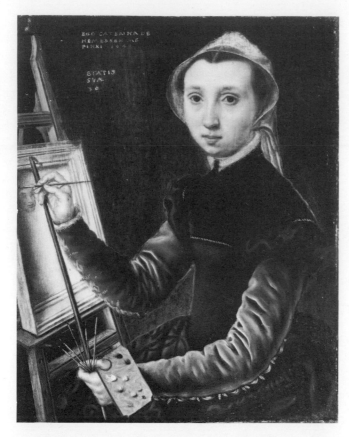

2-4. SELF-PORTRAIT. Katherina van Hemessen. 1548. Note the small palette. (Courtesy of Offentliche Kunstsammlung, Basel, Switzerland.)

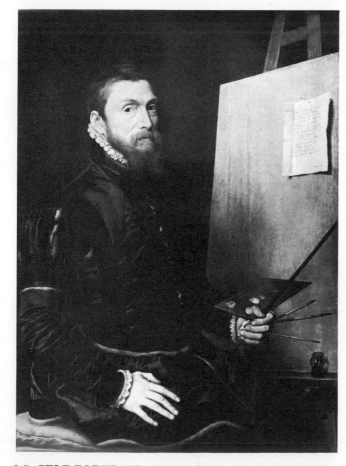

2-5. SELF-PORTRAIT. Antonio Moro. Among this Dutch painter's patrons were Charles V of Spain, Queen Mary of England, and the Duke of Alba. (Courtesy of Uffizi, Florence. Alinari-Art Reference Bureau.)

washed over a light impasto, highlights and luminous patches tended to survive. Because thin, transparent shadows and thick opaque highlights became a tradition in the art of painting, time has taught an important lesson. Doerner writes of paintings in which a white core or impasto was not originally employed, "Such pictures have a drowned look; they have sunk away because there is nothing to support them, as is amply illustrated by the many Titian imitations and copies of later times, the painters of which aimed straight at the final effect without benefit of the luminous white core underneath."

Velasquez was another who worked on brown, red and gray grounds. His usual palette was a simple one, composed of red, yellow, brown, black, white. Rubens used a brownish tone for some panels and a gray tone on larger canvases. Because he was one of the greatest technicians of all time and a man whose style was widely emulated, his procedure is well worth reporting. In *The Secret Formulas and Techniques of the Masters*, Jacques Maroger writes of Rubens, "The technique that he was searching for was one that would produce a lustrous surface, combined with a sort of transparent brilliance, which would enable him to obtain greater contrast between the quality of light and shadow than had been possible with any of the preceding techniques. From his point of view, the shadow should be transparent and the light opaque. This was the fundamental principle he was striving to apply." So it was that transparent shadows and opaque lights became the academic law of painting for many generations.

Many of the Italians had sought a mat effect. With Rubens, if the ground was tinted, the deep colors could be transparent. As Maroger explains, "Whereas if a white ground is used, the dark colors must be opaque if not to appear meager." Hence, the white ground required overloading, while the toned ground could be more liquid and flowing. Needless to say, modern painting has turned its back on glazes and therefore on da Vinci, Titian, Rubens.

Rembrandt followed the techniques of Rubens but never settled for a specific style. Some of his canvases were smooth; others were thick. It was once remarked that some of Rembrandt's portraits could be picked up by the nose. The brown-

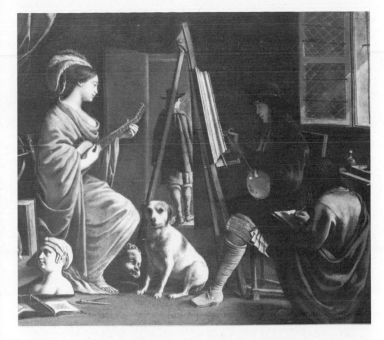

2-6. STUDIO OF THE PAINTER. Mathieu Le Nain (ca. 1607-1677). Born in Laon, France, he worked mainly in Paris with two brothers. Note the small palette. (Courtesy of Art Department, Vassar College, Poughkeepsie, N. Y.)

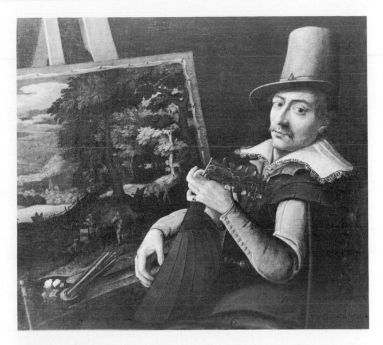

2-7. SELF-PORTRAIT. Paul Brill (1554-1626). Life to this Flemish painter apparently needed its interludes of music. (Courtesy of Museum of Art, Rhode Island School of Design, Providence.)

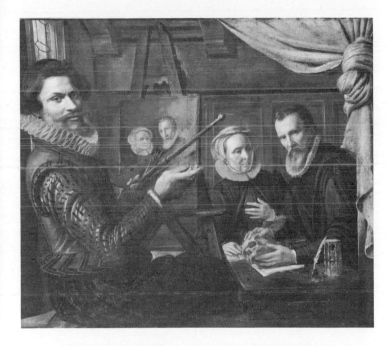

2-8. THE PAINTER IN HIS STUDIO. Herman van Vollenhoven. He lived in the first half of the seventeenth century. The palette shown holds only a few colors. (Courtesy of Rijksmuseum, Amsterdam.)

2-9. SELF-PORTRAIT. Giovanna Fratellini. The palette is restricted and small in size. (Courtesy of Uffizi, Florence. Alinari-Art Reference Bureau.)

ness of so many of his paintings is probably due to glazes, for he often used a pale gray ground.

In 1684 J. B. Corneille recommended half-tints for grounds. (A half-tint is a soft color of medium brightness on which lighter and darker tones could be effectively applied.) In 1756 Bardwell wrote, "Landscapes should be painted on a sort of tanned leather colour, which is made of

2-10. SELF-PORTRAIT. Hyacinthe Rigaud (1659-1743). He was famous as a portrait painter and gratified the sumptuous taste of Louis XIV and his court. (Courtesy of Staatliche Kunsthalle, Karlsruhe, Germany.)

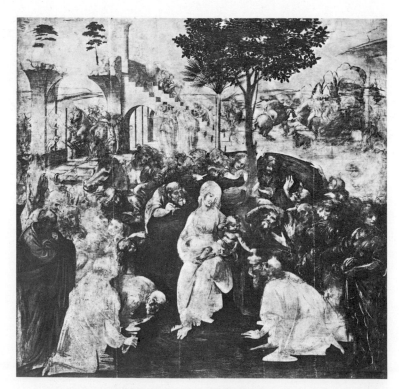

2-12. ADORATION OF THE MAGI. Leonardo da Vinci. In this unfinished work the underdrawing and underpainting are evident. The chiaroscuro style can be seen in its neat development. (Courtesy of Uffizi, Florence, Alinari-Art Reference Bureau.)

2-11A, 11B. THE LAST JUDGMENT and Detail. Hubert van Eyck (1366-1426). The technique was soft, smooth, and almost photographic. The colors are unusually pure. (Courtesy of The Metropolitan Museum of Art. Fletcher Fund, 1933.)

2-13A,13B. MADONNA AND CHILD ENTHRONED WITH SAINTS CATHER-INE, PETER, CECILIA, PAUL, AND THE INFANT JOHN THE BAPTIST and Detail. Raphael. The technique, the handling of color, light and shade are magnificent. Raphael preferred simple but bold color effects. (Courtesy of The Metropolitan Museum of Art. Gift of J. Pierpont Morgan, 1916.)

brown ocher, white, and light red. This colour gives warmth to the shadow colours, and is very agreeable and proper for glazing."

The toned ground is commonly used for pastel and permits the artist to work "over" or "under" it in terms of value. In oil painting, however, it has largely given way to the white ground. Even more significant is the fact that glazing has become a lost art. Although clear dyes have recently been introduced — and require a separate method of handling — the use of opaque paint squeezed from tubes has become the conventional practice.

If the reader is interested in the glazing techniques of the Old Masters, extensive descriptions and instructions will be found in *The Art of Painting in Oil and in Fresco*, by M. J. F. L. Mérimée (London, 1839). This work was quite popular in its day and should be found in most libraries. (It is also mentioned again in the next chapter.)

On the art of glazing, Mérimée quotes Armenini

de Faenza, an Italian who wrote in the sixteenth century: "In operating upon a green drapery, the process we have hinted at is managed in this way. After having laid on the dead color with green, black, and white, in a full and firm manner, some common varnish is then incorporated with yellow lake and verdigris. With this mixture the parts prepared are glazed with a large tool. The same process is used for crimson, yellow, or other drapery — only mixing the appropriate colors with the varnish."

Oil as a Medium

Tempera was a fairly permanent medium but not very flexible. The painter's applications of it dried immediately, and corrections could be made only by over-painting. It is probable that the use of oil (linseed) by the van Eycks first came into use for glazes and not for the pigments of the underpainting itself. With oil there could be better manipulation, greater speed, and much freer modeling.

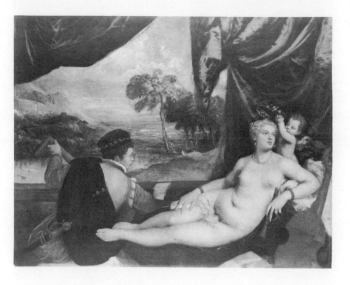

2-14A, 14B. VENUS AND THE LUTE PLAYER and Detail. Titian. The artist spoke of building up his flesh tones layer upon layer, as by nature herself. Yet he worked rapidly and with little apparent effort. (Courtesy of The Metropolitan Museum of Art. Munsey Fund, 1936.)

According to Vasari, "This art was afterwards brought into Italy by Antonello de Messina, who spent many years in Flanders, and when he returned to this side of the mountains, he took up his abode in Venice, and there taught the art to some friends." Adaptations of the medium were made in Florence, too, by da Vinci. Vasari ex-

plains, "This manner of painting kindles the pigments and nothing else is needed save diligence and devotion, because the oil in itself softens and sweetens the colors and renders them more delicate and more easily blended than do the other mediums. While the work is wet the colors readily mix and unite with one another;

2-15A, 15B. THE VISION OF ST. JOHN THE DIVINE and Detail. El Greco. His palette, according to history, had no more than about six colors. These he blended with quick but expert sweeps of his brush for weird effects both in technique and color. (Courtesy of The Metropolitan Museum of Art. Rogers Fund, 1956.)

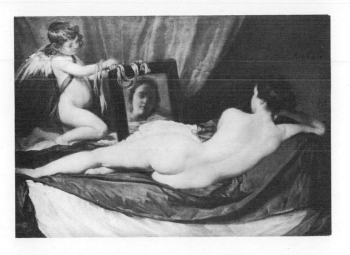

2-16A, 16B. VENUS AND CUPID and Detail. Velasquez. The great Spanish painter's beauty of style, his wonderful sense of light and shade, the perfection of texture and modeling are shown in this painting. (Courtesy of Trustees, National Gallery, London.)

in short, by this method the artists impart wonderful grace and vivacity and vigor to their figures, so much so that these often seem to us in relief and ready to issue forth from the panel."

Antonello and Vasari were contemporaries. While Jan van Eyck's precise methods are not known, the Italians quickly adopted the oil technique for the sound reasons set forth by Vasari. According to Maroger, a white lead paste was used which "had stability and a quality of fluency that made possible a perfect blending of colors." But lead was not a happy choice because of certain chemical shortcomings and it was later abandoned by most painters. Da Vinci recognized

2-17. MAIDS OF HONOR, a Detail. Velasquez. Illustration 9-27 shows the complete picture. Although the colors are not too distinct, they appear to be a red, white, golden yellow, brownish black, plus a few mixtures. (Courtesy of Museo del Prado, Madrid.)

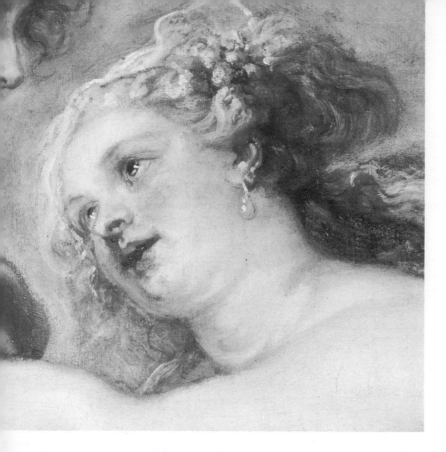

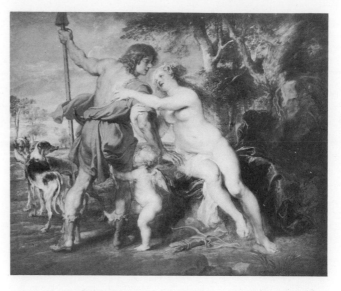

2-18A, 18B. VENUS AND ADONIS and Detail. Rubens. One of the greatest technicians of all time, Rubens worked with transparent shadows and opaque highlights. He often mixed his colors on the canvas itself. (Courtesy of The Metropolitan Museum of Art. Gift of Harry Payne Bingham, 1937.)

this, tried Antonello's paste, and refined the formula, employing water and certain cooking procedures. Maroger writes, "In any case, the original disadvantage of Antonello's medium had been removed. The paste, made by this process with water, was now clear and would no longer change the quality of the colors with which it was mixed."

So the art of oil painting as brought to perfection by the Italian masters spread throughout Europe and was fostered and enlarged by scores of eminent painters, including such men as

2-19A, 19B. CHRIST IN THE STORM and Detail. School of Rembrandt. The technique here is bold, vigorous, and departs from the smooth styles of older masters. Apparently rough textures are blended by the eye for unusual "Impressionist" effects. (Courtesy of The Art Institute of Chicago. Charles H. and Mary F. S. Worcester Collection.)

Rubens and Rembrandt. Yet as Maroger regretfully states, "The last of the masters of the seventeenth century had carried with them into their graves the simple secret of the combination of mastic varnish with the black oil."

Antonello de Messina painted with a smooth style. Because he died at the age of forty-nine, not a great deal of work was executed, nor has much of it survived. One of his portraits will be run in Chapter 9. After learning the craft of oil painting in Flanders, he settled in Venice where he was followed by such painters as Mantegna, Correggio, the brothers Bellini, and eventually by Giorgione, and Titian.

In the Venetian style, the underground was often shaded and modeled in a dark tone such as brown. Then solid layers were superimposed, and glazes added on top. Sometimes the underpainting was more or less neutral, the color effect depending on tinted washes. Flesh tones were often executed entirely with red, white and black, over which a yellow glaze was introduced. At times, a soft yellow pigment was used instead of white. These practices account for the golden tonality of the Venetian school.

Da Vinci's style was similar and has already been mentioned. With oil used as a vehicle for pigments and with compatible varnishes on hand in the studio, painting could be opaque or transparent — and was usually a combination of both. Best of all, work could be done on large scale with incredible speed. Vasari relates that on one occasion, four of the leading painters of Venice (Zucchero, Salviati, Veronese, Tintoretto) were asked to submit designs for the ceiling of a refectory. "But while the other artists were giving themselves with all diligence to the preparation of their designs, Tintoretto made an exact measurement of the space for which the picture was required, and taking a large canvas, he painted it without saying a word to any one and, with his usual celerity, putting it up in the place destined to receive it." Although Tintoretto's rivals complained, he "contrived so to manage matters that the picture still retains its place." Only with oil as a vehicle could such magic have been so easily performed.

It is perhaps natural that during the Renaissance, many formulas were kept secret. The artist who discovered an advantageous technique was likely to keep it to himself. The day had not yet come when art supplies would be freely available and when the science of pigment manufacture would be taken over by chemists. Hence it is that the facile skill of so many masters remains unknown.

After the Italians, Rubens employed heavy oils — as thick as jelly. (Van Dyck is said to have used light oils.) Maroger writes, "Rubens seems generally to have mixed his tones on the canvas itself. It was this method, incidentally, which allowed the Old Masters to use small palettes." Tintoretto's method was the same. He modeled and drew with brown, black and white, and then painted freely with tinted transparent glazes. There are many historic references to the fact that the early artist needed to have many brushes and to keep them clean. Different hues and tones were mixed on palette or canvas and hurriedly applied with separate brushes.

Rembrandt used a smooth style in his earlier years. Then, according to Moreau-Vauthier, "He piled up his impasto impulsively, without method or precaution, trusting to glazes to correct his errors and distractions. His genius had flights which defy all rules."

Pigments and Palettes

The color expression of an artist is naturally limited by the particular pigments he uses. Thus the matter of basic hues, of palettes, is of great consequence to this book. An artist's paints are a key to his vision.

I have collected data on palettes from various sources for many years. Palettes of early painters will be discussed in this chapter; nineteenth-century and twentieth century painters will be discussed in Chapter 3. Special palettes for the special effects of the masters are also given in Chapter 5. As colors and paints are mentioned, the reader may refer to the chart on Pages 106-107. This chart will serve to provide visual samples for more exact reference and matching.

Color expression in ancient times has been mentioned briefly in Chapter 1. In Egypt, Greece, and Rome, color was looked upon in terms of mysticism and symbolism. The ancient painter adhered to prescribed color uses and practices and did not give reign to personal fancies in the mixture of paint; his expression was quite formal

2-20. PAINTER'S PALETTE. Egyptian XVIII Dynasty (ca. 1450-1424 B.C.). One of the earliest known palettes, this has eight colors—still preserved after 3000 years. (Courtesy of The Metropolitan Museum of Art. Rogers Fund, 1948.)

and impersonal. In addition, his technical and chemical knowledge of pigments and dyes, and the formulation of coloring materials, was limited. The Renaissance changed all this, freeing the artist's spirit, as well as presenting him with a generous choice of new vehicles, mediums and colorants.

Illustration 2-20 shows the paint box or palette of an Egyptian artist of the fifteenth century B. C. — some 3,400 years ago. (It is in the Metropolitan Museum in New York. The British Museum has many others fashioned of stone and marble which have from eight to 14 wells. However, none of them contains remnants of pigment.)

In the Metropolitan relic, the original colors are beautifully preserved. There is one compartment or well for each of the following colors: terra cotta red, light yellow ocher, medium yellow ocher, turquoise blue, green, white, black. One empty compartment probably had been filled with an ultramarine blue or purple. As surviving Egyptian wall paintings and coffin decorations still attest, these colors were applied in flat tones without modeling or intermixture and were composed of inorganic pigments — ocher, carbon, silicon, copper, calcium.

It is clearly evident that restricted palettes like this were used up through Greek and Roman times and into the age of Giotto. The same colors have been found in the Parthenon and at Pompeii, virtually without change. If one appreciates that the ancient artist was following dictates prescribed by others rather than catering to his own inner compulsions, the simple, classical palette is easily understood.

With the Renaissance and the invention of oil painting, the art of color suddenly attained one of its most magnificent eras. Color expression reached rare heights of complexity, beauty, and illusion.

This book has already considered some of the techniques of the Renaissance painters, such as da Vinci, Titian, Rubens, Rembrandt. Now specific reference will be made to the palettes.

Long ago, Vasari wrote of the palette of one Lorenzo di Credi: "Indeed, he was overparticular, for sometimes his palette was loaded with twenty-five or thirty of these tones, for each of which he kept a special brush." This may be taken to construe, however, not that di Credi used many base pigments, but rather that he was fussy about preparing a number of mixtures of them. For to all indications the palette of the Renaissance was quite small in number of hues, and this held more or less true into the eighteenth century. Literary references, and old paintings in which palettes are shown, both reveal this. Many such pictures are reproduced on these pages. The pigments were few in number, but with them *the painter might — on palette, canvas or in separate receptacles — create, prepare, or intermix numerous other tones.*

In *The Technique of Painting*, Hilaire Hiler lists one of the palettes of Jan van Eyck (early fifteenth century) as follows:

Brown Verdaccio (a dull tone used mostly for outlining and shading)	Yellow Ocher
	Terre Verte (green earth)
	Orpiment (yellow)
Red Madder	Sinopia (iron oxide red)
Genuine Ultramarine (lapis lazuli)	Peach Black

Eight pigments are involved here, but the finished painting — as typical of van Eyck — would be quite colorful throughout the full range of the spectrum.

Yet in the high Renaissance, numerous paintings were more simply composed in color. Arthur Pope writes of "a brown pigment, like burnt sienna, a yellow like yellow ochre, and a blue like Prussian or cobalt blue. A Venetian red, instead of burnt sienna, might be used to extend the palette down to red-orange; or Venetian red and Indian red, or even vermilion, might be used for occasional small accents, as in the figures, with-

out altering the general scheme." In many cases no blue was used and even green might be omitted. The golden tonality of the Venetian school, most of the paintings of de la Tour, and a few Rembrandts display a limited palette consisting of little if anything more than black, white, red, orange, yellow, and brown. Yet illusion did wonders in the total effect. Pope writes, "It is common in such painting to make neutral, obtained by a mixture of white and black pigments, tell as relatively blue. In this case, a mixture of red and neutral will tell as violet. Many paintings of the Renaissance, although expressing relatively warm and cool colors, contain no positively cool tones at all. No green or blue pigments are employed in producing them."

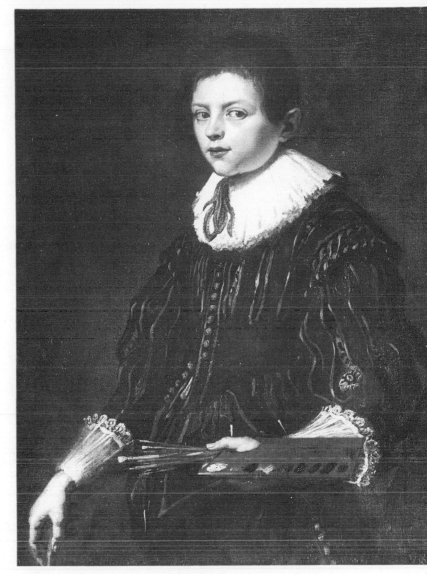

2-22. YOUTHFUL SELF-PORTRAIT. Rubens. This fine painting is said to be a youthful self-portrait of Peter Paul Rubens. (Courtesy of John G. Johnson Collection, Philadelphia.)

It is most unlikely that the Venetians did not have blue or green pigments. Perhaps, the golden tone appealed to them so much that it was glorified and featured — and blue was not necessary to achieve it. Hilaire Hiler also gives Titian's palette, as recorded by his pupil, Giacomo Palma in 1674 (but long after Titian was dead). There are eight colorants and white:

Lead white	Red ocher
Genuine ultramarine	Yellow ocher
Red madder	Orpiment (yellow, used to
Burnt sienna	make green)
Malachite green	Ivory black

2-21. THE AGED PAINTER AT HIS EASEL. Rembrandt. In this self-portrait the palette is in shadow but shows glints of red, golden yellow, and brown. (Courtesy of Louvre, Paris. Photograph by Giraudon.)

According to F. Schmid in *The Practice of Painting*, Hans Holbein the younger, famous for

his portraits of Henry VIII, probably used nothing more than light red, terre verte (green) and flake white (to form flesh tones), ivory black or burnt umber. "The vermilion was placed separately for coloring the lips and for the red of the cheeks, but it seems that Holbein made a sparse use of vermilion and very often omitted the color entirely."

Peter Paul Rubens, king of all technicians, often had a limited palette and achieved the magic of the Venetians. There might be little more than brown, black, white, red. Maroger states, "But from a distance, one has the illusion of perceiving blues, greens, violets The greatest colorists have always obtained the maximum brillance and vibration with a minimum of colors."

Rubens, who liked to mix colors in a hurry and often on the canvas itself, had the palette listed below. This has been determined by studying the colorants which Rubens originally had in his studio and which are still preserved in the Museum at Antwerp (see Hilaire Hiler).

Lead white	Genuine ultramarine
Orpiment (yellow)	Cobalt blue
Yellow ocher	Terre verte (green)
Yellow lake	Vert azur (oxide of cobalt)
Madder (red)	Malachite green
Vermilion	Burnt sienna
Red ocher	Ivory black

It is probable, however, that Rubens did not use all of these colors at any one time.

Seventeenth and Eighteenth Century Pigments and Palettes

As Jacques Maroger has pointed out, the remarkable technical facility of the Old Masters went into gradual decline in the seventeenth century. In a sense, the art of color degenerated, and for several decades — roughly from 1700 to 1760 — there was little progress. Italy went into decline. The northern European countries seemed to lose interest in art, while France gave itself to the pretentions of the rococo. England was having esthetic labor pains.

Yet during the middle and latter part of the eighteenth century, a fascination with the mysteries of color broke upon the world of art. As has been described in Chapter 1, a new breed of philosophical scholars and scientifically-minded savants created an extensive body of literature on color theory. A number of practical handbooks on color in painting were written during the seventeenth and eighteenth centuries, the more important of which will now be discussed.

One of the first eminent treatises on painting techniques — after the time of Cennini and Vasari — was that of J. B. Corneille, a scholar of great talent whose father was one of the first members of the French Academy. The book, published in 1648, told in considerable detail of the craft of the painter. However, it appeared at a rather dull hour in the history of French art, during the reign of Louis XIV, after Poussin and Claude Lorrain and before Watteau and Boucher. Two of the earliest known engravings of a palette were presented in Corneille's work — and are reproduced in Illustrations 2-24A and 24B. It should be noted that the shape of the palette has not changed much since. As listed by Corneille, the basic palette was to consist of flake white at position 1, yellow ocher at 2, light red at 3, crimson lake at 4, brown pink at 5, terre verte at 6, burnt umber at 7, and bone black at 8. (Blue was omitted.) There were other colors, however, in powder form which were to be ground with linseed oil. Among these were ultramarine, vermilion, Naples yellow and vine black. To develop the palette further, a bit of vermilion was to be placed at A, Naples yellow at B, carmine at C, ultramarine at D, and more yellow ocher at E.

LES PREMIERS
ELEMENS
DE LA
PEINTURE
PRATIQUE
Enrichis de Figures de Proportion mesurées fur l'Antique, defirées & gravées par J. B. CORNEILLE Peintre de l'Academie Royale

A PARIS,
Chez NICOLAS LANGLOIS, ruë Saint Jacques, à la Victoire.
M. DC. LXXXIV.
Avec Privilege du Roy.

2-23. TITLE PAGE, *Les Premiers Elemens de la Peinture Pratique* by J. B. Corneille. 1648. This famous treatise on painting had tremendous influence in its time.

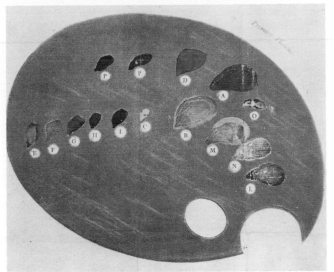

2-24A, 24B. PALETTE RECOMMENDED BY COR-NEILLE. Note shape which still is followed today. The colors were white, yellow, red, brown, green, black—with blue optional. (From *Les Premiers Elemens de la Peinture* by J. B. Corneille, 1648.)

2-26. LE BLON'S PALETTE FOR PORTRAITS. Most of the positions were occupied by flesh tones mixed in advance. (From *L'Art D'Imprimer Les Tableaux* by J. C. Le Blon, 1756.)

And below all these were to be mixed flesh tones, the lighter tints toward the thumb and the deeper shades away from the thumb.

Corneille's handbook became the popular and

2-25. THE PAINTER IN HIS STUDIO. François Boucher. The colors shown on the palette are white, yellow ocher, brown ocher, vermilion, rose madder, crimson lake, burnt sienna, and cobalt blue. (Courtesy of Louvre, Paris. Photograph by Giraudon.)

recognized tool of French painters for several decades. Boucher, for example, followed it some 60 years later, adding cobalt blue, as follows: Flake white, yellow ocher, brown ocher, vermilion, carmine, crimson lake, burnt sienna, cobalt blue. (The color selection was not unlike that later adopted by Cézanne and Gauguin.) Corneille, incidentally, advised grounds in half-tint.

In the eighteenth century, treatises on color in painting began to appear with surprising frequency. One of the first and most unique was that of J. C. Le Blon. As the previous chapter has emphasized, Le Blon is a historic figure in the history of color, being the first man to discover the primary nature of red, yellow, and blue. He not only concerned himself with the elements of color theory, but he tried his best to offer useful advice to the painter.

A Le Blon palette designed for the painting of portraits is shown in Illustration 2-26. In position A was vermilion. B was a mixture of vermilion and white. To the right (L, M, N) were lighter tints involving the addition of yellow ocher to vermilion and white. To the left (F, G, H) were shades involving the addition of black. Wrote Le Blon, "What I have mention'd will suffice to instruct one how to represent a nude, which is the most difficult of all visible Objects; and I persuade myself, that I may be learned very easily by a little good Attention."

Other treatises on color in painting were written

2-27. FRONTISPIECE, *The Art of Painting* by Gérard de Lairesse, 1738. The author, trained in Amsterdam, was eminent throughout Europe and England.

2-28. DIAGRAMS by Gérard de Lairesse. Diagrams like this were used to illustrate points regarding "lively" tints and half tints, and the influence of surroundings. (From *The Art of Painting* by Gérard de Lairesse, 1738.)

by Lairesse in 1738, Hogarth in 1753, Bardwell in 1756, and Mengs in 1783.

Gérard de Lairesse was trained in Amsterdam and became famous as a scholar and essayist in the field of art and color. His fascinating book, *The Art of Painting in All Its Branches*, beautifully illustrated with engravings, was translated and published at London in 1738. In it he wrote, "It's remarkable that, tho' the Management of the Colours in a Painting, whether of Figure, Landscapes, Flowers, Architecture, etc. yields a great Pleasure to the Eye, yet hitherto no one has laid down solid Rule for doing it with Safety and Certainty."

As to color order, he confirmed Le Blon's position, as follows:

The Number of Colours is *six*: and these are divided into *two Sorts*.

The former Sort contains the *Yellow, Red* and *Blue,* which are called *capital* Colours.

The latter is a *mixed Sort,* consisting of *Green, Purple* and *Violet;* these have the name of *broken* Colours.

White and *Black* are not reckoned among the Colours, but rather Potentials or Efficients; because the others cannot have their Effects without the Help of them.

Like others, Lairesse added mixtures to his palette: "First I temper'd on my Pallet, out of my general Mixture, three *particular colours, viz.* one for the main Light, one for the Half-shade, and one for the Shade."

A few of Lairesse's color associations and analogies will be given in Chapter 4, "The Personality of the Artist." Here are some of his diverting observations on the colors of human flesh:

The *different Colours of the Naked* are as manifold as the Objects themselves; nay, almost innumerable: but we shall confine ourselves to the *three Conditions* of *an healthy* and sick Person, and a *dead* Body; applied to a *Child, Man* and *Woman.*

The Child, being in Health, is of a rosy Colour; the Man of a warm and glowing Colour; and the Woman of a fair Colour.

But in Sickness, the Child inclines to yellowish Pale; the Man to dark Pale, or Fallow; and the Woman to a milkish or yellowish White Colour.

Being dead, the Child is violet; the Man more grey, yet somewhat yellowish; and the Woman like the Child, but more beautiful, and having the whiter Skin. . . .

Now, in order to strike the right Colour for each, take these; for the Child, White and Vermilion, it being pretty ruddy; for the Man the same, with the

Addition of some yellow Oker, which makes it more warm, and also more fiery; for the Woman, take White, a little Vermilion and some yellow Oker. And to know perfectly the proper tint of the Tenderness of each of these three Persons, you must, in Finishing, take some Smalt or Ultramarine alone, and, with a soft Fitch, scumble your Blue over *the most tender Parts* of your Figure, so that it lie soft and transparent: And you will perceive, that this Tenderness produces in each Figure, a particular and natural Colour.

Sir William Orpen writes of the first great national British painter, "In all the annals of British art there is no more illustrious name than that of William Hogarth." Because he was an engraver, because he sweated and labored to make a decent living as an artist, and because he ridiculed the social vanities of his day, he was far from popular among the pseudo-aristocrats and fashionable artists who represented top London society. Yet Hogarth did well financially, maintained his simple and honest attitude toward life and had legions of admirers.

When his book, *The Analysis of Beauty*, was published in 1753, it was immediately derided. If Hogarth was not much of a writer, his clarity of thought and direct approach to the problems of art were to be commended. Like Lairesse, he spoke of the variety of human flesh, but in a rather unusual way:

> It is well known, the fair young girl, the brown old man, and the negro; nay, all mankind, have the same appearance, and are alike disagreeable to the eye, when the upper skin is taken away. . . . nature hath contrived a transparent skin, called the cuticula, with a lining to it of a very extraordinary kind, called the cutis; both of which are so thin any little scald will make them blister and peel off. . . . The cutis is composed of tender threads like network, fill'd with different colour'd juices. The white juice serves to make the very fair complexion; — yellow, makes the brunnet; — brownish yellow, the ruddy brown; — green yellow, the olive; — dark brown the mulatto; — black, the negro.

Hogarth described a good palette (Ill. 2-31) as follows:

> There are but three original colours in painting besides black and white, viz, red, yellow and blue. Green, and purple, are compounded; the first of blue and yellow, the latter of red and blue; however these compounds being so distinctly different from the original colours, we will rank them as such. Fig. 94, represents mixt up, as on a painter's pallet, scales of

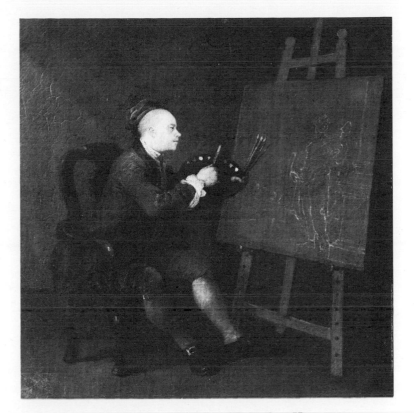

2-29. SELF-PORTRAIT. William Hogarth. He was keenly interested in color theory. (Courtesy of National Portrait Gallery, London.)

2-30. TITLE PAGE, *The Analysis of Beauty* by William Hogarth, 1753. This book was not well received by more prudent contemporaries.

2-31. ENGRAVING. William Hogarth. Note palette at top center. (From *The Analysis of Beauty* by William Hogarth, 1753.)

2-32. BARDWELL'S PALETTE. 1756. (After *The Practice of Painting* by F. Schmid, 1948.)

these five original colours divided into seven classes, 1, 2, 3, 4, 5, 6, 7. —4, is the medium, and most brilliant class, being that which will appear a firm red, when those of 5, 6, 7, would deviate into white, and those of 1, 2, 3, would sink into black.

In other words, row 4 was composed of the five base colors, with whitish tints to the left and blackish shades to the right. Frankly, the palette was not one to be emulated, and it probably was not.

One of the best books on eighteenth century painting and theories of color is that of F. Schmid, *The Practice of Painting.* Schmid has paid special attention to palettes and color circles. He is to be particularly commended for restoring to prominence the work of Thomas Bardwell. Bardwell's book, *The Practice of Painting and Perspective Made Easy,* originally published in 1756, was popular for many years; it was reprinted many times and translated into other languages — often, unfortunately, without credit to the author. In fact, Bardwell's ideas were patented, and no copy of his book was "genuine that has not my name." Yet he was copied, plagiarized, and otherwise exploited with little conscience by others.

Bardwell's palettes were beautifully organized. A redrawing of one of them in black and white outline is shown in Illustration 2-32. In painting a portrait, Bardwell recommended more than one palette. A first palette for the first and second sittings would have white, yellow ocher, light red, vermilion and various tints in pink, rose, blue, green, gray, brown. A second palette for finishing the portrait would contain "the tints laid as in the first, with the additional ones made from Lake, Brown pink, Ivory black, and Prussian blue."

Study the Bardwell palette. To the left are:

1. Flake white	7. Crimson lake
2. Yellow ocher	8. Ultramarine
3. Light red	9. Prussian blue
4. Indian red	10. Brown pink
5. Vermilion	11. Burnt umber
6. Carmine	12. Ivory black

Adjacent to these base colors is a first row of five mixed tints for use in painting flesh:

A. Yellow ocher with flake white
B. Light red with flake white
C. Vermilion with flake white
D. Carmine with flake white
E. Crimson lake and Indian red with flake white

Next is a row of three mixed middle tints:

F. Ultramarine with flake white
G. Ivory black with flake white
H. Prussian blue and yellow ocher with flake white

Finally is a row of four mixed shades:

I. Crimson lake, Indian red, ivory black and flake white
J. Crimson lake and Indian red
K. Crimson lake and brown pink
L. Ivory black and Indian red

Note that the four shades are on the warm and brownish side. (Other palettes were to be used for landscapes.)

Bardwell was followed by John Cawse. Both men were painters of good skill and repute. As Schmid reports, Cawse more or less repeated the principles of Bardwell. Indeed, some of Bardwell's palettes are to be found in Cawse's book *The Art of Painting in Oil Colors,* over 60 years later, without explanation or acknowledgment.

Thus Cawse, like Bardwell, described and illustrated a number of palettes. His palette for a *first* sitting for a portrait was flake white, Indian red, black, a tint mixture of Indian red, black and white. For a *second* sitting he recommended Flake white, brown ocher, light red, Indian red, black. For the *third* or last sitting he wrote, "The colours here used are the same as those for the second sitting, with the addition of vermilion, lake, and Prussian blue, which may be changed for ultramarine."

For the *background* of a portrait, he listed

white, brown ocher, Indian red, raw umber, burnt umber, blue, black, a tint of Indian red with black.

First and second palettes for the painting of a landscape, as devised by John Cawse, are shown in Illustrations 2-33A and 33B. For the first painting, his colors were white (a), brown ocher (b), blue black (c) — with space for three tints of the brown and blue (1, 2, 3). For the finishing, he recommended flake white (a), light ocher (b), brown ocher (c), brown pink (d), burnt sienna (e), burnt umber (f), lake (g), black (h), Indian red (i), Prussian or Antwerp blue (k), ultramarine (1).

Note the absence of pure yellow and green. Space is allowed for three tints each (1, 2, 3) of the light ocher, brown ocher, brown pink, burnt sienna and burnt umber. Further mixtures, of course, could be placed in the blank areas of the palette.

In a memorandum of 1755, Sir Joshua Reynolds left this short record for the arrangement of a palette:

> For painting the flesh, black, blue black, white, lake, carmine, *orpiment,* yellow ocher, ultramarine, and varnish.
>
> To lay the palette:—first lay carmine and white in different degrees, second lay *orpiment* and white, ditto; third, lay blue black and white, ditto.
>
> The first sitting, make a mixture on the palette for expedition, as near the sitter's complexion as you can. . . .

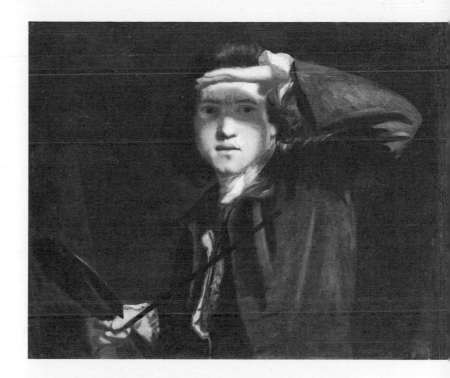

2-34. SELF-PORTRAIT. Sir Joshua Reynolds. He worked with a small and limited palette. (Courtesy of National Portrait Gallery, London.)

Eighteenth century thinking was expressed in the famous work of Anthony Raphael Mengs (1728-1779), court painter in Saxony, Madrid, and Rome. Mengs was something of a Vasari who wrote extensively on painting, architecture and music, plus critical essays on the Old Masters. The first edition of his work appeared in Italy in 1783 and was later translated and published in England in 1796.

Mengs was an active disciple of Johann Winckelmann, the archaeologist who championed a classical revival in art. (See Chapter 10.) Unfortunately, the new estheticism led to certain pedantic and dull exercises which brought lethargy rather than spirit to the art of painting.

However, Mengs was one of the great scholars of his day and was greatly interested in color. (One of his paintings is shown on page 50.) Because he painted in a tight, classical style, his palette was neatly organized and set. Mengs used the following thirteen colors:

2-33A, 33B. PALETTES. John Cawse. A follower of Bardwell, Cawse proposed these palettes for the painting of a landscape. (From *Introduction to the Art of Painting* by John Cawse, 1829.)

1. Flake white	8. Cobalt blue
2. Naples yellow	9. Terre verte
3. Yellow ocher	10. Burnt sienna
4. Brown ocher	11. Raw umber
5. Light red	12. Burnt umber
6. Vermilion	13. Ivory black
7. Crimson Lake	

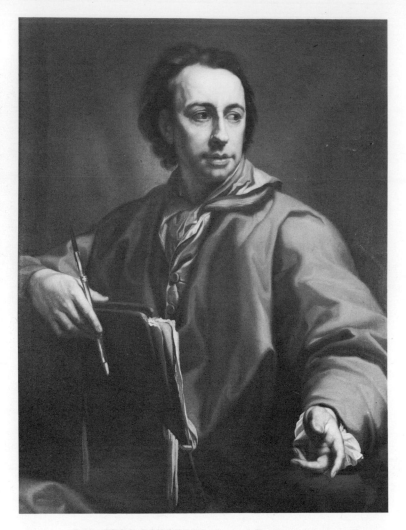

2-35. SELF-PORTRAIT. Anton Raphael Mengs. He was a great scholar and classical painter. His writings were translated into several languages. (Courtesy of Frankfurter Goethe-Museum.)

2-36. PORTRAIT OF GOYA. Lopez. See Illustration 2-37 for diagram of Goya's palette. (Courtesy of Museo del Prado, Madrid.)

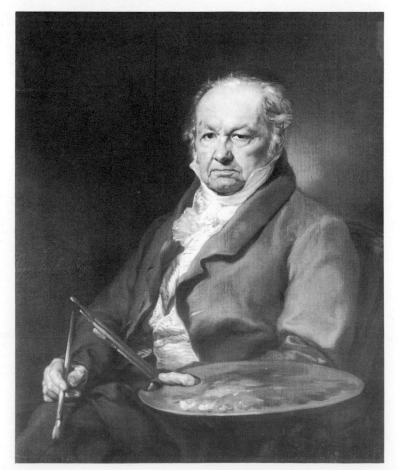

He then added five light tints, presumably for flesh: Naples yellow, yellow ocher, brown ocher, and two tints of white — one with yellow ocher and the other with light red.

Next came the middle tints made up of white with ivory black, yellow ocher and light red; then three shades made up of ivory black with yellow ocher and light red.

Finally, Mengs had four tones for glazing, to which asphaltum was added for transparency. There was a glaze of Naples yellow and crimson lake, one of crimson lake and vermilion, one of crimson lake and light red, and one of crimson lake and burnt sienna.

Before discussing a few palettes of early American painters, let me include the palette of the eminent Francisco de Goya (1746-1828), painter and portraitist to the court of Charles IV of Spain. He was one who preferred the dramatic and realistic in art.

Goya was one of the great individualists of Spanish art. He worked in practically all mediums and was remarkable for a vigorous style and for historical and often bitter satirical compositions. His palette has been described by James W. Lane and Kate Steinitz in an article in *Art News*, December 1-14, 1942. The palette, shown in the Illustration 2-37, was arranged as follows:

1. Flake white	7. Burnt sienna
2. Naples yellow	8. Crimson lake
3. Yellow ocher	9. Cobalt blue
4. Brown ocher	10. Raw umber
5. Light red	11. Burnt umber
6. Vermilion	12. Ivory black

2-37. GOYA'S PALETTE. It contained twelve colors, with green omitted. (After "Palette Index" by James W. Lane and Kate Steinitz, *Art News*, Dec. 1—14, 1942.)

Green is omitted, but Goya could readily mix it using cobalt blue. (Lane and Steinitz do not identify the A, B, C and D colors, but these probably refer to color mixtures and a flesh tone.)

Early American Palettes

The Colonial artists of America were largely English by tradition and often by birth. They were a closely knit group, whose members frequently studied together, journeyed to London together, and painted very much alike. Colonial painters will be discussed more fully in Chapter 13.

Quite a bit is known about palettes in Colonial days. And quite often the Colonial artists painted themselves and each other, palettes in hand. A few such illustrations are included here — and more are shown in Chapter 13. Where facts as to basic color choice are accurately known, they are given here; the discussion in Chapter 13 is more general in scope.

In the Metropolitan Museum of Art in New York is a very engaging painting by one Matthew Pratt (1734-1805). Entitled "The American School" or "The American Academy," it shows a group of artists in the studio of Benjamin West in London (Ill. 2-38). West (1738-1820), American born, went to England at a young age and

2-38. THE AMERICAN SCHOOL. Matthew Pratt. Here are Benjamin West and students in London. The two palettes are described in the text. (Courtesy of The Metropolitan Museum of Art. Gift of Samuel P. Avery, 1897.)

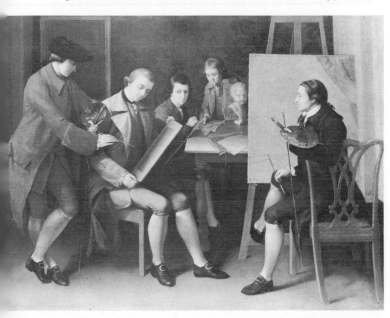

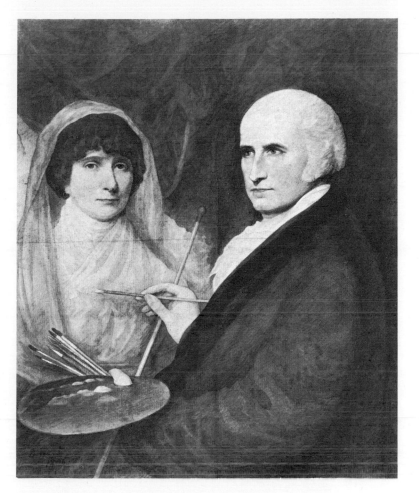

2-39. BENJAMIN WEST AND HIS WIFE. Benjamin West. Unfortunately, the colors on the palette are indistinct. However, the colors employed by West in teaching are fairly well known. (Courtesy of Philadelphia Museum of Art.)

eventually became historical painter to George III and second president of the Royal Academy.

West was the most famous American artist in England. (He was later joined by another expatriate, John Singleton Copley.) In the painting, "The American School," West is at the left, pointing to a drawing by Pratt. The others present have not been identified. The palette held in West's hand contains (in general terms) white, vermilion, burnt sienna, red ocher, an earth green, more white, deep brown, deep greenish blue and mixtures of a bluish tone and a reddish tone. The palette held by the gentleman at the right has white, vermilion, red ocher, yellow, yellow ocher, brown, black, dark blue plus a mixed green.

Benjamin West was visited in London by many Americans, including Charles Willson Peale, Gilbert Stuart, John Trumbull, and Thomas Sully. Charles Willson Peale (1741-1827) founded the first American museum, in Philadelphia, and was a famous painter of portraits.

2-40. STAIRCASE GROUP. Charles Willson Peale. The palette is described in the text. (Courtesy of Philadelphia Museum of Art.)

In two of his paintings palettes are depicted. The "Staircase Group," shows two of Peale's sons, Raphael and Titian, going up a narrow stairway (Ill. 2-40); the picture was originally shown in 1795 with a wood door frame on top and sides and an actual wood step at the bottom. The palette in the painting has white, brown, red, burnt sienna, yellow ocher and a bluish black. However, in "The Peale Family," a palette at the left has glints of yellow ocher, bright orange, white, black, and a dull deep green (Ill. 2-41).

The palette of Gilbert Stuart (1755-1828) was quite accurately recorded by Matthew Harris Jouett in 1816 (Ill. 2-42). The colors were as follows:

1. Antwerp Blue
 (Prussian Blue)
2. White
3. Yellow
4. Vermilion
5. Crimson lake
6. Burnt umber
7. Black

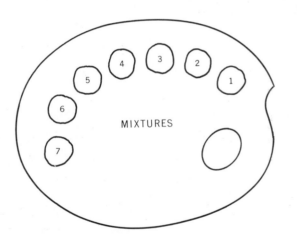

2-42. GILBERT STUART'S PALETTE. Notice that green was left out. This palette was described to Matthew Harris Jouett in 1816 by Stuart himself. (From *Hints to Young Painters* by Thomas Sully, 1873.)

In addition, these were mixtures of yellow and white; vermilion and white; yellow, white and vermilion; vermilion, white and crimson lake; crimson lake and vermilion. Green was to be made by combining yellow and black.

Like West, Gilbert Stuart knew such Colonial painters as John Trumbull, Thomas Sully — and the eminent Benjamin West himself. According to Stuart, "Coloring at best is a matter of fancy and taste Good drawing is the life of all, without which coloring is moonshine."

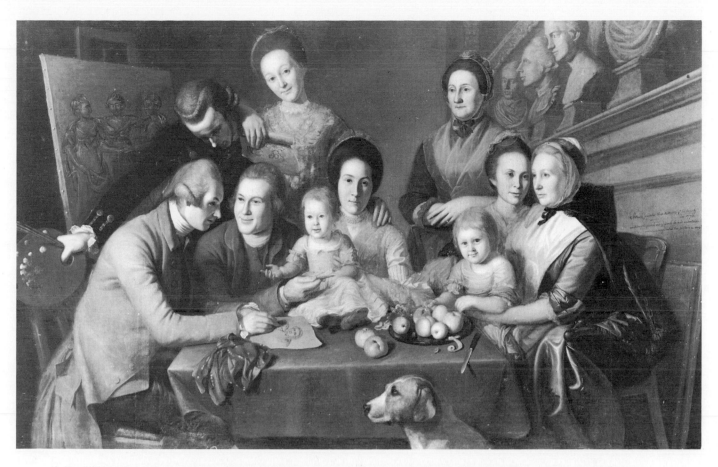

2-41. THE PEALE FAMILY. Charles Willson Peale. Note the palette at the left. The sons were named for Raphael, Titian, Rubens, and Rembrandt. (Courtesy of the New-York Historical Society, New York City.)

2-43. SELF-PORTRAIT. Henry Benbridge (1743-1812). He lived in North Carolina and Virginia and was an early teacher of Thomas Sully. The colors on his palette are white, red, yellow, flesh tone, orange, black, and brown. (Courtesy of The Detroit Institute of Arts.)

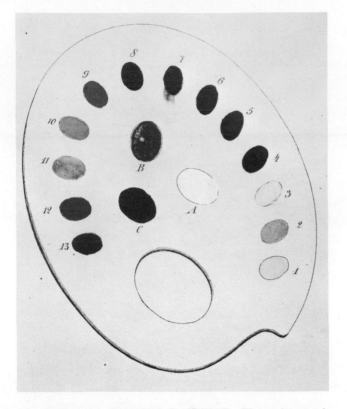

2-44. THOMAS SULLY'S PALETTE. There is an absence of green pigment. (From *Hints to Young Painters* by Thomas Sully, 1873.)

Finally, consider the palette of Thomas Sully (1783-1872) which is described in his book, *Hints to Young Painters*, published a year after his death in Philadelphia. Sully, a historical painter, did such patriotic subjects as "The Passage of the Delaware," and hundreds of portraits. His palette was composed of these pigments and mixtures. (Ill. 2-44).

1. Yellow ocher and white	8, 9, 10, 11. Mixtures of raw umber and white, used for flesh tones.
2. Burnt sienna and white	
3. Ultramarine blue	12. Raw umber, white and burnt sienna
4. Burnt sienna	
5. Vermilion	13. Raw umber and burnt sienna
6. Indian red (red ocher)	A. Flake white
7. Raw umber	B. Yellow ocher
	C. Ivory black

Sully in the painting of portraits recommended a canvas covered with a middle tint composed of black and white. Burnt umber was then used to sketch out the subject "as if you were using water-colors."

The colors of his palette were then applied in subsequent sittings (about six sittings in all), with a free use of glazes. He argued with Gilbert Stuart: "I myself have heard Stuart say that he considered the nose the most important feature in giving the likeness to a portrait. I am sorry to differ in opinion from so great a master, but my experience does not prove it to be so. I believe the mouth to be the most important feature in forming the resemblance."

Chapter 3

Modern Palettes
and Techniques

Palettes and techniques of the nineteenth and twentieth century will be discussed here. Many of the colors listed in the palettes to be described are included in the chart on pages 106-107.

Perhaps the most important book on painting of the early nineteenth century was *The Art of Painting in Oil and Fresco* by J. F. L. Mérimée. The original manuscript had been approved by the Institute of France and published in 1830. W. B. Sarsfield Taylor translated the work into English and had it issued at London in 1839, with a dedication to the president and members of the Royal Academy.

In the book Mérimée discussed varnishes, pigments, vehicles, and the technique of painting. He defended the van Eycks as the inventors of oil painting, eulogized the methods of the Old Masters, referred to Lairesse and Mengs, and reviewed the craft of painting. But if the work was famous in its own time, it soon became an epitaph of a dead past — an obsolete and quaint record of an earlier age.

The Classicists

The classical revival of the nineteenth century, inspired by the German archaeologist, Johann Winckelmann, found its greatest painter in Jacques Louis David (1748-1825), who was the senior and teacher of Ingres (1780-1867). Both were meticulous craftsmen who used color exquisitely but who, like so many masters of the Renaissance, thought of it chiefly as a handy medium for the modeling of form.

David's color was probably as "tight" as his painstaking drawing. There is evidence from recent restorations of his canvases that he successively altered his muted colors, working them over and over to achieve the plastic effect he wanted. As a consequence, some of his paintings look as if they were originally done in black and white and the color added later — as one might stain or tint a photograph. For that matter, David often drew naked figures to be sure of a sculptural effect, and then added the clothing afterward.

According to Moreau-Vauthier, David's palette was composed as follows:

White lead	Cassel earth
Naples yellow	Ivory black
Yellow ocher	Peach or vine black
Ru ocher	Prussian blue
Roman ocher	Ultramarine blue
Red brown	Mineral gray
Burnt sienna	Cinnabar
Crimson lake	Vermilion

Toward the end of his career he added light chrome and dark chrome yellow, but only for the modeling of drapery.

David, and Ingres after him, insisted on sound technical knowledge. The old school demanded a basic grounding in craftsmanship, while the younger generation, led by the romantic Delacroix, was all for kicking over the traces. It is unfortunate that a compromise of some sort was not reached. Although Delacroix might have wished to exploit the spectrum to its fullest, Moreau-Vauthier writes that he "painted with the most complete technical ignorance." Yet

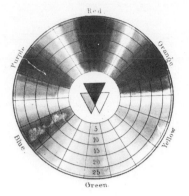

3-1. TITLE PAGE AND FRONTISPIECE, *The Art of Painting in Oil and Fresco* by M. J. F. L. Mérimée. 1839. This famous work on painting told a distinguished story but marked the end of an era.

3-2. SELF-PORTRAIT. Jacques Louis David. The greatest of French classical painters, David worked for photographic realism. (Courtesy of Louvre, Paris. Photograph by Giraudon.)

3-4. MADAM LEBLANC. Jean Auguste Ingres. The major areas are blackish and brownish. The dress is black. The complexion is fair, with pale rosy cheeks and blue eyes. In the brocade are touches of white, soft gold, soft red, soft green. (Courtesy of The Metropolitan Museum of Art, Wolfe Fund, 1918.)

3-3. SELF-PORTRAIT. Jean Auguste Ingres. He was a student of David and a power in French art in the mid-nineteenth century. (Courtesy of The Metropolitan Museum of Art. Bequest of Grace Rainey Rogers, 1943.)

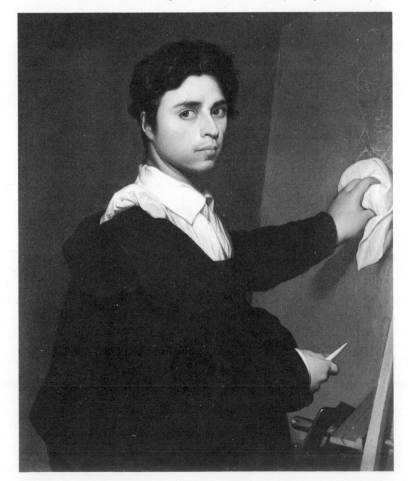

David and Ingres who commanded their materials, often painted in a dull, ashen, and petrified way.

The palette of Ingres according to Moreau-Vauthier, was as follows:

White lead	Cinnabar
Silver white	Red brown
Naples yellow	Van Dyck brown
Yellow ocher	Cobalt blue
Ru ocher	Mineral gray
Raw Verona brown	Prussian blue
Raw sienna	Ivory black
Burnt sienna	Scarlet madder
Vermilion	

Ten of the colors are the same as David's. Both men were "thin" painters and used color as an adjunct to form — not for any intrinsic power as did Turner, nor to construct form itself as Cézanne would do.

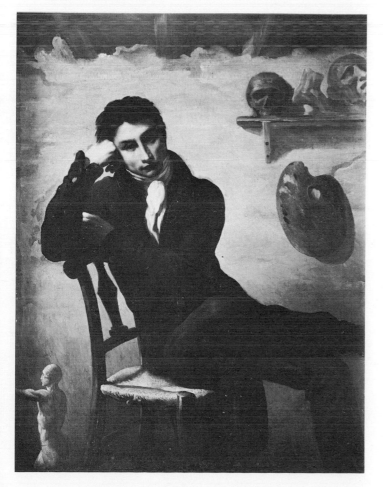

3-5. SELF-PORTRAIT. Théodore Géricault (1791-1824). He inspired Delacroix. (Courtesy of Louvre, Paris. Photograph by Giraudon.)

Eugène Delacroix

Théodore Géricault was one of the first painters of the early nineteenth century to revolt against the French Academy and was the man who helped to kindle the spirit of Eugène Delacroix (1799-1863). It is interesting to note that in the execution of Géricault's most famous painting, "The Raft of the Medusa," Delacroix posed for one of the figures (see Ill. 10-20). Géricault's palette, listed by Moreau-Vauthier, was as follows:

Vermilion	Burnt sienna
White	Lake (crimson?)
Naples yellow	Prussian blue
Yellow ocher	Peach black
Verona brown	Ivory black
Ru ocher	Cassel earth
Raw sienna	Bitumen
Red brown	

Géricault painted rather thickly, with scrupulous attention to detail, but differed radically from Ingres and the Academy because of his romantic attitude and the action and realism of his compositions.

Delacroix, apostle of color, even if not the best of technicians, was one of the most devoted colorists of all time. In his *Journal*, he wrote with considerable emotion:

> David and his school imagined that they could produce the tones Rubens got with frank and vivid colors such as bright green, ultramarine, etc., by means of black and white to make blue, black and yellow to make green, red ocher and black to make violet, and so on. They also used earths, such as umber, Cassel, and ochers, etc. . . . Each of these relative greens and blues plays its part in the attenuated scale, especially when the picture is placed in a vivid light which penetrates the molecules and gives them the utmost brilliance of which they are capable. But if the picture is hung in the shade or parallel to the rays of light, the earths become earths again, and the tones lose all play, so to speak. Above all, if the picture be placed near a richly colored work such as a Titian or a Rubens, it appears what it really is: earthy, dull, and lifeless. "Dust thou art, and unto dust shalt thou return."

Few other artists have shown a passion for color equal to that of Delacroix. His perception and sensitivity were phenomenal. Moreau-Vauthier recounts the following incident about him:

3-6. COMBAT BETWEEN GIAOUR AND THE PA-
SHA. Eugène Delacroix. His approach was a bold one and
gave impetus to Impressionism. (Courtesy of The Art In-
stitute of Chicago. Gift of Mrs. Bertha Palmer Thorne,
Mrs. Rose M. Palmer, and Mr. and Mrs. Arthur M.
Wood.)

Delacroix once painted a yellow drapery without
succeeding in giving it the emphasis he desired. He
determined to go to the Louvre to see some similar
draperies painted by Rubens, and he sent for a hack-
ney cab. It was towards the year 1830, when Parisian
cabs were painted canary yellow. In the street Dela-
croix saw the cab waiting for him in the sun, and
noticed that the yellow of the cab produced violet
in the shadow which was untouched by the sun. He
paid the cabman, and went in again; he knew what
he had wanted to find out.

Yet, the exuberance of Delacroix was not
matched by equal facility with his materials. One
is reminded of van Gogh who also was impatient
and wished he could project his mind directly on
canvas — with no clumsy brushwork to interfere.
Moreau-Vauthier writes: "Delacroix, feverish and
uneasy, was unable to materialize his thought
when he took palette and brushes in hand, and set
himself to paint; his material betrayed him,
because, lacking all confidence in it, he knew not
how to treat it, and he spent his life in making
experiments and trying the most contradictory
receipts."

Entries in *The Journal of Delacroix* (like the
letters of van Gogh) are cherished memorabilia
in the literature of art and color. There are almost
endless descriptions of color combinations, notes

on the pigments he used, ideas to remember in
the execution of future paintings. (The complete
Journal, in French, covers some 1,500 pages.) No
attention to color could be too small.

René Piot, in a delightful book, *Les Palettes de
Delacroix*, has documented this particular in-
terest of the French painter. Following the teach-
ings of artists before him, Delacroix developed
palettes which combined basic colorants with
pre-mixed variations (a practice that was later
abandoned for the most part by the Impression-
ists). And more, he used differently organized
palettes for different projects. A number of these
are described by Piot, and four are illustrated in
full color in his book.

Two such palettes from Piot's work are shown
in Illustrations 3-7A, 7B, and 3-9A, 9B. The first
is a fairly simple one which Delacroix himself
called the palette of Van Dyck. According to
Piot, around 1845 one Baroness de Meyendorf
acquainted Delacroix with the palette of Van
Dyck and the Frenchman made an adaptation of
it for certain paintings in the library of the
Luxembourg palace (Ill. 3-8A, 8B). (There is a
statue of Delacroix in the gardens.) The base
colors of Van Dyck and Delacroix were the same
except that the former used a Titian green and
the latter an emerald. Here are the ten base
colors of the Delacroix-Van Dyck palette:

1. White
2. Naples yellow
3. Yellow ocher
4. Vermilion
5. Ultramarine blue
6. Emerald green
7. Raw sienna
8. Charcoal black
9. Red lake
10. Van Dyck brown

3-7A, 7B. VAN DYKE PALETTE OF EUGENE DELA-
CROIX. This was composed of ten basic colors and eight
mixtures. (From *Les Palettes de Delacroix* by René Piot,
1931.)

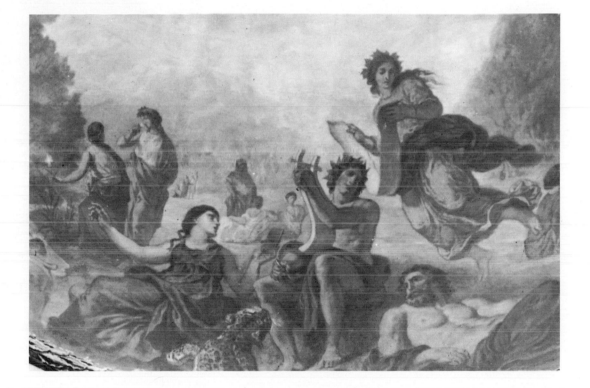

3-8A, 8B. LUXEMBOURG MURAL and Detail. Eugène Delacroix. Subjects are from Dante's *Divine Comedy*. (Courtesy of National Archives of France.)

To this Delacroix added nine mixed colors, a practice followed during his time. These were composed of the original base colors toned with white:

A. Naples yellow with white
B. Charcoal black with white
C. Yellow ocher with white
D. Vermilion with white
E. Raw sienna with white
F. Van Dyck brown with white
G. Red lake with white
H. Emerald green with white
I. Ultramarine blue with white

A second and more elaborate Delacroix palette, which he used for mural paintings in the chapel of the Saints and Angels at St. Sulpice in Paris, had 23 base colors, as follows:

1. White
2. Naples yellow
3. Yellow ocher
4. Ru ocher
5. Vermilion
6. Red brown
7. Cobalt blue
8. Florentine brown
9. Emerald green
10. Raw sienna
11. Burnt sienna
12. Cassel earth
13. Ivory black
14. Raw umber
15. Prussian blue
16. Burnt umber
17. Mummy
18. Brown lake deep
19. Purple madder lake
20. Golden yellow lake
21. Cadmium yellow
22. Verona earth (green)
23. Zinc yellow

The color listed as mummy is defined by Ralph Mayer as follows: "Bone ash and asphaltum, ob-

tained by grinding up Egyptian mummies. Not permanent. Its use was suddenly discontinued in the nineteenth century when its composition became generally known to artists."

As with his Van Dyck palette, Delacroix added mixtures of the base colors. These were as follows:

A. Purple madder lake and white
B. Cadmium yellow and white
C. Prussian blue and white
D. Golden yellow lake and white
E. Naples yellow and white
F. Vermilion and white
G. Yellow ocher and white
H. Florentine brown and white
I. Mummy and white
J. Red brown and white
K. Emerald green and white
L. Vermilion, cadmium yellow and white
M. Vermilion, cadmium and golden yellow lake
N. Cobalt blue, vermilion and white
O. Madder lake, Prussian blue and white
P. Raw sienna and emerald green
Q. Madder lake and white
R. Raw sienna, burnt sienna and red brown
S. Prussian blue, raw umber and white
T. Cassel earth and white
U. Ivory black and white
V. Raw umber and white
X. Burnt umber and white

Impressionism

F. Schmid in his excellent book, *The Practice of Painting*, illustrates a palette devised by Libertat Hundertpfund in 1849, an adaptation of which is shown in Illustration 3-10. Here was a color selection — somewhat like that of David and Géricault — composed solely of base colors or pigments *and completely devoid of mixed tones*. To make this clear, it should be mentioned that a mixed color is one that combines two or more pigments in one paste and is then included on a palette as if it were a separate color by itself. Many examples of mixed colors have been given in the palette lists and descriptions in this and the preceding chapter. Obviously, the artist uses the blank areas of his palette to mix his colors, taking a bit from here or there, swirling things about with brush or palette knife, and applying the mixture to his canvas.

Hundertpfund's palette was made up as follows: (The numbers are as arranged in the illustration. Reds are in the center, with yellows and ochers to the right, and with violets, blues and greens to the left.)

IV. White	12. Cobalt blue
8. Naples yellow	13. Prussian blue
7. Yellow ocher	14. Cobalt green
6. Gold ocher	a. Veronese green
5. Roman ocher	b. Ultramarine ashes
4. Burnt sienna	c. Burnt Veronese green
3. Light red	d. Mummy
2. Vermilion	e. Asphaltum
1. Madder lake	I. Graphite
9. Indian red	II. Blue black
10. Violet mars	III. Ivory black
11. Ultramarine	

3-9A, 9B. DELACROIX PALETTE. This complicated palette had 23 basic colors and an equal number of mixtures. Note omission of number 18 on the diagram, probably through an oversight; this was a deep brown, as listed in the text. (From *Les Palettes de Delacroix* by René Piot, 1931.)

3-10. PALETTE OF LIBERTAT HUNDERTPFUND. 1849. Here is one of the first palettes that was limited to base colors and pigments omitting mixtures — a practice followed by most artists since. (From *The Practice of Painting* by F. Schmid, 1948.)

(Note that the color, mummy, is included here also.) Hundertpfund's palette omitted mixed colors, a practice that has been followed up to the present day.

As the nineteenth century progressed, an artist no longer needed to prepare pigments or vehicles. There were manufacturers and dealers to supply him. In England, for example, which had large tin deposits, manufacturers began to offer prepared colors in tubes. In 1830 Mérimée thought this would be a fad, for he wrote, "It is hardly probable that many English painters have adopted this expedient." But prepared colors in tubes, jars, and packets became the universal rule, and virtually every painter after Delacroix relied on them.

Thus in the several palettes to be described in the following pages, almost all exhibit the pure color, colorant, or toner — as squeezed from tubes. (The term colorant refers to a color that has been preadjusted to a specific hue and set up as a standard for the artist. A toner is a pigment taken straight as it comes from nature or the chemist's laboratory.) Later schools of painting, however, would bring back the mixed or scaled palette in which the artist forces his pigments to answer laws of vision, not the other way around. Mixed palettes will be discussed later in this chapter.

The palette of Jean Baptiste Corot (1796-1875), whose romantic and refined landscapes are so well known, was composed entirely of basic pigments and was fairly extensive, having 17 colors. It is described and illustrated in the article by Lane and Steinitz in *Art News* previously mentioned.

The palette itself was rectangular in shape (Illus. 3-12), and its pigments ran straight across the top and straight down at the left, as follows:

1. Yellow lake	10. Verona green
2. Light cadmium	11. Rose madder
3. Cadmium yellow	12. Robert's lake
4. Lead white	13. Cobalt blue
5. Naples yellow	14. Prussian blue
6. Yellow ocher	15. Emerald green
7. Raw sienna	16. Umber
8. Burnt sienna	17. Cassel earth
9. Vermilion	

About half of these are muted toners and perhaps account for the subtle and restrained taste

←
3-11. SELF-PORTRAIT. Jean Baptiste Corot. Corot's style was soft, delicate, and atmospheric. (Courtesy of Uffizi, Florence. Alinari-Art Reference Bureau.)

3-12. COROT'S PALETTE. It contained 17 colors. (After "Palette Index" by James R. Lane and Kate Steinitz, *Art News*, Dec. 1-14, 1942.)

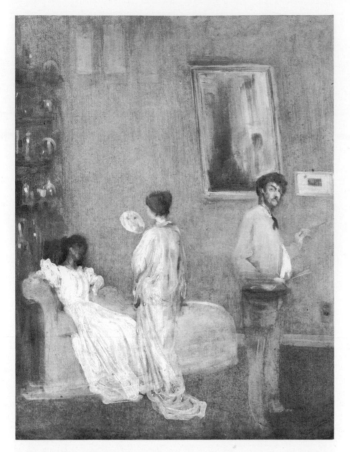

3-13. THE ARTIST IN HIS STUDIO. James McNeill Whistler. In this canvas the colors are mostly pale grays, with slight touches of gold. (Courtesy of The Art Institute of Chicago. Friends of American Art Collection.)

3-14. NOCTURNE IN GREEN AND GOLD; CREMORNE GARDENS, LONDON, AT NIGHT. James McNeill Whistler. (Courtesy of The Metropolitan Museum of Art.)

of Corot. The selection is quite complete and well balanced, and any artist today could do much with it.

James McNeill Whistler (1834-1903) also favored a muted color scheme. Because so many of his effects were subtle and atmospheric, perhaps he found it necessary to work with premixed shades and tones — possibly a scale of grays to which glints of purer hue were added. According to Lane and Steinitz, Whistler's palette consisted of a shallow square box with a number of compartments. Of ten base colors, eight were on the dull side.

1. White	7. Burnt sienna
2. Yellow ocher	8. Umber
3. Raw sienna	9. Cobalt blue
4. Vermilion	10. Mineral blue
5. Venetian red	11. Black
6. Indian red	

As to the Impressionists themselves, quite a bit is known about their color and pigment choices. Impressionist palettes are described and illustrated here, and further references will be found in Chapter 11.

Camille Pissarro (1830-1903), one of the earliest, most versatile of the Impressionists, completely eliminated blacks, browns, and ochers from his palette. He told Cézanne, "Never paint except with the three primary colors and their immediate derivatives." His example was quickly followed, and soon the Impressionists began flicking spectral light over their canvases — not just in highlight but in shadow and everywhere.

Pissarro's palette is shown in Illustration 3-15. It was concisely limited to seven pigments squeezed from tubes:

1. White lead	5. Ultramarine blue
2. Chrome yellow	6. Cobalt blue
3. Vermilion	7. Cobalt violet
4. Rose madder	

3-15. PALETTE OF CAMILLE PISSARRO. Simple and direct, this palette helped to key the bold approach of the Impressionists. (After "Palette Index," by James W. Lane and Kate Steinitz, *Art News*, Dec. 1-14, 1942.)

3-16. ARTIST'S PALETTE. Camille Pissarro. Ca. 1878. This unique work of art, a pastoral scene, was done on a wooden palette. (Courtesy of Sterling and Francine Clark Art Institute, Williamstown, Massachusetts.)

There is a curious absence of green, a color, however, which could readily be mixed from yellow and blue. Yet Pissarro's bold use of pure color in his compositions reflects the simple design of his palette. His broken tones, scintillating daubs, and reliance on visual mixtures all distinguish him as one of the leading and most typical artists of his progressive day.

Monet (1840-1926), who painted in a style similar to that of Pissarro, also eliminated those browns which had been commonly used before, particularly to rough out the masses of a composition and to wash in shadows. Monet preferred a white canvas and wholly opaque pigments. He cast aside the tradition of thinking in terms of light and dark areas (natural to chiaroscuro) and painted as if applying light rays with his brush. So-called values came spontaneously as he worked, not by deliberation.

Monet's colors for the most part were thickly applied with bold and fairly large strokes. More and more he avoided mixed colors for pure primaries. What he saw was not light and shade but illuminated and unilluminated surfaces — with colors shining and reflecting everywhere.

Shown in Illustration 3-17A is a detail photograph of one of Monet's paintings of Rouen Cathedral taken with raking light — a strong beam of light thrown sharply across the canvas from one side. This accents the plastic quality of the artist's technique by revealing the thickness of his paint and other characteristics of his style. It will be noted that Monet — in this painting, at least — worked opaquely but let his application of paint follow the general surface quality of what he saw before him. He was a master at this.

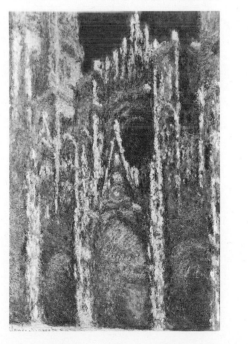

3-17A, 17B. CATHEDRAL OF ROUEN and Detail. Claude Monet. The photograph of the detail, taken with raking light, shows the artist's technique. His pigments were given a plastic texture that was related to the character of his subject. (Courtesy of Museum of Fine Arts, Boston.)

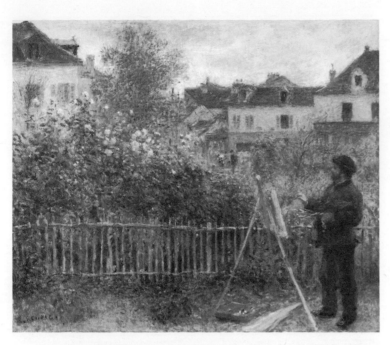

3-18. MONET PAINTING IN HIS GARDEN. Pierre Auguste Renoir. (Courtesy of Wadsworth Antheneum, Hartford.)

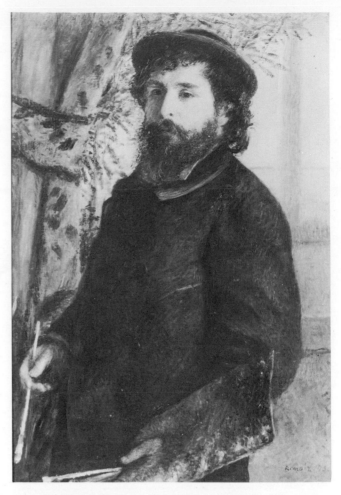

3-19. PORTRAIT OF CLAUDE MONET. Pierre Auguste Renoir. Monet and Renoir had different styles, but they shared a belief in the simple palette. (Courtesy of Louvre, Paris. Photograph by Giraudon.)

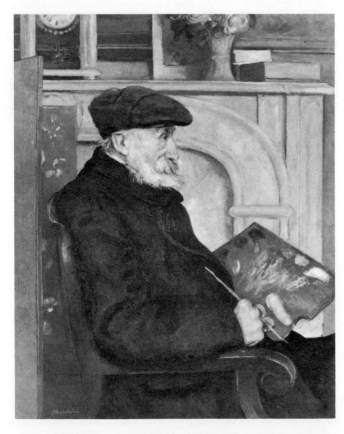

3-20. PIERRE AUGUSTE RENOIR. Albert Andre. Here is Renoir with his palette, as painted by a contemporary. (Courtesy of The Art Institute of Chicago. Stickney Fund.)

3-21. WOMAN READING. Pierre Auguste Renoir. Much of the power and genius of this painter, his mastery over light, is revealed in this simple composition. (Courtesy of National Archives of France.)

Renoir (1841-1919) was not so fascinated by plastic texture and worked more softly and delicately with paint. This is quite evident in any close inspection of his canvases. His palette, recorded in the *French Encyclopedia*, 1935, was as follows:

Silver white	Verona earth (green)
Red madder	Naples yellow
Red ocher	Yellow ocher
Cobalt blue	Raw sienna
Emerald green	Ivory black
Cobalt green	

The son, Jean Renoir, has written of his father, "As he grew older, he simplified his palette more and more. . . . Each nuance is obtained by using paints from different tubes. . . . Renoir used eight or ten colors at most. They were ranged in neat little mounds around the edge of his scrupulously clean palette. From this moderate assortment would come his shimmering silks and his luminous flesh tones."

Renoir delighted in the use of black, but not for paint mixtures. Black was sometimes employed dramatically and impulsively in large areas to heighten the brilliance of the rest of the composition. According to John Rewald in *The History of Impressionism*, Renoir described his methods to the American painter, Walter Pach, as follows:

> I arrange my subject as I want it, then I go ahead and paint it, like a child. I want a red to be sonorous, to sound like a bell; if it doesn't turn out that way, I put more reds or other colors till I get it. I am no cleverer than that. I have no rules and no methods; anyone can look at my materials or watch how I paint—he will see that I have no secrets. I look at a nude; there are myriads of tiny dots. I must find the ones that will make the flesh on my canvas live and quiver. Nowadays they want to explain everything. But if they could explain a picture it wouldn't be art. Shall I tell you what I think are the two qualities of art? It must be indescribable and it must be inimitable. . . . The work of art must seize upon you, wrap you up in itself, carry you away. It is the means by which the artist conveys his passion; it is the current which he puts forth which sweeps you along in his passion.

Renoir's colors are not flat, nor do they match the subject itself. They are mingled, juxtaposed, streaked without apparent unity. Yet from a distance they do indeed "live and quiver."

Cézanne (1839-1906) wanted solidity, not mere scintillation. He saw nature in terms of the cylinder, the sphere, and the cone. Color could give dimension, form, plasticity, structure to nature. He wrote, "Painting, by means of drawing and color, gives concrete shape to sensation and perception."

Cézanne's palette, according to the *French Encyclopedia* of 1935, was comprised of 18 colors:

Brilliant yellow	Crimson lake
Naples yellow	Burnt lake (?)
Chrome yellow	Veronese green
Yellow ocher	Emerald green
Raw sienna	Verona earth (green)
Vermilion	Cobalt blue
Red ocher	Ultramarine blue
Burnt sienna	Prussian blue
Red madder	Peach black

3-22. THE BASKET OF APPLES. Paul Cézanne. He used color for structure, form, dimension. In this painting, he used white, pale blue, red, yellow, and green, with brown on the table and the basket. (Courtesy of The Art Institute of Chicago. Helen Birch Bartlett Memorial Collection.)

Some of these colors are on the muted side, and Cézanne's canvases often have this subdued quality. There is never any hesitancy, however, in the directness and boldness of his execution. Yet his use of color was not clean, pure, and luminous like that of his associates. Pissarro once explained to Matisse, "Cézanne is not an Impressionist, because all his life he has been painting the same picture. He has never painted sunlight; he always paints gray weather."

3-23. THE OLIVE PICKERS. Vincent van Gogh. He was one of the greatest colorists of all time. His use of pigment was strong and dazzling, and it gave solidity to both earth and sky. (Courtesy of The Metropolitan Museum of Art. Mr. and Mrs. Richard Bernhard Fund, 1956.)

The End of the Nineteenth Century

Van Gogh (1853-1890) had an almost visionary sense of color, perhaps intensified by a disturbed mind. He wrote in a letter to Emile Bernard, "Sometimes I work terribly fast. Is it a fault? I can't help it." His palette probably was without much order. Yet he used color with amazing skill and control. Paul Gauguin, who had once lived for a short period with van Gogh, later wrote: "To begin with, I found everywhere a disorder that shocked me. His box of colors was scarcely large enough to contain all the squeezed tubes which were never closed, yet in spite of all this disorder, this mess, there was something brilliant in his canvases."

Van Gogh was undoubtedly one of the greatest colorists in the history of art. He was open minded, eager to learn from others, fascinated by nature, passionate, sincere, and had the drive of true genius. How did he paint? Here is a remarkable statement contained in a letter he wrote to Emile Bernard in 1888:

> At the moment, I am busy with blossoming fruit trees; pink peach blossom, white and yellow pear blossom. I don't keep to any one technique. I dab the colour irregularly on the canvas and leave it at that. Here lumps of thick paint, there bits of canvas left uncovered, elsewhere portions left quite unfinished, new beginnings, coarsenesses: but anyway the result, it seems to me, is alarming and provocative enough to disturb those people who have fixed preconceived ideas about technique. Here, by the way, is a sketch, the entrance to a Provençal orchard with its yellow fence, its screen of black cypresses (against the mistral), its characteristic vegetables of varying greens: yellow salad vegetables, onions, garlic, emerald-green leeks.

> While working directly on the spot all the time, I try to secure the essential in the drawing—then I go for the spaces, bounded by contours, either expressed or not, but felt at all events: these I fill with tones equally simplified, so that all that is going to be soil partakes of the same purplish tone, the whole of the sky has a bluish hue and the greens are either definitely blue-greens or yellow-greens, purposely exaggerating in this case the yellow or blue qualities.

The great passion that went into van Gogh's work is found in most of his paintings—strong, vibrant colors, boldly applied. It is quite apparent that he painted quickly on impulse.

As to van Gogh's palette, perhaps all was in disarray, as Gauguin had noted. Yet van Gogh painted a self-portrait in which a large part of his palette is shown. The original painting hangs in the Stedelijk Museum in Amsterdam. A full-color check on the colors he used is given below. A date on the canvas records the year 1888—two years prior to the artist's death.

The van Gogh palette shows bright hues — red, orange, yellow, green, blue — but in no apparent order. One may guess that van Gogh squeezed his colors from tubes, mixed them together, and brushed them impulsively on his canvas. Nevertheless, his color expression is among the greatest of all time.

Neo-Impressionist painters like Seurat and Signac rejected black, brown and all muted colors from their palettes. According to the *French Encyclopedia* of 1935, Paul Signac (1863-1935) used the following selection:

Cadmium yellow	Emerald green
Vermilion	(Special green)
Red madder	(Special green)
Cobalt violet	Pale cadmium
Ultramarine blue	Silver white
Cobalt blue	Zinc white
Cerulean blue	

There are 11 pure hues and two whites. (The special greens were probably mixed in advance by Signac and put into tubes or containers — a

3-24. THE PIER AT PORT-RIEUX. Paul Signac. As a Neo-Impressionist, Signac used only pure, spectral hues, and applied them in scientific ways. (Courtesy of Rijksmuseum, Otterlo, Holland.)

practice followed by a number of modern painters.) The progression on the palette was in spectral order, beginning with yellow and proceeding to red, violet, blue, green, and back to yellow again. (The pale cadmium probably refers to cadmium yellow light.) An attempt was made to use these sharp colors in tiny daubs as if they were tiny flashes of light and to let the eye mix them for scintillating results.

Among the Nabis, Pierre Bonnard (1867-1947) worked with an even more simple palette consisting of nine colors with white. (See the *French Encyclopedia* of 1935):

Strontaine yellow	Ultramarine blue
Cadmium yellow	Emerald green
Cadmium orange	Cobalt green
Carmine lake	Cobalt violet
Cobalt blue	White

This appears to be an exceedingly good choice and is again without black, brown, gray, or any neutrals. The Nabis (see Chapter 12) introduced various styles of composition and color theories, which had elements of Impressionism, Neo-Impressionism, and Post-Impressionism. Bonnard, the typical proverbial artist — retiring, capricious, indifferent to his material comfort — used color lightly, cleanly and simply, and this is revealed in the simplicity of his palette.

3-25. RED FLOWERS. Pierre Bonnard. He was a member of the Nabi movement and used a simple palette, handling color with a gentle and subtle touch. (Courtesy of The Art Institute of Chicago. Gift of Mrs. Clive Runnells.)

Into The Twentieth Century

This story of color, palettes, and techniques now carries into the twentieth century and is concerned with the revolutionary art trends to be described in Chapter 14, "The Road Down from the Mountain." Fauvism was the first of the new movements, and among its distinguished leaders were Henri Matisse, Maurice Vlaminck, and André Derain (1880-1954) This movement was marked by a violent use of garish colors along with black. Derain's palette, which is shown in Illustration 3-26, included 21 pigments:

Silver white	Coral red
Cobalt blue	Cadmium red
Ultramarine blue deep	Venetian red
Indigo blue	Burnt sienna
Ivory black	Cadmium yellow
Olive green	Baryta yellow
Special green	Brilliant yellow
Emerald green	Yellow ocher
Celadon green	Mars yellow
Cassel earth	Raw sienna
Carmine	

The Fauvists tried to outdo nature in their use of color. They paid less attention to laws of vision than did the Neo-Impressionists; they abandoned themselves to personal feeling and to sensationalism. However, André Derain did not entirely reject reason and sobriety in his use of color. He had studied the Old Masters and respected method and order. His Fauvism therefore represents a sort of deliberate control rather than unconscious fervor.

3-26. PALETTE OF ANDRE DERAIN. This leader of Fauvism used color powerfully — and accepted black. (From the *French Encyclopedia,* Vol. 16, 1935.)

3-27. PORTRAIT OF THE ARTIST. André Derain. With violent colors, Fauvists such as Derain, smothered Impressionism and started new fires in art. (Courtesy of The Minneapolis Institute of Arts.)

It was Henri Matisse (1869-1954) whose commanding personality led the Fauvist rebellion. Yet Matisse painted like a Fauvist for a few years only, and then went on to other achievements. Throughout his life he let color dominate his art and continually experimented with new effects and dimensions.

One of Matisse's palettes, recorded by himself and reproduced in the *French Encyclopedia* of 1935, is shown in Illustration 3-28. It has 16 colors:

Strontaine yellow	Venetian red
Cadmium yellow	Silver white
Light yellow	Ivory black
Cadmium red light	Cobalt violet deep
Cadmium red purple	Ultramarine blue
Burnt sienna	Cobalt blue
Light sienna	Emerald green
Yellow ocher	Special green

Matisse noted that at times he used Prussian blue as if it were a cold black to warm up the entire palette through contrast.

Matisse also had an interest in the Cubist movement, although more ardent exponents were

3-28. PALETTE OF HENRI MATISSE. He painted in many styles and led many movements. (From the *French Encyclopedia,* Vol. 16, 1935.)

3-30. PALETTE OF GEORGES BRAQUE. It had about 16 colors and included earthy reds, browns, greens, and ochers. (From the *French Encyclopedia,* Vol. 16, 1935.)

3-29. THE RED STUDIO. Henri Matisse. The entire ground is a rich terra cotta red. In the details are accents of pink, yellow, blue, green, and black. (Collection of The Museum of Modern Art, New York. Mrs. Simon Guggenheim Fund.)

Pablo Picasso, Georges Braque, Fernand Léger, and Juan Gris. Cubism as an art movement was short lived (see Chapter 14). The Cubists paid little attention to color; they were obsessed with form. Indeed, color was used to convey form and was not given much intrinsic value of its own.

The palette of Georges Braque (1882-1963), shown in Illustration 3-30, was as follows (see the *French Encyclopedia* of 1935):

Persian blue light	Ru ocher
Persian blue deep	Persian green
Peach black	Verona earth (green)
Persian red	Cobalt violet
Persian yellow deep	Rose madder lake
Chrome green (light,	Burnt sienna
medium and deep)	Burnt umber
Yellow ocher	Carmine lake

3-31. MAN WITH A GUITAR. Georges Braque. Here is Cubism. The colors are dull brown, golds, and blacks for a monochromatic and altogether drab color effect. (Collection of The Museum of Modern Art, New York. Lillie P. Bliss Bequest.)

Braque, of course, also included white. He also listed a color which he called "cinabre vert," which may be translated as vermilion green. It may be assumed that the reference was to a chrome green.

Braque's color effects for the most part were muted. He seemed to like brownish wood tones, gray, terra cotta, black, gold, olive green — quite the opposite of the brilliant hues of the Fauvists.

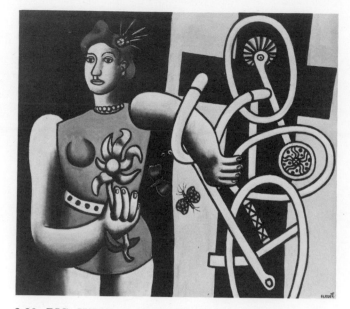

3-32. BIG JULIE. Fernand Léger. The colors are black, yellow, orange, brownish red, vermilion, light gray, without complication or subtlety. (Collection of The Museum of Modern Art, New York. Lillie P. Bliss Bequest.)

3-33. PALETTE OF RAOUL DUFY. It had only pure colors which he mixed with white to form pure tints. Black, however, was used for outlines. (From the *French Encyclopedia,* Vol. 16, 1935.)

His compatriot Fernand Léger (1881-1955), however, was somewhat bolder with color. His palette, according to the *French Encyclopedia* of 1935, was composed as follows:

Ultramarine blue deep	Burnt sienna
Deep madder	Ivory black
Veronese green	Silver white
Emerald green	English vermilion
Cadmium yellow	French vermilion
Cadmium orange	

Léger's paintings show his use of these colors, generally shaded and modeled in a simple way. He looked for stability, was frankly abstract in his compositions, and sought construction with hue. He painted strong images of wheels, cogs, tugs, workers, and acrobats in a static and monumental way.

Now consider the palettes of three modern painters, each highly individual in temperament. Raoul Dufy (1877-1953), a designer of fabrics and ceramics, was especially versatile in watercolor. Suffering from arthritis, he came to America in the later years of his life where he painted race tracks, bridges, cities, and crowds. His simple and decorative compositions have had great mass appeal over the years since his death in 1953.

Dufy's style was based on a keen sense of draftsmanship. Clean colors were washed over calligraphic outline sketches — which, though hastily done, caught the essential character of

3-34. ASCOT. Raoul Dufy. This is typical of his style. While black keyed the composition, it was not otherwise used in paint mixtures. The color effect was thus clean and fresh. (Courtesy of The Art Institute of Chicago. Gift of Mr. Nathan Cummings.)

everything within his range of vision. His oil palette, recorded in the *French Encyclopedia* of 1935, and shown in Illustration 3-33, was as follows:

Mars yellow	Cobalt blue
Mars orange	Cerulean blue
Violet madder bluish	Persian yellow light
Rose red	Brilliant yellow light
Carmine light	Zinc white
Cadmium red purple	Cadmium yellow deep
Mars violet	Veronese green
Ivory black	Verdigris
Ultramarine blue deep	

Dufy's palette was fairly complete. Although it contained black, it was entirely without browns or other muted colors. Dufy, to all indications, mixed pure colors with white for most of his effects. He seldom combined colors — hence the full palette. He had merely to take a daub of pure hue, touch it up with white and proceed. The black was for his outline sketching.

Maurice Utrillo (1883-1955) handled color quite differently from Dufy. This French artist, of Spanish parentage, spent a substantial part of his early life in dissipation. Yet in moments of concentration he painted the streets and buildings of Paris with the mastery of true genius. Here was his palette (see the *French Encyclopedia* of 1935):

Cobalt blue	Venetian red
Ultramarine blue deep	Vine black
Emerald green	Raw sienna
Chrome yellow light	Zinc white
Chrome yellow medium	Verona earth (green)
Yellow ocher	Chrome orange
French vermilion	Chrome green
Crimson lake deep	

3-35. PORTRAIT OF UTRILLO. Arbit Blatas. The artist has attempted to paint Utrillo in the same chalky and eerie tones for which the subject was famous. (Courtesy of The Washington County Museum of Fine Arts, Hagerstown, Maryland.)

There are muted colors here — yellow ocher, Venetian red, black, sienna, Verona earth. Many of the subjects Utrillo painted were gloomy and required gloomy color effects. Dirty and soiled facades were given a melancholy and charming beauty through the judicious use of white.

Illumination effects seem to transfix the city as if by magic. In contrast to Dufy's delight in pure tints, Utrillo was attracted to subtle grays, milky whites, "tender" blues and greens, velvety blacks. Although his early years were wretched, he later achieved fame and material success. He was made Chevalier of Legion of Honor, and he died the good citizen in 1955 at the age of 72.

Finally, here is the palette of the Italian, Giorgio de Chirico (1888–) also recorded in the *French Encyclopedia* of 1935. This painter (to be mentioned in Chapter 15), respected the technical skill of the Old Masters and emulated them in a neat, smooth, representational style. His approach, however, was mystical. Chirico's palette contained these colors:

Zinc white	Veronese green
Ultramarine blue	Emerald green
Cobalt blue	Baryta green
Cerulean blue	Verona earth (green)
Ivory black	Mineral brown
Vine black	Burnt umber
Yellow ocher	Raw umber
Red ocher	Van Dyck brown
Burnt sienna	Brilliant yellow
Raw sienna	Naples yellow
Vermilion	Lemon yellow
Carmine lake	

3-36. THE TAVERN LA BELLE GABRIELLE. Maurice Utrillo. His palette had some muted colors, and with them he achieved weird but charmingly melancholy effects. (Courtesy of The Art Institute of Chicago. Gift of Mr. and Mrs. Carter H. Harrison.)

3-37. THE PHILOSOPHER'S CONQUEST. Giorgio de Chirico. His style was neat and expert. The colors here are green, terra cotta, yellow ocher, dull green, plus grayish white and black. (Courtesy of The Art Institute of Chicago. Joseph Winterbotham Collection.)

This is an unusually large and well-balanced palette and includes a number of muted colors. Chirico was one of the better technicians of modern times who had perfect control over his medium, and was drawn to glazed effects and smooth modeling.

Scaled Palettes

Palettes used by a number of modern American painters have been described by Ernest W. Watson in *Twenty Painters and How They Work*. Palettes, painting cabinets, pigment choices, and so forth are discussed and illustrated for artists such as Louis Bouché, Henry Lee McFee, Hobson Pittman, Andrée Ruellan, Frederic Taubes, and Paul Trebilcock. All the men included are representational painters.

However, the large majority of modern painters have elected to work more freely and spontaneously with color. They have squeezed bright hues from tubes, taken brush or palette knife in hand, and proceeded to mix tones quickly and at will. Some, of course, have flung paint or poured it from cans. This mixing of colors in an impetuous way has been the practice of modern Abstract Expressionists and so-called action painters. They wish to release individual creativity and to avoid anything too methodical, deliberate, or time-consuming.

As mentioned previously, the Old Masters frequently worked with prepared colors, tones, and scales. They generally used certain shades for the foreground, middle ground, and background. Light, middle, and deep tones were often premixed for flesh or drapery. At the same time, however, some of the masters such as Rubens and Rembrandt apparently had small palettes and did much color mixing as required, often on the canvas or panel itself. And in the eighteenth century, as has been mentioned, many palettes were designed to include straight pigments and intermixtures of them.

However, much depends on the temperament of the individual painter and what he is trying to accomplish. A non-objective action painter may wish to cast aside all restrictions. A representational painter may do far better with a neatly organized series of hues and tones. Or if a certain preconceived color effect is in mind, a palette may be prepared in advance and then used in a spontaneous way. This latter practice is the one favored by the author.

In my book, *Creative Color*, a special chapter is devoted to Fixed Palettes, and the subject will be further discussed in Chapter 6 of this book. As I have written in *Creative Color*, "Eminent color effects almost demand fixed palettes. By separating the mixing process from the creative one, each in turn may be given full attention without conflict. The fixed palette will represent the tuning operation. This can be leisurely done, and simple experiments can be performed in anticipation of a final composition. Then when the artist goes about his work he can do so with purely emotional intensity — not having to concern himself with routine matters."

A few decades ago in America, scaled palettes were popularly used by conservative painters. Two of the leading exponents of scaled palettes were Denman Ross and Arthur Pope, both of

Harvard. Their idea of the scaled palette (which could be arranged in innumerable ways) was to ensure color harmony even before the artist put brush to canvas. Ross wrote as follows:

> Considering the Art of Music and the use of musical instruments, it seems that the musician has a great advantage over the painter in having a fixed scale of tones and definite rules for using it, — rules based on good precedents and representing the practice of recognized masters. Thinking of musical instruments and the laws of Counterpoint and of Harmony, the question comes up whether it may not be possible for the painter to convert his palette into an instrument of precision and to make the production of effects of light and color a well ordered procedure — a procedure which everyone can understand and follow.

Scaled palettes of the type described by Ross and Pope lead unquestionably to beauty of color, but they are very likely to be academic. Wilhelm Ostwald has declared that any neat and orderly sequence of color is pleasing to the eye — much in the same way that well-proportioned forms and the lovely growth patterns found in nature are pleasing.

The scaled palettes of Denman Ross could be designed in many ways. The idea was to take a given number of key hues and then produce neat "tone relations" by uniform admixtures of white, black, adjacents, or complements. Often the palettes were quite complex (Ill. 3-38) and might be made up of as many as 30 or more mixtures. It would seem, however, that exercises like this would be better applied to the decorative arts, such as textiles, than to painting. The author favors what he likes to call the fixed palette, but its purpose should not be to establish mere scales but to strike original and unusual chords (see Chapter 5).

The Balanced Palette

Selections of satisfactory, permanent pigments for artists can be found in a number of sources. In *The Artist's Handbook*, Ralph Mayer includes permanent palettes for oil painting, watercolor, tempera, pastel, fresco. Max Doerner in *The Materials of the Artist*, and Hilaire Hiler in *The Technique of Painting* also discuss pigments from this point of view.

In this book, however, the choice of colors for a palette or palettes is not in any way concerned

3-38. SCALED PALETTE BY DENMAN ROSS. Here was an attempt at color beauty through intelligent order. (From *The Painter's Palette* by Denman Ross, 1919.)

3-39. PORTRAIT OF DENMAN ROSS. Durr Freedley. Note the scaled palette on glass panel. (Courtesy of The Fogg Art Museum, Harvard University, Cambridge, Massachusetts.)

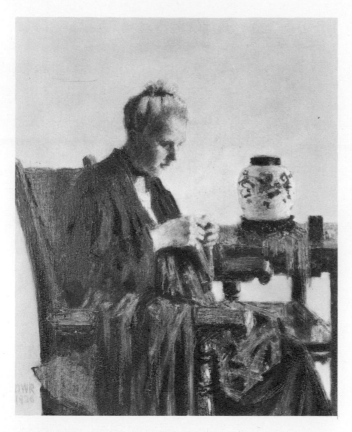

3-40. LADY IN A CHAIR. Denman Ross. He championed rules of color harmony, as against the impulsive expression of modern times. (Courtesy of The Fogg Art Museum, Harvard University, Cambridge, Massachusetts.)

with chemistry, or with permanence, transparency, opacity, or any of the *material* aspects of art. Here, the interest is in visual appearance — how the colors look, how they combine to form other hues, tints, shades, and tones — with visual order and visual response. Assuming that a certain color effect is dramatic, its visual organization will be analyzed. If the color analysis is understood, the *same effect* can be duplicated whether the material used is watercolor, oil, or indeed, tapestry wool, pastel, crayon, dye, ink, or ceramics.

Basic palettes will now be considered. Hiler gives two five-color palettes for oil:

A. Titanium white
 Yellow ocher (pale and brilliant as possible)
 Light red
 Cobalt blue
 Ivory black
B. White (any sort you like)
 Lemon cadmium
 Ultramarine
 Cadmium red (deep)
 Lamp black

It is possible to do fairly well with these selections, both of which are based on red-yellow-blue primaries. However, it would be difficult to achieve a full gamut of colors.

In his *Painting in Oil by the Five-Color Method*, Michael Carver has chosen these:

 Cadmium yellow light
 Cadmium red pale
 Alizarin crimson
 Ultramarine
 Viridian
 (White)

Black is excluded, and earth colors (ocher, sienna, umber) are composed of complementary mixtures of the basic five pigments. Again, fairly good results can be achieved. However, many brilliant hues could not possibly be mixed — clean light orange, vivid yellow-greens, vivid turquoise blues, vivid magentas.

For a limited palette of wide potential, one must learn from science and empirical study — and use common sense.

In process printing the three basic primaries are a magenta-red, a clear yellow, and a turquoise or peacock type of blue. These three (plus black) offer maximum — but not complete — possibilities in the formation of other hues, tints, shades and tones. Yet they leave much to be desired.

Dozens of color circles have been devised from red-yellow-blue primaries. Herbert E. Ives, for example, developed a palette from them which

3-41. RED-YELLOW-BLUE COLOR CIRCLE. This is the basis of most palettes — because pigment mixtures find order and relationship on it.

74

was offered in water and oil base paints. Ives used the term *achlor* for magenta, *zanth* for yellow, and *cyan* for blue.

No selection of three colors can possibly be adequate. Wilhelm Ostwald in his *Color Science*, Part II, describes the limitations and possibilities of pigment mixture. Let the reader study the R-Y-B color circle shown in Illustration 3-41. Great purity of hue can be achieved in the region of the color circle extending from a greenish blue (turquoise) to clear yellow. The two colors will combine to form brilliant greens.

Similarly, a warm red (vermilion) or orange combined with the same clear yellow will form a pure and full range of oranges and yellow-oranges. The rest of the color circle, however, cannot be dealt with so simply. There are no ways, for example, of using *other* hues to form a magenta, an ultramarine, and some purples — just as *other* hues cannot form the brilliant vermilion, the clear yellow, or the turquoise blue mentioned above.

In other words, five key hues are necessary to form a complete, pure, and brilliant color circle. These are a warm red-orange (vermilion), a purplish red (magenta), a clear yellow, a turquoise or peacock blue, and an ultramarine blue.

Some years ago the American Crayon Company produced this five-color palette in tempera; the set contained colors named Magenta, Scarlet, Yellow, Turquoise Blue, Blue.

On the R-Y-B color circle shown in Illustration 3-42, five wedges have been plotted to show the positions of the five ideal hues: magenta, vermilion, yellow, turquoise, ultramarine. To avoid large gaps between the vermilion and yellow and between the turquoise and yellow, two further colors are introduced as indicated by the two X marks. These are a yellowish orange and a greenish yellow. They smooth out the hue circuit and help to simplify color intermixtures. This brings the selection of basic pure hues to seven. The combination of magenta and vermilion will form pure reds. The combination of magenta and ultramarine will form rich purples and violets. The combination of ultramarine and turquoise will form clear blues. All other sections of the circle are accounted for (in full strength) by combinations of vermilion with yellow-orange, yellow-orange with yellow, yellow with yellow-green, and yellow-green with turquoise.

Now consider the Balanced Palette, shown in Illustration 3-44 and the color chart on pages 106-107, which shows the complete color selection in visual samples. Note the four points that follow.

1. In a modern palette it seems important to base the color selection, not only on what happens to be available in pigments, but on certain peculiarities of human vision. For example, while a turquoise blue is primary in the mixture of pigments, more of an ultramarine or cobalt blue

3-42. THE ARTIST'S COLOR CIRCLE. When basic or primary colors are chosen to form a brilliant spectrum, the essential hues (indicated by the wedges) are a red-orange (vermilion), clear yellow, turquoise blue, ultramarine blue, and magenta. Yellow-orange and yellow-green (indicated by X) may be added, but merely to fill gaps.

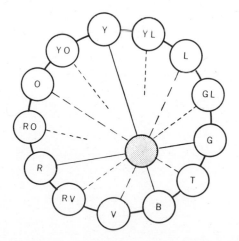

3-43. RATIONAL COLOR CIRCLE. This arrangement, devised by the author in 1938, plots a spectrum in which the steps are in equally perceptible intervals. Because the eye is more sensitive to warm colors than to cool ones (and can see more of them) the warm side of the circle is expanded and the cool side condensed. This throws the complementation point off-center.

3-44. BALANCED PALETTE. This is a diagram of an ideal palette. There are seven pure hues, five rich shades, plus white and black. In practice as well as theory, all colors — and variations of colors — to be seen by the eye can be formed with these hues.

is primary in vision. It is possible to pay respect both to the phenomenon of pigment mixtures and to visual factors in color at one and the same time. Such allowances have been made in the Balanced Palette.

Recent developments in the manufacture of synthetic pigments have materially broadened the range of permanent hues available to the artist. Synthetic pigments include titanium white, phthalocyanine blue and green, and more recently phthalocyanine red and purple; phthalocyanine yellow is a possibility. All these wonders of chemistry assure the availability of any color in virtually any hue or tone.

2. Basic to the Balanced Palette are seven key hues which are neatly spaced as to visual intervals and produce a full, intense color circle. These are:

1. Magenta
2. Vermilion
3. Yellow-orange
4. Yellow
5. Yellow-green
6. Turquoise
7. Ultramarine

3. The seven pure base colors, when mixed with white (WH), will provide pure tints or pastels. The mixing operation is quite simple. However, to mix deep shades it will be convenient for the artist to have five deep or muted colors:

A. A red brown
B. A true brown
C. A golden or yellow ocher
D. An earth green
E. A deep blue

The red brown may resemble what has been known as Venetian red. The true brown could be like burnt umber, the golden ocher like yellow ocher, the earth green like Verona earth, and the deep blue like indigo.

The pure hues combined with the muted ones will form just about any deep shade that an artist may desire, such as maroon, navy blue, forest green, deep violet and purple, olive green, plus a variety of golds and browns. Any toned or grayish colors, of course, can be formed by adding white and black to pure hues or by blending complements.

4. With white (WH) and black (BL) to complete the palette, the selection reaches a total of 14. (A portrait or figure painter could add a mixed flesh tone.)

Palettes are important. With them, artists may envision their color effects in advance. In all fairness, however, painters of different temperament may want and require different color selections and arrangements. And a painter may shift his sights from time to time. Hilaire Hiler, a capable painter as well as scholar, writes, "Personally, if anyone would like to know, I use a different palette for every picture. What could be more logical than that?"

The advantage of the Balanced Palette, however, is that *it is fundamental to color mixtures of any sort.* This means that it can be employed to create other palettes and thus satisfy Mr. Hiler as well as the author who also favors predetermined scales of colors for singular color effects.

Chapter 4

The Personality of the Artist

Art must be personal. Although Schopenhauer described it as eternal and universal rather than transitory and individual, the artist has the task of interpreting, in a personal way, what men may feel or know intuitively but are unable to express.

There have been innumerable definitions of the meaning and purpose of art. Most have come from the art historian or critic and few from the artist himself. Yet so often when the artist has declared himself or written manifestos (so common in the twentieth century), the result has been little more than semantic gibberish.

This chapter is concerned with the personal side of the artist's attitude toward color. Reactions and responses to color are usually emotional in content. And since human beings differ so markedly in temperament, no two of them ever seem to find a common ground of agreement. One man may love yellow and another detest it. So with every hue of the spectrum. In recent years, however, psychologists have found evidence that esthetic tastes and psychic responses have certain consistency — thus providing a degree of order to a once chaotic subject.

Few artists have written coherently on color or attempted to make sense out of their empirical findings. As a consequence, a scholarly review of what artists have had to say about color may offer some insight into the emotional character of the artists, but it may also provide little that has rational bearing on the mysteries of color. The artist by nature is wrapped up in his own feelings. Since his views are highly personal, they are not likely to represent the views of others. If

there is such a thing as "the psychology of color," it is to be found in humanity as a mass and not in artists (or anyone else) as individuals. At the same time, the artist who can give personal expression to mass emotions becomes the true genius.

Da Vinci

Leonardo da Vinci's clear statement of color fundamentals during the Renaissance has been discussed briefly in Chapter 1. His *Treatise on Painting* is an astonishing source of wisdom on the topic of color. As will be seen, da Vinci was a prophet of much that was discovered after him. How he had such vision is difficult (and unnecessary) to explain, except to comment that his was one of the most universally gifted minds of all time.

He brought the art of painting — and the art of color — to its first great height in his development of the chiaroscuro style. As Wilhelm Ostwald stated, "He obtained new effects of relief in his pictures which threw his contemporaries, who had never seen the like before, into astonishment and rapture."

In describing his chiaroscuro style, da Vinci wrote, "The first object of a painter is to make a simple flat surface appear like a relievo, and some of its parts detached from the ground; he who excels all others in that part of the art, deserves the greatest praise. This perfection of the art depends on the correct distribution of lights and shades, called *chiaro-scuro*. If the painter, then, avoids shadows, he may be said to avoid the glory of the art, and to render his work despic-

able to real connoisseurs, for the sake of acquiring the esteem of vulgar and ignorant admirers of fine colors, who never have any knowledge of relievo." In this reference to "fine colors" da Vinci decried art which used color for its sensuous appeal and was without skill in its application. He pleaded for shrewd observation of nature and technical facility, thereby prejudging so many recent Abstract Expressionists who hope that color for its own sake will be enough.

Da Vinci respected nature and was insistent on freedom and individuality: "One painter ought never to imitate the manner of any other; because in that case he cannot be called the child of Nature, but the grandchild. It is always best to have recourse to Nature, which is replete with such abundance of objects, than to the production of other masters, who learnt everything from her."

The artist should not be overly self-confident or think of himself as the beginning and the end of all insight: "Whoever flatters himself that he can retain in his memory all the effects of Nature is deceived, for our memory is not so capacious; therefore consult Nature for everything." In other words, the artist should learn what nature has to teach.

He saw colors in shadows — long before most other artists: "To any white body receiving the light from the sun, or the air, the shadows will

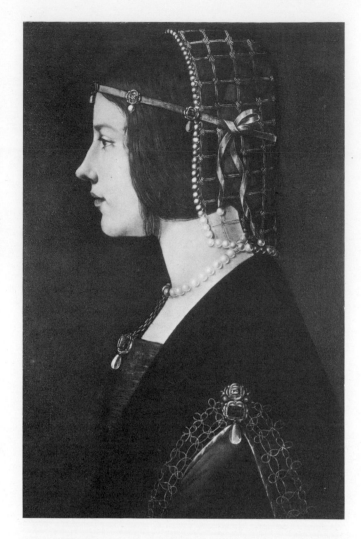

4-1. PORTRAIT OF A YOUNG WOMAN. Leonardo da Vinci. Here is the chiaroscuro style at its best. The palette used probably contained flesh tones, yellow ocher, red, brown, black — with dull green probably made from yellow and black. (Courtesy of Ambrosiana, Milan. Alinari-Art Reference Bureau.)

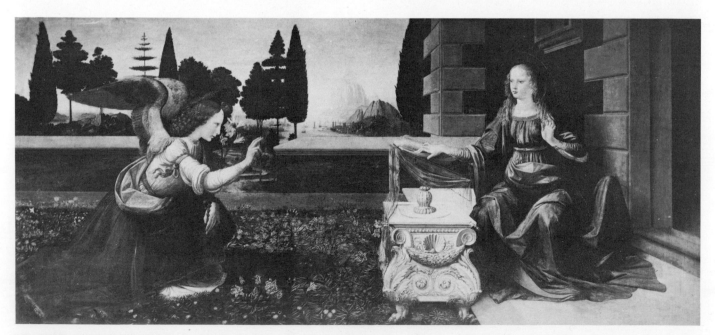

4-2. THE ANNUNCIATION. Leonardo da Vinci. Luminous flesh tones, lustrous silks in red, green, blue, are set against muted blues, greens, and browns in the background. (Courtesy of Uffizi, Florence. Alinari-Art Reference Bureau.)

78

be of a bluish cast." This was readily explained with respect to a white wall standing in the sun: "The shadows of bodies produced by the redness of the setting sun, will always be bluish. . . . The superfices of any opaque body participates of the color of the object from which it receives the light; therefore the white wall, being deprived entirely of color, is tinged by the color of those bodies from which it received the light, which in this case are the sun and sky. But because the sun is red towards the evening, and the sky is blue, the shadow on the wall not being enlightened by the sun receives only the reflection of the sky, and therefore will appear blue; and the rest of the wall, receiving light immediately from the sun, will participate of its red color."

The phenomenon of colored shadows would one day engage the attention of men like Goethe and Helmholtz, and, indeed, of scientists down to the present day.

On the phenomenon of brightness contrast, which also has been the subject of modern studies of perception, da Vinci wrote: "Of different bodies equal in whiteness, and in distance from

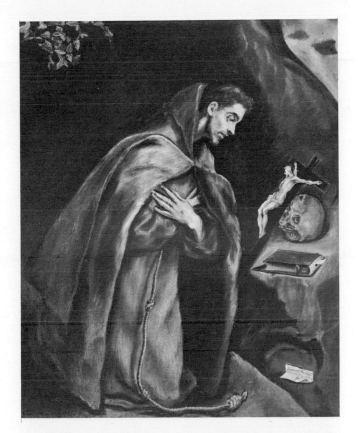

4-4. SAINT FRANCIS. El Greco. El Greco's personality was revealed in his preference for exaggerated forms and unearthly color effects—a style from which he never varied. (Courtesy of The Art Institute of Chicago, Robert A Waller Fund.)

the eye, that which is surrounded by the greatest darkness will appear the whitest; and on the contrary, that shadow will appear the darkest which has the brightest white round it."

On aerial perspective, the key to much painting since the Renaissance: "Any dark object will appear lighter when removed to some distance from the eye."

On simultaneous contrast, which was later expounded by M. E. Chevreul and intrigued the Impressionists and Neo-Impressionists: "Of different colors equally perfect, that will appear most excellent which is seen near its direct contrary: a pale color against red; a black upon white; . . . blue near a yellow, green near red: because each color is more distinctly seen when opposed to its contrary, than to any other similar to it."

Today, when psychological research has found that color impressions are dependent on surroundings, rather than on light energy and the physical conditions of visual stimulation, da Vinci's perspicacity seems incredible: "Colors will appear what they are not, according to the ground which surrounds them."

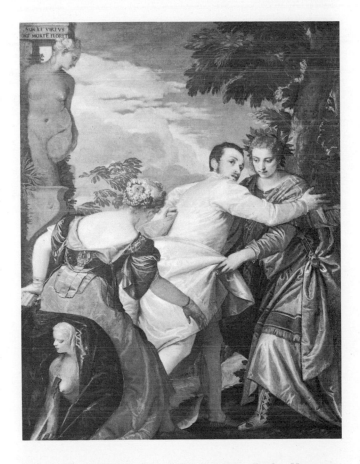

4-3. THE CHOICE OF HERCULES. Paolo Veronese. During the Renaissance there was great fascination with plasticity and texture, both of which required extravagant use of color. (Copyright, The Frick Collection, New York.)

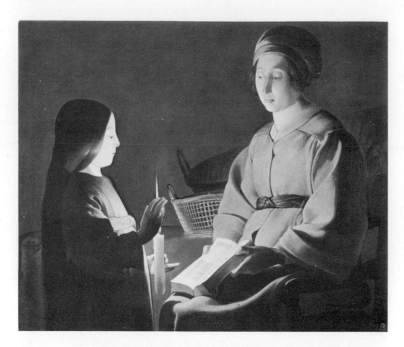

4-5. EDUCATION OF THE VIRGIN. Georges de la Tour. This artist was fascinated by light and shade. His luminous effects seem akin to the supernatural. (Copyright, The Frick Collection, New York.)

And here is the phenomena of color constancy (to be discussed in Chapter 7) tersely stated some four hundred years before psychologists gave it major attention: "The light of the fire tinges everything to a reddish yellow; but this will hardly appear evident, if we do not make the comparison with the daylight."

Finally, Leonardo da Vinci wrote of imagination and accidental effects: "By throwing a sponge impregnated with various colors against a wall, it leaves some spots upon it, which may appear like a landscape. It is true also, that a variety of compositions may be seen in such spots, according to the disposition of mind with which they are considered; such as heads of men, various animals, battles, rocky scenes, seas, clouds, woods, and the like."

Lairesse

In *The Art of Painting in All Its Branches* (1738), Gérard de Lairesse presented a number of interesting color associations. Symbolism of colors has long been a part of religious ritual and heraldry. Lairesse, for example, related white to light, black to darkness, but then went on to associate yellow with luster and glory, red with power or love, blue with duty, purple with authority and jurisdiction, violet with subjection, and green with servitude.

According to Lairesse, white was the color of

childhood, green the color of growth, red the color of manhood, dark violet the color of old age, and black the color of death. Like da Vinci and others, colors were to be related to the elements: "Dark Fillemat shall serve to represent the *Earth*, or Greenness; White, to show the *Water*; Blue, *the Air*; *Red, the Fire*; and *Black, the Darkness above the Element of Fire.*" And spring was green, summer yellow, autumn red, and winter black. (A more detailed discussion of color symbolism will be found in the author's *Color, a Survey in Words and Pictures.*)

Goethe

Goethe's work in color has already been mentioned in Chapter 1. Great as a poet and philosopher, Goethe was also interested in science and art. Color was one of his favored subjects, and he devoted much time and effort to it.

In addition, he wanted to be an artist but was unsuccessful in this regard. In any event, he did

4-6A. ITALIAN COUNTRY ESTATE. Wolfgang von Goethe. The great German poet once dreamed of being an artist. Here is an example of his art. (From *Goethe, Zwölfe Aquarelle,* Weimar, 1958.)

4-6B. ITALIAN FARM HOUSE. Wolfgang von Goethe. This watercolor study is mostly in yellows, browns, and dull greens — and probably has faded. (From *Goethe, Zwölfe Aquarelle,* Weimar, 1958.)

not hesitate to rank himself among the best minds of his day, particularly in the field of color. Thus he wrote, "A dread of, nay a decided aversion for all theoretical views respecting color and everything belonging to it, has been hitherto found to exist among painters; a prejudice for which, after all, they were not to be blamed; for what has been hitherto called theory was groundless, vacillating, and akin to empiricism. We hope that our labors may tend to diminish this prejudice, and stimulate the artist practically to prove and embody the principles that have been explained." In other words, not until Goethe had the artist been given reliable counsel.

Goethe's *Farbenlehre*, or *Doctrine of Colors*, in its original German form (1810) or as translated into English by Charles Lock Eastlake (1840), is a dull volume in some respects but unique for its broad range. The poet discussed physics, physiology, optics, visual illusions, chemistry, biology, geology, natural history, archaeology — plus art, and color harmony. Although at times he betrayed a superficial knowledge of a particular topic, he never hesitated to speak as if with absolute wisdom.

Goethe had strong opinions about esthetic and emotional factors in color. He believed that all colors derived from lightness and darkness, and the two basic primaries were yellow and blue. Some colors were *plus* — yellow, red-yellow (orange), yellow-red (cinnabar). As to yellow: "In its highest purity it always carries with it the nature of brightness, and has a serene, gay, softly exciting character.... Hence in painting it belongs to the illumined and emphatic side."

However, yellow could be readily "contaminated," and this might have disagreeable results: "Thus, the color of sulphur, which inclines to green, has a something unpleasant in it.... By a slight and scarcely perceptible change, the beautiful impression of fire and gold is transformed into one not undeserving the epithet foul; and the color of honor and joy reversed to that of ignominy and aversion."

About carmine red: "The effect of this color is as peculiar as its nature. It conveys an impression of gravity and dignity, and at the same time of grace and attractiveness."

In red-yellow, energy was high: "The red-yellow gives an impression of warmth and gladness,

4-7. THE ARTIST WITH HIS FIRST WIFE. Johann Heinrich Tischbein. He was an intimate friend of Goethe and traveled with him to Italy. Tischbein was one of the leading German portrait painters of his day. (Courtesy of State Museum, Berlin.)

since it represents the hue of the intenser glow of fire, and the milder radiance of the setting sun It is not to be wondered at that impetuous, robust, uneducated men, should be especially pleased with this color."

Among the *minus* colors were blue, red-blue (violet) and blue-red (purple). Regarding blue: "This color has a peculiar and almost indescribable effect on the eye. As a hue it is powerful, but it is on the negative side, and in its highest purity, as it were, a stimulating negation. Its appearance, then, is a kind of contradiction between excitement and repose."

About violet: "Blue deepens very mildly into red, and then acquires a somewhat active character, although it is on the passive side It may be said to distract rather than enliven."

Although Goethe disliked yellow-green, he had a fondness for green itself: "If yellow and blue, which we consider as the most fundamental and simple colors, are united as they first appear, in

4-8. LIGHT AND COLOUR: GOETHE'S THEORY. J. M. W. Turner. The great English painter Turner admired Goethe and read his works. (Courtesy of Director, Tate Gallery, London.)

the first state of their action, the color which we call green is the result. The eye experiences a distinctly grateful impression from this color." If the green were perfectly balanced between yellow and blue, "The beholder has neither the wish nor the power to imagine a state beyond it. Hence for rooms to live in constantly, the green color is most generally selected."

Regarding harmony, yellow and blue were a poor combination. Yellow and red had "a serene and magnificent effect." Orange and purple were exciting and elevating. "The juxtaposition of yellow and green has always something ordinary, but in a cheerful sense; blue and green, on the other hand, is ordinary in a repulsive sense. Our good forefathers called these last fool's colors."

A number of artists of the nineteenth century studied Goethe. Turner was among them, and one of his canvases (now at the Tate Gallery in London) was titled, "Light and Colour: Goethe's Theory" (Ill. 4-8). Although Goethe had such amazing powers of observation, he had little patience with scientific method. Until recently, his views on the physical aspects of color had been all but forgotten. However, a new Goethe "cult" has lately come to praise the master for

his physiological and psychological insight. As modern science finds evidence to show that human perception of color is more and more independent of the physical facts of light energy, Goethe's genius seems almost prophetic. For he championed color as personal experience. If there was light in nature, there also was light *within the eye as well:* "The eye may be said to owe its existence to light, which calls forth, as it were, a sense that is akin to itself; the eye, in short, is formed with reference to light, to be fit for the action of light; the light it contains corresponding with the light without."

Delacroix

Eugène Delacroix was a great hero to the Impressionists, a major figure in the French Academy and the *Ecole des Beaux-Arts*, and one of the foremost powers (with Ingres) in the art of the nation. Called "one of the world's great colorists" by some art historians, the distinction perhaps applies more to his enthusiasm for the subject of color than to the examples set by his work. There is little doubt that Delacroix helped to give color the importance and glory it deserved, that he fought to break down the stifling academic conventions of his day, and that he was the brave herald of a new order in art. Yet his contribution to progress in color rests chiefly

4-9. THE LION HUNT. Eugène Delacroix. The background is mostly soft blue and green, with strong reds and blues in the garments of the figures. (Courtesy of The Art Institute of Chicago. Potter Palmer Collection.)

4-10. THE ABDUCTION OF REBECCA. Eugène Delacroix. He experimented with color throughout his life and worked with many palettes. But those he influenced used brighter color than he did. (Courtesy of The Metropolitan Museum of Art.)

server of color phenomena in nature. Few artists, before or since, have shown so sensitive an eye. He could look out the window of his Paris studio and see wonders:

From my window I see a joiner working, naked to the waist, in a gallery. I notice how strongly the half-tones of flesh are colored as compared with inert matter. I noticed the same thing yesterday in the Place Saint Sulpice, where a loafer had climbed up on the statues of the fountain, in the sun. Dull orange in the carnations, the strongest violets for the cast shadows, and golden reflections in the shadows which were relieved against the ground. The orange and violet tints dominated alternately, or mingled. The golden tone had green in it. Flesh only shows its true color in the open air, and above all in the sun. When a man puts his head out of the window he is quite different to what he was inside. Hence the folly of studio studies, which do their best to falsify this color.

From another studio on the seacoast of Dieppe, he wrote:

I see from my window the shadows of people passing in the sun on the sands of the port; the sand here is violet in reality, but it is gilded by the sun; the shadows of these persons are so violet that the ground about them becomes yellow. Would it be going too far to say that in the open air, and more especially in the effect I have under my eyes, the green reflections must be the result of the ground, which is golden, being illuminated both by the sun, which is yellow, and by the sky, which is blue, these

with his writings, his *Journal*, with the victories he won for freedom of expression, and with the courage he instilled in younger artists to break with the old and to seek release of the spirit through color. What better advice could there be than this:

I have told myself a hundred times that painting, that is to say the material thing called painting, was no more than the pretext, than the bridge between the mind of the painter and that of the spectator. Cold exactitude is not art; ingenious artifice, when it *pleases* or when it *expresses*, is art itself. The so-called conscientiousness of the majority of painters is only perfection applied to the *art of boring*. People like that, if they could do it, would work with the same minute attention on the back of their canvas. It would be interesting to write a treatise on all the falsehoods which can add up to truth.

Like da Vinci, Delacroix was an acute ob-

4-11. FUNERAL. Claude Manet. With Manet, the world was seen in terms of masses, shapes, and forms — with no lines around them. (Courtesy of The Metropolitan Museum of Art.)

two tones necessarily producing a green tone? It is obvious that in the sun these two effects are more pronounced and even almost crude; but when they disappear, the relations must be the same. If the ground is less golden, owing to the absence of the sun, the reflection will appear less green—in a word, less vivid.

While the canvases of Delacroix are quite colorful and show the courage of broken tones, true abandonment to colors was to come from the Impressionists he inspired and who so adored him. Always his eye — and mind — were open for the startling, for the elusive and yet obvious:

In the omnibus, when returning, I observed the effect of the halftone on the horses, bays and blacks, that is to say on a shining skin. One has to paint them as a mass, like the rest, with a local color midway between the high-light and the tone of warm color. On this preparation all that is necessary is a warm transparent glaze for the change of plane in shadow or with reflections and on the projections in this halftone color the high-lights are marked out with light, cold tones. In the bay horse, this is clearly to be seen.

While he did not consider nor assign psychic qualities to color, he was forever a romantic at heart — and an extremely competent analyist of the subtleties of painting:

The more I reflect on color, the more I discover how much the reflected half-tint affords us the principle that must dominate, because it is what gives the true tone, as a matter of fact, the tone that constitutes the value, and the one that counts in the object and causes it to exist. Light, to which the schools teach us to attach equal importance, and which they place on the canvas at the same time as the half-tint and the shadow, is only a pure accident: without understanding that, one cannot understand true color, I mean color that gives the feeling of thickness and the feeling of that radical difference which should distinguish one object from the other.

Delacroix as a precursor of Impressionism will be mentioned again in Chapter 10. His interest in palettes and color organization has been reviewed in Chapter 3.

Seurat

Strangely, not one of the Impressionists had much to say or write about color. This was left mostly to their critics, dealers, and admirers. While they lacked the intellectual capacity of Delacroix, eloquence for them was in their works

4-12. THE ROWER'S LUNCH. Pierre Auguste Renoir. The style is free and spontaneous, and the color bright and natural. (Courtesy of The Art Institute of Chicago. Potter Palmer Collection.)

4-13. VIEW OF THE PORT OF MARSEILLES. Paul Signac. This is typical Neo-Impressionism. The order is scientific, the spots of pigment applied without reference to form. There are spectral colors only. (Courtesy of The Metropolitan Museum of Art.)

and achievements. This, of course, is only right and proper, for where art and reason, emotion and intellect get tied together, the result is usually confusing.

Too, the Impressionists were men who tried to work freely and on impulse. With them art was a matter of release rather than control. With the Neo-Impressionists, however, color as science was investigated. One sees the beginning of a psychological attitude toward the spectrum which was to intrigue Seurat, Signac, Kandinsky, and literally dozens of Abstract Expressionists of the mid-twentieth century.

The esthetic theories of Charles Henry — which influenced Seurat — will be mentioned in Chapter 12. According to Henry, the line that swept *upward* from left to right was pleasant, while its antithesis was found in the line that fell *downward* from left to right. This "feeling" of line, proportion, color, intrigued Seurat, and he formulated a theory accordingly. The Gestalt psychologists later gave these matters careful clinical study and devised such terms as *physiognomic perception* to distinguish the phenomena.

4-14. THE ARTIST IN HIS STUDIO. Georges Seurat. Seurat did this silhouette in black crayon. The texture of the paper suggested Pointillism which he favored. (Courtesy of Philadelphia Museum of Art.)

4-15. DIAGRAM OF CHARLES HENRY'S THEORIES. Charles Henry, friend of the Neo-Impressionists, Seurat and Signac, found positive emotion in the line that swept upward from left to right — and negative emotion in the line that swooped downward. (Adapted by the author from Henry's writings.)

4-16. DIAGRAM OF SEURAT'S ESTHETIC. There was gaiety in luminous, warm colors, and in lines rising from the horizontal. There was calmness in a balance of light and dark, warmth and coolness, and in horizontal lines. There was sadness in a dark, cool color, and in lines descending from the horizontal. (Adapted by the author from Seurat's writings.)

4-17. ENTRANCE TO THE HARBOR, PORT-EN-BESSIN. Georges Seurat. Although there were diligent attempts at good composition, the "embroidery" of pure colored dots led to a certain stiffness. (Collection of The Museum of Modern Art, New York. Lillie P. Bliss Bequest.)

The following statement by Seurat of his "Esthetic" is from *A Dictionary of Modern Painting*:

> Art is harmony. Harmony consists in the analogy of contrary and the analogy of similar elements of *tone*, *color* and *line*, considered according to their dominants and under the influence of light, in gay, calm or sad combinations. The contraries are:
>
> For *tone*, a more luminous (lighter) for a darker.
>
> For *color*, the complementaries, that is to say a certain red opposed to its complementary, and so on (red-green; orange-blue; yellow-violet).
>
> For *line*, those forming a right-angle.
>
> Gaiety of *tone* is rendered by the luminous dominant; of *color* by the warm dominant; of *line* by lines rising from the horizontal.
>
> Calm of *tone* is the equality of dark and light; of *color*, equality of warm and cold; calm of *line* is given by the horizontal.
>
> Sadness of *tone* is given by the dark dominant; of *color* by the cold dominant; of *line* by lines descending from the horizontal.

Van Gogh

Although the Impressionists were reticent in writing about color, the Neo-Impressionists and the Post-Impressionists were not. Both Cézanne and Gauguin were voluble on the subject of color, but by no means as enthusiastic as van Gogh.

To a sensitive (and psychotic) nature, color very often holds tremendous fascination. The schizophrenic may be frightened and disturbed by it as a "catastrophic" intrusion on his inner life. He may shun color. Yet to the manic depressive, color may take on vital action and be accepted as a nourishing life force.

To van Gogh, color was paramount in the art of painting. It must be given full release. He wrote to his brother, Theo, of an imaginary talk with his friends, Bernard and Gauguin: 'Damn it, those mountains, were they blue? Well then, make them blue and don't tell me that it was a blue a little bit like this or a little bit like that. They were blue, weren't they? Good — make them blue and that's all!"

He had psychic feelings toward colors which few if any of the Impressionists shared. Men like Pissarro, Monet, Renoir had been realists. Van Gogh expected far more of painting. He wrote his brother, "I should like to paint men and women with that certain something of the eternal, which the halo used to symbolize and which we seek to achieve by the actual radiance and vibration of our colorings." And again, "I am always in the hope of making a discovery there, to express the love of two lovers by a marriage of two complementaries, their mingling and their opposition, the mysterious vibrations of kindred tones. To express the thought of a brow by the radiance of a light tone against a somber background. To express hope by some star, the eagerness of a soul by a sunset radiance."

His favorite colors were blue and yellow. It was yellow, however, which held particular mystery to him. Psychiatrists would later come to associate yellow with mental disturbance. In an article in *Occupational Therapy and Rehabilitation*, February, 1942, Eric P. Mosse wrote, "Thus yellow is the proper and intrinsic color of the morbid mind. Whenever we observe its accumulative appearance, we may be sure that we are dealing with a deep-lying psychotic disturbance." In November, 1889, van Gogh wrote to Emile Bernard, "Have you seen a study of mine with a little reaper, a yellow wheatfield and a yellow sun? It's not successful, but still in it I have tackled that devilish problem of yellows again I mean the one with a heavy impasto done on the spot, not the duplicate with hatchings, the effect of which is weaker. I wanted to do the first one entirely in sulphur." He was describing his painting, "A Reaper in a Wheatfield at Saint-Rémy." "The field is violet and yellow-green. The white sun is encircled with a great yellow halo. There are other means of attempting to convey an impression of anguish without making straight for the historic Garden of Gethsemane; that to convey something gentle and consoling it is not necessary to portray the figures of the Sermon on the Mount." The Impressionists had not endowed color with any such mystic import.

Where color becomes personal, as with van Gogh, his feelings and interpretations are not likely to agree with the experience of others. Yet, color to van Gogh had profound significance. He could not do without it in painting, nor without it in writing. Witness this moving description of

4-18. THE NIGHT CAFE. Vincent van Gogh. See the text for a vivid description of the colors by the painter. (Courtesy of Yale University Art Gallery. Bequest of Stephen Carlton Clark.)

4-19. THE GARDEN OF THE SAINT-REMY ASYLUM. Vincent van Gogh. This was painted less than a year before the artist died. It is probably true that his vision was abnormally sensitive. (Courtesy of Rijksmuseum Kröller-Müller, Otterlo, Holland.)

4-20. THE CAFE AT NIGHT. Vincent van Gogh. The color effect is magnificent. The sickly yellow light of the café spreads out weakly in a star-lit night that is deep blue. (Courtesy of Rijksmuseum Kröller-Müller, Otterlo, Holland.)

one of his most famous works, "Night Café" (Ill. 4-18) in a letter to his brother, Theo:

> For three nights running I sat up to paint and went to bed during the day. I often think that the night is more alive and more richly colored than the day. . . . I have tried to express in this picture the terrible passions of humanity by means of red and green. The room is blood red and dark yellow with a green billiard table in the middle; there are four lemon-yellow lamps with a glow of orange and green. Everywhere there is a clash and contrast of the most alien reds and greens, in the figures of the little sleeping tramps, in the empty dreary room, in violet and blue. The blood red and the yellow green of the billiard table for instance contrast with the soft tender Louix XV green of the counter on which there is a pink nosegay. The white coat of the proprietor, on vigil in a corner of this blaze, turns lemon yellow, or pale luminous green. . . . The color is not locally true from the *trompe-l'oeil* realist point of view; it is a color suggesting some emotions of an ardent temperament. In my picture of the "Night Café" I have tried to show that the café is a place where one can ruin one's self, go mad, or commit a crime.

Note again his mention of lemon yellow. The whole composition, in effect, is bathed in an eerie yellow light.

Shortly before his death, van Gogh seemed to grow even more sensitive to color. Everything he looked upon seemed to vibrate. Nothing escaped his attention; color was in the slightest detail. In the asylum where he was confined in his latter years, he wrote to Emile Bernard of "The Garden of the Asylum at Saint-Rémy":

> Here's the description of a canvas in front of me at this moment. A view of the park of the asylum where I am: on the right a grey walk, and a side of the building. Some flowerless rose-bushes, on the left a stretch of the park, red ochre, the soil parched by the sun, covered with fallen pine-needles. This edge of the park is planted with large pine-trees, the trunks and branches being of red ocher, the foliage green darkened by a tinge of black. These tall trees are outlined against an evening sky striped violet on yellow, which higher up shades off into pink and then into green. A wall—more red ocher—shuts out the view, or rather all of it except one hill which is violet and yellow ocher. The nearest tree is merely a large trunk which has been struck by lightning and then sawn off. But a side-branch shoots up very high and then tumbles back in an avalanche of dark green pine-needles. This sombre giant, proud in his distress, is contrasted—to treat them as living beings —with the pallid smile of a last rose on the fading bush right opposite him. Beneath the trees are empty stone seats, gloomy box-trees, and a reflection of the sky—yellow—in a puddle left after the rainstorm. A sunbeam, the last ray of light, raises the deep ocher almost to orange. Here and there small black figures wander about among the tree trunks.

> You will realize that this combination of red ocher, green saddened by grey, and the use of heavy black outlines produces something of the sensation of anguish, the so-called *noir-rouge* from which certain of my companions in misfortune frequently suffer. Moreover the effect of the great tree struck down by lightning and the sickly greeny pink smile of the last flower of autumn merely serve to heighten this idea.

Kandinsky

Direct expression through color has become popular among the abstract and non-objective painters of modern times. A lot of so-called action painting is based on color — a fling here and a swish there — and the impact of what is seen relies primarily on visual and emotional responses to the spectrum.

The idea that color holds intrinsic beauty or meaning in painting has had the powerful championship of Wassily Kandinsky, with splendid examples in his abstract works and able writings. He wrote, "Generally speaking, color directly influences the soul. Color is the keyboard, the eyes are the hammers, the soul is the piano with many strings. The artist is the hand that plays, touching one key after another purposively, to cause vibrations in the soul." He followed this with an italicized expression of his credo: "*It is evident therefore that color harmony must rest ultimately on purposive playing upon the human soul; this is one of the guiding principles of internal necessity.*"

People are not all alike, however, either in physical size or emotional temperament. Much of what Kandinsky has to say (like Goethe before him) is individual to Kandinsky and may not find universal concurrence. Yet, he speaks with great authority, and all artists since are indebted to him for inspiring interests and speculations that go far beyond mere naturalistic phenomena.

According to Kandinsky, "Inner necessity is the basis of both small and great problems in painting. . . . The starting-point is the study of color and its effects on men."

To begin with, there were two great divisions: warm and cool; light and dark. Any one color

4-22. QUIET SOLITUDE. Maxfield Parrish. Here is the tight technique by one of America's most popular artists of a few years ago. The paints are transparent glazes, meticulously applied. (Collection of Ralph Powers, Montville, Connecticut.)

4-21. MONT VALERIEN. Maurice de Vlaminck. Here is the loose technique. The colors are intense, opaque, impulsively applied. (Collection of The Museum of Modern Art, New York. Lillie P. Bliss Bequest.)

4-23. LITTLE PLEASURES, NO. 174. Wassily Kandinsky. He expressed the doctrine of "inner necessity," the starting point of which was the study of color. (Courtesy of The Solomon R. Guggenheim Museum, New York.)

could have two principal notes — being warm and either light or dark, or cold and either light or dark. "Generally speaking, warmth or coolness in a color means an approach to yellow or to blue." In this, Kandinsky agreed with Goethe.

Now, color has movement, antithesis, inclination (Ill. 4-24A). Yellow, for example, has a spreading movement and tends to approach the viewer (Ill. 4-24B). Blue moves in upon itself, "like a snail retreating into its shell," and it draws away from the viewer. Red is more stable, it "rings inwardly with a determined and powerful intensity. It glows in itself, maturely, and does not distribute its vigor aimlessly."

In his personal feelings toward color, Kandinsky begins to speak strictly for himself: "*Yellow is the typical earthly color*. It never acquires much depth. . . . If we were to compare it with human states of mind, it might be said to represent not the depressive, but the manic aspect of

4-24A. KANDINSKY'S COLOR CIRCLE. "As in a great circle, a serpent biting its own tail . . . appear the six colors that make up the three main antitheses. And to the right and left stand the two great possibilities of silence — death and birth." (From *The Art of Spiritual Harmony* by Wassily Kandinsky, 1914.)

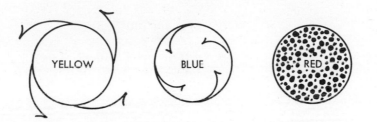

4-24B. KANDINSKY'S COLOR THEORY. According to Kandinsky, yellow spreads and moves toward the observer. Blue moves in upon itself and retreats. Red is stable and rings inwardly. (From *The Art of Spiritual Harmony* by Wassily Kandinsky, 1914.)

madness." One immediately thinks of van Gogh.

"Blue is the typical heavenly color, the ultimate feeling it creates is one of rest." When mixed with black it echoed grief. Mixed with white it reached complete quiescence.

Green, a mixture of yellow and blue, did not appeal to Kandinsky: "In the hierarchy of colors green represents the social middle class, self-satisfied, immovable, narrow." It wasn't much of a color, in fact, and held a mediocre place in art: "Absolute green is the most restful color, lacking any undertone of joy, grief or passion. On exhausted men this restfulness has a beneficial effect, but after a time it becomes tedious. Pictures painted in shades of green bear this out. As a picture painted in yellow always radiates spiritual warmth, or as one in blue has apparently a cooling effect, so green is only boring."

White is "a symbol of a world from which all colors or material attributes have disappeared. . . .

4-25A, 25B. TWO COMPOSITIONS IN BLACK AND WHITE. Wassily Kandinsky. In one there is "cool tension toward the center," and in the other "dissolution is in progress." (From *Point and Line to Plane* by Wassily Kandinsky, 1947.)

4-26. THE DAY OF THE GOD. Paul Gauguin. One man may think in terms of design and pattern. (Courtesy of The Art Institute of Chicago. Helen Birch Bartlett Memorial Collection.)

4-27. NUMBER 1. Jackson Pollock. To another man there is free action without plan or deliberation. (Collection of The Museum of Modern Art, New York.)

White, therefore, acts upon our psyche as a great, absolute silence. . . . It is not a dead silence, but one pregnant with possibilities. White has the appeal of the nothingness that is before birth."

Black is "something burnt out, like the ashes of a funeral pyre, something motionless like a corpse. The silence of black is the silence of death."

Orange "is like a man convinced of his own

| RED | ORANGE | YELLOW | GREEN | BLUE | VIOLET |

4-28. RELATIONSHIPS BETWEEN COLORS AND LINES. As expressed in line, there is action toward red and quietude toward blue and violet.

RED ORANGE YELLOW

GREEN BLUE VIOLET

4-29. RELATIONSHIPS OF COLORS AND FORMS. The warm colors take sharp angles because they can be sharply focused by the eye. The cool colors tend to lose clarity from a distance and therefore take the softer shapes.

powers. . . . Violet . . . has a morbid, extinct quality, like slag. . . . There remains brown, unemotional, disinclined to movement."

Kandinsky was quite aware of what might be called the full *gestalt* of color, its relation to form, vision, performance, and sensory impressions in general. With form, for example, he related red to the square, yellow to the triangle, and blue to the circle — a conclusion reached independently by this writer, and to which could

be added, orange to the rectangle, green to the hexagon, and violet or purple to the oval (Ill. 4-29).

There are reasons for these associations. Warm colors (red, orange, yellow) are sharply focused by the human eye and can be seen in clear detail at a distance. Red further tends to appear solid and substantial, orange somewhat lofty or incandescent, and yellow like sunlight itself. Cool colors, on the other hand (green, blue, violet)

tend to create blurred images on the retina. They tend to appear more transparent, vague, atmospheric and therefore to require softer forms.

Color has definite primacy over form, shape, pattern, design. Any number of qualified scientists have confirmed this. According to David Katz, "Color, rather than shape, is more closely related to emotion." Speaking of the "Mind at Large," Aldous Huxley remarks that "it evidently feels that colors are more important, better worth attending to, than masses, positions and dimensions."

In abstract or non-objective art, color has definite "immediacy" and impresses itself on eye, mind and emotion with strong impact. Indeed, appreciation of form requires a certain amount of intellectual effort, while reaction to color is quite unconscious and spontaneous.

Kandinsky's Analogies of Colors and Music

"The sound of colors is so definite that it would be hard to find anyone who would express bright yellow with bass notes, or dark lake with the treble."

"A parallel between color and music can only be relative. Just as a violin can give warm shades of tone, so yellow has shades, which can be expressed by various instruments."

"To use again the metaphor of the piano, and substituting form for color, the artist is the hand which, by playing this or that key (i.e., form), purposely vibrates the human soul in this or that way."

On the "inner sound" of red: "This inner sound is similar to the sound of a trumpet or an instrument which one can imagine one hears when the word 'trumpet' is pronounced. This sound is not distorted; it is imagined without the variations that occur depending upon whether the trumpet is sounded in the open air, in a closed room, alone or with other instruments, if played by a postilion, a huntsman, a soldier or a professional."

"Light warm red has a certain similarity to medium yellow, alike in texture and appeal, and gives a feeling of strength, vigor, determination, triumph. In music, it is a sound of trumpets, strong, harsh and ringing."

"The pure, joyous, consecutive sounds of sleigh bells are called in Russia 'raspberry jingling.' The color of raspberry juice is close to . . . light, cool red."

"In this lies the great difference between a deepened red and a deepened blue, because in red there is always a trace of the material. Corresponding in music are the passionate, middle tones of a cello. A cool, light red contains a very distinct bodily or material element, but it is always pure, like the fresh beauty of a young girl's face. The ringing notes of a violin exactly express this in music."

"The vermilion now rings like a great trumpet or thunders like a drum."

On orange: "Its note is that of a church bell (the Angelus bell) a strong contralto voice, or the *largo* of an old violin."

"Keen lemon yellow hurts the eye as does a prolonged and shrill bugle note to the ear, and one turns away for relief to blue or green."

"In music, absolute green is represented by the placid, middle notes of a violin."

"In music, a light blue is like a flute, a darker blue a cello; a still darker the marvelous double bass; and the darkest blue of all—an organ."

On violet: "In music it is an English horn, or the deep notes of woodwinds."

White is "like the pauses in music that temporarily break the melody." Of black: "In music it is represented by one of those profound and final pauses, after which any continuation of the melody sees the dawn of another world."

Chapter 5

Six Paths to
Color Expression

This chapter deals with the chief subject of this book — color expression. It will discuss how great painters have visualized their art and the world about them; how they have composed their pictures in terms of light, contrast, color arrangement; how they have painted; the colors they have used. I have chosen six examples of great paintings, and will attempt to show how they

were conceived. Analytic palettes will be presented so that the same effects can be studied and emulated.

The Vision of the Artist

The sense of vision is by no means a matter-of-fact reaction to external stimuli. The eye is far more than a camera and the retina far more

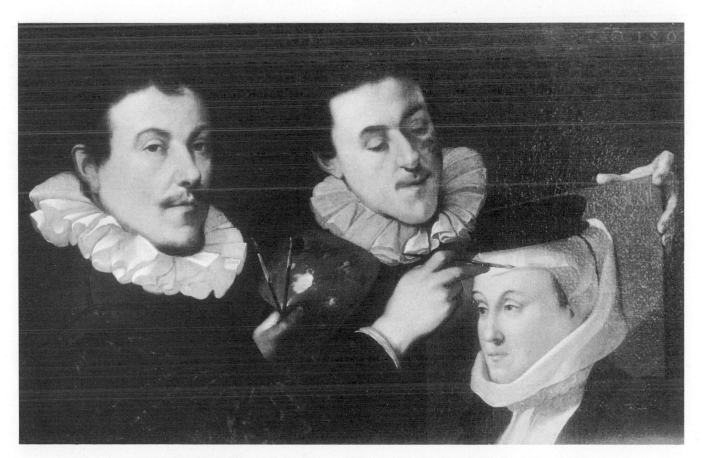

5-1. SELF-PORTRAIT. Joseph Heintz, 1599. On the small palette are black, burnt umber, crimson lake, vermilion, white, and flesh tint. Many early artists used no green or blue. (Courtesy of Berne Art Museum, Switzerland.)

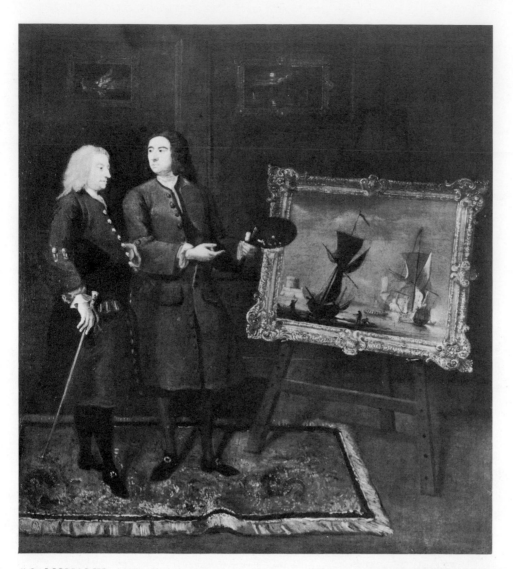

5-2. MONAMY AND WALKER. Artist unknown. (Copy after Hogarth.) In this eighteenth century British painting the palette shows white, red, yellow ocher, reddish brown, dull brown, and black — and no green or blue. (Courtesy of The Art Institute of Chicago. A. A. Munger Collection.)

5-3. PORTRAIT OF THE ARTIST. George Henry Story (1835-1922). He was at one time Curator of Paintings at The Metropolitan Museum of Art in New York. The palette he holds contains white, yellow, yellow ocher, red, red oxide, deep blue, brown, black — plus flesh tones, and mixtures. (Courtesy of The Metropolitan Museum of Art. Gift of Mrs. George H. Story, 1906.)

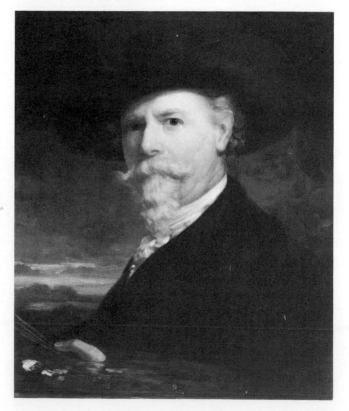

than a photographic plate. Seeing is definitely a talent, a matter of education and training.

James P. C. Southall writes in his *Introduction to Physiological Optics:*

> Good and reliable eyesight is a faculty that is acquired only by a long process of training, practice and experience. Adult vision is the result of an accumulation of observations and associations of ideas of all sorts and is therefore quite different from the untutored vision of an infant who has not yet learned to focus and adjust his eyes and to interpret correctly what he sees. Much of our young lives is unconsciously spent in obtaining and coordinating a vast amount of data about our environment, and each of us has to learn to use his eyes to see just as he has to learn to use his legs to walk and his tongue to talk.

Perception (defined by Webster as "awareness of objects, consciousness") is influenced by intelligence. Thus all men do not see alike for the simple reason that they are not equally aware or equally conscious. The Gestalt psychologist has made this clear indeed. According to David Katz, "All visual percepts are influenced by knowledge that comes from experience." Interests and attitudes are important factors. The sky has different aspects to a child hoping for a sunny day, a farmer hoping for rain, and a sailor hoping for a steady breeze. Even more complex than this, the face of a woman will appear one thing to a lover, another to a mother, and still another to the family doctor.

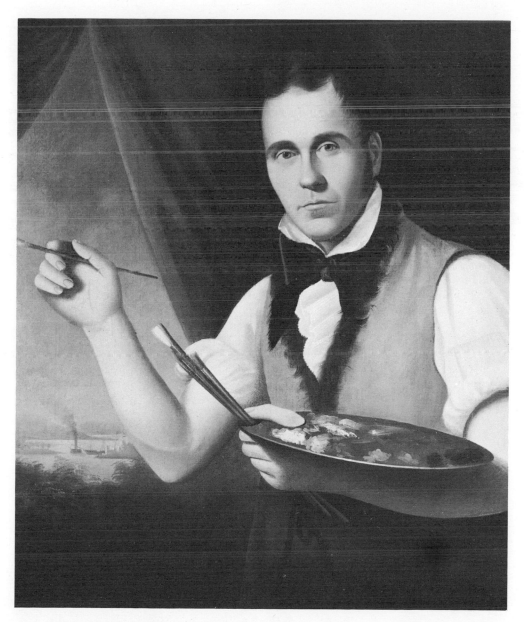

5-4. SELF-PORTRAIT. Francis Matté. He was a nineteenth century Canadian painter. The color effect is brilliant. On the palette are red, yellow, brown, green, white, and mixtures. (Courtesy of The Detroit Institute of Arts.)

Thus it is quite certain that an artist sees differently from other men. He may be more sensitive, more discerning, more responsive. He may see purple in the mist shrouding a mountain, blue in the shadows of sunlight, glints of multicolor in a piece of black or white cloth. He may emphasize "visions" such as these and hence bring them to the consciousness of others.

Yet if the perception of the artist is singular, one should not assume that his intellectual capacity is equally so. Some of the faults of modern art can be traced to this false assumption. The two things do not necessarily go together. In fact, they seldom do. Few great painters have been good philosophers or scientists. And few great philosophers or scientists have been good painters.

There is little doubt that the artist, no matter how realistic, still makes his own interpretation. Arthur Pope insists that the Old Masters were not realists but that their painting was "definitely abstract." Realism may be a poor word here, and so may the word abstract. Yet one agrees with Pope when he states, "The rendering of color was always a matter of *expression* of what seemed essential relations within conventional limitations, and not at all a matter of an *imitation* of all the variations of color in the subject itself."

For example, in portraits and figures, there was often full modeling in highlight and shadow and

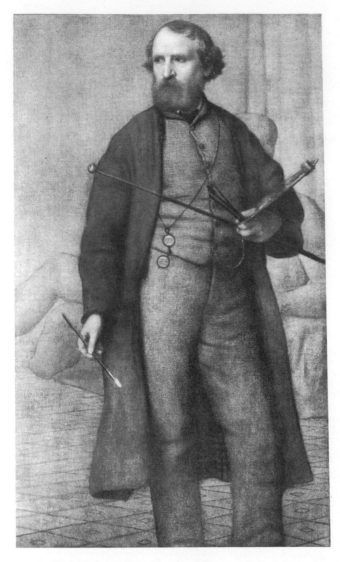

5-5. SELF-PORTRAIT. William Page. He was a nineteenth-century American painter. He idolized the Venetian school and became known as the Titian of America. He used a warm deep palette with underpainting and glazes. (Courtesy of The Detroit Institute of Arts.)

5-6. ENTRANCE TO TENJIN'S CASTLE IN HEAVEN. Detail of painted scroll. Artist unknown. Kamakura Period (1186-1334). In Japanese painting, an over-all tone with little contrast was common. The ground became the atmosphere, with touches of lights and darks superimposed. Colors were soft in key. (Courtesy of The Metropolitan Museum of Art. Fletcher Fund, 1925.)

yet few or no cast shadows — a natural impossibility. Writes Pope, "Painting was a completely rationalized expression of ideas about objects, not simply a matter of momentary appearance." The light falling on a man seated at table was painted to appear just as bright under the table as above it — as if the table cast no shadow at all. A simultaneous view of an interior and the out-of-doors was frequently painted as if the illumination intensity was identical in both places. (This would be impossible in photography unless two exposures were made separately and then brought together in one print.) What the older artist wanted was representation rather than realism, permanence rather than the ephemeral, and idealization rather than truth.

The Old Masters also composed their subjects in unusual ways. Aside from matters of rhythm, proportion, balance, design, the vital medium of color was creatively employed. Here are examples.

5-8. JOHN THE BAPTIST: SALOME ASKS HEROD FOR THE HEAD OF THE BAPTIST. Giovanni di Paolo (ca. 1450) (Courtesy of The Art Institute of Chicago. Mr. and Mrs. Martin A. Ryerson Collection.)

5-7. ILLUSTRATION FROM THE ROMANCE OF AMIR HAMSAH. Artist unknown. Mughal School, Period of Akbar (1556-1605). In much Indian painting, colors of similar value or brightness were frequently used — as against great contrasts of the western style. (Courtesy of The Metropolitan Museum of Art. Rogers Fund, 1918.)

5-9. CHRIST APPEARING TO HIS MOTHER. Rogier van der Weyden (ca. 1400-1464). Here the artist handles indoor and outdoor illumination as if they were one. Such experience may be true to human perception but it is not factual. (Courtesy of The Metropolitan Museum of Art. Bequest of Michael Dreicer, 1921.)

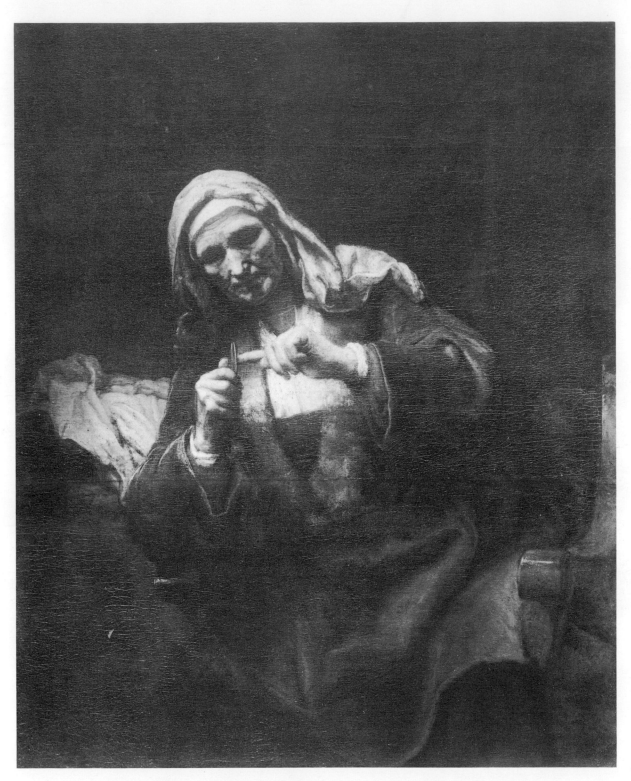

5-10. OLD WOMAN CUTTING HER NAILS. Rembrandt van Rijn. Here there is a crowding of darks, to create a field size that will give dramatic emphasis and luminosity to details. (Courtesy of The Metropolitan Museum of Art. Bequest of Benjamin Altman.)

In figure painting, it was common for the artist to give the major area to his dark colors, spreading them over the greater part of his canvas to lend dramatic punch to small touches of gleaming hue and brightness. Rembrandt had a penchant for this mode of expression.

Many early landscapes used aerial perspective.

The foreground featured dark masses, with medium and lighter tones applied to middle and far distances.

Turner and some of the Impressionists liked to crowd their lights, so to speak, making them dominant in a canvas and then offsetting them with minor areas of deeper tones. This mode

5-11. THE SERMON ON THE MOUNT. Claude Lorrain. Many early landscapes were composed as shown here. There were dark masses in the foreground silhouetted against paler middle ground and still paler far distance. (Copyright, The Frick Collection, New York.)

5-12. MERCED RIVER, YOSEMITE VALLEY. Albert Bierstadt. Here is a classical example of aerial perspective. The softening of colors and values into the distance creates striking illusions of depth. (Courtesy of The Metropolitan Museum of Art. Gift of the sons of William Paton, 1909.)

5-13. VETHEUIL IN WINTER. Claude Monet. Here is a good example of the crowding of lights, an effect favored by many of the Impressionists. The colors are mostly whites and pale blues, with black accents. (Copyright, The Frick Collection, New York.)

became the style of most of the Impressionists.

There were palettes and color effects based on depth of color, on brightness, on purity, on soft tonality, or on any other element that might appeal to the individual artist.

As to the harmony of colors, many painters favored elementary hues, such as red, yellow, green, blue. Here would be such varied talents as Raphael, Rubens, El Greco, Mondrian, and Léger. The effects seem classical and almost symbolic. They are powerful perhaps because they combine universal elements in color appeal.

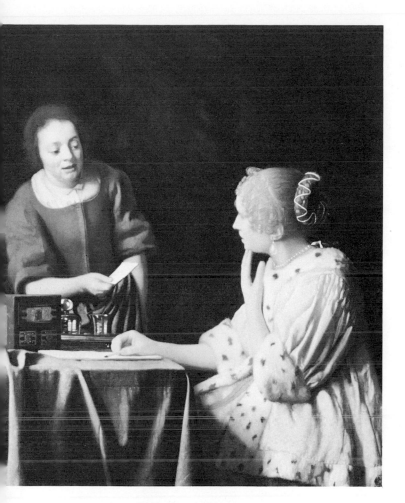

5-14. MISTRESS AND MAID. Jan Vermeer. He liked the combination of primary yellow and primary blue, here set against a deep neutral background. Other Old Masters often featured primary red, yellow, green, and blue. (Copyright, The Frick Collection, New York.)

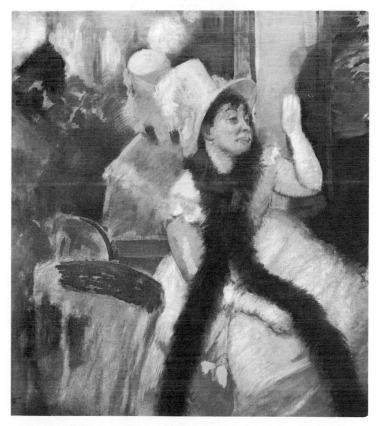

5-15. WOMAN IN ROSE HAT. Edgar Degas. Here there is a use of subtle and intermediate colors, red-orange, gold, pink, gray-green. The effect is more sophisticated. (Courtesy of The Art Institute of Chicago, Joseph Winterbotham Collection.)

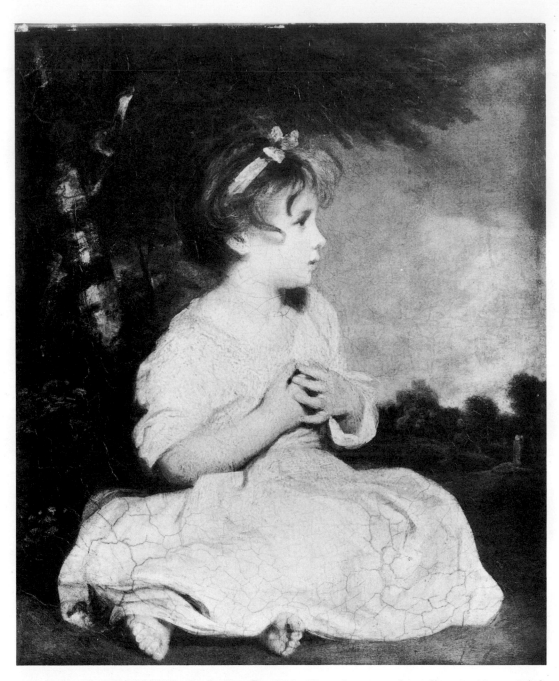

5-16. AGE OF INNOCENCE. Sir Joshua Reynolds. There is a general tonality of gold, two-thirds warm and one-third cool, as the artist planned. (Courtesy of Director, Tate Gallery, London.)

Many artists such as Titian, de la Tour, Rembrandt, and Reynolds sought a predominant tonality — usually golden, yellowish or a sulphur-like yellow. Van Gogh and Lautrec delighted in a "gaslight" pallor.

Various painters liked complements, a full palette, evenness of tone, high contrast, low contrast, or cold-warm opposition. Much of such variety and difference of viewpoint will be ap-

parent in the pictures and palettes to be considered in this chapter. From the rather amazing diversity of expression to be found in the long history of color in art, one might conclude that there is nothing left for the future but repetition of the past. This is not true, fortunately, for modern research into the mysteries of human perception has opened new doors that await original development by artists yet to come.

Color Chart of Pigments and Palettes (pages 106-107).

Care should be taken with the color chart that follows. The color samples included have been made from permanent materials, but even so they should not be exposed to light.

An artist's color expression is naturally limited by the range of his palette, yet, despite their restrictions, many of the great masters achieved unusual effects from simple arrangements of hue and with limited pigment choices, as will be seen by the color samples and descriptions presented on the next two pages.

TRADITIONAL PIGMENTS. The pigments to the right were commonly used by great artists of the past. Other pigments, of course, are now available. For example, there are other reds, yellows, greens, blues, and browns, but they tend to look much the same as the hues included here. A palette composed of colors like these (plus white and black) would make it possible to duplicate virtually any color effect by any artist in any century. It is important to bear in mind, however, that the samples shown have been chosen more for their visual appearance than for their chemical composition. Other matching pigments could be substituted.

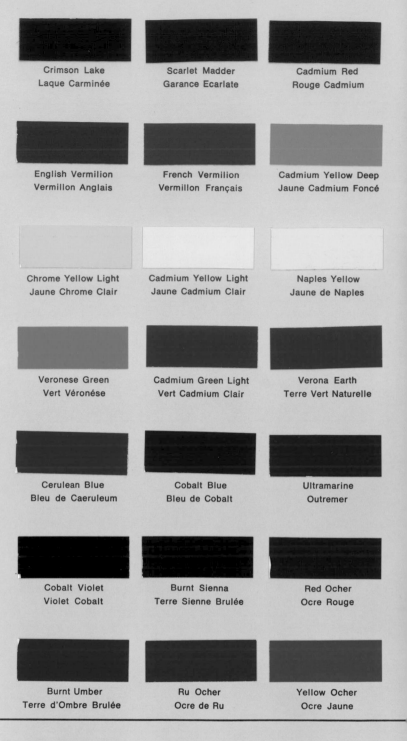

Crimson Lake
Laque Carminée

Scarlet Madder
Garance Ecarlate

Cadmium Red
Rouge Cadmium

English Vermilion
Vermillon Anglais

French Vermilion
Vermillon Français

Cadmium Yellow Deep
Jaune Cadmium Foncé

Chrome Yellow Light
Jaune Chrome Clair

Cadmium Yellow Light
Jaune Cadmium Clair

Naples Yellow
Jaune de Naples

Veronese Green
Vert Véronése

Cadmium Green Light
Vert Cadmium Clair

Verona Earth
Terre Vert Naturelle

Cerulean Blue
Bleu de Caeruleum

Cobalt Blue
Bleu de Cobalt

Ultramarine
Outremer

Cobalt Violet
Violet Cobalt

Burnt Sienna
Terre Sienne Brulée

Red Ocher
Ocre Rouge

Burnt Umber
Terre d'Ombre Brulée

Ru Ocher
Ocre de Ru

Yellow Ocher
Ocre Jaune

THE BALANCED PALETTE. A selection like that shown opposite is necessary if the artist is to have unlimited expression. It can be used as a basic palette from which a painter can work directly, or its colors can be mixed to create predetermined scales and effects. For either method, the standards have been chosen on sound practical as well as scientific principles.

106

THE DA VINCI PALETTE. The colors at the right do not presume to represent the *pigments* employed by da Vinci. Rather they have been chosen on a visual basis. The magnificent chiaroscuro effects of this great master can be achieved today if the artist arranges his palette accordingly and forms color scales that follow da Vinci's original procedures.

THE EL GRECO PALETTE. The pale gray tone is the key to this unusual palette. El Greco always kept his deep tones fairly pure and moved up into highlights by adding dull whites for weird chalky effects. The pale tones were thus weak in hue and the deep tones comparatively rich. His color effects can be accomplished today if the color samples to the right are carefully matched.

THE REMBRANDT PALETTE. Like Titian, da Vinci, and many Renaissance painters, Rembrandt favored a golden quality in his compositions. He used rich, warm red, yellow, flesh, and creamy tones, and suppressed his blues and greens. With a palette containing no more than six pigments, astonishingly luminous effects were achieved. Highlights and feature areas were always pure in hue; shadows were always formed with rich shades. There were virtually no pastel tints.

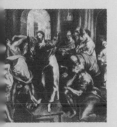

THE TURNER PALETTE. Turner was one of the greatest colorists of all time. He discovered new principles and invented new color arrangements. In the palette at the right, the light tone is pure and the deeper tone grayish. If color scales are formed in this manner, the amazingly brilliant effects of sunrise and sunset achieved by Turner can be created today. In fact, a good part of modern color expression in art traces directly to the genius of Turner.

THE IMPRESSIONISTS' PALETTE. Many of the Impressionists and Neo-Impressionists eliminated black, white, and brown from their palettes and relied on visual mixtures to form shaded and toned colors. Others, however, like Monet and Renoir, admitted shades but used them chiefly for accent purposes. Most effects in Impressionism depend on pure colors and pure pastel tints on white grounds, put together as though they were point light sources.

107

Evidences of Temperament

There have been temperamental artists, of course, men of great success and great failure — and above all, men of great tragedy. Yet much of this can be exaggerated. Among the Impressionists, for example, one is struck by their middle-class backgrounds and their commonplace, bourgeois existences. Van Goghs and Gauguins to the contrary, painters by a large majority have been hard-working souls living dull humdrum lives — at least in outward appearances. Yet one is not to deny their absorption and dedication. If many artists have dwelt in conventional circumstances and followed conventional ways, their private creative lives have perhaps lifted their spirits— and their works.

It is not necessary to be insane in order to be a genius; sometimes it helps and sometimes it hinders. The artist sees differently from other men in many cases, and therefore may feel differently. He is exceptional or he would not become an artist. None of this, however, need set him apart as eccentric, On the contrary, the presumed Bohemian life of the artist has all too often been an affectation. Artists of the Renaissance and of the eighteenth and nineteenth century did not live in attics either physically or figuratively. The French were responsible for the Bohemian reputation of artists, and this reputation did not come until the first World War. Aristocracy and wealth have always patronized the painter. He stopped dressing for dinner and eating well when he became a rebel, a democrat, and a free-thinker. A new and independent mode of life has been good for him. A man can have security without freedom, or freedom without security. Most artists of recent times admirably have made the second choice.

Carl Jung has neatly divided human temperaments into two groups, the extrovert and the introvert. Artists are found in both camps. The extrovert is likely to be more influenced by color than by form. He is likely to be outwardly oriented, that is, to be more affected by the world about him than by his own inner cerebrations. He will reason intuitively and inductively, from the specific to the general. He likes warm and vibrant colors, modernity as against tradition, and if he has mental ills he is likely to become a manic-depressive. He is more likely to have a Latin and Gallic temperament. In a broad way, he is quite French.

The introvert, on the other hand, is likely to be more sensitive to form than to color. He is inwardly oriented, less affected by the world than by himself. In other words, he is logical and deliberate. He will reason deductively. He likes cool and subdued color, and if he has mental ills he is likely to become a schizophrenic. He has more of the characteristics usually considered typical of Germanic and Nordic peoples.

On the matter of artistic temperament, let me recommend *The Art of Color* by Johannes Itten. As a highly capable teacher, Itten has rightly emphasized the need for personal expression in the use of color. No color, color scale, or color scheme can possibly be all things to all men. Itten's book shows examples of the color expression of various young people (and also includes photographs of them). Some liked bold color, others somber color. There was symmetry and order, as well as pure fancy. Itten writes:

> There are subjective combinations in which one hue dominates quantitatively, all tones having accents of red, or yellow or blue, or green, or violet, so that one is tempted to say that such-and-such a person sees the world in a red, yellow, or blue light. It is as if he saw everything through tinted spectacles, perhaps with thoughts and feelings correspondingly colored.
>
> In my studies of subjective color, I have found that not only the choice and juxtaposition of hues but also the size and orientation of areas may be highly characteristic. Some individuals orient all areas vertically; others stress the horizontal or diagonal. Orientation is a clue to mode of thought and feeling. Some individuals incline towards crisp and sharply bounded color areas, others to interpenetrating or blurred and haphazard patches. Individuals of the latter kind are not given to clear and simple thinking. They may be quite emotional and sentimentally disposed.

The effort and the exercise of trying to find personal expression through color and form is most helpful to any artist, and should be pursued. Itten draws the following conclusions:

> Among painters, I perceive three different attitudes toward problems of color.
> First there are the epigoni, having no coloration of their own but composing after the manner of their teachers or other exemplars.
> The second group is that of the "originals"— those who paint as they themselves are. They com-

pose according to their subjective timbre. Though the theme changes, the chromatic expression of their paintings remains the same. . . .

The third group is that of the universalists—artists who compose from inclusive, objective considerations. Each of their compositions, according to the subjet to be developed, has a different color treatment. That there should be but few painters in this group is understandable, for their subjective timbre must comprehend the entire color circle, and this happens rarely. Besides, they must possess high intelligence, admitting of a comprehensive philosophy

The Color Triangle

As has been mentioned earlier, this chapter will discuss the color expression of six great painters and show how what they did was based on a naturally and psychologically designed Color Triangle. None of this will concern rules or laws, but mere observations on the unique concepts of outstanding painters, concepts which in most instances have become part and parcel of art tradition.

Color solids and color order systems will be discussed in the next chapter. In the field of sensation, psychologists generally accept the arrangement suggested by A. Höfler in 1897 (Ill. 5-17). This is composed of a double pyramid or octahedron, with white at the top apex, black at the bottom; the top and bottom are connected by a gray scale. Red, yellow, green, and blue are placed on the four corners of the central parallelogram which brings the two pyramids together. These four hues are primary to the eye.

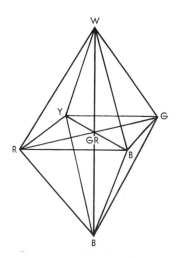

5-17. HOFLER'S PYRAMID. The field of psychology has long regarded this three-dimensional "solid" as a satisfactory diagram of the way in which color sensations find order and relationship in human experience. (From a drawing by Höfler, 1897.)

Höfler's diagrammatic solid visualizes the world of color sensation in a simple and effective way. Pure colors are arranged around the horizontal axis of the parallelogram. Tints containing white run up toward the white apex. Shades containing black run down toward the black apex. Modified, grayish tones occupy the inner part of the figure near the neutral gray scale.

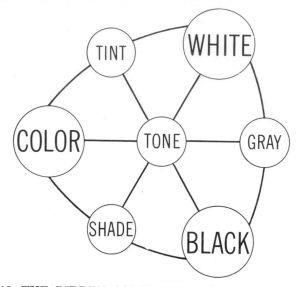

5-18. THE BIRREN COLOR TRIANGLE. Color sensations may be grouped into the seven basic forms charted here. There are pure color (any and all), white, and black; tint, tone, shade, gray. And there are harmonious relationships in all straight paths.

The Birren Color Triangle (Ill. 5-18) follows the concepts of A. Höfler, Ewald Hering, and Wilhelm Ostwald; it is both remarkably simple and clear in showing visual and psychological color relationships.

There are but *seven* forms of color, no more, no less, from the standpoint of human perception. Three of these forms are primary and four are secondary. The first form is pure color (any and all, but founded on red, yellow, green, blue). The second primary form is white, and the third is black. None of these forms resembles the others in the least — they look nothing alike.

Pure color and white create the tint form. Pink, for example, has both pure hue and white in its makeup. Pure color and black create the shade form. A color such as maroon resembles both red and black. White and black combine to produce gray. Finally, pure color, white *and* black create the tone form. Rose is a tone, and in its subtlety, it suggests touches of pure color, white, and black or gray.

Regardless of the vastness of the world of color,

the thousands of variations seen by the human eye are sorted by the brain into the seven forms of the Color Triangle. In fact, the brain tries its best to simplify what the eye sees, to make order out of chaos and to reduce a complexity of sensations to simple elements and forms. This is the *human nature* of color.

Because the Color Triangle is straightforward in its arrangement, any of its directions or paths is visually and psychologically harmonious. There is beauty of sequence from color to tint to white, from color to shade to black, from white to gray to black (Ill. 5-18). In cross directions, concords exist in paths from tint to tone to black, from shade to tone to white, and from color to tone to gray. Similarly, pure colors are harmonious with white and black (the primary forms), while tints, shades, and gray are harmonious with tones (the secondary forms).

The Color Triangle will now be used to trace six paths to color expression as followed (intuitively perhaps) by six great masters. In each case the feeling is different, the effect singular and compelling.

The chart of color samples on pages 106-107 contains palettes developed by the author to carry out the six effects to be described. These palettes are not those of the original masters but have been selected to enable the artist of today to duplicate what is seen visually in the color reproductions of the paintings.

Are there more than six paths for color? Indeed there are! Possibilities are limitless, and new

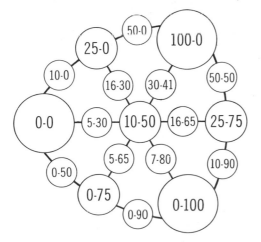

5-19. THE BIRREN COLOR EQUATION. If pure color (0-0), white (100-0), and black (0-100) disks are spun on a color wheel in the proportions shown here (and matched in paints) perfect visual order will be achieved. The first numeral in each instance indicates white content. The second numeral indicates black content. The color content will be the sum left over to equal 100.

modes of creative expression will be featured in chapters that follow. What is of great concern to the artist is the fact that majesty and originality of color expression need not be haphazard but can be thought through. The Color Triangle can be used as a divining rod — to be pointed here and there to locate fresh wellsprings.

The Color Expression of Leonardo da Vinci

Da Vinci was a complex and highly intelligent man. It is quite probable that the chiaroscuro style he developed was by no means a happy accident, but the result of discerning observations of nature. One learns from his writings of his interest in sunlight, shadow, illumination, space relationships, three-dimensional form. Indeed in his day, the greatest accomplishment of the artist was to achieve roundness, depth, dimension, and relief on a canvas or panel.

Not many of da Vinci's paintings have survived. And more, the colors he used have undoubtedly faded or been masked by subsquent restorations. Yet with a fair knowledge today of the pigments employed in the early sixteenth century, it becomes possible to reconstruct these Renaissance color effects and to work out a palette that will enable the artist of today to simulate what was done over four hundred and fifty years ago.

The da Vinci palette shown on the chart on pages 106-107 does not assume to duplicate either the actual pigments or the hues employed by da Vinci. Rather, its purpose is to offer a fixed palette adjusted on a *visual basis* to da Vinci's mode of expression. In other words, if the colors on this palette are matched and used exclusively in a modern composition, the strangely beautiful chiaroscuro style of da Vinci can be readily duplicated. The artist can, on short order, gain a first-hand knowledge of Renaissance concepts.

What da Vinci discovered was both a syle of painting and a principle of color which resulted in astounding beauty and realism. Where formerly the painter had added white to a rich color to show full light, and black to show shadow, da Vinci knew this was unnatural. His colors in bright light got purer, not paler, while the colors in shadow had a certain richness and were not flat.

111

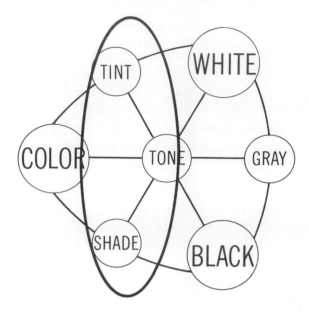

5-20A. THE COLOR EXPRESSION OF LEONARDO DA VINCI. In general, the color sequences were from tint, to tone, to shade. The tints were clean in hue. Most important of all, as the colors fell into shadow they remained soft. This was the chiaroscuro style. White was not added to pure color for highlights or black to pure color for shadows, as before da Vinci. He had discovered a new principle — visually true — and it influenced the art of painting for many generations.

5-20B. MONA LISA. Leonardo da Vinci.

Refer to the diagram of the Color Triangle on which da Vinci's principle is indicated (Ill. 5-20A). It is quite apparent that in executing a composition, da Vinci applied flat planes of full color. Shadows were then glazed over these areas to get plastic form. Thus the lightest areas also tended to be the purest in hue — an effect which was original at the time and which other painters emulated. Flesh tones became remarkably luminous.

In the "Mona Lisa," which is quite familiar to all who have studied art, not much pure color is evident. The reds seem to have faded. Yet note the irridescence of the flesh and the golden luster of the sleeves. The light areas are the richest and are given added purity by being set against larger areas of darkness.

What is of major importance, however, is that da Vinci applied glazes to his flat, pure tones, so that there is mellowness of color throughout. Nothing seems either chalky or dirty. His scales work vertically on the Color Triangle, from pure colors or rich tints, to tones, to shades. And once again, it should be emphasized, the brightest areas are always the purest. Da Vinci did not weaken his highlight with white as virtually all

artists before him had done; he left them pure.

The da Vinci palette on the color chart on pages 106-107 is taken less from the "Mona Lisa" than from "The Annunciation" and "The Virgin of the Rocks." The palette shows two tones of flesh, two tones each of gold, orange and blue, a light and dark brown, plus one tone of a dull green, and a warm white. If an artist today will match these standards and remember to keep his light areas pure, he can effectively repeat the chiaroscuro style, even if he dispenses with glazes and uses opaque paint. He can mix the colors of the da Vinci palette as he wishes, and his color effects will be quite majestic.

The Color Expression of El Greco

El Greco worked in quite another way. Refer to the diagram of the Color Triangle in which his principle is indicated (Ill. 5-21A). In practically all of his numerous paintings, his colors in shadow were rich and pure (and often a bit dirty), while his light areas and highlights were invariably whitish and chalky. It is quite apparent that he had deep colors on his palette and added white to them as he painted. Thus his procedures were

quite different from those of da Vinci — and so were his color effects.

The sequence was from rich shade, to tone, to whitish or grayish lights. If this was untrue to life, it was harmoniously consistent, and the viewer today senses that he is seeing color expression not so much of this world as of the imaginative and creative world of El Greco. The compositions seem blackish and whitish in character, with color nicely balanced between the two extremes.

An El Greco palette is given on the color chart on pages 106–107. This is based on various of his paintings, most of which have a similar and consistently good color expression. Again let me emphasize that the palette is visual in organization and has no reference whatever to the pigments El Greco may have used in the early seventeenth century. There is, first of all, a chalky white and a slightly grayish black. To these are added a flesh tone, a dull red, dull blue and gold, making a total of six colors in all. (The tan color seen on the jacket of the man to the left can be formed by combining red with gold; the greenish color in the garment of the man to the right can be formed by combining gold with blue.)

To simulate the color art of El Greco, one needs merely to apply the full, deep colors in shadows and then work up toward white by adding a chalky white paint. Black can be concen-

trated for maximum depth. A color sequence like this is quite simple and is easily repeated today. However, it by no means has the subtlety or complexity of da Vinci's chiaroscuro method.

The modern artist must recognize that the color expression of El Greco has a certain eerie quality. It suggests the supernatural, or at least, the unreal. To use it for a portrait or for a landscape is to establish a color mood that is weird rather than mundane or familiar. This indeed may be what an artist wants.

The Color Expression of Rembrandt

Rembrandt was one of the most versatile painters of all time. His color expression and style closely resemble da Vinci's, though with less refinement. Rembrandt probably worked quickly, was facile with paint, brush, and palette knife.

While Rembrandt often used a full palette, the great majority of his paintings were quite restricted as to pigment choice. He was fond of a dominant, golden tonality, an effect that was pervaded by golden light and self-luminous. He evidently discovered that where such an illumination condition was depicted, blues had no place and would contradict the golden atmosphere. So it was that his palette was often limited to warm white, golden yellow, red, brown, and olive green.

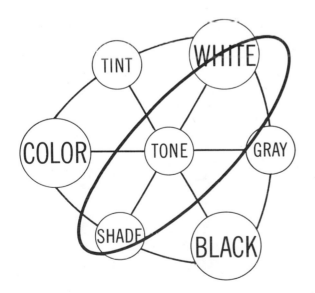

5-21B. CHRIST DRIVING THE TRADERS FROM THE TEMPLE. El Greco.

5-21A. THE COLOR EXPRESSION OF EL GRECO. The color sequences were from shade, to tone, to white. The richest hues were concentrated in the deep areas and became weaker and chalkier as they scaled up toward

white. This was an *unnatural* state of affairs, but it seemed perfect for El Greco's religious subjects. (See El Greco palette on color chart, pages, 106–107.)

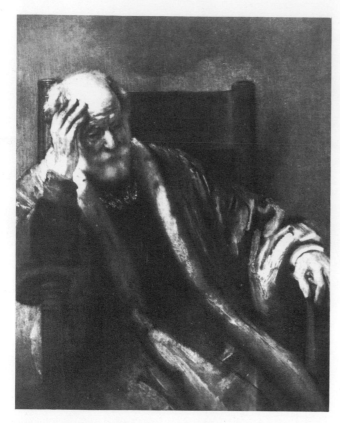

5-22A. AN OLD MAN IN THOUGHT. Rembrandt van Rijn.

5-22B. THE COLOR EXPRESSION OF REMBRANDT. The color sequences in most of Rembrandt's paintings were from pure color, to shade, to black. He crowded the darks — always rich in hue and seldom with any white in them — over the major area of his canvas. Purity and brightness of color were then confined to highlights and features. This resulted in tremendous brilliance, luminosity, and concentration of visual attention at the will of the artist.

Rembrandt's "An Old Man in Thought" is shown in illustration 5-22A. It is quite typical of the master's work. Three ingenious devices have been used.

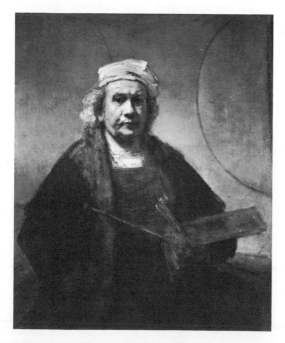

5-23. SELF-PORTRAIT. Rembrandt van Rijn. Unfortunately, the artist let the colors on the palette seen here fade off into nondescript browns. Otherwise the world might have had a true visual picture of Rembrandt colors. (Copyright, London County Council.)

First, Rembrandt employed the Law of Field Size (to be discussed in Chapter 7), whereby the major area of the composition, in warm, muted tones, allows for powerful emphasis of smaller bright areas — the face of the old man and the highlights of his robe.

Second, these smaller, brighter areas — the old man's face and the touches of red and rose on the garment — appear lustrous through the simple expedient of using the lightest and purest colors for them.

Third, the over-all effect is one that induces a feeling of golden light. In other words, Rembrandt forces the viewer to participate in the final result, to encourage human perception to sense a luminous atmosphere within the painting.

Refer to the diagram of the Color Triangle on which Rembrandt's principle is indicated (Ill. 5-22B). Then study the six colors of the Rembrandt palette on the color chart on pages 106-107. These are a warm white, a flesh tone, golden yellow, warm red, olive green, and blackish brown.

Luminosity, translucency of flesh tone, purity and iridescence of color in the art of Rembrandt are achieved through sequence from pure color, to shade, to black — with white or flesh tone as a

superimposed accent. There are seldom any pastel tints and virtually no gray. Thus Rembrandt and El Greco are poles apart in color expression.

Where a Rembrandt palette is used, whites and flesh tones must be contained in relatively small areas of the painting. The white must not be mixed with the gold, red, green or brown. (Yet the gold, red, green, and brown may be freely mixed with each other.) The principle is to hold a deep, rich tone over the major field or ground, and to confine the bright and pure touches to small areas of emphasis.

The palette is an easy one to employ, though it may belong to another century. Perhaps the resourceful artist of today can add to it and expand its magic. In its day and for generations after, the Rembrandt color effect stood as one of the high achievements in the art of color.

The Color Expression of
J. M. W. Turner

Turner's vision was unique and led to a new principle of color arrangement that influenced Impressionism and much of modern art expression. Turner was one of the greatest colorists of all time, and surely one of the most original.

In studying Turner's works and in reading what little has been written about his life and techniques as a painter, one learns that he was impatient with the traditional need for good drawing and craftsmanship and anxious to give his major if not complete attention to color. Later in life, he turned aside from pictures that told stories or had any connections with mythology or history. According to Sir William Orpen, "As he grew older, and particularly after his visit to Venice in 1832, Turner became more and more ambitious of realizing to the uttermost the fugitive radiances of dawn and sunset. Light, or rather the color of light, became the objective of his painting to the exclusion of almost everything else, and few of his contemporaries could follow him as he devoted his brush more and more to depicting the fugitive radiances of dawn and sunset."

Turner's major principle is indicated on a diagram of the Color Triangle (Ill. 5-24A). The sequence — and it was completely new to color expression — runs from pure light tints or pastels to grayish tones. In other words, light colors were

made pure, and softer or deeper colors were neutralized. This was precisely the opposite of the principle followed by El Greco. And in contrast to the styles of da Vinci and Rembrandt, Turner in his more abstract paintings seldom used deep colors or rich shades. Rather, the over-all quality was grayish, not blackish, and it created a field upon which purer tints and pastels shone radiantly. At times his paints seemed lustrous and iridescent.

Turner's painting "The Fighting Téméraire" is **shown in black and white in Illustration 5-24B.** Note the moon to the left and the setting sun to the right. Though the composition may appear

5-24A. THE COLOR EXPRESSION OF TURNER. The color sequences were from tint, to tone, to muted grays — the precise opposite of the principle followed by El Greco. Also, the light tones were the purest and the deep tones the weakest. This concept was new and revolutionary and as important to the art of color as da Vinci's chiaroscuro. Turner's brilliant use of color broke sharply with the past and anticipated much color expression that followed after him.

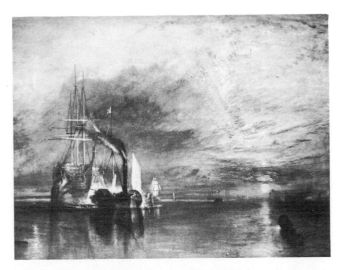

5-24B. THE FIGHTING TEMERAIRE. J. M. W. Turner.

115

5-25A. SUNFLOWERS. Claude Monet.

5-25B. THE COLOR EXPRESSION OF THE IMPRES-
SIONISTS. The color sequences were from pure color, to
tine, to white for the most part. Several Impressionists and
Neo-Impressionists eliminated blacks and browns entirely.
Color mixtures were to be visual. Through adroit arrange-
ments of fine dots, daubs, or lines composed of pure hues
or pure tints, just about any color or color modification
could be achieved. Pigments were to be used as if they were
light sources.

conventional today, it was attacked as being radi-
cally exaggerated when it was originally ex-
hibited.

Now refer to the Turner palette on the color
chart on pages 106-107. In selecting these colors,
I have taken certain liberties. For example, I have
given major attention to Turner's later and more
abstract paintings and have eliminated all but
one deep color — a warm gray. Otherwise, I have
kept true to Turner's principle (but not to the
actual pigments he employed).

On the Turner palette is a white, a luminous
yellow, a pure and a muted pink, a pure and a
muted orange, a pure and a muted green, a pure
and a muted blue, plus a medium warm gray and
a deep warm gray. The lighter color in each pair
is pure, while the deeper tone is more neutral.

It should be emphasized that these sequences
(from a light pure tint to a medium grayish
tone) run contrary to the way in which paints
normally react when mixed with white. A
medium red, pink, green or blue grow weaker if
white is added to them. Yet according to Turn-
er's principle, the pale color is the purer and the
medium color the weaker.

An artist today who prepares a Turner palette
is advised to hold his compositions clean and
pure in the light areas, and grayish in the me-
dium areas — with dark areas either omitted en-
tirely or limited to a few minor touches. The pure
tints can be intermixed, and so can the muted
tones. The medium warm gray can be used where
lower values are wanted.

Effects of luster, iridescence, and luminosity
will readily be accomplished once Turner's prin-
ciple is understood. For in the rapture and dis-
coveries of the great English painter, the art of
color reached one of its highest peaks.

The Color Expression of
The Impressionists

Chapter 3 has described and listed the palettes
of such modern painters as Delacroix, Renoir,
Cézanne, and Signac. In the latter years of the
nineteenth century, paints and pigments became
widely available in tubes. The artist no longer
had to concern himself with chemistry. Now the
entire spectrum was at his command and he
could proceed without having to bother with the
materials of his craft.

The Impressionists, of course, worshipped
color and created one of the greatest epochs in
the history of the art of color. Interested in the
mysteries of light, spectrum analysis, and physio-
logical optics, they devised new techniques based
on new viewpoints.

A painting by Claude Monet, "Sunflowers," is
shown in black and white in Illustration 5–25A.
Like other Impressionists, he favored a white
canvas, wholly opaque paints, and a little under-
painting, tinting or even drawing. The artist was
to go about his work swiftly and directly, take
his easel out of doors, and apply his paints as if
they were rays of light.

Pure colors were naturally preferred. However,
most of the Impressionists (Monet, Degas, Ren-
oir, Cézanne) did not hesitate to use black, but

116

usually for emphasis in solid areas and not in paint mixtures. In time, brown was looked upon with suspicion, and often it was omitted from the palette. In spirit, thus, the sequence was from pure colors, to clean tints, to white (Ill. 5-25B).

It was the Neo-Impressionists, Seurat, Signac, who rejected black, brown and all muted colors, and in this were followed by the Fauvists, Derain, and Vlaminck.

Among the Impressionists, Monet perhaps was the most typical, not alone in technical style but in attitude of mind. As a matter of fact, it was one of his paintings which gave the movement its name. For many years, it was his habit to paint in the open, to portray haystacks, water lilies, cathedrals, over and over as seen under different conditions of changing daylight.

In Monet's case, the brush and palette knife were wielded in twists and turns to follow the directions and textures of his subjects. Colors were radiant, atmospheric, vivid point light sources which the eyes of the viewer blended together for heightened intensity.

An Impressionists' palette will be found on the color chart on pages 106-107. It is composed of white, madder red, vermilion red, yellow, orange, cerulean and ultramarine blue, green, yellow ocher, burnt sienna, cobalt violet, and black. While there is nothing unusual in this selection, bear in mind that not a great deal of paint mixing was done. The Impressionists worked as swiftly as possible and did not want to waste either time or energy.

The Impressionists created a fabulous art of color. Impressionism was one of the great schools of all time; its originality and power have not since been surpassed.

The Color Expression of The Modern Painter

The principle of the Balanced Palette is indicated in a diagram of the Color Triangle (Ill. 5-26A). This is used in Kandinsky's "Improvisation No. 30ß see at right (Illustration 5-26B). Because of scientific improvements in the manufacture of pigments, the artist of today has an increasingly wide choice. However, when an ideal palette is set up, it should be used not merely as a font from which the artist can work directly,

but as a color and pigment source which he can draw upon to create other fixed palettes of infinite variety. Indeed, all of the palettes described in this chapter — those of da Vinci, El Greco, Rembrandt, Turner, and Monet — can be readily prepared and set up from the Balanced Palette. The Balanced Palette, in fact, becomes a source from which just about any color effect can be pre-set and predetermined.

As to the importance of a good palette, any painter would do well to listen to the counsel of Stanton Macdonald-Wright:

> Some have adopted the idea of mixing all colors from three fundamentals and to them the palette is complicated. To answer these objections a simple statement of principle is all that is necessary. First, one's palette must be adequate to the task; it must be comprised of permanent colors; it must have enough colors to save the artist the time he would

5-26A. THE COLOR EXPRESSION OF THE MODERN PAINTER. With recent developments in the manufacture of pigments, the artist has access to an unlimited array of color and to unlimited color expression. Where painting is abstract or non-objective, natural phenomena can be disregarded for more personal and creative achievements. Wholly new and unprecedented effects lie waiting to be released through modern knowledge of the wonders of human perception.

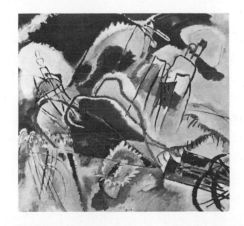

5-26B. IMPROVISATION NO. 30. Wassily Kandinsky.

otherwise require to mix them. The pigments he chooses must be as nearly saturated as possible. To answer in detail, the most complicated palette is that which has only three colors. When we speak of complications we mean complications for the painter, and this abbreviated palette makes for him a useless number of complications and robs him of his time, not to speak of the impossibility of his obtaining saturated colors from his mixtures. I would advise a greater number of pigments rather than a smaller; but before using them I should obtain authentic information as to their durable qualities. The more already mixed tints, tones, neutralizations, etc., we have, the richer our work should be and the more time we save in producing it.

A generous palette, well designed and balanced, seems required today. But it must be used imaginatively and not monotonously.

Kandinsky used a full palette, as have most painters of recent years. It dates to the time of the Impressionists, Fauvists, and Orphists. However, where it is used prosaically or haphazardly it is responsible for the curious similarity of color expression observed in modern times. Although he has had the spectrum at his command, the contemporary painter all too often has employed it with little imagination and virtually no special manipulation. Color expression has been spontaneous rather than deliberate. Because of this, much of the Abstract Expressionism of recent years, although different in form and pattern, has been more or less uniform and monotonous in color effect. One misses the widely varied moods and illumination qualities achieved in the past — which depended largely on singular principles of color arrangement.

Toward Tomorrow

There are, of course, far more than the six paths of expression described and illustrated in this chapter. There are other directions, other principles to be exploited which have no precedents. What the future holds in the eyes of the writer will be presented in Chapters 6, 7, and 8.

Color expression is not a one-way street but a maze of highways running in diverse directions. The purpose of this work is to offer a map of creative exploration so that the ambitious painter will not wander aimlessly about, but will be in a position to pick and choose his realms of exploration, realms which the writer hopes will be creatively new, fresh, and different.

118

Ten Great Names in the History of Color Expression in Art

JAN VAN EYCK. A Flemish painter who, with his brother, Hubert, is credited with the invention of oil painting in the early part of the fifteenth century. This achievement revolutionized the art of painting and color.

LEONARDO DA VINCI. He was a great color theorist and genius in almost all fields of human endeavor. His development of the chiaroscuro style was remarkable and dominated Western painting until well into the nineteenth century.

TITIAN. He led the golden school of Venice and was one of several geniuses in the art of color of his time. His luminous color effects have been emulated ever since.

PETER PAUL RUBENS. He was one of the finest technicians of all time, a man of great intellect, and prodigious energy. His skill as a craftsman has never been surpassed—but many of his secrets have been lost.

GEORGES DE LA TOUR. He had a wonderful eye for color and light and used these elements to create astonishing illusions of form and space. His was a unique and sculptured style that held mystery and wonder.

REMBRANDT VAN RIJN. Few artists have been more monumental. He was an experimentalist with color and one of the first painters to give expression to inner temperament and personality.

J. M. W. TURNER. On color expression alone, he was without equal. His vivid effects anticipated Impressionism and much of modern abstract art.

EUGENE DELACROIX. He was great, not so much for the surviving examples of his art, but for his love of color. He led the revolution of color and broke with the past.

VINCENT VAN GOGH. No other painter had a greater passion for color. His art represents the obsession of sheer genius—against all reason and hope of success.

WASSILY KANDINSKY. He was among the first of the Abstract and Non-Objective painters. To him, color had intrinsic beauty and power and should be pursued for its own sake. He was the prophet of a new age of color in art.

Chapter 6
The Harmony of Science and Art

This chapter is concerned with color order systems, formal modes of color harmony, and color expression, with vision and visual phenomena, and with artists who have respected these things in their paintings. Chapters 7 and 8 will present more complex data on perception, color induction, color constancy, and other phenomena which promise new lands of conquest for the future.

Color is a progressive art. One can have pity for any artist who fails to understand this. Left wholly to his own intuition and devices, he probably could spend the better part of a lifetime making discoveries and reaching conclusions which were known long ago. In other words, the artist who turned his back on what his predecessors have accomplished — striking out entirely on his own — would likely end up becoming a fair painter of the sixteenth, seventeenth or eighteenth century.

Great painters have not as a rule been great color theorists. Da Vinci stands alone among the great masters. The nineteenth century had Delacroix, Seurat, Signac, Cézanne (and van Gogh in his letters). The twentieth century has had Kandinsky. Goethe had very much wanted to be a painter but had lacked the talent. As will be seen shortly, a German contemporary of Goethe, Philip Otto Runge, became fairly eminent both as painter and theorist.

Color Solids and Systems

The development of color circles has been related in Chapter 1, "The Quest for Method and Order." Pigments and palettes were then covered in Chapters 2 and 3. This chapter will discuss three-dimensional concepts of color, color systems, and color "solids" which attempt to plot the larger world of color sensation.

It was Ewald Hering who made the important observation that the natural symbol of color was a triangle and that all derivatives of a color (tints, shades, tones) could be arranged within a triangle which had pure color on one point, white on the second, and black on the third. This remarkable discovery, subsequently elaborated upon by Wilhelm Ostwald, became the basis of the Birren Color Triangle which was used to chart various natural paths of color expression in the last chapter.

Ogden Rood, Wilhelm Ostwald, and others have sought to trace the history of color solids through the years. The attempt to devise a three-dimensional form which might contain the world of color within its dimensions is no easy task, requiring both imagination and resourcefulness.

Ogden Rood in 1879 wrote of the endeavor of Tobias Mayer, a German mathematician who, in 1758, proposed the idea of arranging red, yellow and blue on the points of a triangle and then placing binary mixtures inside. (The primaries were probably taken from Le Blon who discovered the red-yellow-blue principle around 1730.)

6-1. COLOR SOLID. Tobias Mayer. 1758. (From description in *Modern Chromatics* by Ogden N. Rood, 1879.)

6-2. COLOR PYRAMID. J. H. Lambert. (From a description by Lambert, 1772.)

In Mayer's scheme, triangles above the central triangle contained measured additions of white; triangles below the central triangle contained measured additions of black (Ill. 6-1). The solid was far from adequate, for, according to Ostwald, "the dull mixtures arising in the middle of the first triangle were repeated in the other triangles."

In 1772 J. H. Lambert designed a pyramid, also around red, yellow, and blue primaries (Ill. 6-2). Lambert, a physicist and philosopher, reasoned as follows: Colors were subtractive in mixture and formed black. Thus a base triangle would contain red, yellow, blue and their mixtures, with black naturally produced in the center. To this fundamental triangle white was added to form other triangles, and these triangles grew smaller and smaller until a white apex was reached. Lambert had made progress, especially in the idea of diminishing his colors as they approached white.

In 1810, the same year in which Goethe's *Farbenlehre* was published, Philip Otto Runge published an important work of his own, *Die Farbenkugel (The Color Sphere)*. In his day Runge was perhaps the most distinguished German painter of the Romantic School. Like Delacroix, he broke with Classicism and attempted to bring new life into the art of his country. Runge

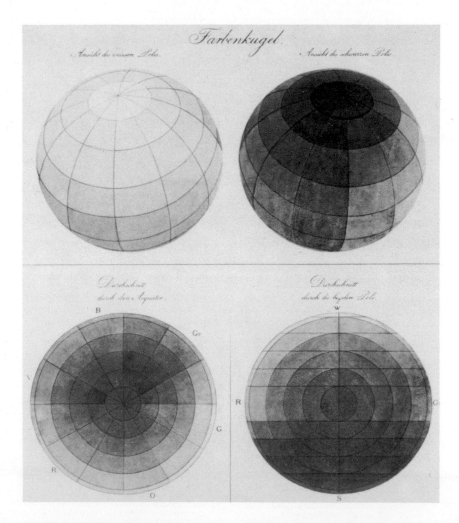

6-3. COLOR SPHERE. Philip Otto Runge. A highly important development in the field of color organization. (From Runge's *Die Farbenkugel,* Hamburg, 1810.)

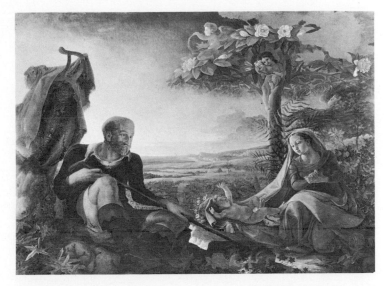

6-4. SELF-PORTRAIT. Philip Otto Runge. He was famous as a classical painter. (Courtesy of Kunsthalle, Hamburg.)

6-5. REST DURING THE FLIGHT TO EGYPT. Philip Otto Runge. The treatment is refined. Soft tones of terra cotta red, green, ocher are seen against a pale blue sky. (Courtesy of Kunsthalle, Hamburg.)

hit upon a concept which was quite sound and the plan of which has been followed ever since in color order systems.

The world of color took the shape of a sphere (Ill. 6-3). Pure hues ran about an equator, with white at the top pole and black at the bottom. Color mixtures lay within the sphere, and an axis in shades of gray ran from white at the top to black at the bottom. Transitions were continous, however, rather than in steps, and here Runge made color measurement and exact designation almost impossible.

M. E. Chevreul took a retrogressive step in proposing a color hemisphere in which (as with Mayer's) black-containing mixtures appeared twice (Ill. 6-6). The impracticability of Chevreul's hemisphere is confirmed by the fact that it was never fully carried out in actual colors.

In 1876, Wilhelm von Bezold, following a pattern set by Helmholtz, devised a cone which comprised additive mixtures of color (Ill. 6-7) — the precise opposite of Lambert's pyramid. At the base of the cone pure colors scaled toward white at the center, in the manner of light mixtures. Color mixtures then scaled in diminishing steps toward a black apex. Such a plan would hardly do for a scientist, or for an artist.

6-6. HEMISPHERE. M. E. Chevreul. A retrogressive step in the development of color order theory. (From a description in *The Principles of Harmony and Contrast of Colors* by M. E. Chevreul, London, 1820.)

6-7. COLOR CONE. Wilhelm von Bezold. 1876. This is opposite in plan to Lambert's pyramid. (From *The Theory of Color* by Wilhelm von Bezold, 1876.)

121

6-8. DOUBLE-CONE. Ogden N. Rood. 1879. A conception later followed by most theorists. (From *Modern Chromatics* by Ogden N. Rood, 1879.)

Ogden Rood in 1879 came up with what today is regarded as the best answer — a double cone (Ill. 6-8).

A belt of pure hues ran about the circumference, scaled up toward a white apex and down toward a black one; a gray scale connects the white and black. All tints, shades and tones lay within the double cone. Wilhelm Ostwald, who followed the same general pattern, wrote, "The Double Cone must be regarded as the final and enduring solution to the color solid problem."

This is somewhat similar to Höfler's pyramid, described in the last chapter. However, Höfler's pyramid is used, not for color organization, measurement, or specification, but merely to explain visual and psychological color relationships.

In America, the best known color system is that of Albert H. Munsell (1859-1918). Born in Boston, he devoted his life to art. After study in Europe, he became senior instructor at the Massachusetts Normal Art School. In 1900, at the age of 41 he developed and patented his Color Sphere. Munsell's system has since been extended and improved by leading American scientists. As a method of color designation, it has become a national standard in the United States, as well as in Great Britain, Japan and elsewhere.

Munsell's color solid and his method of color identification have been discussed in many books. The plan consists essentially of a sphere or "tree" (Illusts. 6-9, 10). The three dimensions of color are hue (red, yellow, blue, etc.), value (light or dark), and chroma (pure or grayish). Scales run both vertically and horizontally, the center vertical scale consisting of neutral grays extending from black up to white.

Colors of high value appear on upper scales, while colors of low value appear on lower scales. Grayish colors are near the gray axis and become purer on outer boundaries. In color designation, three references are made, one for hue, the second for value, and the third for chroma. For example, 7.5R 5/10, would signify a red hue located at point 7.5R on the Munsell color circle. The 5/ would signify a medium value, halfway between white (9) and black (1). The /10 would signify a chroma ten steps removed from a neutral gray at value 5. The color would thus be a fairly pure vermilion red.

6-9. COLOR SOLID. Albert H. Munsell. This has the shape of a tree, with light colors near the top and dark colors toward the bottom. (From *A Color Notation* by Albert H. Munsell, 1916.)

6-10. SECTION OF MUNSELL COLOR SOLID. All colors in horizontal rows have the same brightness or value. All colors in vertical rows have the same purity of chroma. (From *A Color Notation* by Albert H. Munsell, 1916.)

6-11. COLOR SOLID. Wilhelm Ostwald. Pure colors run analogously around the equator. From here they scale uniformly toward white and toward black. (From *Color Science* by Wilhelm Ostwald, 1931.)

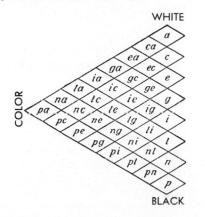

6-12. SECTION OF OSTWALD SOLID. All rows parallel to color-black have an equal white content (the first letter in each equation). All rows parallel to color-white have equal black content (the second letter). All vertical rows have apparently equal hue content. (From *Color Science* by Wilhelm Ostwald, 1931.)

The system of Wilhelm Ostwald (1853-1932) is designed in the shape of a double cone, again with pure hues around an equator, white at the top apex and black at the bottom, with a neutral gray scale connecting the two (Illusts. 6-11, 12). Ostwald's brilliant work in chemistry won him the Nobel Prize of 1909. He was one of the foremost scientific minds ever to devote major effort to color, and this he did at about the age of 60.

Ostwald arranged his pure colors on the points of triangles, as Ewald Hering had suggested. Hue was on one point, white on the second, and black on the third, with tints, shades and tones located within these confines. In the visual and psychological sense, every color variation was composed of these three elements — and one element could not be increased without at the same time decreasing one or both of the other two elements ($C+W+B=1$). His triangles and his double-cone solid constitute a masterpiece of invention. There is concordance in any of three directions. In paths parallel to color and black are scales having equal white content. In paths parallel to color and white are scales having equal black content. In paths parallel to white and black are scales having apparently equal hue content. The Birren Color Triangle described in Chapter 5 follows these principles.

Whereas the organization of the Munsell system is based on hue, value and chroma, that of Ostwald's system is based on color, white and black. For example, 7*nc* would be a warm red as on his color circle which contained an *n* amount of white and a *c* amount of black — in other words, a fairly intense red and somewhat like Munsell's 7.5R 5/10.

Conventional Color Harmony

Color solids are not ordinarily used for purposes of color harmony. There are some exceptions in the decorative arts — wallpaper, textiles, carpeting design — and here Ostwald's system fares better than Munsell's because of superior visual and psychological order. However, as will be brought out later in this chapter, scientific color organization has influenced some outstanding art in the works of painters such as Morgan Russell, Stanton Macdonald-Wright, Hilaire Hiler, and Ben Cunningham.

In general conception, Munsell's scales are not likely to be visually pleasing. Color harmonies built around related or uniform values will bring together colors having different and conflicting elements — a blackish yellow, for example, with a whitish purple. With Ostwald, his "isovalent" colors (those having equal hue, white and black content) look well together and are quite satisfying to the eye. Further, Munsell's followers have often insisted that a color scheme is harmonious if its component colors cancel into neutral gray when spun on a color wheel. This defies what most persons look upon as true beauty, for example, the predominant warmth of a Venetian master or the predominant coolness of many seascapes and landscapes of the Impressionists.

Chevreul

Modern laws of color harmony trace largely to M. E. Chevreul. What he set forth in 1839 has been part of art education ever since. When today a student hears of the harmony of adjacents, complements, triads, and so forth, he is learning from Chevreul. Here are Chevreul's principles,

as presented in *The Principles of Harmony and Contrast of Colors*. (The author has inserted a few alternate terms to clear up some of Chevreul's vocabulary.)

Harmonies of Analogous Colors

1. The *harmony of scale*, produced by the simultaneous view of different tones [values] of a single scale, more or less approximating.

2. The *harmony of hues*, produced by the simultaneous view of tones [values] of the same height [brightness], or nearly so, belonging to scales more or less approximating.

3. The *harmony of a dominant colored light*, produced by the simultaneous view of different colors assorted comfortably to the law of contrast, but one of them predominating, as would result from seeing these colors through a slightly stained glass.

Harmonies of Contrasts

1. The *harmony of contrast of scale*, produced by the simultaneous view of two tones [values] of the same scale, very distant from each other.

2. The *harmony of contrast of hues*, produced by the simultaneous view of tones [values] of different height [brightness], each belonging to contiguous scales.

3. The *harmony of contrast of colors*, produced by the simultaneous view of colors belonging to scales very far asunder, assorted to the law of contrast: the difference in height [brightness] of juxtaposed tones may also augment the contrast of colors.

Ostwald

In instructions that accompany the Ostwald *Colour Album*, suggestions and rules are offered as to principles of color harmony. Because the Ostwald system is so well organized visually and psychologically, the advice given is quite sound — but perhaps more appropriate to abstract commercial design than to the fine art of painting. Egbert Jacobson in his *Basic Color*, has designed and written a magnificent book which can be consulted to great advantage in matters related to the outstanding contributions of Wilhelm Ostwald.

In going over Ostwald's rules of color harmony which follow, refer to his Triangle (Ill. 6-12). The letters in all cases refer to tints, shades, and tones on the Triangle. The numerals refer to the pure hues of Ostwald's color circle:

Gray Harmonies. These presuppose the use of at least three Shades in the Achromatic Scale, the intervals of which must be equal. Thus while *ceg* or

cgl, for instance, give harmonious combinations, *cel* or *egp* would be inharmonious.

Monochromatic (or Self-Colored) Harmonies result when rule No. 1 is applied to the members of the Isotint, Isotone, and Isochrome Series. Examples are, for the Isotints, *la*, *le*, *li*; for the Isotones, *ec*, *ic*, *nc*; and for the Isochromes, or Shadow Series, 17*ca*, 17*ec*, and 17*ge*.

Heterochromatic Harmonies, or Harmonies of different Hues. These are the only harmonies which, up to the present, have been thought worth considering, and since the following laws were unknown, and previous attempts at systematisation have usually been based on an incorrectly divided Color Circle, successful results have not hitherto been obtainable.

The principal law is that, in the first place only Isovalent Colors, viz. those containing equal amounts of White and Black, should be combined. These Colors are designated by the same letters, and their Hues should be equidistant in the Chromatic Circle. Their numbers in this Circle therefore show equal differences. The divisions of the Circle to be taken into consideration are those into 2, 3, 4, 6 or 8 Parts. These give respectively numerical differences of 12, 8, 6, 4, and 3. Examples are:—

Dyads 9*ie*, and 21*ie*.
Triads 5*ga*, 13*ga*, 21*ga*.
Tetrads 31*c*, 91*c*, 15*lc*, 21*lc*.
Sextads 1*ng*, 5*ng*, 9*ng*, etc., up to 21*ng*.
Octads 2*ca*, 5*ca*, 8*ca*, etc., up to 23*ca*.

Harmonies based on three or more subdivisions of the Color Circle are more interesting if one or several members are omitted. Unilaterally Oriented Color groups, possessing individual characteristics varying with the region of the Chromatic Circle from which the Colors have been taken, may thus be obtained.

In adding Achromatic Colors to Harmonies of different hues, the letters must correspond. Thus in the triad based on *ga* given above, White *a* and Gray *g* are the only achromatic colors suitable, and in no case must Black be used.

In all these Harmonies Single Colors may be supplemented by other members of the Isochromes belonging to them. Thus in the Dyad Harmony 9*ie*, 21*ie*, we may add 21*ea*, 21*gc* and 21*lg*. Several such shades adjoining each other may likewise be added, subject to compliance with the Law of Gray Harmonies.

If, finally, the areas of Colors placed in juxtaposition are very unequal, the Isovalent Color occupying the smaller area should be replaced by a purer color taken from the same Isotint Series. If for instance in the Harmony 9*ie*, 21*ie* the Red occupies a comparatively small area then 9*ic* or 9*ia* should be substituted for it.

Many years ago the writer carried out Ostwald principles in elaborate form. While they lead to beauty and harmony of color, the results tend to be academic and are not recommended for the

6-13. SELF-PORTRAIT. Rosa Bonheur (1822-1899). A famous painter of horses and other animals, Rosa Bonheur lived in the early days of Impressionism but painted in a realistic and romantic style. (Courtesy of Uffizi, Florence. Art Reference Bureau.)

fine arts. A painter would do well to perform a reasonable number of experiments, if only to get a feeling for color order — as a musician or composer might play scales on a piano. But formal laws of color tend to submerge and suppress the personality of the artist. This can be inimical to creative impulses. Yet he who denies himself any understanding of color order will find his own house of color in permanent disarray.

Emperical Conclusions

A series of observations and conclusions on color harmony which the author has drawn from his own experience will be given here. They are taken in large part from the book, *Color — A Survey in Words and Pictures*, and are somewhat academic. The rest of this chapter — and indeed the rest of the book — will be concerned with more original, creative, and modern inquiries which promise provocative ventures into wholly new dimensions of color expression:

Primitively, the eye is drawn to unique hues: red, yellow, green, blue, white, black. It prefers pure colors to modified colors.

The emotional quality of any color will differ as its particular tone or hue variation differs. Ordinarily, primary hues are vigorous and impulsive. Secondary hues are more refined and perhaps easier to live with. Yet tints differ from shades or tones. Consequently, personality is as much influenced by tone as by color.

The red, orange, yellow region of the spectrum is warm. The green, blue, violet region is cool. Warm hues generally make the most pleasing shaded colors. Cool hues make the best tinted colors.

There seems to be a natural law of color harmony relating to the combination of light tints with dark shades. Here it is: Tints or pale variations of pure colors which are normally light in value (yellow, orange, red, green) look best with shades or deep variations of pure colors which are normally dark in

125

6-14. PORTRAIT OF THE ARTIST. Augustus Edwin John (1878-1961). He was one of the most eminent British painters of his day and worked in the conservative tradition. The colors on his palette (seen in part only) are blue, red oxide, vermilion, yellow, and mixtures. (Courtesy of The Metropolitan Museum of Art. Bequest of Stephen C. Clark.)

value (blue, purple, violet). This means, for example, that pink will look better with navy blue than lavender or pale blue will look with maroon. Peach, soft yellow, soft yellow-green will look better with deep reds, blues and violets, than very pale tints of red, blue or violet will look with brown, olive or deep green.

In the harmony of pure hues, all look well with black and white. Combinations in which analogy exists seem to relate to the emotions. Dominantly warm and dominantly cool schemes inspire radically different *feelings*. Combinations based on contrast seem to relate more to *vision*. Red with green, or yellow with blue will thrill the eye; but deep emotional qualities are lost because the warmth of one hue cancels the coolness of the other, to the detriment of both.

Apparently, colors accord best when they are either similar or almost wholly unalike. J. P. Guilford writes, "There is some evidence that either very small or very large differences in hue give more pleasing results than do medium differences. This tendency is much stronger for women than for men." In short, schemes involving monochromatic or adjacent colors, or schemes involving opposites, are superior to others.

In the harmony of color forms, as discussed in connection with the Color Triangle, pure hues combine well with tints and white; pure hues with shades and black; white with gray and black; white with tone and shade; tint with tone and black; pure hue with tone and gray—all these arrangements respect natural laws of analogy. They look right because they arrange colors in terms of sensation and seem to gratify the emotions.

The most neutral of all forms is a tone, not gray.

126

6-15. SELF-PORTRAIT. Henri Rousseau (1844-1910).
Here is the inspired primitive and amateur to whom recognition came long after death. The palette shown (indistinct) is of primary hues. (Courtesy of National Gallery, Prague, Czechoslovakia.)

Because a toned color contains pure hue, white and black, it naturally accords with all these primary forms—and also with tint, gray and shade.

This Illusory World

Writers on color such as Josef Albers and Johannes Itten (both formerly with the Bauhaus) have made quite a feature of visual phenomena such as afterimages, brightness contrast, simultaneous color contrast, additive and subtractive color effects. Vision is a curious process, and seeing is not always believing. Perhaps the most comprehensive (and beautiful) review of visual phenomena of interest to the artist will be found in *The Interaction of Color* by Josef Al-

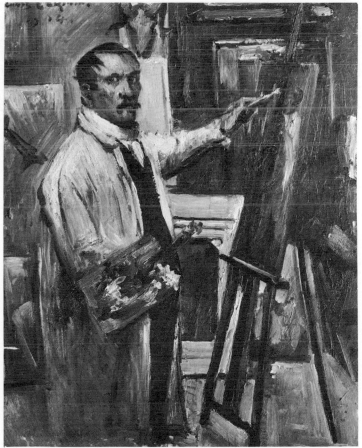

6-16. SELF-PORTRAIT. Lovis Corinth (1858-1925). A German Expressionist, Corinth worked with a slashing brush. His palette was often of muted grays and tans, coarsely applied. (Courtesy of Pinakothek, Munich.)

6-17. THE AFTERIMAGE. Upon staring at an area of color, the eye will bring up a reaction to its complement, both as to hue and brightness. Here the afterimage of the black disk at the left will appear as white when attention is shifted to the dot at the right.

bers. This is one of the most elaborate works on color in art ever produced and is well worth careful study. In it, Albers — with the aid of his students — discusses and illustrates a long list of perceptual illusions and visual effects. While the results and conclusions, in many cases, seem technical and academic, one may assume that an artist of talent, adding emotional qualities, and "inner necessities" to what otherwise might seem to be purely optical, could create original and stirring art forms.

A few classical, optical demonstrations will be included here. In the case of the afterimage, when the retina of the eye is stimulated over a period of time (30 seconds or so) by a given hue, there is an afterimage in which the color is the complementary of the original color (Ill. 6-17). After peering at red the afterimage will be green. Yellow and blue are also complementary. This relates to the phenomena of simultaneous contrast which was made famous by M. E. Chevreul and which the Impressionists and Neo-Impressionists so exhaustively studied.

If areas of neutral gray (preferably narrow stripes) are placed on backgrounds of pure colors, the gray will take on the hue of the complement or afterimage. The complementary effect will be all the more evident if the gray and the pure hues have similar values or degrees of brightness. Albers has prepared a number of charts to demonstrate this, but once the illusion is grasped, more than a few examples seem superfluous. Illustration 6-18 shows this illusion. The Gestalt psychologist, Kurt Koffka has explained it as follows: "On a ground half red, half green, lies a gray ring. Looked at naively, it will appear more or less homogeneously gray. Now divide

the circular ring into two semicircular ones by laying a narrow strip of paper or a needle on top of the boundary between the red and the green fields. At once the semicircular ring on the red field will look distinctly greenish, that on the green field, distinctly reddish."

If, then, colors affect each other due to afterimage phenomena, this becomes apparent only when the viewer concentrates his attention for a considerable length of time. Otherwise the phenomena may go unnoticed.

6-18. ILLUSION OF FIELD DIFFERENCE. If a gray ring is placed on a ground, half of which is red and half green, it will remain gray. However, if a black line is introduced, the section of the gray ring over the red will appear greenish — and pinkish over the green field. (From *Principles of Gestalt Psychology* by Kurt Koffka, 1935.)

6-19. ILLUSION OF BRIGHTNESS CONTRAST. Both arrows are the same, but appear light or dark depending on background. (From *Visual Illusions* by M. Luckiesh, 1922.)

6-20. EFFECT OF BACKGROUND. The center gray dots are the same. Note how they tend to vary from left to right. (From *Visual Illusions* by M. Luckiesh, 1922.)

Just as complements affect each other, so do contrasts in brightness. It is quite elementary to say in these sophisticated days that when bright and dark areas are placed next to each other, the bright area will tend to make the dark area appear darker by comparison, and the dark area will tend to make the bright area appear brighter. Here again, one or two examples are every bit as sufficient as ten or a dozen (Illusts. 6-19, 20).

In what is known as the Von Bezold phenom-enon — or spreading effect — white lines or pattern on a pure color will tend to make the whole area appear relatively bright (Ill. 6-21). The white, in effect, seems to "spread" over the color. Black lines or pattern on a pure color also tend to spread over the area and to deepen the total impression. The illusion is quite subtle and hardly applicable to average realistic or abstract compositions of the artist.

In a similar way, light areas tend to look

6-21. THE VON BEZOLD EFFECT. The gray pattern is the same throughout. Note how the black and white grounds seem to "spread" over the pattern to make it appear deeper or paler. (From *The Theory of Color* by Wilhelm von Bezold, 1876.)

6-22. EFFECT OF ILLUMINATION. Bright illumination tends to shift the hues of colors toward yellow, while dimness of illumination tends to shift them toward violet. (Developed by the author.)

larger than dark areas. Warm colors tend to look nearer than cool colors. These two effects are readily explained. Because brightness is more stimulating to the retina of the eye than darkness, it tends to make a larger image, "spilling" over on its edges. Because red is only slightly refracted by the lens of the eye, it tends to focus at a point *behind* the retina. Hence, to see it clearly the lens grows convex, enlarging the red image and pulling it nearer. In reverse fashion, blue tends to focus at a point in *front* of the retina. To see it clearly, the lens flattens out, pushes the blue image back and makes it appear smaller and farther away.

There are a number of other phenomena bearing on the anomalies of vision, a few of which deserve mention. Colors will tend to appear brighter and purer as the light that strikes them is increased. If the illumination over an area of color keeps growing more intense, glare will eventually result, and the colors seen will disappear into a blaze of brightness, with the quality of hue vanquished. At the same time, orange appears yellower with increased intensity of illumination, while violet appears, bluer (6-22). However, the psychological primaries (see Chapter 7) will not shift. It is traditionally known among artists that colors in highlight tend to move toward yellow, while colors in shadow tend to move toward violet. As visualized on a color circle, for example, red grows orange in highlight and purple in shadow. Green goes yellower in highlight and bluer in shadow.

A bit more pertinent is the fact that under normal illumination, the apparent chroma or saturation of a color increases with its size — from a reasonably small area to one that covers about 20 degrees of the visual field. Stated in another way, a pure color such as red seems to become redder and redder until it attains an area of about 3½ inches at a distance of one foot, 12 inches at three feet, etc., after which its chroma will become duller if the area of the color is made larger.

What the Impressionists and Neo-Impressionists did not know — and which might well have discouraged them — is that very small areas or dots may appear entirely colorless or gray. Quite singular is the fact that dots of colors as different as orange and violet will appear no different from a distance, being seen (if at all) as grays of light or medium brightness. Blue, blue-green, and green tend to appear green where the size is quite small, while orange-reds and purples tend to appear pinkish.

This phenomenon is quite observable in paintings executed in the Pointillist or Divisionist technique. The dullness of some of Seurat's color effects has at times been attributed to a darkening of pigments, but the inability of the eye to have clear color perception of small particles may be more responsible. Colors are seen, of course, because the many dots on the canvas average out to convey color impressions. However, because of the limitations of the eye, (a) the colors on the canvas tend to appear duller as the observer stands farther away, and (b) a desired scintillation demands fairly close inspection so that the individual dots can be discerned — and diffused — and not lost in grayness.

6-23A, 23B. THE REVERSIBLE STAIRWAY AND CUBE. The figures will fluctuate and reverse their positions as they are visually studied. (From *Visual Illusions* by M. Luckiesh, 1922.)

To return to more obvious visual phenomena, a few artists have attempted to convert the optical illusion into an art form. One device is to take advantage of the disposition of human vision to let its attention fluctuate and to "read" a form, pattern or design in different ways. For example, the reversible stairway and cube (Illusts. 6-23A, 23B), both appear to have one perspective at a given moment and another perspective at another moment — shifting back and forth the more the viewer stares. Obviously, endless variations of this illusion are possible — and somewhat monotonous. The directions pointed out in the next chapter of this book are far more promising and dynamic.

Despite criticism, however, I would grant that if an artist felt so disposed, he might exploit the optical illusion for plastic and three-dimensional effects. There are some painters today who admit

6-24. THE RELIEF-INTAGLIO EFFECT. This is an egg poacher with indented cups. If the illustration is turned up-side-down, the cups will appear to bulge out. (Developed by the author.)

6-25A, 25B. THE INTERACTION OF COLOR. The originals of these two illustrations are silk-screen printed in attractive shades of lavender and violet. In illustration 6-25A, the overlapping rectangles on a light ground are subtractive and seem transparent. In Illustration 6-25B, the overlapping rectangles on a deep ground are additive and appear as projected areas of light. (From *The Interaction of Color* by Josef Albers, Yale University Press, 1962.)

the virtue of depth effects and others who condemn them, insisting that if an artist works on the flat plane of a canvas, why should he try to imply otherwise?

The Old Masters, of course, did their best to build three-dimensional worlds within the confines of gilded frames. They resorted to perspective, chiaroscuro, visual trickery, and to actual relief in some instances.

The Impressionists strove to give a canvas a feeling of atmospheric space. Cézanne added colors to build structure and form. Among the Cubists, Braque and Gris worked for depth effects with forms, planes and angles that stood one behind the other. Cézanne had also used planes and visual angles, appreciating that reality itself had dimension. If nature stood out in relief, why should an artist flatten it? Picasso following the lead of Braque, tried for the illusion of volume in his Cubist period, relying on planes

rather than the outmoded conventions of highlights and shadows, linear perspective, and the like.

Here are the methods that help to assure dimensional effects. (This is from the author's book, *Creative Color.*)

1. By contrasting brightness against darkness (but not against blackness).

2. By contrasting pure colors (or black and white) against grayed colors.

3. By contrasting warm colors against cool colors.

4. By contrasting detail, texture, and microstructure against plainness or filminess.

5. By introducing perspective to distinguish near from far distances.

6. By implying a continuation of background design elements running behind foreground feature elements.

7. By showing highlights and cast shadows.

8. By using recognizable objects which, because of familiarity and relative size, will give mental clues to their near or far positions.

6-26. GUITAR AND FLOWERS. Juan Gris. Here art is carefully planned, formalized, and presented in man-made geometry. (Collection of The Museum of Modern Art, New York. Bequest of Anna Erickson Levene in memory of her husband, Dr. Phoebus Aaron Theodor Levene.)

6-27. IRIS BY THE POND. Claude Monet. Here the artist has followed nature and let her influence his execution and handling. (Courtesy of The Art Institute of Chicago. Art Institute Purchase Fund.)

Synchromism

The scientific, rational, and organized methods discussed in this chapter have been respected by some artists and used as sources for inspiration and expression. The four men to be discussed have developed eminently successful modes of expression, in the opinion of the writer. They have been creative, original, and of first rank.

Tight control of color has its hazards to an artist. The naturally organized colors of a sunset and the logically arranged hues of a color circle may both be a delight to behold momentarily, but museums are not likely to hang colored photographs of sunsets and color circles on their walls. Neither would convey anything of human spirit.

Thus, when an artist elects to pursue law and order in his compositions and color arrangements, he necessarily takes chances at becoming academic if not trivial. What he creates must not be obvious charts or diagrams, but pictures which have beauty and mystery and which somehow transport the feelings of the observer. Art forms in which there is definite scientific control should not be mere flights of the imagination. The artist may work with neatly graded color scales in rhythmic patterns. He may handle his paints in a subtractive way, or he may manipulate them to simulate additive mixtures. For example, in the subtractive mixture of red and green, the result would be a dark brown. This is the way pigments naturally mix together. However, if the red and green were colored lights, the mixture would be additive, and the resultant color would be light yellow. Hence an artist, although he uses pigments, can apply them in ways that duplicate the additive mixtures of lights. Further he may seek effects of luminosity, transparency, space, but always with expert knowledge of what he is doing.

The school of Orphism led by Robert Delaunay (about 1912) will be mentioned in Chapter 7. Although it had a basis in Impressionism and in scientific phenomena, its exploitation of color was hardly original. Almost at the same time (about 1911), two Americans launched another movement in Paris and Munich which they called Synchromism. These American artists, Stanton **Macdonald-Wright (1890-1973) and Morgan** Russell (1886-1953), came to Paris in order to study painting. What is significant about their work is that they were pioneers, if not founders, of American Abstract Art, a distinction now recognized over 50 years later.

Both men were original and individual. Morgan Russell was born in New York and studied painting with Robert Henri. (Henri was important to the course of modern art in America, as will be seen in Chapter 13.) Russell then went to Paris where he met Matisse and, with Macdonald-Wright, founded the school of Synchromism.

E. P. Richardson writes that the two of them "with the quick adaptability of the American temperament ... founded an *avant-garde* movement of their own in Paris, in opposition to the earth colors of Cubism. They called it Synchromism and equipped it with all the apparatus of dogmatic creed, public manifestos, and challenges both to the public and to other artistic rivals."

6-28. SYNCHROMY NUMBER 3: COLOR COUNTER-POINT. Morgan Russell. 1913. This painting is an early example of abstract painting by an American. The colors are all bright — red, yellow, green, blue, and purple. Mixtures appear to be subtractive. (Collection of The Museum of Modern Art, New York.)

6-29. FOUR PART SYNCHROMY, NUMBER 7. Morgan Russell. 1914-1915. The same pure hues — red, gold, yellow, green, blue, purple — are used in all four parts, but in different arrangements and shapes. (Collection of Whitney Museum of American Art, New York. Gift of the artist in memory of Gertrude V. Whitney.)

The Synchromism of Russell and Macdonald-Wright was not the same by any means as the Orphism of Robert Delaunay. In fact, Synchromism probably preceded Orphism by a year or so. Synchromism, notably in the work of Russell, was wholly non-objective. Color was all-important. In explanation, Russell wrote, "Painters often say they work with form first, hoping to obtain proper color afterwards. I think it should be done in the contrary manner. I work solely with color, its rhythms, contrasts and certain directions motivated by color masses. In the accepted sense of the word there is no subject matter; the 'subject' is blue violet or red or yellow and it evolves according to the particular shape of my canvas."

Synchromism as a color movement in art went into decline, and both Russell and Macdonald-Wright reverted to representational painting. Then as Abstract Expressionism came into vogue,

the stars of Russell and Macdonald-Wright loomed bright. Their work had been included in the famous Armory show of 1913. Thirty-eight years later, in 1951, they were honored in a retrospective exhibition of the Museum of Modern Art in New York devoted to the history of abstract painting and sculpture in America. Let me refer to a painting by Russell, "Theme from St. Mark." (not shown). This work is a splendid example of his viewpoint and style. The owner of the painting, who prefers to remain anonymous, dates it around 1920. The theme referred to by the artist is from the Gospel according to Mark: "And then shall they see the Son of man coming in the clouds with great power and glory. And then shall He send his angels, and shall gather together His elect from the four winds, from the uttermost part of the earth to the uttermost part of heaven."

The writer would hesitate to guess what Rus-

6-30. CONCEPTION SYNCHROMY. Stanton Macdonald-Wright. 1915. The colors in this non-objective composition are white, light blue, lilac, orchid, pure red, yellow, and yellow ocher, with some deep tones of blue, violet, and brown. The effect is still vigorous and modern. (Collection of Whitney Museum of American Art, New York.)

sell had in mind. The colors are rich, subtle, the texture thick and opaque. Yet one gets a feeling of lightness and movement and of a color sense that is remarkable. There is more to "Theme from St. Mark" than the impulsive hues of Fauvism and Orphism. Obviously the painter, if he sought to be bold, also wanted subtlety and an artful show of discrimination.

Macdonald-Wright, on the other hand, had a lighter, more radiant and lyrical touch than Russell. He was American-born of Spanish and Dutch forbears who came to America in the seventeenth century. He also journeyed to Paris where he met Russell and created, with him, the remarkable and unique principles of Synchromism.

Macdonald-Wright's compositions have a colorful, light, airy and transparent beauty. Many of his harmonies are based on the additive mixtures of lights, which are simulated with pigments. There is fine intellectual order in design and strong emotionalism with color.

In 1913 Macdonald-Wright wrote in a catalog for one of his exhibitions, "For me form translates itself as color. When I conceive of a composition of forms, at the same time my imagination generates an organization of color that corresponds to it Each color has a position of its own in emotional space and possesses a well defined character. I conceive space as a plastic entity which in painting can only adequately be expressed by color. Thus I envisage this space as though it were a spectrum extending from my eyes into measureless depth."

"Conception Synchromy" is shown in Illustration 6-30, and "Synchromy" in Illustration 6-31. While these are in black and white, color is boldly and carefully used. Macdonald-Wright, knew his way around in the complex world of color. He not merely had a natural sense of color, but he devoted serious study to it over many years. (During his later years he had extensive correspondence with the author of this book.) and has written a *Treatise on Color*. He says of this book, "I still think it is the only valuable *discipline* for balanced color harmony." Perhaps this discipline is what gives his art a quality like certain music.

6-31. SYNCHROMY. Stanton Macdonald-Wright. 1917. Spectral colors are used, often handled as if they were additive mixtures of light rays. One senses fine creative order and control. (Collection of The Museum of Modern Art, New York.)

6-32. A STRUCTURE OF YELLOW. Hilaire Hiler (1898–1966). The artist gave yellow sharp forms to suit the ease with which this hue is focused by the human eye. There are permutations of pure yellow toned with golden yellow and yellow-orange. Because of subtle gradations, the composition has different appearances under different lighting conditions. (Collection of Mrs. June Oppen Degnan, San Francisco.)

6-33. VIOLET TO BLUE-GREEN DIAGONAL SHADOW SERIES. Hilaire Hiler. 1948. The title describes the color effect. The natural order for color is composed to satisfy the creative feeling of the artist. (Courtesy of the artist.)

Structuralism

Hilaire Hiler and Ben Cunningham are also champions of the organized approach to color. Hiler is both artist and scholar, and one of the leading color theorists of recent years. He has writen several outstanding books on color and art, and his *The Technique of Painting* has been mentioned in Chapter 2.

Hiler was born in St. Paul, Minnesota, in 1898. He was exceptionally well trained, studying art, painting, and teaching in this country and in England, France, Germany, and Mexico. He has great intellectual as well as emotional endowments, and his paintings have unusual depth. The highly temperamental media of color is subjected to discipline and rational control, and the results are most impressive.

According to Hiler, in a monograph on his theories, "Structuralism is an approach to design which is based on a scientific method. Feeling is not ignored or neglected, nor is intellect looked on as incompatible with emotion. Its meaning is that the intelligence of the head may be utilized to accompany and to complete that of the heart."

There is little doubt that the intuitive appeal of color takes care of "the heart." Organization, control, method, thus take care of "the head." The combination leads to highly civilized art expression.

Hiler's compositions have grace in pattern and rhythm. Colors are pure, spectral, or muted, but are controlled to express what is personal to the artist in a complete, unified way. Hiler has been bothered by the amateurish and neurotic in art. He argues wisely and convincingly, and though there may be strictness in what he produces, the glory of his color somehow makes it sympathetic, human, and exciting to the beholder.

One of his compositions, "Some Dimensions and Directions of Color" (not shown), is quite unique. This is a beautiful and complex achievement. The whole of the spectrum is displayed in its manifestations from full purity to full depth (light tints are omitted). Some 1,300 shades and tones are present. "The oval form of the arrangement is dictated by the optical distance of each hue from a theoretical gray center." One senses an amazing order so often found in nature, the

6-34. HOMEOMORPHS OF VIOLET. Ben Cunningham (1904–1975). Color flows concordantly from blue and crimson toward a composite violet. The interplay of similar forms (homeomorphs) complements an artful display of spectral light, all elements of the composition working perfectly together. (Courtesy of the artist.)

color sequences of refracted and dispersed light seen in iridescent things such as oil on water, the logarithmic grace of many natural growth patterns.

With Ben Cunningham, color control is also dominant. Born in Colorado in 1904, he studied architecture and then fine art in California. He was active as a muralist and maintained a studio in San Francisco for about 15 years. He painted for a time in France and in 1944 settled in New York, where he came to teach and work creatively with color.

Cunningham acknowledges a debt to Wilhelm Ostwald and often organizes his art in terms of Ostwald's concepts. He writes, "For the artist-painter, Ostwald's structuralization of the color solid based on an order and relation of each surface color sensation to every other color — determined by a threshold interval analogous to the structure of the human nervous system — provides a new tool not heretofore available." What Cunningham means is that there is beauty in order, and where color order is adjusted to the facts of human perception, art finds new well-springs of expression.

His paintings are always carefully and beautifully designed. Although some painters may be blessed with natural and impulsive endowments, with Cunningham one sees and feels the remark-

able skill of a master. What he does commands respect.

There are intriguing shapes, patterns, and colors which are not precisely of this world but still fully convincing and satisfying. His imaginative world would be a good one in which to live — not a shambles like the world of so many of his contemporary Abstract Expressionists.

One of his unique works is "Painting for a Corner." It has been designed, as the title states, in two planes set at a right angle. As an example of what might be called geometric abstraction or geometric non-objectivism, this work is a masterpiece. If it has the look of being done "with mirrors," give Cunningham credit for a wholly original effect. As the viewer gives his attention, he begins to sense dimension and distance. The forms do not appear to be flat surfaces; they seem to be suspended and to float in space. The colors, mostly in the gold to orange to red range, are dominated by a yellowish illumination; they contribute to the impression of a dream world in which the phantasy of the artist indicates method in madness.

6-35. JOSEPH'S COAT. Ben Cunningham. The colors are pure. The abstract forms blend like transparent overlays. This results in much fascination for reasons that cannot be explained simply, which is to the artist's credit. (Courtesy of the artist.)

Chapter 7

The Wonders of Perception

In his *Farbenlehre* (1810), Goethe wrote, "The theory of colors, in particular, has suffered much, and its progress has been incalculably retarded by having been mixed up with optics generally, a science which cannot dispense with mathematics; whereas the theory of colors, in strictness, may be investigated quite independently of optics."

The artist must recognize that color expression — and indeed color perception — have very little to do with the physics of light, optics, or the physiological structure of the eye. Modern concepts of color derive largely from the genius of Isaac Newton (ca.1666). Though Newton in his day was violently criticized for his views, he became the patron saint of color and still is justifiably revered. What must be understood, however, is that the doctrines set forth by Newton have been variously accepted, changed, rejected. Progress has come a long way. As far as the *art* of color is concerned, little of Newton remains, except the vague presence of his spirit.

The great physicist James Clerk Maxwell appreciated this when he wrote, "The science of color must . . . be regarded as essentially a mental science." What did he mean? Color as light energy is mere stimulation, and such stimulation may or may not be recorded in a set, definite or invariable way. Light energy, in short, rings the doorbell of human mind and emotion and then departs. What happens after the departure is not the concern of the physicist. The trouble with many so-called scientific attitudes toward color is that skepticism may interfere with and even destroy illusion.

Though no artist of good mind would pose as an authority on science, the scientist, unfortunately, does not hesitate to impose his pedantic views on the artist. The scientist wants proofs where no proofs can possibly be offered. Arthur Eddington wisely wrote, "We cannot pretend to offer proofs. *Proof* is an idol before whom the pure mathematician tortures himself." So if an artist lets himself be tortured by a scientific outlook toward color, the error is his.

Eddington says further, "We all know that there are regions of the human spirit untrammeled by the world of physics." Art is one such region, and the scientist should advisedly keep out.

The "Psychology" of Color

Few illustrations accompany this chapter, and only one painting — Albert Pinkham Ryder's "Toilers of the Sea." (Ill. 7-1). Ryder was a genius in converting pigment to the appearance of light and of inducing weird but convincing effects of colored illumination. If the chapter lacks representative works of art, this is because it tells of perceptual phenomena which to a large extent have not been exploited by the artist. In other words, here I shall endeavor to tell of new things, new visions which could well lead to a new world of color expression.

I shall then proceed in Chapter 8 to a series of studies suggesting what the surface of this new world of color might look like. Let me try my best to bring to the artist a group of modern concepts and findings which in my opinion promise a third great epoch for the art of color.

Even before Goethe (1810), P. Bouguer, a

7-1. TOILERS OF THE SEA. Albert Pinkham Ryder. Here was a master in the creation of induced color effects. His small canvases appear as though seen through a magic window in the weird sulphur light of another world. (Courtesy of Addison Gallery of American Art, Phillips Academy, Andover, Massachusetts.)

French student of optics, surprisingly concluded in 1760 that "the sensibility of the eye is independent of the intensity of the light." This book has mentioned that the visual process involves the brain as well as the eye. A person has to *learn* to see and to make sense out of what he sees. In certain cases of hysterical blindness the person may be able to point to things seen and even to trace their outlines, but what is seen will be completely meaningless.

The experience of color is not a matter-of-fact reaction to light energy. James Southall has written, "From the standpoint of psychology, colors are the properties neither of luminous objects nor of luminous radiations but are contents of consciousness, definite qualities of vision." First of all, there is no close, orderly, or measurable relationship between light energy and the sensation of color. It is impossible to seize upon certain wave lengths or intensities and to establish them as fixed stimuli forever the same to the eye. What, for example, is the difference between black and white or between gray and white? Physics cannot answer this satisfactorily in any straight-line comparison of sensation and degree of light energy. White is not synonymous with

bright light or black with feeble light — or even with no light at all.

With the eyes tightly closed in a dark room, one does not have a sense of black but a deep subjective gray that seems to fill space. This gray has not the depth or solidity of a black surface. Again, black always appears blacker the stronger it is illuminated. No average surface absorbs all light. What the eye sees as black may reflect five per cent or more of the light shining upon it. Yet such a surface looks increasingly blacker when more light strikes it — and when, in fact, more light is reflected into the eye.

More curious than this phenomenon is the transformation of a white surface into the appearance of a gray surface without changing in any way the volume of light reflected by it. In a classical experiment devised by the great psychologist, Ewald Hering, a piece of white cardboard is placed on a window sill. The observer faces the light, and holds a second white card with a square hole in its center over the first card. He looks through this hole at the first card. If both cards are exactly horizontal, and if the upper one does not cast a shadow over the lower, they both will appear white (Ill. 7-2).

However, if the upper card is tilted toward the window sill, it will immediately reflect more light. As a result, the card seen through the hole will appear gray or even black. By changing the conditions of the experiment the lower card shifts from white to gray — yet the volume of light it reflects is not modified in the least. Here, the sensation of grayness or whiteness is independent of the volume of radiant energy.

Black is decidedly positive, not negative. Black is a sensation quite different from nothingness. Physiologically *black* implies the absence of stimulation: psychologically the recognition that illumination is absent is itself a positive perception. Helmholtz, himself a physicist, understood this: "Black is a real sensation, even if it is produced by entire absence of light. The sensation of black is distinctly different from the lack of all sensation."

Black is a color that is in every way as definite and unique as red or blue or white. It mixes in with other colors to change their appearance. An orange light in a dark room will maintain its same general appearance whether the intensity of

the light is strong or weak. It will merely be a bright or a dim orange. But lower the intensity of an orange paint by mixing black with it and it will change to brown. In light rays black seldom plays much of a role. There is no such thing as brown or maroon in a rainbow or a sunset. Yet in life, black is found everywhere, an integral part of other full hues, modifying their aspect and forever making itself apparent in vision. Southall says, "To argue that because a black body apparently does not deliver a specific physical stimulus to the retina, therefore black is a mere negation or complete lack of sensation, is not only to beg the question from the start but to deny the evidence of our senses."

Color discrimination and perception are sharpened by training and intelligence. An artist may actually see more than a layman. An elderly person whose vision may have grown dim, and the fluids of his eye turned yellow, may still see normally because of the corrections made by his brain. His mentality, in effect, will compensate for the deterioration of his visual sense — a very happy state of affairs.

Also pertinent are recent experiments in which a viewer is conditioned to associate a certain figure such as a square projected on a screen with a certain pitch of sound. After several hundred trials the viewer may presently "see" the figure when the sound is heard, but when, in fact, the figure is not actually before him on the screen.

The Birren Color Triangle of Chapter 5 charts visual and psychological relationships that have to do essentially with the human nature of color. Here black and white and four chromatic hues,

7-2. THE CLASSICAL EXPERIMENT OF EWALD HERING. When the upper white card is tilted forward or back, the card underneath appears to change in brightness.

red, yellow, green and blue, are primary, and unitary or invariant. Perception of them is rarely subject to change under different viewing conditions. They do not resemble any other color and all other colors appear to be mixtures of them.

The psychologically primary red, which shows no trace either of yellow or blue, is outside the spectrum. (The spectral, primary red of the physicist is a warm vermilion or ruby.) The psychological red finds its complement in a bluish green having a dominant wave length of 495 mμ (the millionth part of a millimeter). Goethe noted this over 150 years ago when he wrote, "We may here remark that those have been mistaken who have hitherto adduced the rainbow as an example of the entire scale; for the chief color, pure red, is deficient in it, and cannot be produced." The true red, as Goethe found, was a carmine, not a vermilion.

The psychologically primary yellow, without apparent trace of red or green, has a dominant wave length of about 577 mμ.

The psychologically primary green, with no trace of yellow or blue, has a dominant wave length of about 513 mμ.

The psychologically primary blue, with no trace of red or green, has a dominant wave length of about 473 mμ.

While these wave lengths vary with different observers, they represent acceptable averages. Incidentally, a greenish yellow (555 mμ) has greatest brightness when the eye is light-adapted, while a bluish green (507 mμ) has greatest brightness when the eye is dark-adapted.

So it is that the psychological primaries remain stable, not only as intensities differ but throughout the entire range of view. While orange may look like red and yellow, red and yellow do not resemble orange. And the same holds true for other intermediate hues which show glints of the primaries, but from which the primaries are completely different.

In Gestalt psychology, the warm colors (red, orange) are considered "hard," while the cool colors (green, blue) are considered "soft." (Goethe used the terms positive and active for the warm colors, and negative and passive for the cool ones.) Red and orange, for example, reach maximum stimulation in vision before green or blue. They have higher purity or saturation, and more of a "powerful" effect. In other words, red and orange are more exciting to the nerves of the eye than are green or blue.

Investigation has shown that brightness difference is more important than hue difference in the discrimination of patterns on grounds. A gray figure, for example, is likely to have more "stable organization" on a slightly deeper gray ground than it would on a blue ground of the same value.

Yet, all colors are not alike in this respect. When grays of equal value (brightness) are combined with hued figures, red and orange will "segregate" the most, while blue and green will "segregate" the least. The former are therefore hard and the latter soft. Also pertinent is the fact that colors "articulate" better against gray when they are on the figure or pattern rather than on the background. This is especially true of the hard colors. Red letters or patterns on a gray ground of similar value are easier to perceive than gray letters or patterns on a red ground. The abstract painter may find profit in this.

Similarly, in color fusion, the hard colors will dominate the soft colors. If a red card is exposed to one eye and a blue card to the other (simultaneously), perfect fusion in the brain will result in a sensation of purple. However, *before* fusion takes place, the brain will insist on seeing red more often and for longer periods than it will see blue. White here will also be dominant over black.

Color Induction

The term "induced colors" refers to colors experienced in perception which are subjective in character or which have a quality that seems to be independent of the physical nature of the stimulation. In afterimage phenomena, for example, the stimulation by an area of red will *induce* a sensation of green. Colored shadows also may be considered as being induced and may be surprisingly vivid (Ill. 7-3).

Pressure on the eyeball, a blow on the head, may induce flashes of color. After staring at a brilliant object, such as a light source or the sun itself, a person will "see" a series of colors which follow one another in odd sequence. If the stimulus is of high intensity, the sequence may begin at green and proceed through yellow, orange, red, and purple. If the stimulus is weaker, the

7-3. COLORED SHADOWS. If a weak neutral light exists in an environment and a strongly hued light is directed at an object, the shadow cast by that object will appear complementary. With red light (R), for example, the shadow will be greenish, and quite intensely so.

sequence may begin at purple and proceed through green, blue, into black. This so-called flight of colors was observed as far back as the time of Aristotle.

More unusual, a person under hypnosis, who is told that a certain neutral area is red, may experience a green afterimage. Vision and perception are dynamic processes indeed. Hallucinogenic drugs, disease, toxic poisoning, mental ailments may all induce weird color effects or partial color blindness. Dreams may be colored, and so may the hallucinations of the insane. If color sensations go from "the outside in," so to speak, they also go "from inside out." Afterimages, for example, seem to be projected from the eye and will be small or large depending on whether the eye is focused near or far.

Quite recently, color induction has become a subject of great concern to the human sciences. It is probably the most exciting development in the field of color and light today, with the possible exception of the laser. (The laser in its usual form is a beam of ruby red light which promises revolutionary developments in many fields, such as communications). Suddenly after many generations of scientific effort and enlightenment, man is brought face to face with the awareness that he knows little indeed about the

color sense and has much to learn. Many of his past theories and assumptions will have to be substantially revised.

A good demonstration of color induction will be found in a black and white disk devised by C. E. Benham in 1894 (Ill. 7-4). When there is intermittent stimulation of the eye, color reactions may be induced which are quite pronounced. If Benham's disk is held close to a light source and spun slowly to the right, the inner rings will be red and the outer rings blue. Spun slowly to the left, the order of the colors will be reversed.

7-4. THE MAGIC DISK OF C. E. BENHAM. 1894. When this disk, in black and white, is held under a light source and spun slowly to left or right, bands of soft colors will be induced and clearly seen.

7-5. INDUCING COLOR SENSATIONS. Black and white disks such as these can be used to induce color sensations. (From "The Prevost-Fechner-Benham Subjective Colors" by Jozef Cohen and Donald A. Gordon, *Psychological Bulletin,* March, 1949.)

144

7-6. COLOR INDUCTION DIAGRAMS. These diagrams relate to the unusual experiments of Edwin D. Land in color induction. (Developed by the author.)

There are many variations of Benham's disk (Ill. 7-5). Why or how the color induction takes place is not known. Benham's disk will induce blue and green colors under sodium vapor light which has no such wave lengths. Since the disk is black and white only, how can hued images be formed? There is astonishing independence between physical stimulus and the response of human perception.

Edwin D. Land, president of the Polaroid Corporation and a scientist of unusual capability, reported in *Scientific American* for May, 1959, some "Experiments in Color Vision" which caused international excitement — and debate.

According to Land, the eye "does not need nearly so much information as actually flows to it from the everyday world. It can build colored worlds of its own out of informative materials that have always been supposed to be inherently drab and colorless."

In Land's experiments, a colorful scene (flowers, miscellaneous objects), was photographed

twice by a dual camera — one image through a red filter (for a long wave length record) and the other image through a green filter (for a short wave length record). These images were on ordinary black and white film, and positive transparencies (also in black and white) were made from them (Illusts. 7-6, 7-7).

Then with a dual projector the transparency made with the red filter was projected with red light and the transparency made from the green filter was projected with ordinary (incandescent) light, and the two images were combined on a screen. The result was a comparatively full range of colors. Though only red light and white light were employed in projection, the scene showed yellow, orange, green, blue.

Wrote Land, "It appears, therefore, that colors in images arise not from the choice of wave length but from the interplay of longer and shorter wave lengths over the entire scene." This runs counter to classical color theory which supposed that to see any given color, wave lengths

145

A

B C

D

E

7-7. LAND'S EXPERIMENTS. Ca. 1958. Here are objects used in some of the earliest of Edwin D. Land's experiments. A full-color setup (A) was photographed, using a dual camera, through a red filter (B) and a green filter (C), for long wave and short wave records. Two black-and-white positive transparencies were then made. The two images were projected in register (D), using red light for the B transparency and *ordinary incandescent light* for the C transparency. Though the light sources were red and white respectively, the resulting projected scene (E) showed a surprisingly full gamut of hues, including greens, blues, and violets. (Adapted from "Experiments in Color Vision" by Edwin D. Land, *Scientific American,* May 1959.)

of it must exist in the stimuli. However, blue wave lengths are not needed for perception to experience blue, or green wave lengths, or indeed any other. When Land used a red filter over a tungsten lamp for one image, and sodium vapor light for the other, in neither case did the light beams contain green or blue; however, the composite image was fully colored, containing greens and blues.

Land therefore stated, "We are forced to the astonishing conclusion that the rays are not in themselves color-making. Rather they are bearers of information that the eye uses to assign appropriate colors to various objects in an image." He continued, "The study of color vision under natural conditions in complete images . . . is thus an unexplored territory."

Unfortunately the artist — or the printer or lithographer — is not able to produce full-color scenes from two tubes of paint or two printing inks. "Our coloring materials do not distinguish clearly between wave lengths that are fairly close together. If we could find pigments with much narrower response curves, we would suspect that these might provide full color. . . . "

Land's work has recently been repeated and his findings confirmed. Because of Land there is a sharp break with the past. Deane B. Judd, one of America's leading color authorities, writes, "Recently Land has stated that color perception has almost nothing to do with the wave length of light reaching the eye of the observer. In this sense of predicting from physical measurements of a scene what colors will be perceived there, we cannot yet measure color."

A few experts have wondered if Land's effects were not — in part, at least — due to human intelligence. Must the scenes and the images be of familiar objects? Would full-color results be achieved if the images projected were entirely abstract?

The answer is yes. Lawrence Wheeler of Indiana University, a worker in optics, using a complex image of geometric squares (Ill. 7-8), was able to induce "responses of purple, red, yellow-red, yellow, yellow-green, green, blue-green, blue, and purple-blue . . . from a complex image in which each of 100 squares contained a different mixture of red and tungsten light." (*Journal of the Optical Society of America*, August, 1963.)

7-8. ABSTRACT COLOR INDUCTION. When a complex, geometric image, such as shown here, was projected with red light and tungsten light, a full color range was induced. (Adapted from Lawrence Wheeler, "Color Perception and the Land Tri-Color Projections", *Journal of the Optical Society of America*, August, 1963.)

7-9. EFFECT OF ILLUMINATION LEVEL. Under normal illumination (left) the eye has a perfect sense of color values. As illumination grows dim, however (right), colors of deeper value tend to blend together for a foreshortening effect. However, white will always be seen as white. (Developed by the author.)

The Magic of Color Constancy

Land's findings are particularly intriguing because of their newness. Of perhaps greater interest to the artist — and to his creative efforts — is the phenomenon of color constancy. Here everyone can be his own scientist, using his own perception as a laboratory. Color constancy involves visual experiences which seem to contradict the facts of stimulation. Thus it is more related to psychology than to physics. Most significant of all, the artist, the student of color, or even the layman — if he is alert to his own reactions — can study many illusive effects, and through his own process of observation become quite an authority. As Judd admits, "The phenomena associated with adaptation can be observed readily; but it is a different story to explain them quantitatively."

There is first of all adaptation to strong and weak illumination, and secondly to chromatic illumination. Visual adaptation to light and dark involves physiological elements, while chromatic adaptation (color constancy) is far more complex and probably involves the higher centers of the brain.

The nerves on the retina of the eye consist of rods which react chiefly to light and are scattered over the entire area of the retina, and cones which are sensitive to color and are concentrated in the center of the retina (fovea). There is a double process to the art of seeing. In very dim light, the rods are most active and the world has a flat and misty appearance that is more or less without color or detail.

As illumination increases, the cones become active, and the world takes on form, color, texture. In full daylight the cones do most of the seeing, and the rods become inactive.

It should interest the artist to know that in normal daylight the eye has a perfect sense of color and color values. A gray scale will be seen in all its steps. As illumination grows dim, how-

ever, deeper values blend together and the gray scale tends to foreshorten at the deep end (Ill. 7-9). In very dim light, almost all gray values (and colors) reflecting less than 20 per cent are confused and look alike. *Yet in any light, and as long as the eye is able to see, white will remain white in human perception, regardless of what happens to the appearance of any other values or colors.*

A practical lesson to be learned here is that as far as light and dark values are concerned in a work of art, the artist must consider the eventual illumination under which the painting will be seen. Values that appear neat enough in good light, for example, may "fall apart" in a softly lit interior. At the same time, as will be brought out later in this and the next chapter, by a resourceful manipulation of color values in a painting, any lighting effect may be simulated — and be independent of the illumination under which the painting may be seen.

If one were to hold a white card in his hand under varying lighting conditions, he could observe the phenomenon of color constancy. In full sunlight the card would appear white. It would continue to appear white if a cloud passed over the sun or even if he entered his house and walked down into the dim recesses of his basement. As the Gestalt psychologist, David Katz noted, "The impression of an object's color is notably independent of the local stimulus condition."

Now if the observer continued to gaze at the white card under the pinkish, orange, and yellow light of dusk, the white sensation would persist. Still more remarkable, if he took the card inside at night and put red (or blue, green, yellow) light bulbs in the electric sockets in his living room, the white would still appear white — *even though it actually was no longer white but red* (or any other hue).

Writes Katz, "The way in which we see the color of a surface is in large measure independent of the intensity and wave length of the light it reflects." Ewald Hering, the German psychologist, put it this way: "Seeing is not a matter of looking at light waves as such, but of looking at external things mediated by these waves; the eye has to instruct us, not about the intensity or quality of light coming from external objects at any one time, but about these objects themselves."

Color constancy is nature's way of enabling man to hold the world to a normal and consistent appearance, even though the physical conditions of light energy and retinal stimulation vary tremendously. The facility, incidentally, is also shared by lower animals. For example, chickens trained to pick up white grains of rice, rather than colored grains, continued to do so when red illumination was introduced and the grains were no longer white but red.

Here are a few other significant points regarding color constancy. It is best maintained when the whole field of view is involved and when the person stands within the illuminated environment, not apart from it.

A certain amount of time is required for perception to adapt itself. If red light is suddenly thrown into a room, a person will be immediately conscious of the fact that objects in view are reflecting colored light. Soon, however, the eye will adapt to the red illumination, discount it, and a normal appearance will tend to be restored. The white surface which looked red for a short while, will go back to looking white.

If the whole field of view is not involved, if the surfaces modified are isolated or seen through a small aperture, color constancy may be lost.

According to M. D. Vernon, "A white surface in red light may, up to a point, appear less red than a red surface in white illumination, even when the former reflects more red light than the latter." In an instance like this the stronger red stimulation may look weak and the weaker red stimulation look strong.

In a similar, weird fashion, red areas may appear to grow weaker under red light, while areas which contain little or no red may seem to grow redder. Here once again, the facts of stimulation are contradicted.

Man's gift of color constancy is beyond the capacity of a camera. As a matter of fact, an artist with a capable hand and eye can do things which far exceed the realism possible in photography. You and I can walk in and out of a house, take a plane trip during which we alternately read a magazine and look out a window, sit in a cocktail lounge at the airport (which is lit with artificial light), and admire the sunset — and all

the while the world about us appears genuine and relatively uniform.

No camera, even if it had an automatic shutter, could do this. It could not photograph a room interior overlooking an outdoor garden and record both *at one and the same time*. Any such attempt would have to force underexposure or overexposure of something. Indeed, within reasonable limits, there is no such thing as underexposure or overexposure in human perception. The camera could not photograph a white house seen in orange dusk and have the house remain white. It could not photograph a white card in full light and a white card in shadow (simultaneously) and come out with *two* white cards. All this has to do with realism which the artist can readily duplicate but before which the camera is helpless. Amazingly different changes in light intensity and in the chromatic quality of illumination are taken in easy and efficient stride by human perception. Mostly man does not give these experiences a second thought until they are pointed out for him.

Many lessons follow an understanding of the above simple phenomena. An artist can begin to manipulate his materials, experiment with the human elements of color constancy and invent new and creative modes of color expression. As a prelude to this, consider the following:

An artist, standing in the shade of a tree, will have trouble trying to portray a white barn out beyond in the sun. He will never be able *to match* what he sees, even though his paint is as white as the barn paint, because he will be in weaker light than his subject. Similarly, an artist, sitting in a studio with his palette near a window, will not be able to duplicate the deep shades he sees at the rear of the room. When illuminations differ in real life the eye can jump readily from one to the other and see no great differences in the appearance of objects and surfaces. If representation is wanted, the artist will have to paint what he sees. If he attempts to be scientific, to duplicate the "facts" before him, he may end up portraying white tablecloths with gray paints and orange pumpkins (in shadow) with brown paints.

In nature the sky may be 1000 times brighter than the shaded side of a barn. Here the ratio might be 1000 to 1. On a flat canvas, however, the ratio of brightness difference can hardly exceed a mere 15 or 20 to 1. This assumes that the whitest white reflects about 80 per cent and the blackest black about four or five per cent.

Yet with the magic of color constancy to exploit, any lighting effect — real or abstract — is possible, and the artist can induce color experiences of infinite variety.

Modes of Appearance for Color

As I have emphasized in this book, perception is the freshest and most exciting field of modern inquiry in color expression. I have every faith that it will one day lead to a new school of color as great as that of Impressionism — and just as original and different from the past.

It should be understood that many color sensations and appearances have their origin in the brain or in certain curious interpretations of the eye and brain. For example, a particular red color may appear filmy like a patch of sunset, structural like paint or cloth, transparent like a piece of cellophane, lustrous like a piece of silk, metallic like a Christmas tree ornament, luminous like a traffic light, three-dimensional like a bottle full of red dye. And it is conceivable that all such reds could be chosen to match and would therefore be identical to a scientific instrument.

These different modes of appearance (Ill. 7-10) can be described as follows: Film colors — like the sky — appear to fill space. Surface colors are localized, opaque, structural. Volume colors occupy three-dimensional space. Fog will look like a filmy gray until objects are seen through it; then it will tend to have volume.

Film colors thus are celestial in character and representative of light itself. Seldom if ever do they seem to contain black. Surface colors, on the other hand, are more terrestrial and usually show modifications of gray or black.

Surface colors can be made to resemble film colors by viewing them through an aperture screen (a card with a hole in it). A localized color on a flat plane may suddenly seem to become atmospheric and to fill the space between the surface which has the color on it and the aperture screen which is held in front. In the art of painting, therefore, filminess might well require a flat technique, and surface color a textured one.

7-10. MODES OF COLOR APPEARANCE. The original of this study, in yellows, golds, and grays, is meant to convey impressions of different modes of appearance — film color, volume color, surface color, luminosity, transparency, metallic luster, silk luster, iridescence, microstructure, and so forth. (From a painting by Bernard Symancyk.)

Glitter and iridescence (to some extent) demand eye movement to be rightly appreciated. What is the difference between white cotton and white silk? White silk in shadow will still look like white silk, while white cotton will remain cotton even if it is taken into brilliant sunlight. Luster is a visual phenomenon that has little to do with the physical facts of light reflection. Incidentally, colors which appear lustrous in central vision may appear luminous in peripheral vision.

Illumination Effects —
The Law of Field Size

In the past century John Ruskin wisely wrote:

While form is absolute, so that you can say at the moment you draw any line that it is right or wrong, color is wholly *relative*. Every hue throughout your work is altered by every touch that you add in other places; so that what was warm a minute ago, becomes cold when you have put a hotter color in another place, and what was in harmony when you left it, becomes discordant as you set other colors beside it; so that every touch must be laid, not with a view to its effect at the time, but with a view to its effect in futurity, the result upon it of all that is afterwards to be done previously considered. You may easily understand that, this being so, nothing but the devotion of life, and great genius besides, can make a colorist.

What Ruskin did not anticipate, however, is that the psychologist would later come to investigate, explain, and put to practical use a whole body of knowledge about perception. Chevreul, and the Impressionists and Neo-Impressionists devoted much attention to the effects of simultaneous contrast, illusions which are more or less optical in nature.

Today emphasis is on the larger field of perception, particularly on happenings that seem

7-11. APPEARANCE UNDER NORMAL LIGHT. Here the cylinder appears in normal highlight and shadow and in a normally illuminated setting. There is a perfect sense of color values from white to black.

to take place in the brain. For example, the ability of the eye to see color, detail, form and the like naturally depends on illumination. Yet a consciousness of illumination does not require that a person look about for light sources. Illumination creates and destroys space, just as it makes visible the world and all things seen in it. When objects are illuminated, space is perceived, and the space between the eye and the objects is perceived as being illuminated.

It so happens that judgments of illumination depend less on physical degree of light energy than on an interpretation of what is before a person. This is a fortunate situation for the artist. A well-composed sunlit or moonlit painting by van Gogh will look the part whether seen in broad daylight or under the soft glow of a candle.

The reason that this is the case involves the Law of Field Size. To portray brilliant light, soft light, or dim light it is unnecessary to use only light, medium, or deep colors. The artist who attempts to paint twilight by combining many deep grays and blacks will have merely a dirty-looking canvas — something untrue to human experience. His problem is not to use all light colors to portray brilliance, and all deep colors to portray darkness, *but to use care in the distribution of his lights and darks.* (This applies to abstract painting also.)

As a matter of fact, intense light very often creates intense shadow – and striking light and dark contrasts may be necessary to simulate bright sunlight. On the other hand, in dim light, white and pale colors are the only ones that remain high in value; other colors go deep.

When the larger field — the major area of a composition — is bright, an impression of bright illumination follows. When the larger field is deep, an impression of dim light follows.

Thus, the artist by a clever handling of field sizes over his canvas can achieve almost any

152

7-12. APPEARANCE UNDER DIM LIGHT Here dim light is implied. The larger area is dark. However, the color values still run from white to black; this is wholly true in human perception.

7-13. APPEARANCE IN MIST. There is a sense of mist and distance brought about by a general field of gray. One is conscious of an illumination effect rather than a mere showing of gray tones.

7-14. EFFECT OF LUMINOSITY. The cylinder is now luminous — the brightest area in sight. The light that shines forth is diffused in the ground, and this helps the effect.

effect of illumination (Illusts. 7-11, 12, 13, 14). Yet because of color constancy, he will always work from white to black; but the relative distribution of all other tones will vary as he wants the illumination effect to vary.

Katz feels that a painting ought to be of generous size. "The *more* of a picture we perceive the clearer is our impression of the illumination the artist is representing." With the exception of miniatures (and these should be smoothly done), too close an observation may make the viewer conscious of paint, and illusion may be lost. Every painting has an ideal viewing distance.

As to luminosity, Katz writes, "The artist creates the illusion of a luminous object in a picture not so much by painting the object in particularly bright colors as by distributing the light and shadow appropriately with reference to the object within the pictorially represented space." For an object to appear truly luminous it must be the brightest and lightest thing in sight.

As will be seen in the next chapter, intelligent application of the Law of Field Size will enable an artist to create truly unique and startling color expressions. By keying his compositions in terms of lightness, darkness, and grayness, certain effects of illumination can be induced in the response of the beholder. And from this established quality, the artist will be able to make his incidental touches do surprising things — to appear lustrous, iridescent, luminous, drenched with chromatic light, soaked in hued mist. Although illusion is involved, the ends of personal creation will be strikingly served.

Books, rules, observations, principles cannot make an artist. But they can provide him with tools that will add to his competence and enable him to achieve results which might otherwise be crude and inexpert.

154

Chapter 8

An Art of Color
for the Future

This chapter will conclude the first part of the book concerned with "The Practical Methods" in the artist's quest for color expression. The second part, "The Historical References," will present a comprehensive view of color expression from the time of the Renaissance to the present.

Perhaps a good artist and colorist is born and not made. Yet like a writer or a composer, the making that comes of education, training, understanding is essential. The writer must have an adequate vocabulary, a knowledge of syntax. The composer must have familiarity with keys, counterpoint, the nuances and qualities of sounds.

It seems, however, that in recent years the artist is expected to take counsel from no one. He is to create in pristine freedom, show canvases that follow only his particular "inner necessity," completely devoid of outside influences.

As will be mentioned later on, there have been a number of dead ends in the history of the art of color. Points of no return were reached in such art movements as Suprematism and Neo-Plasticism. To a large extent much of the action painting of recent years has been retrogressive in that it has relied on primitive and impulsive means to ends. When the color is applied at random, when the palette (if there is one at all) comes straight from cans or tubes, the *forms* and *patterns* may be unique but the color effects are likely to be quite ordinary.

I agree with the Gestalt psychologists that color precedes form in its impact on human consciousness. An artist may stick to black and white if he chooses, but he will be handicapped without color. And when he uses color, whatever he might do will fail to be "soul-stirring" if his effects are mediocre. Color may enhance or weaken form.

Nothing seen by the eye, in fact, can possibly be colorless — and this *includes* black and white (both of which are colors). Even space itself is filled, even if with emptiness. Space is gray, pulsating, alive, for the simple reason that man's senses distinguish it this way.

Perhaps there may be emotion in abstract hue and form, or in stark realism. Yet it should be emphasized that color cannot be divorced from form. Architecture that is built of marble or stone is not colorless; it is gray, and gray is a color. If a person should find black and white drawings more moving than colored drawings (perhaps because they avoid the distraction of color), this does not disprove the basic sensitivity to color which is part of human makeup.

If a man's rational defences are disturbed by a drug like mescaline, for example, the world about him is likely to become a kaleidoscope of brilliant hue. It can be said that man has color inside him, and in his psyche are the makings of skyrockets, illuminated fountains, and northern lights!

Thus, I would advise any creative artist — if he wants to break with precedent — to set his color effects first before he does anything else. I would advise him to think of color first, feel for it, manipulate it. Even if his final intention is to undertake a microscopically detailed subject, I would ask to see what colors he intends to use,

8-1. SOLIDITY AND DIMENSION. In this study there is maximum contrast in the near figure and softness in the background. This agrees with findings in nature and with the laws of human perception. The figure tends to appear both round and in three-dimensional space.

8-2. AN EFFECT OF LUSTER. In the original of this study, bright red, yellow, green, and blue are shaded toward black. A gray ground sets up a subdued field. The extreme luster achieved seems to exhibit more vividness than that found in the pigments themselves.

what they look like in abstract daubs, *and particularly what quality of illumination, what perceptual mode or mood he hopes to induce in his viewers.* I would tell him not to isolate color from form. If other people do not unconsciously separate the two, why should the artist consciously try to do so?

Controlling the Color Effect

The average artist is in constant search for new ideas and approaches. He strives for original expression, for art forms that will be unique to his temperament. Yet in practice, everything he does may be carried out with one and the same palette. He may put a lot of red in one composition, and blue in another, thinking that he is achieving variety. But he may overlook the fact that no matter what he does, all his paintings appear as if they had been executed under one lighting condition. Qualities of illumination are not induced in those who view his art. Practically all recent Abstract Expressionist paintings can be justly criticized for having this monotonous fault. One artist after another has tried his best to be different. Many have succeeded as far as design goes, but the color effects clearly trace back to the same pots, jars, and tubes, and to the same studio with the same ordinary lighting. Yet if one studies great paintings of the past, one quickly realizes that *most of them imply and induce qualities of illumination which are not those of the room or gallery in which the paintings are seen.*

It is quite easy to understand the reason for the uniformity of recent paintings, for the artists have used the same pigments and materials, and virtually all of them have worked directly from palette to canvas without bothering with preconceived illumination effects or pre-mixed color arrangements.

Yet where the wonders and mysteries of human perception are grasped, color expression becomes fascinatingly without limit.

My intention is to demonstrate a series of perceptual illusions, tell how to devise them, and suggest possible applications. It is not to tell an artist how to paint with color, or even how to be an artist. These demonstrations should be regarded as tools, even though the examples may be lacking in many respects.

156

Illusions are demonstrated in the eight studies shown on the several pages that follow. The designs are abstract so as to permit as much emphasis as possible on color rather than on form.

The same is true of the black and white studies included in this chapter (Illusts. 8-1 through 8-15). These are merely *described* as to color. The originals — non-objective compositions — were made from palettes developed by the writer in collaboration with Bernard Symancyk of New York.

However, both the original color effects of the black and white reproductions and the full-color studies of the art itself were made from predetermined and pre-mixed palettes. In no instance did the artist engage in any impulsive application of paint from tube to canvas. Indeed, the mixing of the palettes in the majority of the studies occupied more time than did the final execution with brush and palette knife.

Illustration 8-1 shows a simple experiment in aerial perspective. The form in the foreground is strong in contrast. In back of it the several colors become increasingly gray. This unusual effect was well known to the Old Masters. All this is just as nature herself handles distance. As in the other studies, there is major attention to color *effects* and minor attention to color *schemes*. To explain the difference, a color *scheme* is a mere combination of hues (planned or otherwise) in which there is simple visual or optical response. Color schemes are *out there*, so to speak, on the canvas, and a person does little more than register them with the seeing apparatus of his eye and brain.

A color effect, on the other hand, is not merely seen — it is *perceived*. The viewer contributes to the result. A well-planned arrangement *induces* impressions that go beyond a matter-of-fact response, beyond a simple consciousness of pigments or materials. Something is added by human perception. The artist not only portrays; he achieves the participation of those who are witness to his creative effort.

In Illustration 8-3 an effect of iridescence is implied. In the colorful original, tints of pink, yellow, and turquoise are softly graded toward a neutral gray. An artist merely needs to keep

8-3. AN EFFECT OF IRIDESCENCE. Here the study is meant to convey an impression of iridescence. In the original, the light areas in all cases are bright pastels; these shade toward a neutral gray for the deeper values. Turner used this principle.

8-4. AN IMPRESSION OF RED ILLUMINATION. In the original of this study, an over-all impression of red illumination is induced. The effects of red light on surface colors were matched in oil paint. The composition is put together so that it has the appearance of being showered with red light.

8-5. AN IMPRESSION OF YELLOW ILLUMINA-
TION. Here colors influenced by yellow light are arranged
in a non-objective study. Although ordinary oil pigments
were used, human perception overlooks this fact and insists
on seeing the result as a phenomenon of illumination.

8-6. AN IMPRESSION OF TINTED ATMOSPHERE.
For this study, the effect of tinted atmosphere, mist, or
even water, is interpreted. The whole composition seems
pervaded by a blue-green tonality. Again, the incidental
colors seem less like pigments than like ordinary surface
colors drenched with a blue-green wetness.

8-7. AN IMPRESSION OF YELLOW-GREEN LIGHT.
Once a unique principle is understood, magical things can
be done with human perception. In this study, a weird
yellow-green atmosphere is arbitrarily planned and made
to cast a pallor on all in view. The artist induces effects
that transcend his medium.

this principle in mind for successful results.

Illustration 8-2 attempts to create an effect of luster. Here the gradations are pronounced and not subtle. The exact colors used in the original are described in the legend under the halftone itself. An artist merely has to follow what is described.

In all four cases, fixed palettes have been set in advance. The artist has then worked freely with them. He has not used paint as paint, but as a stimulus of perception.

The underlying principles of these studies are not unduly complex. Bringing the Law of Field Size into practical operation, in each study the larger area of the composition is neatly controlled. Where luster is wanted, all toning is done toward black. Red is shaded toward maroon, and blue is similarly deepened. The trick, of course, is to subdue all colors uniformly as if they fell under the same shadow. The direction of this suppression is toward black.

The eye (perception) is encouraged to accept the composition as one being seen under slightly dim light. Thus when touches of pure red and blue are applied in the highlights, they seem "brighter than bright," and a sensation of luster results.

As to iridescence (Ill. 8-3) the phenomenon in nature is due not to pigments but to the diffraction of light brought about by the splitting up of white light into its component hues. One of the characteristics of iridescence, such as seen in mother-of-pearl, is that the glistening colors tend to shift and change when seen from different angles — an effect quite difficult to achieve in a static composition.

While luster requires the contrast of blackness, in iridescence the direction of suppression is toward gray. Here again, application of the Law of Field Size sets the stage. The ground, the red, the blue, are toned with gray as if seen in mist. When pure tints (pastels) are introduced, they sparkle brightly, and the viewer is convinced that iridescence is present. If the artist, through strategy, uses his colors resourcefully, the viewer participates and sees the desired effect.

In the original of 8-3, yellow-orange and green are intended to shine forth as luminous light sources in an atmosphere or mist dominated

8-8. MAGENTA AND VIOLET LIGHT. In this study the background is in rich shades of violet. Superimposed are irregular shapes lit from one side with an intense magenta. Although the result is convincing, the artist has created a setting that is not of this world but of his own imagination.

8-9. A REMBRANDT COLOR EFFECT. The colors and color values of this study are taken from a portrait by Rembrandt van Rijn. This shows, in an abstract way, how the master achieved his startling effects, building up from suppressed deep colors to pure light ones.

8-10. INFLUENCE OF COLORED LIGHT SOURCE. Here a colored light source — a bright lemon yellow — has been put on the canvas at upper right. It is then made to cast its influence throughout the composition. The non-objective forms, which in natural light could be any color, become rich tans and mustards, because of the lemon light.

8-11. PIGMENT MANIPULATED AS LIGHT. The forms float about in blue moonlight. Into this atmosphere comes a beam of red light which illuminates certain minor areas. This manipulation of pigment as if it were hued light has fascinated artists for centuries.

by yellow-green illumination (an effect that fascinated Vincent van Gogh).

In Illus. 8-11, red and blue are used as luminous light sources shining in a blue environment.

When colors are to appear luminous, the following conditions must be met:

The luminous areas, lines, or touches must be relatively small.

They must be the purest colors in the composition.

They must have the highest value or brightness.

The larger field must be somewhat deeper and grayer than the luminous areas.

Hence, extremely deep values must be avoided on the background. Where light shines into the eye, vision is blurred. Thus, contrast between the luminous areas and the ground must be moderate for perception to take part.

Where two luminous color sources are to be portrayed, as if from two different sides of a composition—i.e., red from one side, blue from the other—where the two lights may overlap, the result would be a pale lavender, not a deep purple. This is because lights are additive, while pigments are subtractive in mixture. There is physics in one instance (light) and chemistry in the other (pigment).

In Illus. 8-14, the effect is one of transparency, but is accomplished with opaque materials. The important point here is to make sure that where the colors overlap, the mixtures are *subtractive* and quite dark.

To induce general effects of colored light striking and pervading a composition — thus bringing in the phenomenon of color constancy — paints must be manipulated as if they were lights. The action of colored light on paint is not the same as paint upon paint (or light upon light).

Certain chosen key colors are studied as they actually appear under differently tinted light sources. What takes place physically is matched with paints as far as possible. Then when these matched paints are applied to canvas, the process nicely reverses itself. Through the magic of perception, the eye is induced to experience an impression of colored illumination. What many Old Masters achieved through insight and genius, the modern painter can duplicate through knowledge of the psychology of vision.

160

8-13. LUMINOSITY IN VIOLET MIST. In this study, luminous light sources shine into a violet atmosphere — a man-made effect. Non-Objective art, free of any need for obeisance to nature, can and should give the artist complete release, providing that he understands the makeup of his own perception.

8-12. LUMINOSITY IN PINK MIST. The ragged cone-like forms seem to be lit from within. They shine in yellow, blue, and green, into a pink-drenched atmosphere. It is unusual that great brilliance and luminosity can be accomplished with a ground that is high in value, as in this example.

8-14. TRANSPARENCY WITH OPAQUE PIGMENTS. Here is transparency achieved with opaque pigments. Impressions are more important than facts in art. A great painter is one who can transport his viewer beyond the outer canvas into inner vision and feeling.

8-15. EVOKING EMOTION WITH COLOR. In this study, an attempt is made to show color modes of diverse kinds. An artist should not think of paint merely as paint, but as a means of inducing singular and stirring reactions in the mind, emotion, and perception of the beholder.

Indeed, a new world of *effects* lies waiting to be explored and conquered. Natural phenomena can be readily duplicated or implied, and nonrepresentational compositions can be freely approached.

For example, conceive of an abstract art of misty effects in any tint a painter wished — in eerie yellow-greens, tranquil blue-greens, lush purples. The art of color of the future has all this

in addition to the studies described on these pages. One may conceive of luminous color shining out of mist, of paint converted to light, of perception in a new legerdemain of art in the future!

Color as Personal Expression

Color is something to know about, to ponder over, to experiment with. Nothing is easier to enjoy without effort; nothing is closer to emotion.

That artist is wise who will avoid being too objective, too critical. Let him get over the notion that nature is full of mysterious secrets which must be unearthed in equally mysterious ways. When you study color, use the knowledge you gain to express your own personality.

Man's sense of art is neither completely a matter of inspiration, nor of cultural training. If man happens to see harmony and stability in certain forms and symmetrical arrangements, if the order of the Color Triangle (Chapter 5) pleases him, he must realize that perception itself, the eye-brain of man, holds responsibility for everything.

Beauty (or ugliness) is not out *there* in man's environment, but *here* within man's brain. Where formerly some artists strove to find laws in nature, now one may be sure that such laws, if they exist at all, lie within the psyche of man.

The perception of color — including feeling and emotion — is the property of human consciousness. If man is awed by what he sees in his surroundings, he should be far more impressed by what lies within the sanctuary of his own being. This is where to look, not in ignorance but in sensitive understanding.

PART II. THE HISTORICAL REFERENCES

Chapter 9

The Old Masters

This part of the book offers a review of color expression in art as exemplified in great paintings and the views of great artists. The viewpoint is a special one, for it concerns itself chiefly with color and therefore with any school or movement in art that has featured color or at least taken it seriously to heart. An effort has been made to provide a straightforward account that will serve as a reference section for the first part of the book.

There may be great drawing without color, or even great art without color. But in the field of painting, the artist who betrays an ignorance of color or an ineptness with it is likely to have his works judged as mediocre. Surely, color is one of the most vital of the factors in the art of painting. And in some recent modes of expression it is *the* most important factor.

It is unnecessary to go too far back in history to begin this review of color expression in art. Before the invention of oil painting in the fifteenth century, artists were limited in their choice of pigments. The older methods of painting, with such vehicles as wax, lime (fresco), tempera, did not allow much latitude. The preparation of pigments and dyestuffs has always been a highly complex process and it still is. Synthetics and coal-tar colorants, in fact, were not discovered until the nineteenth century.

Before that time, and back to the beginnings of history, man secured his colors from wide and sometimes curious sources: from earths, clays, minerals, semiprecious gems; from roots, berries, nut shells; from bones, ground insects, cuttlefish, snails. In ancient times, the color-making process was often mysterious and was thought to have a sort of alchemical magic. Thus with great

limitations placed on the colors available to him, the ancient artist did the best he could. A good part of his time and skill probably went into the making of his own colors. The vehicles he employed, the methods and procedures of his trade were kept a secret. He is to be admired not only for his vision and insight as an artist but for his technical facility and craftsmanship.

Certainly the early artist was handicapped by lack of a generous supply of coloring materials, but it is also apparent that his notions about color were quite different from those held since the Renaissance. In other books, the author has

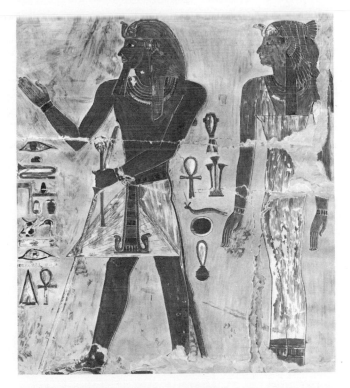

9-1. EGYPTIAN WALL PAINTING. ca. 1600 B. C. From the Temple of Hat-shepsut. The palette was a simple one of red oxide, yellow, blue, green, white, black, and was used symbolically. (Courtesy of The Metropolitan Museum of Art.)

9-2. ROMAN PAINTING. First century B. C. From the Villa Boscoreale. Colors are bold and handled both decoratively and realistically. (Courtesy of The Metropolitan Museum of Art. Rogers Fund, 1903.)

taken up the matter of a classical tradition in color expression as distinct from a creative tradition. Briefly, virtually all ancient art — that of Egypt, Asia Minor, India, China, and Greece — used color symbolically and the palette of the artist was restricted to a few rather primary hues repeated over and over in accordance with prescribed practice. The creative spirit inspired by the Renaissance, however, brought an end to this and the artist was able to give free rein to his visual and emotional fancies.

Centuries ago, Pliny wrote of the ancient Greek painters and their palettes, "It was with four colors only, that Apelles, Echion, Melanthius, and Nichomachus, these most illustrious painters, executed their immortal works; melinum for the white, Attic sil for the yellow, Pontic sinopsis for the red, and aramentum for the black." Broader palettes will be seen in archaeological restorations, such as the wall paintings at Pompeii, but generally, ancient artists were more likely to be obvious than subtle with color and to keep their hues few in number and apply them simply and boldly.

The Birth of Modern Art

The white-yellow-red-black palette described by Pliny in the first century A.D. was repeated and commonly used during and after the Renaissance. Many of Rembrandt's portraits were executed in this palette. However, with the invention of oil painting, the expression of the artist found a release never before enjoyed.

The story of modern painting usually begins with Giotto di Bondone (ca. 1276-1337). Though born a modest shepherd boy, he had amazing precocity and became the greatest artist of his day. What Giotto contributed was a daring and startling naturalism and bright colors, which broke sharply with the stiff formality of the past and heralded the Renaissance. In color expression, however, Giotto was limited by his pigments and by the fresco technique which required him to fuse his colors on moist plaster. This had a tendency to bleach out many hues, give them a white and "milky" look, and prevent much manipulation. Yet Giotto was one of the first artists, according to Sir William Orpen, "to depict action, to substitute the dramatic life for the eternal repose of the divine. To his contemporaries, his realism must have seemed amazing."

It was naturalism indeed that obsessed the Renaissance masters. They wished to paint with such fidelity and illusion that the viewer would be tempted to walk into the composition itself and look at it from all sides. There was sudden attention to perspective, to the glory of illumination, to the modeling effects of highlight and shadow, to detail and texture. In the years after Giotto, this fascination with three-dimensional relief sometimes led to a form of representation in which there was full highlight and shadow and yet a total absence of *cast* shadows. Figures, nature, and architectural details might show light streaming from one direction — usually the left — but none of the material things in view threw shadows on the area about them. Such

9-3. SAINT FRANCIS RECEIVING THE STIGMATA. Giotto de Bondone. He worked mostly in fresco; this is one of his very few panel paintings. It is done in brown, red, green, and blue, with the background in gilt. (Courtesy of Louvre, Paris.)

naturalism, which was surrealistic in effect, is found in the art of men like Fra Angelico (ca. 1387-1455), Fra Filippo Lippi (ca. 1406-1469), Paolo Uccello (ca. 1396-1475), and Botticelli.

Greatest of these men perhaps was Sandro Botticelli (1445-1510), a romantic and a mystic,

who came under the patronage of the Florentine Medici during part of his life. Once apprenticed to a goldsmith, Botticelli devoted his life to art and became "a jeweler in colors." He had a smooth, lucid style, and manipulated his colors — red, blue, green, gold — with unusual power and brilliance. An excellent example of his work is "The Birth of Venus," Illustration 9-4. Because of his exquisite line and modeling, and his phenomenal sense of light, shadow, and form, Botticelli's paintings look well in black and white.

The Invention of Oil Painting

Botticelli and his predecessors worked mostly with fresco (moist plaster) or tempera (egg yolk used as a vehicle to hold pigment in suspension). Such techniques had limitations, required constant attention to chemical and mechanical problems; the materials were difficult to manipulate in any plastic, viscous, or fluid way. There were, of course, a number of painting and coloring methods involving various sizings, casein, distemper, or a combination of them. Many old works of art, for example, which look as though they had been executed in oil, are tempera paintings coated with a varnish. Egg tempera may be mixed with either water or oil, therefore it would be natural for an artist working in tempera to discover the merits of oil as a pigment

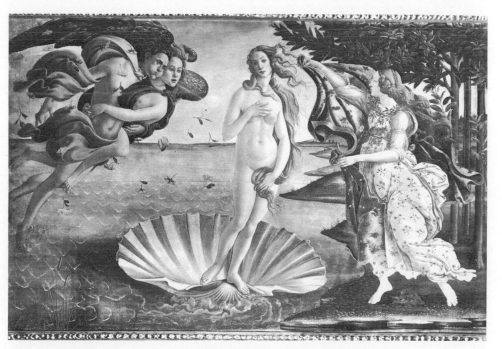

9-4. THE BIRTH OF VENUS. Sandro Botticelli. Tempera. The colors are exquisite— pale blue and green, flesh, gold, rose, and lilac, all harmoniously composed. (Courtesy of Uffizi, Florence. Alinari-Art Reference Bureau.)

9-5. SELF-PORTRAIT. Giorgio Vasari. The world owes much to the records and accounts of this great Italian architect, painter, and historian of Renaissance art. (Courtesy of Uffizi, Florence. Alinari-Art Reference Bureau.)

9-7. THE CRUCIFIXION. Hubert van Eyck. (Courtesy of The Metropolitan Museum of Art. Fletcher Fund, 1933.)

vehicle and to appreciate its versatile working qualities.

The eminent Renaissance artist and historian, Giorgio Vasari (1511-1574), who was a contemporary of many of the Italian masters, credited the invention of oil painting to one John of Bruger

9-6. VIRGIN AND CHILD, WITH SAINTS AND A CARTHUSIAN DONOR. Jan van Eyck. His colors are exceptionally pure—red, blue, and gold. (Copyright, The Frick Collection, New York.)

in Flanders in 1550. Scholars have since determined that the reference was to Jan van Eyck (ca. 1370-1440) who, with his elder brother, Hubert (ca. 1366-1426), is generally given the credit.

But whether or not the van Eycks were the *very first* to paint in oil, most certainly they were outstanding masters of the new technique and their works are unquestioned masterpieces — they were the best of the Northern artists until the time of Rubens some two hundred years later. A splendid example of Jan van Eyck's work is seen in Illustration 9-6, "Virgin and Child, with Saints and a Carthusian Donor."

The art of the van Eycks is naturalistic in the extreme. There is almost microscopic detail, patient attention to texture, form, solidity. Unlike fresco or tempera, oil paints did not need to be laid flat; they could be modeled, applied thick or thin, opaque or transparent. Representation was virtually without limitation. And colors were rich, luminous, and as real as life itself. Chapter 3 offers a list of the colors Jan van Eyck used for his palette.

Considerable mystery surrounds the development of oil painting; it flourished at the beginning of the Renaissance and history has confirmed the fact that Antonello de Messina (ca. 1430-1479), a young Sicilian, went to Flanders where he studied the new media for about six years. He then went to Venice, where he generously shared his learning with a number of rising young artists.

In northern Europe, the van Eycks were followed by such painters as Rogier van der Weyden (ca. 1399-1464) and Hans Memling (1433-1494) who carried on the tradition of meticulous craftsmanship. Flemish culture was founded on a bourgeois society of wealthy merchants. Art that appealed in such a society was likely to be matter of fact. In Italy, and in France, on the other hand, the artist was supported by a mighty church and a more sophisticated aristocracy; he was therefore required to be more stylistic and imaginative. As a result of the difference in these two cultures, the Flemish became artistic-photographers of life, whereas the Italian and French artists, inspired by religious fervor, mythology, and romanticism, found expression for their own spirit, instead of depicting only what they saw with their eyes.

The art of oil painting soon replaced all medieval techniques. In fifteenth-century Italy, oil painting came of age. No period in all history produced so many geniuses in so short a span of years. And the most phenomenal genius of them all was Leonardo da Vinci.

Famous painters of the Italian Renaissance existed by the score. Any one would deserve a separate chapter in this book — entire volumes have been devoted to many of them — and it is no small chore to crowd the stories of numerous great artists into a few pages. The best are likely to receive insufficient attention and some, regretfully, will be omitted entirely. The following section will give necessarily brief accounts of certain outstanding figures.

Leonardo da Vinci (1452-1519)

Art history records that da Vinci studied the technique brought to Italy by Antonello de Messina and found it wanting in several respects. Being highly inventive, he improved upon it and developed a formula of his own. This made pos-

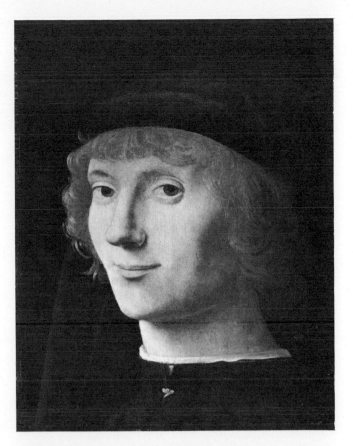

9-8. PORTRAIT OF A YOUNG MAN. Antonello de Messina. (Courtesy of The Metropolitan Museum of Art. Bequest of Benjamin Altman, 1913.)

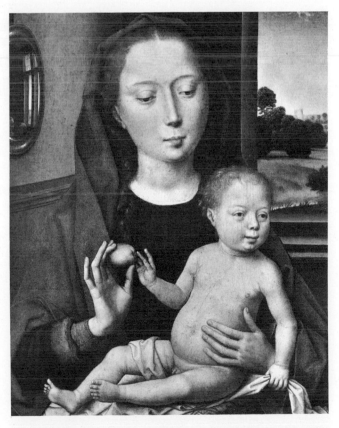

9-9. MADONNA AND CHILD. Hans Memling. Flemish. An early example of tempera and oil. The shawl is rich red, the ground soft green and blue to heighten the flesh tones. (Courtesy of The Art Institute of Chicago. Mr. and Mrs. Martin A. Ryerson Collection.)

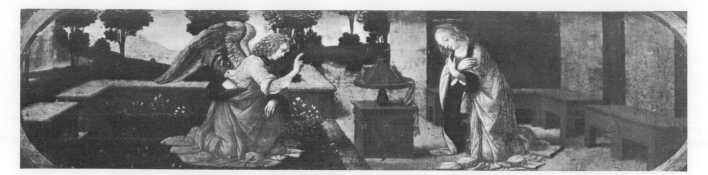

9-10. THE ANNUNCIATION. Leonardo da Vinci. The highlights are pure in color, the shadows deep and blackish. This distinguishes the chiaroscuro style. (Courtesy of Louvre, Paris.)

sible the creation of his chiaroscuro style, which made him the foremost painter of his day.

Closely studied, color application previous to the Renaissance is seen to be rigid and usually betrays a struggle on the artist's part to maintain control over his medium; all too often the medium conquered and the artist failed. But the advent of oil painting freed the artist from the restrictions of previous methods. He could now do almost anything his heart desired; he could lay on a flat tone, model it with transparent glazes for shadow, add opaque touches for highlights, or even paint in thick relief.

Before da Vinci's contributions to oil painting technique, it was normal practice to take a pure color, mix white with it for highlights, and mix black with it for shadows. This gave form to a figure or object, but the result was somehow "dead" and artificial.

The artist needed to be more resourceful, to sharpen his perception, to manipulate nature and not just copy what he saw. For example, Vasari wrote, "A sallow color makes another which is placed beside it appear more lively, and melancholy and pallid colors make those near them very cheerful and almost of a certain flaming beauty."

This is an excellent description of the chiaroscuro style created by da Vinci — an outstanding contribution to the art of color and one that was imitated by countless artists who came after Leonardo. What is meant by his chiaroscuro style? First of all, in *visual appearance* no previous paintings had quite the subtlety of da Vinci's canvases. One sees luminosity in flesh tones, a sense of "roundness," and plasticity.

There is an eerie light, shadows of translucent beauty. In drapery, da Vinci did not merely add white or black to a hue. Rather, the drapery in full light is the purest tone of all, and it is subdued in shadow. A painter before Leonardo would perhaps model a piece of folded red drapery by using a strong red in the shadow and a weak red in the highlight; however, da Vinci kept his highlight color pure and his dark color weak — a different manner completely. The striking beauty of the chiaroscuro style — emulated by Rembrandt and many others — lies chiefly in this device. Da Vinci's painting methods and his mellow color "scales" were noted in Chapter 5.

Although da Vinci speaks of chiaroscuro in his *Treatise on Painting*, he failed to give any detailed instructions. The technique was based on transparent glazes over opaque underpainting — plus, of course, the genius of a master. Vasari described da Vinci's "Mona Lisa" in these glowing terms:

Leonardo undertook to execute, for Francesco del Giocondo, the portrait of Mona Lisa, his wife; and after toiling over it for four years, he left it unfinished; and the work is now in the collection of King Francis of France. . . . In this head, whoever wished to see how closely art could imitate nature was able to comprehend it with ease; for in it were counterfeited all the minutenesses that with subtlety are able to be painted, seeing that the eyes had that luster and watery sheen which are always seen in life, and around them were all those rosy and pearly tints, as well as the lashes, which cannot be represented without the greatest subtlety. The eyebrows, through his having shown the manner in which the hairs spring from the flesh, here more close and here more scanty, and curve according to the pores of the skin, could not be more natural. The nose, with its

beautiful nostrils, rosy and tender, appeared to be alive. The mouth, with its opening, and with its ends united by the red of the lips to the flesh tints of the face, seemed, in truth, to be not colors but flesh. In the pit of the throat, if one gazed upon it intently, could be seen the beating of the pulse. And, indeed, it may be said that it was painted in such a manner as to make every valiant craftsman, be he who he may, tremble and lose heart.

"Mona Lisa" is the most renowned of all **paintings and known to virtually everyone.** Assuming that Vasari was fairly accurate in what he said, a few questions need answering. He spoke of "the eyebrows," and yet the portrait as seen today has none. One may gather that the eyebrows mentioned by Vasari were originally a light glaze which has since faded or perhaps was rubbed off when the painting was cleaned. "Those rosy and pearly tints" of Mona Lisa's cheeks, "the red of the lips" are now yellowish and dull. Moreau-Vauthier in *The Technique of Painting*, reaches the conclusion that the original flesh was indeed "rosy;" that da Vinci had mixed a madder red with white and the pigment had disintegrated or faded; that in painting the lady's hands, however, a cheaper but more permanent red ochre had been employed. So today, Mona Lisa's hands are pinker than her cheeks. Vasari would be dismayed.

Possibly, the strange illumination effects seen in the few surviving paintings of da Vinci came about as an accident — perhaps Leonardo was trying too hard to achieve relief. Vasari wrote:

> It is extraordinary how that genius, in his desire to give the highest relief to the works that he made, went so far with dark shadows, in order to find the darkest possible grounds, that he sought for blacks which might make deeper shadows and be darker than other blacks, that by their means he might make his lights the brighter; and in the end this method turned out so dark, that, no light remaining there, his pictures had rather the character of things made to represent an effect of night, than the clear quality of daylight; which all came from seeking to give greater relief, and to achieve the final perfection of art.

Michelangelo (1475-1564)

Although Michelangelo Buonarroti is often considered the greatest of all artists in the western world — his murals on the ceiling of the Sistine Chapel have been called the greatest of

9-11. DETAIL FROM MONA LISA. Leonardo da Vinci. (See Color Plate III.) Vasari described her eyebrows. But what happened to them? (Courtesy of Louvre, Paris.)

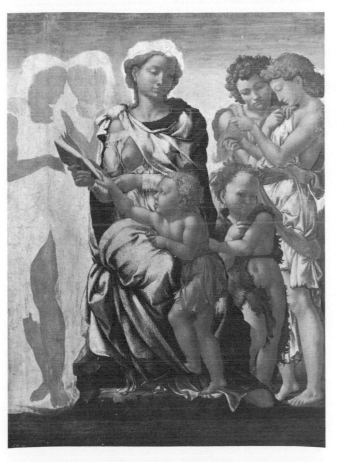

9-12. SAINT JOHN AND ANGELS. Michelangelo Buonarroti. His method of painting can be noted in this unfinished work—from line sketch, to flat tone, to relief, and modeling. (Courtesy of Trustees, National Gallery, London.)

all individual works of art — he was a sculptor at heart and had little interest in color. He used the simplest of palettes and handled color almost wholly as a medium for the expression of form. His technical knowledge of fresco painting and of pigments was limited and his first Sistine panel had to be done over.

An obstinate and cantankerous man. Michelangelo led a furious life. He knew da Vinci and quarreled with him. According to history, Michelangelo had no intention of becoming a painter. This had been forced upon him by an eccentric Pope who demanded that the greatest living sculptor spend his time painting the ceiling of a chapel.

Michelangelo pleaded to have the assignment given to a prolific young painter, Raphael Sanzio. Of himself he wrote, "This is not my profession. . . . I am uselessly wasting my time." But he spent four years on the Sistine Chapel Murals, creating one of the august wonders of human talent and endurance. His sculptural masterpieces at the Tomb of Lorenzo de Medici in Florence and his plan for the dome of St. Peters in Rome are also considered wonders of genius and skill.

Raphael (1483-1520)

Michelangelo was a harassed man, a pagan, and a revolutionary. Raphael Sanzio, his kindly young contemporary, was the exact opposite. However, Michelangelo lived to be 89 years old; Raphael died when he was only 37. Angelic in appearance, charming in disposition, and with striking talent, Raphael became the most patronized artist of Rome. Having admired da Vinci, the young Raphael came under his influence, gave up the style of painting to which he had been trained under an artist named Perugino, and adopted the chiaroscuro and glazed styles of the Florentine and Venetian schools.

Raphael's art is familiar to most persons. It is gentle art, lovely in composition, neat in execution, and rich but unoriginal in colors. Raphael represents the cultured perfection of the Renaissance, the ideals for which the Renaissance stood. He was the pampered and proficient decorator of an edifice others had built.

The Florentine school was justly eminent for

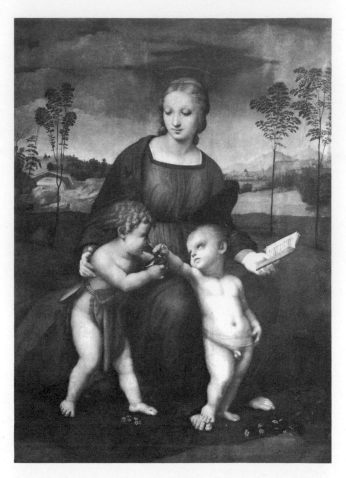

9-13. THE MADONNA OF THE GOLDFINCH. Raphael Sanzio. One of the most finished stylists of his day, he preferred simple blues, reds, and flesh tones. (Courtesy of Uffizi, Florence. Alinari-Art Reference Bureau.)

da Vinci, Michelangelo, and Raphael. Padua had Andrea Mantegna (1431-1506) and the brilliant Antonio Correggio (1494-1534) of whom Vasari wrote, "It is considered certain that there never was a better colorist, nor any artist who imparted more loveliness or relief to his things, so great was the soft beauty of his flesh tints and the grace of his finish." Also prominent were the Bellini brothers, Giovanni (1430-1516) and Gentile (ca. 1429-1507), who had been among the first to take advantage of the new oil technique brought from Flanders by Antonello de Messina. Both displayed talent and were soon laden with commissions. Orpen writes, "So beginning with the brothers Bellini, and afterwards continued by painters of equal eminence, there came into being that unrivalled series of mural paintings in public buildings which make Venice today the most wonderful art city in the world."

The talented Bellini brothers left Padua and went to Venice. After them came the greatest painters of the entire Venetian school, Giorgione and Titian (Tiziano Vecelli).

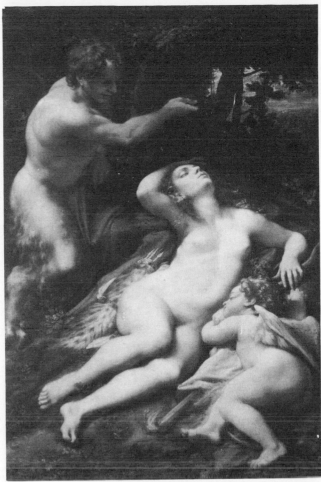

9-14. JUPITER AND ANTIOP. Antonio Correggio. Vasari thought him supreme as a colorist. Here there is a subtle, expert use of luminous flesh tones set against muted browns and blues. (Courtesy of Louvre, Paris.)

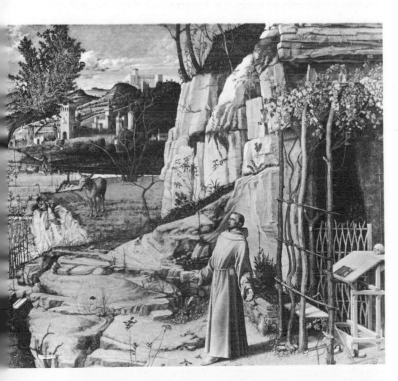

9-15. SAINT FRANCIS IN ECSTASY. Giovanni Bellini. In this striking composition a cool bluish light is cast over all to affect the tones of green, slate blue, brown, and gold, which surround the saint. (Copyright, The Frick Collection, New York.)

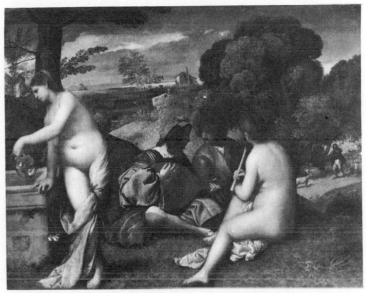

9-16. PASTORAL CONCERT. Giorgione. The golden glow which marks the Venetian school shines over rich terra cotta red, olive green, brown, and flesh. (Courtesy of Louvre, Paris.)

Giorgione (1478-1511)

Giorgione, which means "Great George," was of peasant origin. A precocious youth, he loved both music and painting. William Orpen writes that "everything in a Giorgione is subordinated to beauty," and that "his first concern is to create *melody* of line and *harmony* of color." Though few of his works have survived, those that remain show consummate skill. Here one finds the "golden glow" which typifies the entire Venetian school, a lush atmospheric effect in which every single color note contributes to a concordant symphony. In this, Giorgione initiated an effect that was widely imitated and that influenced scores of artists who followed.

Titian was one of the imitators. According to Vasari, Titian's early work was often mistaken for that of Giorgione. In 1507, Titian painted an angel on the facade of a building, for which Giorgione was one day congratulated. As Vasari relates, the incident was a distressing one, for "Giorgione felt much disdain... he would scarcely let himself be seen; and from that time onward

he would never allow Titian to associate with him or be his friend."

Titian and Giorgione had both been pupils of Giovanni Bellini. Giorgione died at the age of 33, but Titian lived on for about 65 years after Giorgione's death. During his long and active life, Titian produced a great body of work. Wrote Vasari, "There has been scarce a single lord of great name, or Prince, or great lady, who has not been portrayed by Titian."

Titian (ca. 1477-1576)

Titian must be accepted as one of the greatest colorists of all time. John Ruskin ranked him as one of the seven supreme colorists, the others being Giorgione, Veronese, Tintoretto, Correggio, Reynolds and Turner (Chapter 5). His golden effects were universally appreciated and became law to men like Sir Joshua Reynolds. According to Vasari, Titian gave careful attention to his subjects but, in the manner of Giorgione, he made drawings only to familiarize himself with what he was about to create. After this, however, he painted "broadly with tints crude or soft as the life demanded, without doing any drawing, holding it as certain that to paint with colors only, without the study of drawing on paper, was the true and best method of working, and the true design," writes Vasari. He is said to have worked more with his fingers than with his brush when he manipulated his paints.

This method, apparently, was considered crude by some of Titian's contemporaries, including

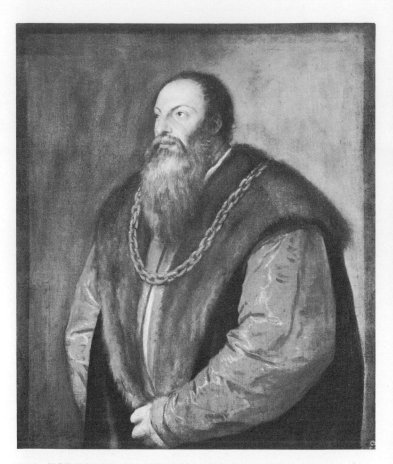

9-18. PORTRAIT OF PIETRO ARETINO. Titian. Note the looseness and freshness of style. The colors are olive green, bright orange, gold, black, and a creamy white. (Copyright, The Frick Collection, New York.)

Michelangelo. Vasari reports, "Discoursing on Titian's method, Buonarroti commended it not a little, saying that his coloring and his manner much pleased him, but that it was a pity that in Venice men did not learn to draw well from the beginning." For the palette of colors used by Titian, refer to Chapter 2.

Titian's paintings have a fresh quality born of his relatively free style. Although it may seem "tight" today, in the sixteenth century Titian's art was judged as being remarkably spontaneous. According to Vasari, his canvases were "executed with bold strokes and dashed off with a broad and even coarse sweep of the brush, insomuch that from near little can be seen, but from a distance they appear perfect."

Titian was surely the foremost painter of the female nude. His "Venus of Urbano" is perhaps the greatest nude of all time; it is certainly one of the best known and has been copied and imitated again and again. Another famous nude, "Venus and the Lute Player" is at the Metropolitan Museum in New York.

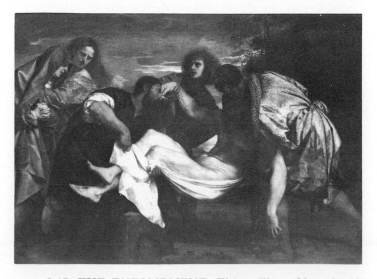

9-17. THE ENTOMBMENT. Titian. The golden glow is here, intensifying the beauty of red, blue, gold, green, and brown. (Courtesy of Louvre, Paris.)

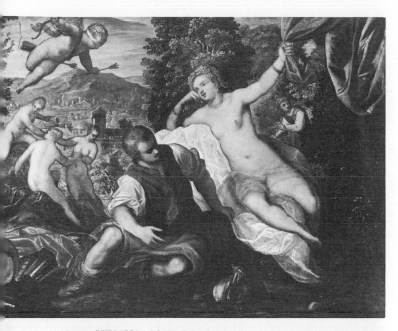

9-19. VENUS AND MARS IN A LANDSCAPE WITH
THREE GRACES. Jacopo Tintoretto. Ruskin called him
a great colorist. Here there is sensuous use of red and
flesh tones set against muted greens and browns. (Cour-
tesy of The Art Institute of Chicago. Charles H. and Mary
F. S. Worcester Collection.)

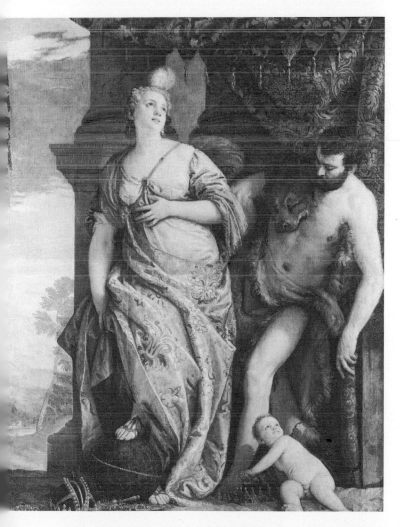

9-20. WISDOM AND STRENGTH. Paul Veronese. An-
other favorite colorist of John Ruskin. The textures here
are astonishingly realistic. Almost a full palette is in evi-
dence. (Copyright, The Frick Collection, New York.)

9-21. RENAISSANCE ROME. Giovanni Paolo Pannini
(ca. 1691-1765). Here is art on the grand scale. This mon-
umental painting measures about 5½ by 7½ feet. (Cour-
tesy of The Metropolitan Museum of Art. Gwynne M.
Andrews Fund.)

After Titian came Jacopo Tintoretto (1518-
1594) who nailed this legend in his workshop —
"The Design of Michelangelo and the Coloring
of Titian." He executed some of the largest and
most decorative paintings of his day. His "Para-
diso" in the Ducal Palace in Venice is said to be
one of the biggest paintings in the world, meas-
uring some 34 by 84 feet. Despite Tintoretto's
business-like ambition and productive capacity,
he was an extremely able artist and managed
color with keen skill and insight.

Even more sensitive to color was Paul Ver-
onese (1528-1588), who had worked side by side
with Titian and Tintoretto and who was also
represented in the Ducal Palace. Veronese had a
sensuous eye for what was rich and elegant. At
one time he was rebuked by the inquisitors of
his day for treating "The Last Supper" as though
it were a wedding feast, replete with the glitter
of crystal, silver, jewels, silks, and satins. Al-
though sometimes considered irreverent, this
painting is nevertheless much admired for its
honest, rich, and luminous tones.

Peter Paul Rubens (1577-1640)

Rubens was born one year after the death of Titian. He began his apprenticeship as an artist in Antwerp when he was barely 14 years old. Later he went to Venice where he copied the paintings of Titian and Veronese and was thereupon retained by the Duke of Mantua. After visits to other Italian cities and to Spain, he returned to Antwerp where he became court painter and founded the School of Antwerp, often referred to as the Antwerp picture factory. In 1609 he married, designed a palatial residence for himself and his bride, and settled down to an energetic career.

No painter in all history was more facile or had a more skilled technical knowledge of oil painting than Rubens. He has been the envy of all artists since. Indeed, how he achieved his effects, how he secured such clean hues, how his paintings endured so well, remain a mystery. Over 100 years later, Sir Joshua Reynolds declared that painters should go to men like Rubens to instruct themselves in the art of painting. In modern times, Jacques Maroger wrote in *The Secret Formulas and Techniques of the Masters*, "From the time of his death until our time, painters of all schools have tried to rediscover his lost secrets; they have copied him — from Antoine Watteau to Paul Cézanne — in their efforts *to learn how to paint.*"

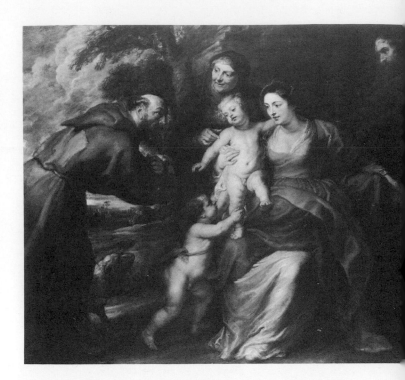

9-23. THE HOLY FAMILY WITH SAINT FRANCIS. Peter Paul Rubens. (Courtesy of The Metropolitan Museum of Art. Gift of James Henry Smith, 1902.)

Like Titian and other Italian Renaissance painters, Rubens worked with glazes. This required great skill and has since become an almost lost art. Through the application of glazes, the surface of the canvas takes on a gem-like brilliance that is most difficult to duplicate in any other way. Referring to glazes, Moreau-Vauthier says of the paintings by Titian, Rubens, and Rembrandt, "To prove this, it will only be necessary to try to copy some of these pictures without using glazes; a general heaviness will be the result, a lack of all the luminous depth and delicacy of the original." But glazes are fragile, and only a technician like Reubens could be successful with them. In *The Art of Oil Painting*, Mérimée, a nineteenth-century scholar, came to the conclusion that Titian's paintings assumed a golden tone due to the yellowing of his glazes. Rubens' pictures, however, showed no such signs of deterioration. The latter master had probably anticipated what would happen and had adjusted his glazes accordingly. If this is true, Rubens certainly deserves the acclaim of posterity for expert craftsmanship. The basic colors used by Rubens are listed in Chapter 2.

History records that Rubens established a "picture factory," employed a number of the best painters of the day, including a son of Pieter Breughel, and took on commissions for all manner

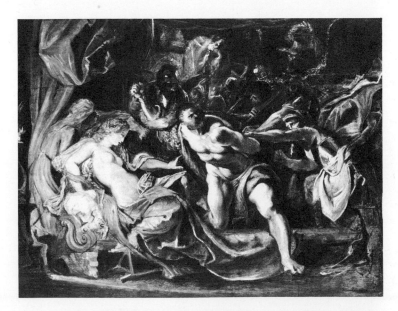

9-22. SAMSON AND DELILAH. Peter Paul Rubens. This relatively small composition (about 20 by 26 inches) shows the skill and facility of Rubens as a technician—one of the greatest of all time. (Courtesy of The Art Institute of Chicago. Robert A. Waller Fund.)

of art works from huge murals for churches and palaces to landscapes and portraits. A good example of his style can be seen in Illus. 9-22, "Samson and Delilah," a small but great work. Note the vigorous expression. It is remarkable that the greatness of Rubens did not seem to be sacrificed by his "factory" method, for his personality and skill dominated throughout. Many of his large wall paintings are regarded as among the major glories of the craft of oil painting. So eminent was he that he often assumed the role of court diplomat in the state affairs of Holland, Spain, and England. When asked, "Does the ambassador . . . amuse himself with painting," he replied. "No, I amuse myself sometimes with being an ambassador."

Although knighted by Charles I of England in 1629, Rubens gave up politics a few years later. After the death of his first wife he married again and devoted his last years to art and domestic life. He excelled in every branch of painting, was amazingly prolific, stood head and shoulders above most men in intelligence, princes and kings included. Here was a giant indeed. There was little mysticism or asceticism in Rubens — all was health and contentment. Of one of his landscapes, Dr. Richard Muther wrote, "The struggle of the elements, in fact everything, glitters with moisture, and the trees rejoice like fat children who have just had their breakfast."

El Greco (1541-1614)

El Greco (Domenikos Theotocopoulos) developed a unique and original expression with color that is quite unlike chiaroscuro. He was born in Crete and trained in Venice, where he is said to have been employed in the workshop of Titian. Eventually he went to Toledo, Spain, and there he spent the rest of his life.

More than any of the other Old Masters, El Greco anticipated and foreshadowed the art movements of later centuries. His dramatic distortion of figures and forms was less realistic than imaginative. He held color to be more important than drawing; this is evident in his art, which throughout his life had a consistently eerie and spiritual beauty.

Unlike most Renaissance painters, he avoided the soft transition, the molded and glazed style, preferring abruptness and bold contrast. Thus

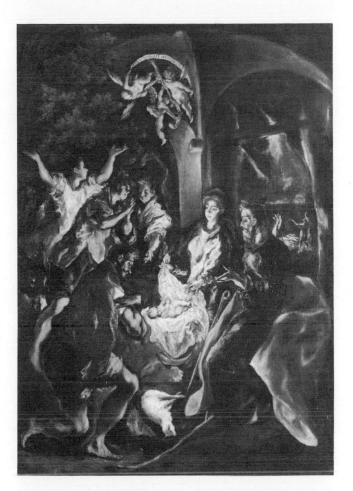

9-24. THE ADORATION OF THE SHEPHERDS. El Greco. The lighting effect here is eerie. A cool chalky white highlights everything. In the outer areas are rose, gold, yellow-green, dull green, and dull brown. (Courtesy of The Metropolitan Museum of Art. Rogers Fund, 1905.)

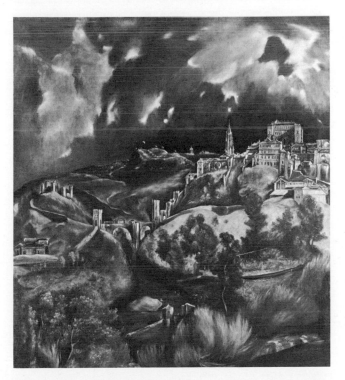

9-25. VIEW OF TOLEDO. El Greco. All is green, blue, white, and black—nothing else. The mood created is dramatic and compelling. (Courtesy of The Metropolitan Museum of Art. H. O. Havemeyer Collection.)

175

there is action and even violence in his compositions. In the chiaroscuro style, the highlights are pure and shadows dull; in El Greco's work the reverse is found (see Chapter 5). The rich tones and the dull or "muddy" pale tones that distinguish his work produce a strange and eerie visual effect, unearthly and of tremendous power.

Modern artists have learned much from El Greco. He showed them the dramatic possibilities of elongated forms, of the weightlessness of figures suspended in the air rather than supported from the ground. His "ghost-like" lighting effects give color an intrinsic power that goes far beyond the subjects they picture. His "View of Toledo," for example, is, *on color alone,* truly fantastic (Ill. 9-25). This striking landscape can be viewed right-side-up or upside down, and for sheer "mood" of color is wondrous indeed.

Diego Velasquez (1599-1660)

Velasquez met Rubens in Spain when he was about 30 years old. The two became friends and spent several months with Philip IV, King of Spain. Philip, an amateur painter, became the patron of Velasquez and sent the artist to Italy to study. Velasquez painted numerous portraits

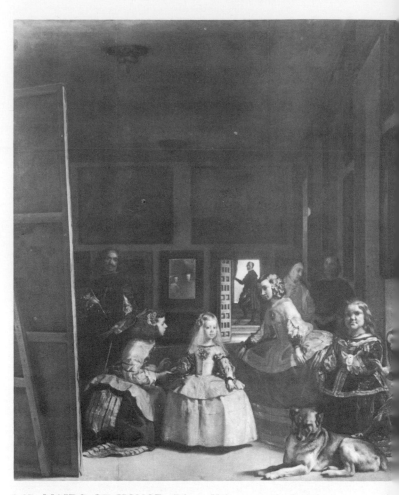

9-27. MAIDS OF HONOR. Diego Velasquez. A description of this remarkable painting is given in the text. (Courtesy of Museo del Prado, Madrid.)

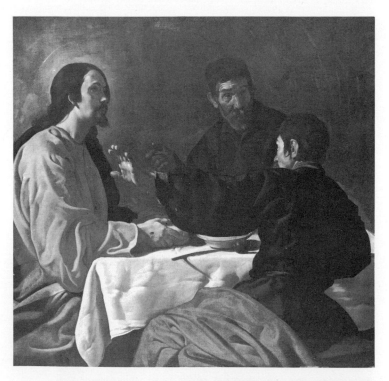

9-26. CHRIST AND THE PILGRIMS OF EMMAUS. Diego Velasquez. The over-all effect is one of induced warm light. Christ wears a rich orange robe with black over one shoulder. There is dark brown on the central figure, blue on the figure to the right, and soft white on the table cloth. (Courtesy of The Metropolitan Museum of Art. Bequest of Benjamin Altman, 1913.)

of King Philip at various ages; 26 portraits of the monarch are known to exist today, and probably many others have been lost or destroyed. Velasquez also painted portraits of the crown prince, who died before he was 20 years old.

Velasquez knew wealth and privilege most of his life because of his protection by the king. Although he was unquestionably the greatest Spanish painter of his day, and one of the foremost in Europe, after his death followed by a funeral attended by knights and nobility, his fame went into eclipse behind the sun of the Italians. He was rediscovered in the latter part of the nineteenth century, and properly ranked among the immortals.

A genius with light and vision would best describe this painter. No artist had a better eye in such matters. His "Maids of Honor" is surely one of the greatest paintings of all time (Ill. 9-27). Velasquez posed himself with the Infanta Margarita and her maids. In the distance, the king and queen are seen reflected in a mirror,

while at an open doorway a noble is drawing back a curtain. William Orpen states that, "When one stands before this canvas, one is not concerned with any consideration of who it was painted by; it fills the mind and suffices." The artist is at the left and holds a palette in his left hand. A detail of this palette and a description are presented in Chapter 2.

Critics consider this painting "the complete expression of Velasquez eyesight." And what eyesight! As the first part of this book attempted to explain, one of the most universal of all visual phenomena is that termed color constancy — the curious fact that a white surface will appear white under all conditions of illumination, quite independent of the physical amount of light energy reflected. Velasquez, genius that he was, understood this intuitively. Thus with a general distribution of light tones in the foreground of "Maids of Honor," he implied strong light. In the far distance, dim light is implied by a general distribution of deeper tones. In the reflected image of the king and queen, and in the far doorway, small touches of brightness give a feeling of distance and dimension that is more realistic than a photograph and, indeed, could not have been achieved by a camera had one been invented then. (On this point, see Chapter 7.)

Rembrandt (1606-1669)

Before proceeding to a discussion of one of the greatest masters of the ages, Rembrandt van Rijn of Amsterdam, a brief comment will be made on Anthony van Dyck of Antwerp (1599-1641). Van Dyck was an accomplished and prolific portraitist, who spent many highly successful years in England. He is particularly noteworthy for his great and lasting influence on English portrait painting. Most important museums have one or more examples of his work.

Rembrandt ranks as one of the greatest portrait painters of all time. Few artists have been more versatile, more discerning in spirit, or diverse in style. The English painter, Millais, wrote, "I have closely examined his pictures . . . and have actually seen beneath the grand veil of breadth, the early work that his art conceals from untrained eyes — the whole science of painting."

A precocious young man, Rembrandt early

9-28. JAMES STUART, DUKE OF RICHMOND AND LENNOX. Anthony Van Dyck. His distinguished style is kept in restraint here with black, brown, and white. (Courtesy of The Metropolitan Museum of Art. Gift of Henry G. Marquand, 1889.)

9-29. SELF-PORTRAIT OF THE ARTIST IN HIS STUDIO. Frans van Mieris the Elder (1635-1681). Flemish. Note the studio props. The colors on the palette are chrome orange, gold, red, white, green, and brown. (Courtesy of The Detroit Institute of Arts.)

married a well-dowered young lady of quality and soon became a portrait painter of wealth and position. This happiness did not last long, however. An extravagant way of life led to oppressive debts, and the death of two children and his beautiful wife, Saskia, brought tragedy.

In spite of his success as a portrait painter, Rembrandt was not satisfied to spend his time flattering vain people. His portraits became scenes in which Rembrandt was less concerned with individual faces than with general circumstances. He painted not merely the people of his day, but the age in which he lived. In this, he was one of the first Expressionists — "The first artist who, in the modern sense, did not execute commissions, but expressed his own thoughts. The emotions which moved his innermost being were the only things which he expressed on canvas. He does not seem to think that anyone is listening to him, but only speaks with himself; he is anxious, not to be understood by others, but only to express his moods and feelings," wrote Dr. Richard Muther. A typical Rembrandt composition is found in Illustration 9-30A and B, a portrait of "Flora."

Even though his life was unhappy and debt-ridden, Rembrandt had prodigious energy, painted with a vengeance, and left the world some of its most remarkable examples of luminous color.

In his portraits, Rembrandt worked with a limited palette — little more than a red, yellow, brown, black, and white. By suppressing the color tone of the major areas of his canvas, he could concentrate interest, brilliance, and light around the eyes of his subject and so achieve a fantastic and dramatic beauty. Unfortunately, followers of Rembrandt had no such skill and the great Dutch Master's influence produced a host of "brown gravy" imitators. This drab practice was not abandoned until Impressionism was accepted.

Long before psychologists explained the perception of illumination in art and spoke of a Law of Field Size (see Chapter 7), Rembrandt had mastered the phenomenon through sheer genius. His lighting effects often have the appearance of glass panels illuminated from behind — or glossy screens upon which lantern slides are projected. Flesh tones are translucent. He could create a

9-30A, 30B. FLORA. Rembrandt van Rijn. The colors are brown, flesh tones, white, gold and touches of red. The detail (9-30B) gives excellent insight into his style. (Courtesy of the Metropolitan Museum of Art. Gift of Archer M. Huntington, 1926.)

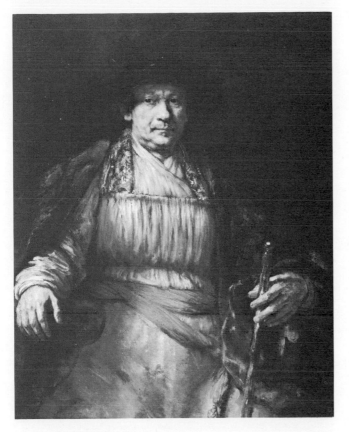

9-31. SELF-PORTRAIT. Rembrandt van Rijn. He did numerous portraits of himself, often in costume. The colors are similar to those in his "Flora"—brown, white, gold, red. (Copyright, The Frick Collection, New York.)

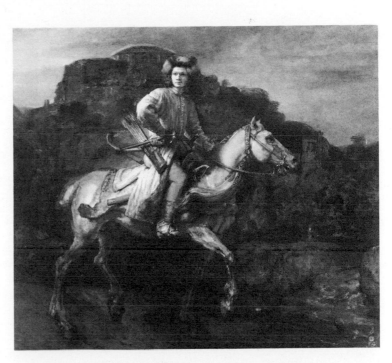

9-32. THE POLISH RIDER. Rembrandt van Rijn. In order to build up strong, luminous accents, he liked to keep the major areas of his canvas suppressed in tone. (Copyright, The Frick Collection, New York.)

new technique with a palette knife, paint in opaque or transparent style, show the facility of a Rubens as a technician, the inventiveness of a da Vinci, the golden tones of a Titian — all in one painting.

The Protestant Dutch, who formed an independent republic during the life of Rembrandt, produced many other exceptional painters, such as Pieter de Hooch (ca. 1629-1684), Jan Vermeer (1632-1675), Meindert Hobbema (1638-1709), Esaias van de Velde (ca. 1591-1630), Job Berckheyde (1630-1698). Most were genre painters, impeccable stylists with high technical skill and sophistication in the use of color. Among them, perhaps Vermeer is the "perfect" one for keenness of vision and mastery over light and shade.

The French

The great art of the Renaissance traces from Italy and Flanders to Spain and Holland. The English hit their stride in the eighteenth century, but little came from France until the nineteenth century, and then the French became

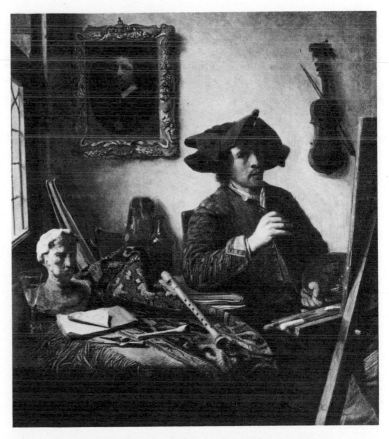

9-33. ARTIST IN HIS STUDIO. Job Berckheyde. To all indications the artist is a musician as well as a painter. (Courtesy of Uffizi, Florence. Alinari-Art Reference Bureau.)

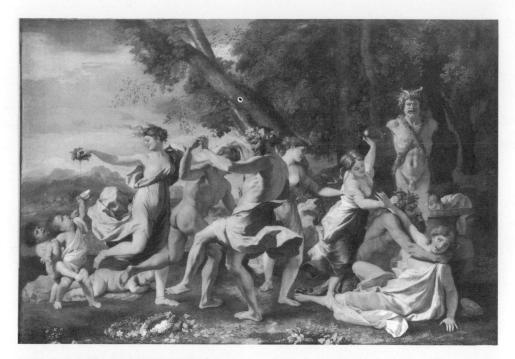

9-34. BACCHANALIAN WRESTLING GAME IN FRONT OF A STATUE OF PAN. Nicolas Poussin. The color effects have a golden overtone. (Courtesy of Trustees, National Gallery, London.)

leaders in the western world of art. The French kings were generous patrons. Francis I, for example, welcomed to his court such men as Leonardo da Vinci, Benvenuto Cellini, and Andrea del Sarto. Two early French painters, Nicolas Poussin (1594-1665) and Claude Lorrain (1600-1682), gave glory to the landscape. Lorrain, often referred to simply as Claude, was greatly admired

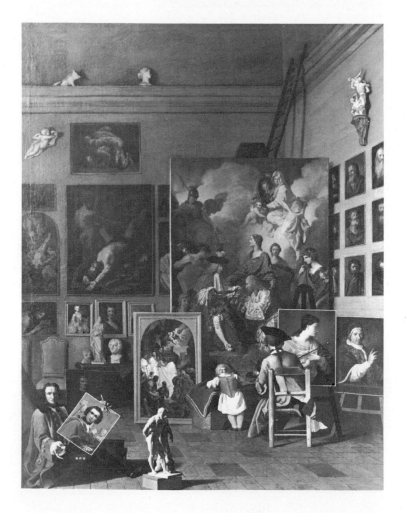

9-35. THE STUDIO OF THE PAINTERS. Pierre Subleyras. In the lower left hand corner, the artist holds a portrait of himself, while his students, young and old, proceed with their lessons. (Courtesy of Art Gallery, Academy of Fine Arts, Vienna.)

9-36. A SEAPORT AT SUNSET. Claude Lorrain. Here a golden setting sun lights up an idyllic world. (Courtesy of Louvre, Paris.)

9-37. ADORATION OF THE SHEPHERDS. Georges de la Tour. A single candle seems to transfix this scene for all eternity. It is painted in yellows, golds, red, browns, and faint purples. (Courtesy of Louvre, Paris.)

by Turner and is said to have been the first painter ever to put the sun itself on a canvas — and with remarkable success. He will be mentioned again in the next chapter. The styles of these two men were more European than specifically French.

The recently rediscovered Georges de la Tour (1593-1652), once a favorite of Louis XIII, was one of the great early French painters. Though he was famous in his day, after his death his identity all but vanished. Canvases of startling beauty were attributed to other painters, such as Vermeer and Velasquez.

In 1915, however, de la Tour was properly restored to the "hall of fame," of art, and after this his reputation took wings. He is rated among the best of the Old Masters and without doubt is one of the foremost colorists in the long history of art.

In most of de la Tour's art, the universe itself seems majestically illuminated by the divine power of a single candle. This light, coming from within the canvas itself, shines forth on serenely composed human beings who look sculptured, and transfixed by the wonders of the light. Note this in "Adoration of the Shepherds," Illustration 9–37. There is mystery in de la Tour, a sudden quietude created by luminous tones of yellow, offset by golds, reds, and soft purples.

9-38. THE REPENTANT SAINT PETER. Georges de la Tour. This picture is particularly good in all details. (Courtesy of The Cleveland Museum of Art. Gift of Hanna Fund.)

Jean-Antoine Watteau (1684-1721), although his life was short, became one of the most important of all figures in French painting. Born of humble parents and disinherited by his father, Watteau spent his early years as a poverty-stricken hack. Under the tutelage of one Claude Gillot, the ambitious and talented Watteau began producing a number of spirited canvases; as a result he was elected to the French Academy at the surprisingly young age of 33 years.

Watteau is important to the story of color in art. He created a new approach that was more than a century ahead of his time and that anticipated the school of Impressionism. To quote Sir William Orpen:

He would cover his canvas copiously and, to all appearance, vaguely with a thick layer of pigment,

181

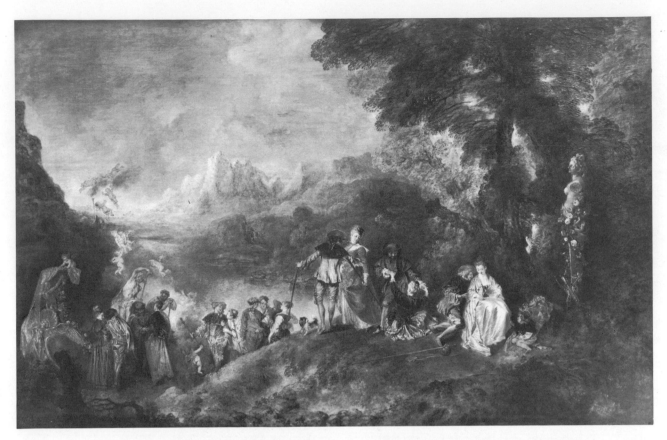

9-39. EMBARKATION FOR CYTHERA. Jean-Antoine Watteau. Here a full palette is used and the picture is pervaded by a warm, misty light. (Courtesy of Louvre, Paris.)

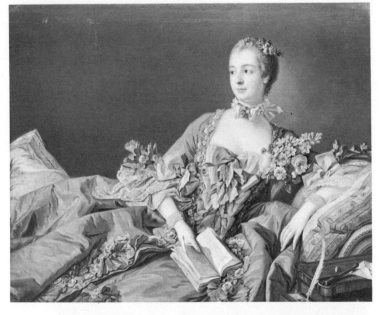

9-40. PORTRAIT OF MADAME DE POMPADOUR. François Boucher. He was official painter to the French court of Louis XV in the midst of the Rococo period. This portrait is representative of the decorative and feminine tastes of the artist. (Courtesy of National Galleries of Scotland.)

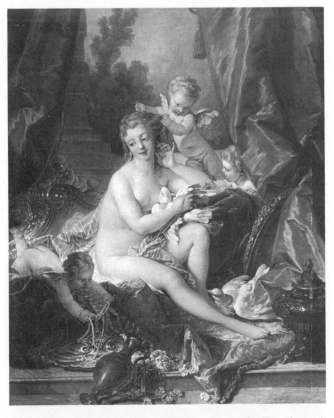

9-41. THE TOILET OF VENUS. François Boucher. A picture that is typical of French Rococo painting—sophisticated, fussy, decadent. Yet it is completely charming. The colors are soft flesh tones, silken blue, velvety red, and shining gold. (Courtesy of The Metropolitan Museum of Art. Bequest of William K. Vanderbilt, 1920.)

and on this he would proceed, so to speak, to chisel out his detail. Figures, sky, and landscape background were then built up by a series of minute touches, which gave his pictures a peculiarly vibrating and scintillating effect. His division of tones and his wonderful orchestration of complementary colors make Watteau a forerunner of the prismatic coloring of the more scientific painters of the nineteenth century.

But Watteau did not achieve the better part of his dreams. After a trip to London, he returned to France exhausted and in poor health. He died when he was only 37 years old.

After Watteau, French painting, like French architecture and decoration, went from the baroque to the rococo. Under the influence of the court of Louis XV and Madame de Pompadour, an artificial sort of elegance prevailed. The paintings of François Boucher (1703-1770), Jean Honoré Fragonard (1732-1806), and Jean Baptiste Greuze (1725-1805) show a simplicity and frivolity of viewpoint that belong more to pam-

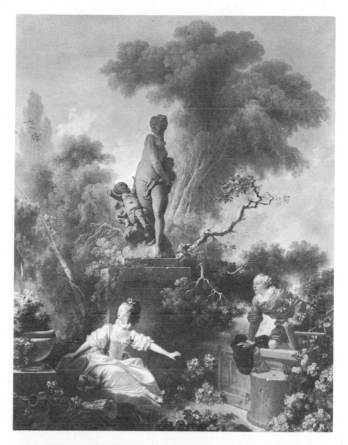

9-43. THE MEETING. Jean Honoré Fragonard. He was a student of Boucher. This is one of a series of ornate panels done for Madame du Barry. The colors are all sweet and decorative. (Copyright, The Frick Collection, New York.)

9-42. BOUCHER ROOM. Northeast corner. Madame de Pompadour had Boucher decorate this elegant room, which is now part of The Frick Collection. (Copyright, The Frick Collection, New York.)

9-44. THE BROKEN JUG. Jean Baptiste Greuze. Here is the French mood of the eighteenth century, even to the ornate oval frame. The colors are all creamy and sweet. (Courtesy of Louvre, Paris.)

9-45. THE WHITE TABLECLOTH. Jean-Baptiste Siméon Chardin. This composition is mostly in white, soft red, brown, and dull green. (Courtesy of The Art Institute of Chicago. Gift of Annie Swan Coburn to the Mr. and Mrs. Lewis Coburn Memorial Collection.)

pered luxury than to social necessity as art forms. However, Jean-Baptiste Siméon Chardin (1699-1779) was the exception, painting for the bourgeoisie rather than for the court and picking as his subjects the poetic reality of familiar things and the tranquil households about him — a viewpoint that was quite apart from the art currents of his day in France.

The English

The major achievements in British art began when Hans Holbein the Younger (ca. 1497-1543) painted his famous portraits of Henry VIII. In 1526, Holbein, one of the foremost painters of Europe, went to England where he lived in the household of Sir Thomas More. Appointed court painter in 1536, he did for a king what no other painter has ever accomplished before or since —

9-46. SIR THOMAS MORE. Hans Holbein the Younger. The drapery in the background is an olive green, the fur collar is brown, the cape itself black, the sleeves red velvet. (Copyright, The Frick Collection, New York.)

he created an eternal, visual image. There is only one pictorial characterization of Henry VIII in anyone's mind, and this is the Henry VIII of Hans Holbein. Even Velasquez did not succeed to this degree despite his numerous recorded portraits of Philip IV of Spain.

Thus began greatness in English art. However, there was no successor to Holbein for over a century, for the first great English-born painter was William Hogarth (1697-1764). Aside from Holbein, there was little prestige in English art previous to Hogarth and the eighteenth century, but Hogarth was followed by a succession of geniuses — Reynolds, Gainsborough, Lawrence, Constable, and Turner.

Unlike the aristocratic court painters of France, Hogarth painted English life as he saw it about him. He was one of the few artists in any country to produce art for the masses. First as an engraver and then as a story-telling painter, he did many series with titles such as "Marriage à la Mode" (Ill. 9-47), "The Harlot's Progress," "The Rake's Progress," all moralistic dramas in pictures.

Being an eminently practical man, Hogarth took an interest in color and color theory, and some of his views are related in Chapter 2. However, he was more concerned with primary colors, pigments, and palettes, than with color expression.

Sir Joshua Reynolds (1723-1792) was an entirely different kind of painter; he was as conscious of cultural refinements, of cosmopolitan and sophisticated ways, as Hogarth was indifferent to them. There was little that was "down to earth" in Reynolds. Rather, he was a learned and intelligent man who studied the Renaissance masters, less as a craftsman than as an esthete anxious to give his own country the sublimity known to Europe.

Reynolds rightly thought little of the color in the British art of his day. He wrote, "There is not a man on earth who has the least notion of coloring; we all of us have it equally to seek for color and find out, as at present it is totally lost to the art." And so, seek for and find out he did. However, if he vied with the Old Masters that he admired and emulated, his craftsmanship was wanting, and in time some of his colors faded out completely. It is said of his portraits that they

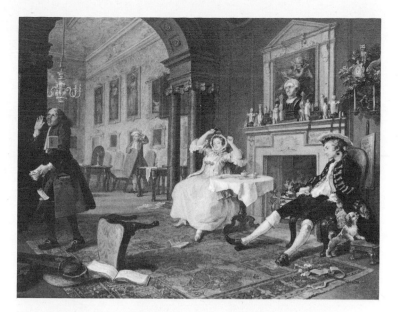

9-47. BREAKFAST SCENE. William Hogarth. From his "Marriage à la Mode" series. He was interested in color, but gained most fame for his satirical portrayals of British life, and for his engravings. (Courtesy of Trustees, National Gallery, London.)

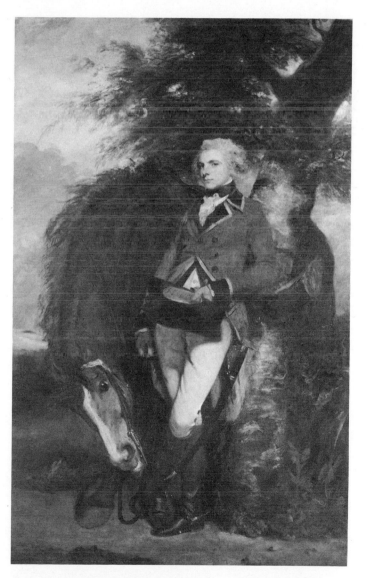

9-48. COLONEL GEORGE K. H. COUSSMAKER, GRENADIER GUARDS. Sir Joshua Reynolds. Here two-thirds warmth (red, brown, olive) and one-third coolness (blue), demonstrate the Reynolds formula for beauty in color effect. (Courtesy of The Metropolitan Museum of Art. Bequest of William K. Vanderbilt, 1920.)

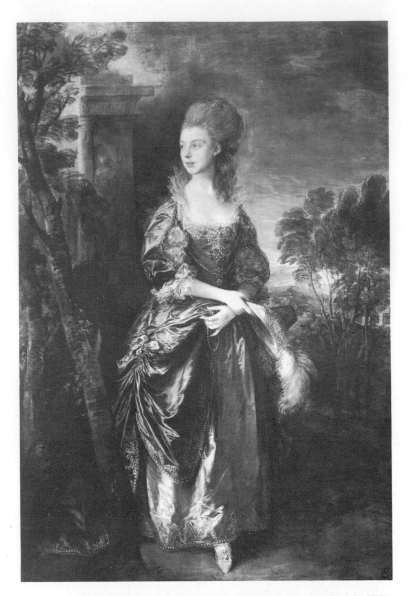

9-49. THE HONORABLE FRANCES DUNCOMBE. Thomas Gainsborough. This composition, beautiful in detail, is done mostly in flesh tones, white, and blue, with the background neutral. (Copyright, The Frick Collection, New York.)

died before the subjects did. In his *Discourses on Art*, Reynolds gave this often-quoted formula for a proper color effect:

It ought, in my opinion, to be indispensably observed that the masses of light in a picture be always of a warm mellow color, yellow, red, or a yellowish-white; and that the blue, the gray, or the green colors be kept almost entirely out of these masses, and be used only to support and set off these warm colors; and for this purpose a small portion of cold colors will be sufficient. Let this conduct be reversed; let the light be cold, and the surrounding colors warm, as we often see in the works of the Roman and Florentine painters, and it will be out of the power of art, even in the hands of Rubens or Titian, to make a picture splendid and harmonious.

Reynolds had a capable rival in Thomas Gainsborough (1727-1788) who in many respects was a better painter and craftsman and had a superior eye for color. To refute Reynolds' dictum, he is said to have painted his now famous "Blue Boy," keying the composition to a cool effect and delighting the world of art. Richard Wilson (ca. 1713-1782), George Romney (1734-1802), Sir Henry Raeburn (1756-1823), and Sir Thomas Lawrence (1769-1830) also did important portrait work.

It was a golden age for portrait painters in England. Soon, however, a new form of naturalism in landscape paved the way for a complete revolution in the art of color.

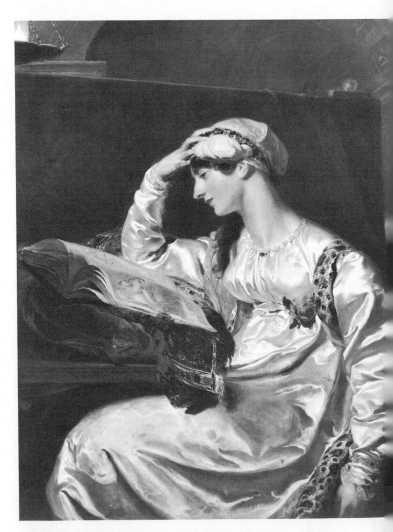

9-50. MRS. JENS WOLFF. Sir Thomas Lawrence. (Courtesy of The Art Institute of Chicago. Mr. and Mrs. W. W. Kimball Collection.)

Chapter 10

From Classicism to
Romanticism to Realism

In his *Fourth Discourse on Art,* Sir Joshua Reynolds spoke words of wisdom regarding the staid art of the past and the need for a new expression that would free the mind and spirit of the artist:

> The great end of the art is to strike the imagination. The painter, therefore, is to make no ostentation of the means by which this is done; the spectator is only to feel the result in his bosom. An inferior artist is unwilling that any part of his industry should be lost upon the spectator. He takes as much pains to discover, as the great artist does to conceal, the marks of his subordinate assiduity. In works of the lower kind everything appears studied and encumbered; it is all boastful art and open affectation. The ignorant often part from such pictures with wonder in their mouths and indifference in their hearts.

While these sentiments may seem strange coming from a man often accused of being both ostentatious and assiduous, they reveal the weakness of an old art and the crying need for a new. Much of Renaissance and later painting is vapid because there was too much attention to detail. The artists were trying to be *real* to the point of triteness. Long before the camera was invented, men of sagacity realized that rigid and unimaginative depiction of outward appearance could be as boring as life without spirit. Rembrandt, notably, was distressed by excessive fidelity and insisted on projecting himself into his paintings.

But the free spirit that seemed ready to burst forth upon the world in the late eighteenth and early nineteenth centuries was abruptly halted by the works of a German archaeologist. Despite violent changes in the world, revolution in

10-1. VENETIAN ROOM. Renaissance. There are brocaded-silk walls and gilded ornamentation. Such Venetian tradition in decoration was emulated in France up through the reign of Louis XV. (Courtesy of The Metropolitan Museum of Art.)

10-2. PHILADELPHIA ROOM. Early Georgian. In England, at the time of painters like Sir Joshua Reynolds, this style was dominant. Pictured here is an American room originally in Philadelphia. (Courtesy of The Metropolitan Museum of Art.)

France, world colonization by England, social, economic, and religious protestation in Europe, and war everywhere, art grew tighter and deader. Neo-Classicism spread rapidly over the world.

The chief prophet of the Neo-Classicist movement was Johann Winckelmann, the German

10-3. PORTRAIT OF JOHANN WINCKELMANN. Anton Maron. One of the first of modern archaeologists. (Courtesy of Frankfurter Goethe-Museum.)

10-4. ADAM DINING ROOM. Designed by Robert Adam in 1765-1768 for Lansdowne House, Berkeley Square, London. It is painted gray with white ornamentation and has mahogany doors. (Courtesy of The Metropolitan Museum of Art. Rogers Fund, 1932.)

archaeologist and art historian who, following excavations at Herculaneum and Pompeii, began publishing a number of exquisite books on his findings, from 1760 on. Perhaps never in the history of art and decoration has any one man or any precise body of work had so great and startling an influence. In interior and exterior architecture, for example, the return to Classicism, which Winckelmann inspired, broke the English Georgian period of decoration in half. The brothers Adam turned from Chippendale and his gracious school and introduced formal Greek sculpture and Greek ornament into British homes. In France, the rococo flourishes and curves of the Louis XV style were abandoned in favor of the straight Louis XVI mode. In America, the Georgian Capitol at colonial Williamsburg — without a Greek column in sight — went out of fashion and pseudo-Greek temples were designed for the United States Capitol and Jefferson's Monticello.

All this had an unfortunate effect on art. In Winckelmann's native Germany, art became a pedantic obeisance to antiquity and *a priori* estheticism. Painting stiffened and remained in a coma until awakened by certain so-called Expressionists a century later. In fact, most of Belgium, Holland, Italy, and Spain saw art grow anemic, if not directly because of Winckelmann and his Neo-Classicism then because of the dead past which Winckelmann had dug up and put on exhibit. The broad, human appeal of art lost its attraction; people found other more engaging interests.

England helped the cause of art and color with such geniuses as Turner and Constable. But after them, she withdrew inside her island, her art under the influence of a brotherhood of pre-Raphaelites who, as Reynolds so disliked, gave themselves to arid precision, scrupulous attention to detail, and cold artificiality.

Classicism in art, if it had any merit at all, found its noblest exponents in two French artists, Jacques Louis David and his pupil, Jean Auguste Ingres. Let me continue this story with them, then cross over to England to discuss Turner and Constable, and return to France again in order to conclude this chapter properly. This is about how progress in the art of color took place, for in the nineteenth century, France

assumed leadership in painting and has held this supremacy ever since.

Classicism in painting existed in France during most unlikely times — through revolution and the overthrow of Louis XVI in 1793, through Napoleon and Waterloo, two Republics, and the restoration of the Bourbons. And all during these times, art was cherished. The artist himself was immersed in politics but continued to hold the enthusiastic regard of a much agitated and embroiled public.

It is remarkable that the French government, revolutionary or otherwise, always fostered and encouraged art, distributed prizes, made generous purchases, and left the painter free to do as he wished. Consider, for example, that on January 21, 1793, Louis XVI was guillotined, and on July 27 of the same year, the Louvre was opened as a public museum! Love of art had indeed become part of the French psyche.

Jacques Louis David (1748-1825)

The new, classical direction in French painting was typified in the canvases of Jacques Louis David, a distant relative and student of Boucher who was at one time a favorite of Madame de Pompadour. A craftsman and technician of the first rank, David traveled to Italy, developed an amazingly clear-cut chiaroscuro, and soon demonstrated that he could out-paint anyone alive at that time.

Although married to a royalist, he was an enthusiastic supporter of Robespierre, for which he was imprisoned and narrowly escaped execution. However, when the Institute of France was created, David became a member of the section on fine arts. Now he was again on top and the omnipotent man in French art.

This prestige was confirmed under Napoleon whom David looked upon as the new Caesar. David painted the emperor in such historic compositions as "Bonaparte Crossing the Alps," and "Napoleon Distributing the Eagles to His Army," but these are by no means his best accomplishments. He became the official painter of the Empire. When Napoleon was exiled, David went to Brussels where he spent the rest of his life.

David is perhaps one of the finest technicians in art. A remarkable example of his finished style is to be found in all of his carefully styled

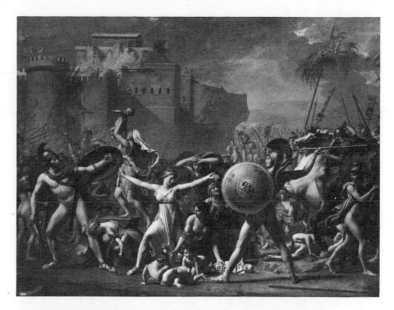

10-5. BATTLE OF THE ROMANS AND SABINES. Jacques Louis David. Softly toned colors are applied as if over a photograph. (Courtesy of Louvre, Paris.)

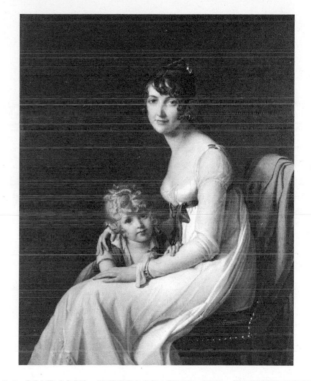

10-6. MADAME DESBASSAYNS DE RICHEMONT AND HER DAUGHTER, CAMILLE. Jacques Louis David. There is an exquisite sense of perfection in this picture. The style is chiaroscuro; the colors are handled delicately. (Courtesy of The Metropolitan Museum of Art. Gift of Julia A. Berwind, 1953.)

works. A description of his palette is given in Chapter 3. His craftsmanship must be admired, despite its cold and dry Classicism. He renounced the rococo in art and replaced it with a dignified symbolism. Yet he also entombed French art in the dead past and, through his pupil Ingres, established an esthetic empire that had to be overthrown, and was overthrown by the Impressionists.

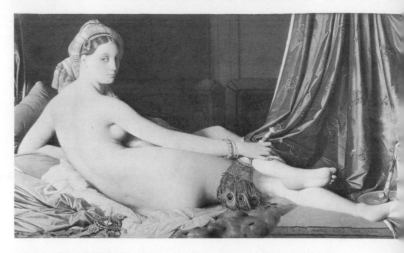

10-8A. ODALISQUE. Jean Auguste Ingres. There are two versions of this picture. This is the original version, done in shades of warm gray with only slight hints of color which results in the look of a faintly tinted photograph. (Courtesy of Louvre, Paris.)

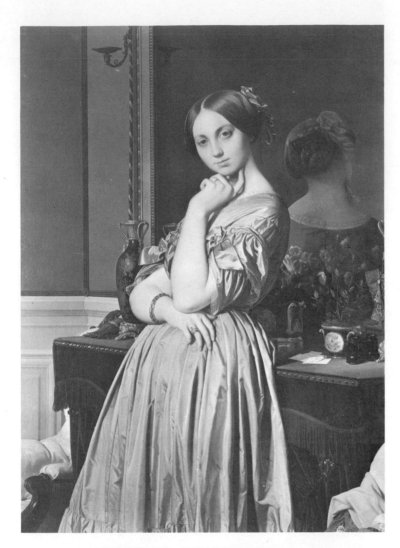

10-7. COMTESSE D'HAUSSONVILLE. Jean Auguste Ingres. Perhaps more charm than spirit is shown here. The colors are flesh, soft blue, warm gray, pale white, and black. (Copyright, The Frick Collection, New York.)

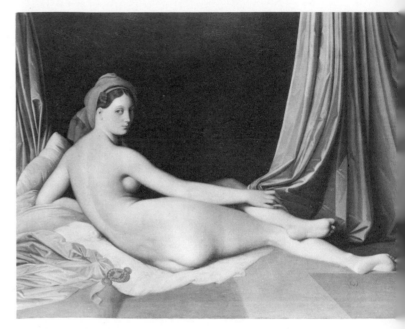

10-8B. ODALISQUE. Jean Auguste Ingres. Here is the second version. The background is a blackish brown, the curtains are blue, and there are blue, white, and gold fabrics. (Courtesy of The Metropolitan Museum of Art.)

Jean Auguste Ingres (1780-1867)

Ingres, at the age of 21, was awarded the Prix de Rome and studied in Rome for nearly 18 years. During this time, like David, he became an able craftsman, sending pictures now and then to Paris where they were duly admired for their purity and precision.

When Ingres retired to France in 1824, the old Classicists and a new breed of Romanticists were at loggerheads. David, in exile in Brussels, died within a year. Ingres, much to his pleasure and surprise, was showered with honors, elected to the Institute, made a grand officer of the Legion of Honor, and a senator as well. More significant to French art, however, was the fact that Ingres became the most distinguished and revered teacher in France and a reigning monarch at the Beaux Arts School.

Ingres in his capacity as instructor was adamant in his insistence on good drawing above all else. "A thing well drawn is always well enough painted." He held low regard for color and relegated it to mere covering for well-executed form. "Rubens and van Dyck," he admonished, "may please the eye, but they deceive it — they belong to a bad school of color, the school of falsehood." The palette used by Ingres is described in Chapter 3.

Pride as well as stubbornness ruled Ingres. He deplored the French Salon which, according to

his view, "stifles and corrupts the feeling for the great, the beautiful." In protest, he refused to exhibit at the Salon or to serve as juror.

Although Ingres had on one occasion been kind and helpful to the youthful Edgar Degas, who became a leading Impressionist, he felt nothing but enmity toward Eugène Delacroix, leader of a new romantic movement. For a number of years, Ingres opposed the appointment of Delacroix to the French Academy, despite the fact that Delacroix became famous and had a legion of followers and admirers.

As will be touched upon later in this chapter, Romanticism and Delacroix fought Classicism and Ingres bitterly — the fight was between color and line, between free expression and discipline. The Romanticists won. And a large part of the victory was due to English painters. It can be said that the victory of color over line and form became the triumph of the nineteenth and twentieth centuries.

Joseph Mallord William Turner (1775-1851)

Turner is generally regarded as England's greatest painter. Born in humble circumstances he led an active, mysterious, and highly successful life. He never had trouble making a living. He started by selling drawings at the age of 10 in his father's hairdressing shop; later he put in backgrounds on architectural drawings, tinted prints for engravers, did topographical sketches for a magazine, all this while he was studying watercolor and oil painting.

At the age of 24, Turner was elected an associate at the British Royal Academy; he was fully honored and elected Royal Academician three years later. He traveled extensively, became a man of property, maintained studios and galleries in London and eventually died a wealthy man.

There is no reliable record of Turner's personal life. After he had been dead 10 years, a journalist named Walter Thornbury wrote a biography generally regarded as slanderous. However, his great champion John Ruskin declared "Turner had a heart as intensely kind, and as nobly true, as ever God gave to one of his creatures." In any event, from what is known, it seems that Turner was a taciturn man who liked to keep to himself. It is said that his contribution to an evening of talk was, "Rummy thing, painting."

Turner's idol in the field of painting was Claude Lorrain, often referred to by art historians as the father of landscape painting. Claude Lorrain, born in France, went to Rome at an early age and remained there most of his life. As noted previously, he put the sun in many of his paintings. He did not pause or hesitate to resort to this audacity and created astonishing effects of light and illumination unequalled in his day and for many years after.

Because landscapes were not in demand by art connoisseurs, Claude Lorrain was obliged to include figures and to hint at story-telling, history, and mythology. Perhaps this was unfortunate, for today no one has the slightest interest in the *meaning* of his pictures, but only in their glowing beauty which has not dimmed in nearly 300 years.

Turner admired the French landscape artist so much that he bequeathed two of his own paintings to the British nation — "Dido Building Carthage" (Ill. 10-10A) and "Sun Rising Through Vapor" (Ill. 10-10B) — with the request that they be hung near Claude Lorrain's "Marriage of Isaac and Rebecca," and "Embarkation of the Queen of Sheba." (See next page.)

Turner's "history paintings," however, did not add much to his posthumous fame, for they look too theatrical. He was at his best when he gave free rein to his fancy and when he employed his almost miraculous sense of color.

He worked interchangeably with watercolor and oil. Later in life, he handled oil as if it were watercolor and was responsible for a number of innovations, among them a vivid and intense luminosity. In the beginning, however, Turner's paintings were dark and somber. As he matured, he brightened his hues, using them in pure and powerful form. Toward the end of his career, he abandoned himself to color phenomena, to the mysteries of sunlight and moonlight, eventually becoming abstract in his views and anticipating both Impressionism and Abstract Expressionism.

Turner was a man in a hurry. He was too impatient to become a good technician. Even Ruskin, despite complete admiration for the man — "the greatest of all painters, past and present" — found reason to grieve, "No picture of Turner's is seen in perfection a month after it

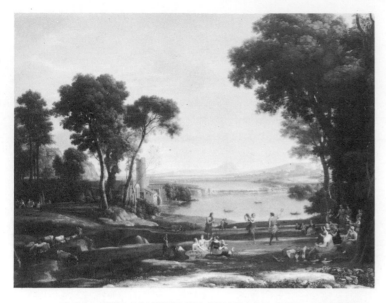

10-9A. THE MARRIAGE OF ISAAC AND REBECCA. Claude Lorrain. (Courtesy of Trustees, National Gallery, London.)

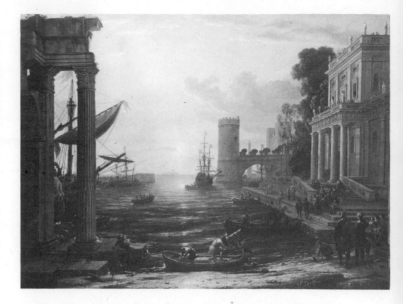

10-9B. THE EMBARKATION OF THE QUEEN OF SHEBA. Claude Lorrain. (Courtesy of Trustees, National Gallery, London.)

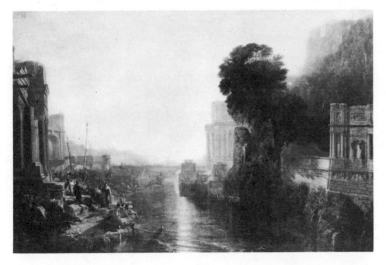

10-10A. DIDO BUILDING CARTHAGE. J. M. W. Turner. (Courtesy of Trustees, National Gallery, London.)

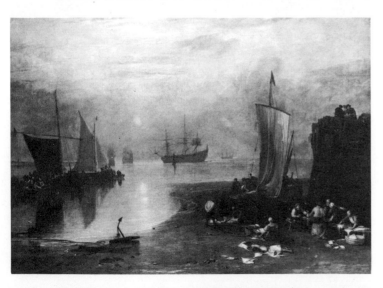

10-10B. SUN RISING THROUGH VAPOR. J. M. W. Turner. In this picture and Illustration 10-A, note the resemblance to works of Claude Lorrain. Later, Turner worked in a more abstract way, featuring color and letting it dominate design, form, and idea. (Courtesy of Trustees, National Gallery, London.)

is painted . . . a painful deadness and opacity comes over them." Although many of his oils became ruins, he was so prolific that enough survive to attest to his genius as a colorist. Turner himself seemed indifferent to the deterioration of his paintings, for in his gallery, during his lifetime, the roof leaked and canvases were allowed to rot.

Turner was bitterly criticized for his "vulgar" use of bold colors. One critic called him the "over-Turner" of tradition. Another referred to one of his paintings as a "mass of soapsuds and whitewash." It was viciously said by certain critics that his art betrayed the "wonderful fruits of a diseased eye and a reckless hand," that he saw "nothing in nature beyond poached eggs and spinach," and that he was guilty of "flinging a pot of paint in the public's face."

But he paid little attention and was not troubled by such attacks. There were many who understood him. Constable wrote of a painting of sunrise, "Turner has outdone himself; he seems to paint with tinted steam, so evanescent and so airy. The public thinks he is laughing at them, and so they laugh at him in return."

As a matter of fact, Turner was not exaggerating his colors; he was painting the truth, and English art had not known truth. Wrote Ruskin:

When you have got all the imitable hues truly matched, sketch the masses of the landscape out completely in these true and ascertained colors; and

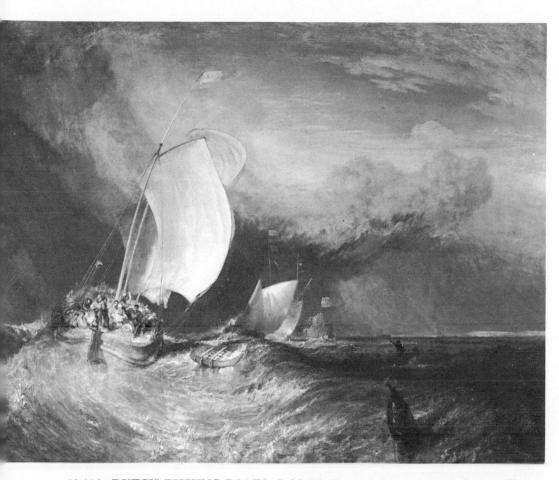

10-11A. DUTCH FISHING BOATS. J. M. W. Turner. This is typical of many Turner seascapes. Emphasis is in the white sail and blue sky; otherwise, the colors are soft and low in key. (Courtesy of The Art Institute of Chicago. Mr. and Mrs. W. W. Kimball Collection.)

10-11B. TURNER'S PALETTE. (Courtesy of Director, Tate Gallery, London.)

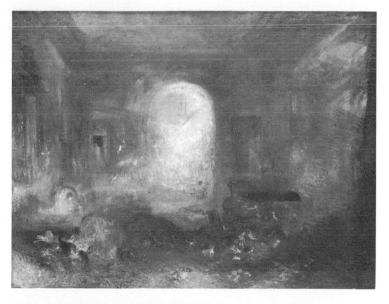

10-13. INTERIOR AT PENTWORTH. J. M. W. Turner. Here Turner was obviously delighting himself in color — cream tones, warm golds, tans, orange, and red. (Courtesy of Director, Tate Gallery, London.)

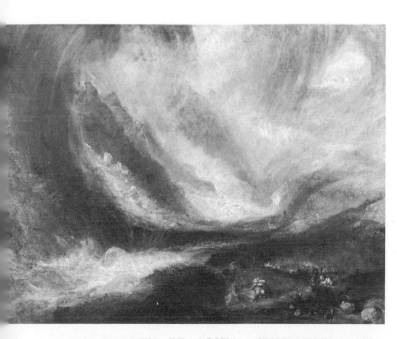

10-12. VALLEY OF AOSTA — SNOWSTORM, AVALANCHE, AND THUNDERSTORM. J. M. W. Turner. Note how closely this composition comes to total abstraction. The colors are mostly grays, with glints of gold and blue in the sky, and earthy reds and browns in the lower right-hand corner. (Courtesy of The Art Institute of Chicago. Frederick T. Haskell Collection.)

193

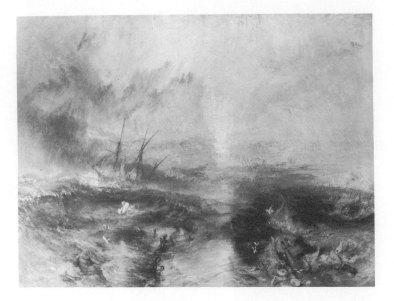

10-14. THE SLAVE SHIP. J. M. W. Turner. Observe the touch of surrealism in the lower right corner. (Courtesy of Museum of Fine Arts, Boston.)

you will find, to your amazement, that you have painted it in the color of Turner — in those very colors which perhaps you have been laughing at all your life — the fact being that he, and he alone, of all men, *ever painted nature in her own colors.*

Turner — An Evaluation

Ruskin's tribute to Turner as a colorist is fully justified. In the opinion of the author, if painting were to be judged strictly in terms of color expression — aside from technique, composition, or any other professional qualities — Turner could readily be cited as the greatest colorist of all time, more eloquent than any of the Old Masters, more spontaneous than any of the later Impressionists, and more startling than the Fauvists or Orphists of the twentieth century.

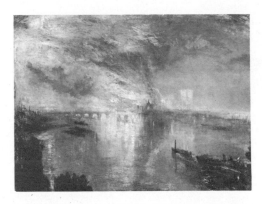

10-15A, 15B. BURNING OF THE HOUSES OF PARLIAMENT and Detail. J. M. W. Turner. The extraordinary color effects in this magnificent painting is described in the text.

Although Turner wrote and said virtually nothing about himself, he was vitally interested in color. Unlike the majority of artists, he changed his style from time to time and was an experimentalist throughout his life. According to Sir John Rothenstein, "In regard to color not only was Turner endowed with a prenaturally observant eye and retentive memory, he had a scientific interest in its possibilities that led him to the annotation of Goethe's treatise and to the perusal (not that they ever satisfied him) of such tractates as were available." One of his paintings, entitled "Light and Color: Goethe's Theory," is shown in Chapter 4, Illustration 4-8.

What of Turner's viewpoint? Rothenstein writes, "His mind was colored by pessimism about the human predicament, the vulnerability of man to chance and circumstances, and in particular to man's impotence before the incalculable forces of nature — avalanche, whirlwind, hurricane, and (the outrageous conspiracy of two destructive but opposed elements) the 'fire in the flood.'" He painted these furies time and again. Of "The Slave Ship" (Ill. 10-14), William Makepeace Thackeray, a contemporary of Turner, wrote, "The sun glares down upon a horrible sea of emerald and purple . . . gasping dolphins redder than the reddest herrings; horrid spreading polypi, like huge, slimy, poached eggs, in which hapless niggers plunge and disappear."

How did Turner paint? In the magazine, *Spectator*, of Turner's day, a critic wrote of "The Burning of the Houses of Parliament" (Ill. 10-15A, 15B.)

> The burst of light in the body of the flame, and the flood of fiery radiance that forms a luminous atmosphere all around the objects near, cannot be surpassed for truth. . . . And the execution is curious: to look at it close, it appears a confused mass of daubs and streaks of color; yet we are told that the painter worked on it within a few inches of the canvas for hours together, without stepping back to see the effect. Turner seems to paint slovenly — daubing, as one would say; yet what other painter preserves equal clearness of color?

Turner worked with brush, palette knife, fingers, lumps of opaque paint, transparent glazes, and varnishes — all to put on canvas, not a method of painting but a blinding vision.

This was *Impressionism* in every sense of the word and as remarkable as anything done later by any French painter with the exception of Dutch-born van Gogh. By studying the paintings, Ruskin, in a tabulation of over 60 Turner pictures, was able to give data on lighting conditions, hours of day or night, quality of illumination and direction from which light came.

Chapter 5 explored Turner's phenomenal sense of color and color aptitude. The Impressionists and Neo-Impressionists a century later, painted in dabs or dots and *relied on visual effects and optical color mixtures, but Turner worked with the whole of perception and made the brain of the viewer — not just the eye — contribute to his spectacular effects.* He was so far ahead of his times that he surpassed Impressionism even before it had been born! Technically, he achieved his extraordinary quality by contrasting purity of tone against grayness of tone, by capitalizing what the psychologist would later term the Law of Field Size (see Chapter 7). As a result, those who stand before his paintings are drawn into a participation and behold a brilliance that is not in the pigments, but is an illusion created by Turner's magic. Note the comments in Chapter 5 referring to Turner's "The Fighting Téméraire."

When Turner died he left a fortune of more than half a million dollars and a large body of his work to his nation. Among other things, he wanted a fund set up for the relief of impoverished artists.

Twenty years after his death, Claude Monet and Camille Pissarro visited London and stood before the great paintings of Turner. Pissarro, a kindly soul, was enthralled. Monet, however, is said to have been antipathetic "because of the exuberant romanticism of his [Turner's] fancy." In this, the French painter was probably jealous and unfair. The Neo-Impressionist, Paul Signac, later confirmed Turner's influence. Apparently, the Impressionists *did* study Turner, although they hesitated to admit it. In 1889, Signac wrote, "They study his works, analyze his technique."

Indeed, Turner was preeminent as an Impressionist, even though the term was unknown in his day. In connection with twentieth-century Abstract Art, Michel Seuphor writes, "It is true that in 1841 or thereabouts Turner came so close to abstract painting that his works have no parallel in his century."

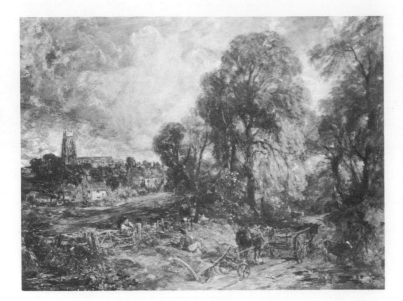

10-16. STOKE-BY-NAYLAND. John Constable. This picture is painted in a relaxed style that demonstrates great skill. (Courtesy of The Art Institute of Chicago. Mr. and Mrs. W. W. Kimball Collection.)

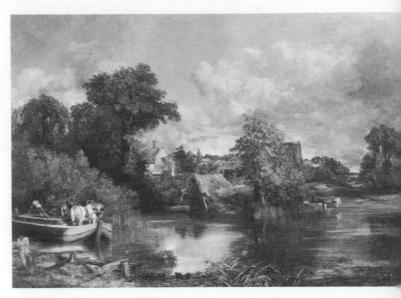

10-17. THE WHITE HORSE. John Constable. Nature is glorified for her own sake, without story or allegory. (Copyright, The Frick Collection, New York.)

John Constable (1776-1837)

The English landscape painter, John Constable, born a year after Turner, fared better in Europe than he did at home. Turner became a wealthy man through painting, but Constable could scarcely earn a living for many years. He did not sell a picture to anyone but a personal friend until he was 38 years old. It seemed that in his day, people did not want nature quite so pure, without figures or hint of allegory or history. Constable admired nature as he saw her, and he felt that no fictitious elements were needed. He wrote in middle-age, "My art flatters nobody by imitation; it courts nobody by smoothness, tickles nobody by pettiness; it is without fal-de-lal or fiddle-de-dee; how can I hope to be popular?"

He had great talent and was ably encouraged and trained. Although he began as a portrait painter, he soon devoted himself to the landscape. Constable liked pure and brilliant colors and did not hesitate to use them. He employed broken tones, filled his shadows with complements, gave nature the scintillation it demanded, and which an out-of-doors painter knew was essentially true. Yet England remained unimpressed.

In one notable incident, in 1821, Constable exhibited a charming landscape, "The Hay Wain," at the Royal Academy (Ill. 10-18). It attracted small attention. Later, it was sold to a French collector who sent it to the Paris Salon in 1824.

There was instant glory then for the patient Constable, for he was awarded a gold medal. Most flattering of all, a painter of rising power, Eugène Delacroix, leader of the French Romanticists, was enthralled by the freshness of Constable's style and as a consequence obtained permission to retouch his own "The Massacre at

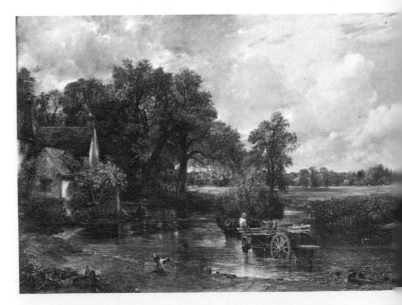

10-18. THE HAY WAIN. John Constable. This painting brought the artist considerable fame and inspired Delacroix. (Courtesy of Trustees, National Gallery, London.)

196

Scio" which was in the same exhibition (Ill. 10-19). Delacroix did this in about two weeks, using the strongest and most vivid of hues. And because Delacroix became the champion of color and the precursor of Impressionism, the influence of Constable, though indirect, merits recording in the story of color.

With a European reputation to comfort him, Constable still found rejection in England. Once when approached by an engraver who wanted to copy his work in black and white, Constable said, "The painter himself is totally unpopular and will be so on this side of the grave." However, when he was 53 years old he was elected to the Royal Academy. Recognition came rather late but nevertheless, when he died, he left a modest fortune.

Unappreciated in his own country during his lifetime, Constable gained immortality after his death. He was supreme as a landscape artist and inventive as a colorist. His brilliant touches of white and color — Constable's snow — influenced much of the art of following generations.

Eugène Delacroix (1799-1863)

After Turner and Constable, English art declined and withdrew into isolation. The initiative went to France — a fact hardly open to dispute, at least in the history of color expression.

In France, the Classicism of David and Ingres was being attacked. "Who will deliver us from the Greeks and Romans?" cried Jean Géricault (1791-1824). This unusual painter challenged the French Academy with a series of dramatic, action paintings. He felt that the enemy of art — whatever was stiff and petrified — could be overwhelmed. Géricault died when he was 33 years old and his leadership was assumed by a friend and fellow-student, Eugène Delacroix. Now art and color entered a new and memorable epoch. A self-portrait of Géricault and a description of his palette will be found in Chapter 3.

Delacroix came of a substantial family but was left impoverished at the early death of his father. Recognized as a young man of exceptional talent, however, he was aided by a Baron Gros and was soon on his way to fame.

His repainting of "The Massacre at Scio" and his admiration of Constable have been mentioned. The turbulent energy of Delacroix and

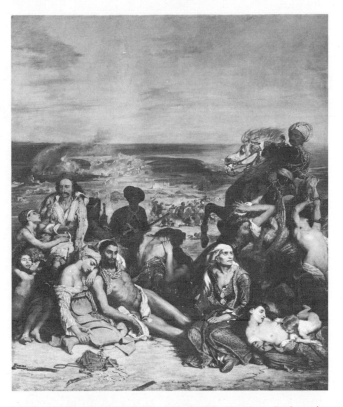

10-19. THE MASSACRE AT SCIO. Eugène Delacroix. Delacroix retouched this painting in vivid colors after seeing Constable's "The Hay Wain." (Courtesy of Louvre, Paris. Photograph by Giraudon.)

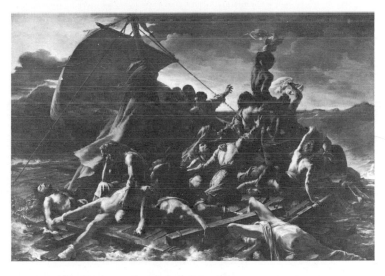

10-20. THE RAFT OF THE MEDUSA. Jean Géricault. He wanted drama and action. not the formality of classicism. Here color contrasts are extreme—deep, strong reds, blues, and blackish browns. (Courtesy of Louvre, Paris.)

his brilliant colors offended the Classicists. Delacroix was rejected by the academicians, but heartily worshipped by a young generation of rebels. His battle with Ingres for color over line became the topic of the day in art circles. "How hot the disputes of the Ingrists and Delacroix fanatics are," wrote the press. Ingres, who had been elected to the Institute of France when he was 44 years old, was instrumental, at least par-

tially, in keeping Delacroix out until the Romanticist was 60 years old.

Delacroix admired Veronese and Rubens. He took an early interest in color and color theory and was one of the few artists ever to express his views in writing. A number of his observations on nature, and his general enthusiasm for color, are presented in Chapter 4 on "The Personality of the Artist." "The enemy of all color is gray," he declared, "Banish all the earth colors." And again, "Give me mud, and I will make the skin of a Venus out of it, if you allow me to surround it as I please."

He became the prophet of Impressionism and was idolized for his courage. He once gave the youthful Manet permission to copy one of his paintings. John Rewald, in his monumental book, *The History of Impressionism*, relates an incident that reveals the extent of the admiration Delacroix inspired in the young French painters:

> Delacroix's isolation had increased during the last years of his life, and he may himself have been ignorant of how great was the respect in which he was held by the new generation. Indeed, he had lost all contact with it. . . . Nor did Delacroix suspect that in this same house Monet and Bazille, from the window of a friend's apartment, used to observe him at work in his garden studio. Usually, they were able to discern only Delacroix's arm and hand, seldom more. They were astonished to see that the model did not actually pose but moved freely about while Delacroix drew it in action, and that sometimes he began to work only after the model had left.

He was also a hero to Vincent van Gogh who once wrote to his brother Theo:

> You know that there were thousands of reasons why I went south and threw myself into my work there. I wanted to see a different light, I thought that to observe nature under a clearer sky would give me a better idea of the way in which the Japanese feel and draw. I also wanted to see this stronger sun because I felt that without knowing it I could not understand paintings by Delacroix from the standpoint of execution and technique, and because I felt that the colors of the prism were blurred by mist in the North.

In the hands of Delacroix color was resurrected. He was one of the most ardent and enthusiastic colorists of all time. Yet in spite of his romantic passion and his rebellion against Classicism, he painted in a somewhat traditional style; his spirit was more eloquent than his actual technique, and his color research became a valuable legacy to the art of France. The artists who followed hailed Delacroix as the standard-bearer of the spectrum, the brave one who, flag flying, helped to guide the art of color into a free future. His keen interest in the way others painted, in basic colors and palettes, is well covered in Chapter 3. "Liberty Leading the People" (not shown), a patriotic subject, is a fine example of Delacroix exhilarating style.

Gustave Courbet (1819-1877)

With the advent of Courbet, French painting shifted from Romanticism to Realism. Courbet and Delacroix were contemporaries, and both were men of great popularity and influence. Courbet, born of a wealthy family, studied law but soon gave it up for painting. In the confusion of his times, he became a champion of democracy, with a deep sympathy for the masses. Because painting was an "art of sight," he felt that it was meant to concern itself with true things. He wrote, "To translate the manners, the ideas, and the aspect of my own times according to my perception, to be not only a painter but still more a man, in a word, to create a living art, this is my aim."

This credo had great appeal for the younger generation of artists and Courbet soon had followers eager to overthrow Classicism. In one of his large paintings, which he called "The Studio of the Painter: A Real Allegory" (Ill. 10-21), Courbet illustrated his love of realism. Shown on this canvas are the kinds of people he liked — the beggar, laborer, gravedigger, tradesman, preacher — grouped together with some of his good friends, and with Courbet himself in the center of it all busily engaged in painting a landscape. "Angels!" he once declared, "but I have never seen angels. What I have not seen I cannot paint."

Courbet's style was free, direct, and broad. Being adored by a host of disciples, he agreed to open his studio to them, but not to teach. In 1862 some 40 neophytes arrived, contributed 20 francs each for rent and a model, and set to work.

However, Courbet was not suited to such a

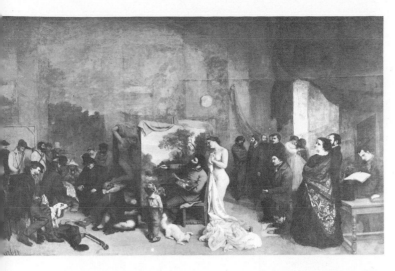

10-21. THE STUDIO OF THE PAINTER: A REAL ALLEGORY. Gustave Courbet. His models are at the left, his friends at the right. And all was true and real. He signaled a shift in French art from romanticism to realism. (Courtesy of Louvre, Paris.)

10-22. THE BROOK OF LES PUITS-NOIR. Gustave Courbet. This is a small painting (about 18 by 22 inches) and perhaps represents a preliminary sketch for a larger composition. As such, it shows Courbet's easy-flowing and "Impressionist" style. (Courtesy of The Art Institute of Chicago. Mr. and Mrs. Martin A. Ryerson Collection.)

prosaic life and the studio was closed. At one time he was a friend of Whistler and is credited with some influence on Whistler's work. Later the two men disagreed and the friendship ended. Courbet knew Corot, Boudin, Manet, Monet, Bazille, Renoir, Pissarro, and Cézanne. All paid tribute to him and admittedly tried to emulate his principles of painting. The magnificence of his style is evident in any study of his remarkable paintings.

During the reign of Napoleon III, Courbet was involved in politics. When the Commune was established in Paris in 1871, he took a prominent part in the revolution and was appointed President of the Commission of Fine Arts. Among other rash acts, he allowed a column commemorating Napoleon I to be pulled down, and although he had once fought to preserve the treasures of the Louvre and to save the *Arc de Triomphe* from mob destruction, he was arrested, fined, and imprisoned. Broken in health and spirit, he died in exile.

Delacroix and Courbet were major prophets of the Impressionist movement. Though they differed in many convictions, both were devoted to a new world of creative expression in which color was paramount.

The Barbizon School

There were lesser prophets, too. Among them were Jean François Millet (1814-1875) and Jean Baptiste Corot (1796-1875). Millet and Corot were associated with what was known as the Barbizon School. A group of young Impressionists visited the school now and then to observe and criticize. Millet, of Dutch peasant stock, was

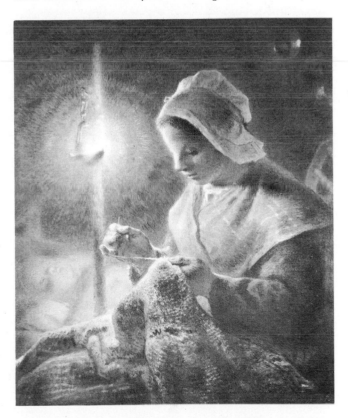

10-23. WOMAN SEWING BY LAMPLIGHT. Jean François Millet. His choice of humble subjects, usually peasants working, appealed to young artists. The colors here are a luminous white and yellow set against red, dull golds, and green, with brownish black. (Copyright, The Frick Collection, New York.)

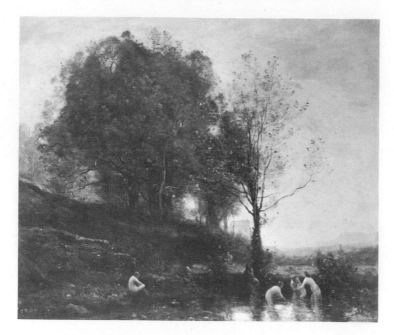

10-24. BATHING NYMPHS AND CHILD. Jean-Baptiste Corot. The pale light of dawn and soft colors are typical of Corot. (Courtesy of The Art Institute of Chicago. Mr. and Mrs. W. W. Kimball Collection.)

chiefly interested in drawing and painting peasants. However, as Pissarro declared, Millet's drawing was far superior to his painting.

Perhaps because of his choice of subjects, Millet attracted many younger artists. What he did was often attacked as being socialistic, and this in itself was exciting to young minds. Later, van Gogh copied numerous Millet drawings of peasants digging, sowing, threshing, wood-cutting, and sheep-shearing. For this, van Gogh referred to black-and-white engravings only, inventing his own color schemes.

Corot is a name familiar in the art of the landscape. Somewhat like Pissarro in disposition, Corot was gentle, patient, kind, friendly, and affectionately regarded by the artists of his day. In fact, Pissarro, Corot's junior by some 34 years, became Corot's disciple and devoted follower, proudly announcing himself "pupil of Corot." Born in Paris, Corot studied hard and eventually went to Rome where he developed the poetic style for which he is so well known. He broke away from the dull brown shades of his day, substituting limpid and liquid tints of blue, green, gold, and pearl gray.

Although he began exhibiting regularly in the Salon from 1827 on, his work was neither praised nor censured — it was simply ignored. In consequence, he did not sell a canvas for 30 years! This is astonishing indeed, for Corot's landscapes

had phenomenal success toward the end of the nineteenth century and commanded august prices.

He was a subtle colorist, preferring to paint in the gentle light of early day, "when all nature sings in tune," and to retire indoors during the brilliant hours, a practice reversed by later painters.

Corot gave Pissarro this advice: "The first two things to study are form and values. These two things are for me the serious bases of art. Color and execution give charm to the work." Yet even more telling was this: "Since you are an artist, you don't need advice."

Regrettably, the friendship of the two men declined, for Corot did not approve of the new tendencies of Impressionism, nor of the influences of Delacroix and Courbet. So there came a parting of the ways, and Pissarro was no longer "pupil of Corot."

Johann Jongkind (1819-1891)

In the work of Johann Jongkind of Holland, Impressionism was again anticipated. This Dutch artist knew, before Monet, how to put luminosity, fluidity, and glittering movement on canvas. As Corot and Pissarro had been friends, so too were Monet and Jongkind, after Jongkind settled in France. Jongkind was tall, lanky, awkward, and interested in nothing but his art. A friend of Courbet had declared, "I love this fel-

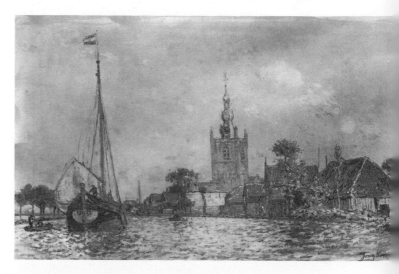

10-25. THE CHURCH OF OVERSCHIE. Johann Jongkind. That he influenced Monet is evident in the painting shown here. This small canvas (about 12 by 20 inches) is done in muted blues, reds, and grays applied in small daubs. (Courtesy of The Art Institute of Chicago. Mr. and Mrs. Martin A. Ryerson Collection.)

low, Jongkind. He is an artist to the tip of his fingers; I find him a genuine and rare sensibility. With him everything lies in the *impression*."

Jongkind was a specialist in atmosphere and worked brilliantly with color. He had a knack for putting down, succintly, the dramatic appearance of a movement. Because of this, he deeply influenced Monet. Here was art (unfortunately commercial at times) that glowed, moved, and assumed dimensions. The young Monet, after requesting Jongkind's criticism of some sketches, wrote, "From that time on, he was my real master; it was to him that I owe the final education of my eye."

In his later years Jongkind lost his mind and was confined in an insane asylum. Of this, Monet said to his friends, "The only landscape painter we have, Jongkind, is dead to art; he is completely mad."

Eugène Boudin (1824-1898)

The French painter, Eugène Boudin, was also a precursor of Impressionism, a man who proclaimed the necessity of working with clean colors and exploiting the magic of light. Corot said to him, "You are king of skies."

Visited and encouraged by Courbet in Le Havre, Boudin wrote, "Courbet has already freed me somewhat of timidity. I shall try some broad paintings, things on a big scale and more particular in tone."

As a young man under 20, Monet was introduced to Boudin and experienced an immediate dislike for him. Yet Boudin was anxious to help and insisted that Monet examine certain drawings. After a number of refusals, Monet accepted the invitation. He wrote later, "My eyes were finally opened and I really understand nature; I have learned at the same time to love it."

Thus Boudin became one of the early teachers of Monet. Boudin, Monet, and Jongkind became fast friends, all three being fascinated by nature's colorful phenomena.

Adolphe Monticelli (1824-1886)

The trend was now unmistakable: Impressionism was near, and this movement would proclaim the primacy of color as never before in the history of art.

Not many general books on painting say

10-26. APPROACHING STORM. Eugène Boudin. Here is an impression of sunlight about to be obscured by clouds. The colors are white, blue, and golden yellow, with accents of red. (Courtesy of The Art Institute of Chicago. Gift of Annie Swan Coburn to the Mr. and Mrs. Lewis L. Coburn Memorial Collection.)

10-27. MEDITATION. Adolphe Monticelli. One of the most original stylists of his day, his bold technique and his use of rich color forecast art movements far beyond Impressionism and Post-Impressionism. (Courtesy of The Art Institute of Chicago. Gift of Joseph Winterbotham.)

much, if anything, about Adolphe Monticelli. This remarkable French artist, born in Marseilles, as a painter was heir to the golden tradition of the Venetians. He studied for a while in Paris but spent most of his life in his native city on the Mediterranean.

Monticelli was one of the most unusual color

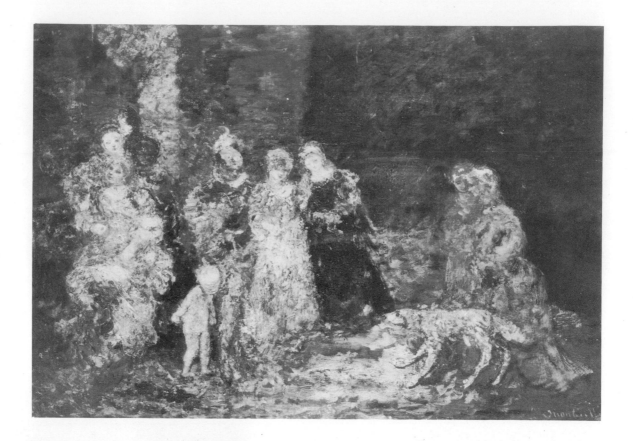

10-28A, 28B. THE FAIRIES and Detail. Adolphe Monticelli. The ground is deep and blackish, setting off rich shades of red, gold, and blue-green. The texture is thick, viscous, opaque here, and glazed there—all highly forceful and original. (Courtesy of The Art Institute of Chicago. Charles H. and Mary F. S. Worcester Collection.)

technicians of modern times. In his bold, original, and impulsive use of color he foreshadowed the Impressionists, Post-Impressionists, the Expressionists, and the Abstract Expressionists — all in one brilliant lifetime of creativity. He admired Veronese, Rembrandt, Watteau, Delacroix, Courbet, and in his own turn, he was admired by Cézanne and van Gogh. "Monticelli taught me chromatism," vowed van Gogh with gratitude. Cézanne, in the later years of Monticelli's life, wandered through Provence with him where they painted side by side and shared artistic and intellectual interests.

The painter from Marseilles was a prodigious worker; the decade before he died was his most fruitful and original period. In this short span of years at the end of his life, he produced over 800 pictures! There were portraits, flowers, fruit, scenes of the park, the opera, the circus, and masquerade balls, all frenzied compositions "that dripped with light and were saturated with

warmth," according to one critic. His effects are well described in *A Dictionary of Modern Painting*:

He had conquered his idiom and he enriched it with all the technical means his instinct suggested: thick layers of paint, varnish, mixtures of tones, shading, glaze. In this oily, kneaded, tormented mixture forms seem to bog down, colors to vanish. And then, as the attention persists, the forms reassemble, and the colors emit vivid glows. Golden yellows, midnight blues, reddish shadows, sumptuous blacks sprinkled with touches of emerald and a few drops of vermilion: everything that would be a thick pudding with others is, with him, an alchemist's secret.

Monticelli was indifferent to Classicism, Romanticism, and Realism. "I paint for 50 years hence," he said. "I am the luminous center; it is I who light." Simply, he put his own individuality and temperament on canvas, invented lighting effects that were of his inner vision and not that of the outer world. It is startling to look at his paintings and realize that, although he belongs to the nineteenth century, what one sees is as fresh and contemporary as any art proffered in the twentieth century.

James McNeill Whistler (1834-1903)

Whistler's father, George Washington Whistler, was a United States Army officer and later a railway engineer. The elder Whistler accepted an assignment in Russia, moved his family there, and thus at an early age his son was exposed to European ways and learned to speak fluent French.

Young James Whistler attempted to follow in his father's footsteps but flunked out at West Point; he then became a surveyor and draftsman for the United States Government, resigned in 1855, and immediately sailed to Paris determined to become an artist.

As a later chapter on Impressionism will relate, Whistler participated in the revolution of the Impressionists (which he later seemed to regret) and in 1862 studied side by side with such artists as Monet, Renoir, Sisley, and Bazille, when all were young and ambitious. The same year, he exhibited in the first show of the rebellious painters, the *Salon des Refusés*. Here his "The White Girl" was rightfully proclaimed an outstanding work of art (Ill. 10-29).

Whistler was a cantankerous man, witty, strange in his ways, impulsive, satirical, and amazingly brilliant of mind. He received great encouragement from Gustave Courbet, for which he was less than grateful. Courbet, in fact, was largely instrumental in bolstering Whistler's courage and eagerness to be creatively original.

He did much traveling, in Italy, Belgium, Holland, to South America, and between Paris and London. The young American became interested in Japanese art and it influenced his views on tone and color. In England, however, he was unpopular, not alone for his free style of painting, but for his stinging arrogance.

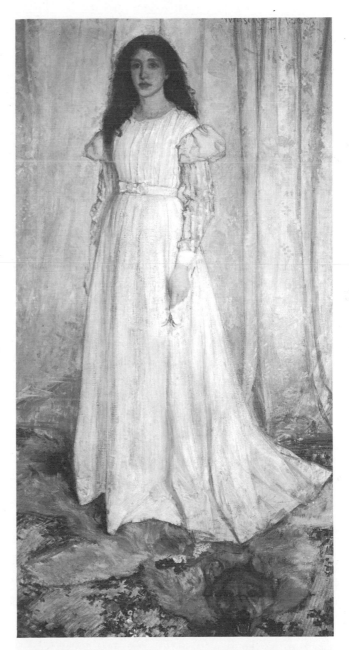

10-29. THE WHITE GIRL. James McNeill Whistler. This famous painting, done when Whistler was 28 years old, set him apart as one of the prodigies of his day. (Courtesy of National Gallery of Art, Washington, D. C.)

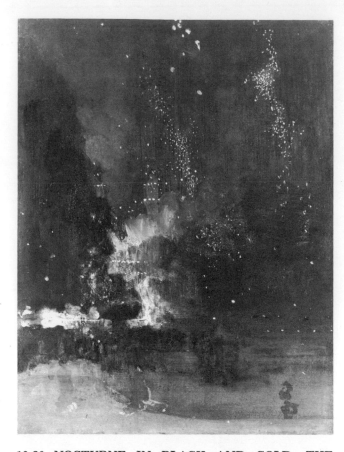

10-30. NOCTURNE IN BLACK AND GOLD: THE FALLING ROCKET. James McNeill Whistler. Here is the painting that was once presented at a trial in London to support Ruskin's accusation that Whistler was guilty of "flinging a pot of paint in the public's face." The field is in deep blues, with touches of gold and soft yellow in the luminous spots and areas. (Courtesy of The Detroit Institute of Arts.)

10-31. OLD BATTERSEA BRIDGE. James McNeill Whistler. This picture demonstrates Whistler's remarkable ability to achieve effects of luminosity and depth, of mist, fog, and the stark beauty of night. (Courtesy of Director, Tate Gallery, London.)

In 1877, John Ruskin unwisely wrote for the public press, "I have seen, and heard, much of cockney impudence before now; but never expected to hear a coxcomb ask 200 guineas for flinging a pot of paint in the public's face."

Apparently, Ruskin had forgotten that the same insult had been directed at his hero, Turner. In any event, Whistler sued Ruskin and was awarded a farthing. The victory was a hollow one, for Whistler had to pay his legal fees, and the affair threw him into bankruptcy.

However, his fortune was restored in time. In 1883, for example, his presently popular masterpiece, "Portrait of the Artist's Mother," generally known as "Whistler's Mother," won a gold medal at the Paris Salon and was later bought by the French Government.

In 1890, he finally settled in Paris, conducted classes in art, and here spent most of his last days. Perhaps he was more audacious than profound. But his love of color was boundless. Even the titles of many of his canvases reveal this: "An Arrangement in Brown," "Harmony in Gray and Green," "Nocturne in Blue and Green," "Symphony in White." His nocturnes, in truth, are among the foremost atmospheric paintings of all time — achieved, possibly, more with ingenuity than feeling. Whistler, it seems, had greater daring than true emotion; yet with a few daubs of pale tint he could imply thick fog, distant lights, and night seemingly boxed in three dimensions within a frame. Many of his color effects are exquisite.

His life had been one of seemingly endless quarrels and unpleasant encounters. At one time, he even quarreled with himself. John Rewald, in *The History of Impressionism*, quotes him as saying, "Courbet and his influence were disgusting. ... It is because that damned Realism made an *immediate* appeal to my painter's vanity and, sneering at all traditions, cried aloud to me with the assurance of ignorance: 'Long Live Nature!' Nature, my dear boy, that cry was a great misfortune for me. ... Oh, my friend, if only I had been a pupil of Ingres! ... How he would have guided us sanely!"

Chapter 11

The Flowering of Impressionism

Impressionism needed rich soil and the sharp cut of a plow in order to germinate, grow, and eventually flower. France provided this.

At the beginnings of Impressionism, the French Academy of Fine Arts, part of the *Institut de France*, still despotically governed the arts of the country. During the Classical revival, typified in the works of David and his pupil Ingres, art remained "petrified," and strict academic training — style, execution, and subject — was controlled by autocratic rule. John Rewald writes of Ingres, "He never tired of proclaiming the superiority of line over color, a statement which led his followers to regard paintings merely as colored drawings."

Classicism, however, was being powerfully challenged and could not possibly survive much longer. Yet the Academy held out until its influence was almost destroyed by decadence within and a horde of storming rebels without.

Some of the artists who opposed the Academy's domination, notably Delacroix, fought in terms of Romanticism against Classicism, and color against line. Delacroix's statement, "I open my window and look at the landscape. The idea of a line never suggests itself to me," heralded the Impressionist philosophy.

At this point, it should be explained that Impressionism was not a "school" so much as it was a brotherhood of spirit. Men like Manet, Degas, Monet, Renoir, and Cézanne by no means painted alike or even held similar views. What they had in common was a new attitude toward nature, a desire to be free of convention and pedantry. As Monet declared, "The effect of sincerity is to give one's work the character of a protest, the painter being concerned only with conveying his impression. He simply seeks to be himself and no one else."

There are certain vital dates in the history of Impressionism. The first date is probably 1862. It was in 1862 that four future leaders of Impressionism — Monet, Renoir, Sisley, Bazille — came to the Paris studio of a Swiss painter and art teacher named Gleyre. They did not come to learn from the "master" but to befriend each other and join in the new rebellion. Whistler also attended Gleyre's school.

If Gleyre's teaching meant little (it is doubtful if he really taught at all), his prodigies were

11-1. ACADEMIE JULIAN. Charles C. Curran (1861-1942). Paris was a thriving and enterprising center of art toward the end of the nineteenth century. The Académie Julian, with several branches, catered to hundreds of ambitious students from all over the world. (Courtesy of The Art Institute of Chicago. Gift of Kate L. Brewster.)

not unhappy. Indeed, they were apparently free to give vent to youthful high spirits. Rewald quotes Renoir as relating, "While the others shouted, broke the window panes, martyrized the model, disturbed the professor, I was always quiet in my corner, very attentive, very docile, studying the model, listening to the teacher ... and it was I whom they called the revolutionary."

But within a year, interest in the Atelier Gleyre was at an end. The young generation of artists in Paris was beginning to boil and froth. In 1863, a jury for a national exhibition at the Salon of the French Academy rejected so many canvases of the great and near-great that the Emperor himself, Napoleon III, felt concerned. Upon viewing the accepted and rejected works in person, and wishing to do the impossible — play fair to all art — he granted permission for a separate showing, which was called the *Salon des Refusés*.

What is unusual here is that revolt, heresy, and freedom were given outlets. The great Cour-bet, who had felt the sting of Salon rejection in other years, hailed the decree and was termed hero of the hour. Although Courbet was represented in the main Salon, one of his paintings was declared immoral and not fit for showing even among the *Refusés*!

The *Salon des Refusés* hung the works of Whistler, Manet, Pissarro, and Jongkind. The beginnings of Impressionism could be witnessed there. Art created in principle and practice from observations of nature was now being exhibited in the formality of an official French gallery.

The vibrant, "broken" color technique was not yet evident. But paintings by Manet, with brave color accents, brought high praise and very little criticism. Slick brushwork and all the poses and pretensions of the academician were abandoned. Unquestionably the world of art was headed for startling adventures.

After the closing of Gleyre's studio, and following the *Salon des Refusés* of 1863, the rebels that were to found Impressionism settled down to

11-2. CONCERT IN THE TUILERIES GARDENS. Edouard Manet. Life at the time of Impressionism was not unlike that de-picted here by Manet. France had its own romantic and artificial Victorian age. (Courtesy of Trustees, National Gallery, London.)

11-3. THE ARTIST'S STUDIO. Frédéric Bazille. Not all the Impressionists were as well off financially as Bazille, but studio life, café life, parties, were all part of the new movement. The visitors here are probably Manet, Monet, and Renoir. (Courtesy of Louvre, Paris.)

diligent work. Monet left for Chailly with his good friends Renoir, Sisley, and Bazille. Here they familiarized themselves with the compact manner of the Barbizon School of naturalistic painters. Later, they went to the Seine estuary and to the Channel beaches. Pissarro, on the banks of the Marne, remained loyal to Corot, painting realistically and naively. Cézanne at Aix struggled out of Romanticism and stubbornly probed nature for the secrets of form, solidity, and color, an effort that was to make him the most influential artist of his day. Degas was restricting himself mostly to figures and portraits and did not attach himself to Impressionism until about 1870.

In those early days, Manet was perhaps the standard-bearer of the new movement. Respected as an artist and moderately successful, he was popularly known for a nude exhibited at the *Salon des Refusés*, "Lunch on the Grass." This charming and unassuming painting is of a nude woman and artists. The Emperor, however, had pronounced it immodest, in spite of the fact that the Emperor himself had purchased a classically conceived nude, complete with cupids and embellishments, "The Birth of Venus," by Cabanel.

The new "school" was thus being formed by men who knew one another, and sympathized and met together. Though their natures, capacities, viewpoints, and subjects differed materially, they all had one absorption — to break with the art of the past and work out a future of their own making. And they all rallied under the same standard, color. (In a small magazine called *The Impressionists* published in 1877, Georges Rivière wrote, "Treating a subject for its colors and not for the subject itself is what distinguishes Impressionists from other painters.") They could, in effect, choose nudes, dancers, houses, ships, still life, landscapes, seascapes, or any subject they desired; being Impressionists, color and light dominated all nature, regardless of the subject matter.

Then came 1870, another important year in art. Germany fought a victorious war with France. Manet, Renoir, Degas, and Bazille were put in uniform and marched to the front; Bazille was killed. Monet, Pissarro, and Sisley took refuge in England where their exposure to the striking canvases of Turner and Constable hastened the evolution of Impressionistic ideals. Cézanne fled with a young model to L'Estaque on the Mediterranean near Marseilles; he, too, succeeded in escaping the draft.

After the war, the group again picked up its brushes and went feverishly about its ambitions, perhaps wiser for the experience of 1870. By 1874, they were all back in Paris.

1874 proved to be a momentous year for the Impressionists, for this was the year that Durand-Ruel, an influential French art dealer, arranged the first of many exhibitions featuring Impressionist paintings. Up until this time, the Impressionists had not fared well. A few of them occasionally had pictures accepted by the Salon, but mostly their work was rejected, Cézanne's particularly. Rarely, if ever, did any one of them sell a picture. But due almost entirely to the enthusiasm and unflagging efforts of Durand-Ruel, Impressionism eventually achieved recognition as an important new art movement.

Monet and Pissarro met Durand-Ruel in London during the war of 1870. The dealer was attracted to the Impressionists from the very beginning, became their friend, lent and gave them money, exhibited their paintings, and was more philanthropic than wise, for he once narrowly escaped bankruptcy as a result. Of all the men who have sought to make a business of art,

probably not one ever demonstrated greater loyalty, faith, constancy, and generosity than did Durand-Ruel for the Impressionists. He was personally upset by the refusal of France to accept them and decided to open galleries in London, Brussels, Vienna, and finally in New York (1887) in order to introduce the new art. America was the first to show real interest.

The historic exhibit that Durand-Ruel opened in Paris on April 15, 1874, was instigated by Monet. There was little hope of accomplishing anything through the Academy of Fine Arts or the Salons, so space was arranged at the studio of a photographer, Félix Tournachon, better known as Nadar. Manet declined to join the group; he was doing well and had been represented at the Salon of 1873. But the rest held together — Pissarro, Degas, Cézanne, Monet, Renoir, and Sisley. About 165 works were shown and all were greeted with scorn. A journalist named Leroy spoke jeeringly of "impressionists," meaning to be satirical but, in truth, giving the new art movement its name.

After 1874, the movement began to build strength, if not financial success. Classicism began to weaken and finally faded into obscurity.

It has not been often in the history of art that a well-knit group of artists have clung together with such steadfast devotion. Including the show at Nadar's, the group held eight joint exhibitions within 12 years. There were some changes and defections, of course, such as Monet, Renoir, and Sisley in 1880, but considerable harmony prevailed. More about the progress of Impressionism and its inspired metamorphosis into Neo-Impressionism and Post-Impressionism will be told in the next chapter.

One more date should be mentioned before this chapter proceeds to the significance of color in Impressionism and before brief notes are presented on its creators and exponents.

In 1883, Edouard Manet died and the founding group scattered to various parts of France, according to varying interests. Lionelli Venturi commented, "Monet tended toward a symbolism of color and light, Pissarro was attracted to Pointillism, Renoir wished to assimilate elements of academic form, Cézanne concentrated on problems of construction, and Sisley took satisfaction in style."

Undoubtedly, the early Impressionists were geniuses in large or small degree; time has confirmed this valuation. But their earthly rewards were negligible and their fame was largely posthumous. Twentieth century art lovers spend millions for paintings that were sold for a pittance, if at all, during the lifetime of the artists. For example, in 1875, an auction was held at the Hôtel Drouot. About this auction, John Rewald relates that "the public, exasperated by the few defenders of the unfortunate exhibitors, wanted to obstruct the sale and howled at each bid. . . . Monet's prices varied between 165 and 325 francs, Sisley's between 50 and 300. Renoir, surprisingly enough, obtained the lowest. Of his works, 10 did not reach 100 francs and several of them had to be bought back by him." For the reader's information, the value of a franc in 1875 was about 20 cents in American money.

Perhaps the joy of creativity is its own reward. Camille Pissarro sold canvases for 300 francs and less and once wrote to a friend, saying, "What I have suffered is beyond words. What I suffer at the actual moment is terrible, much more than when young, full of enthusiasm and ardor, convinced now as I am of being lost for the future. Nevertheless, it seems to me that I should not hesitate, if I had to start over again, to follow the same path."

At this point, some of the various features of Impressionism deserve attention, after which notes on individual painters will be presented. Impressionism, at least until 1875, was not strictly a technique of Pointillism or Divisionism. Although the term Impressionism generally defines the entire art revolution of the last half of the nineteenth century, there are, in fact, three periods — Early Impressionism as so far described, Neo-Impressionism, and Post-Impressionism. Pointillism and Divisionism belong to Neo-Impressionism. Here is a remarkably good description of early Impressionism by John Rewald:

Monet had already made extensive use of vivid brushstrokes, and so had Renoir, who in his study *Summer*, exhibited at the Salon of 1869, had introduced large dots into the background, representing leaves. At the *Grenouillère* the two friends now used rapid strokes, dots and commas to capture the glistening atmosphere, the movement of the water and the attitudes of the bathers. What official artists

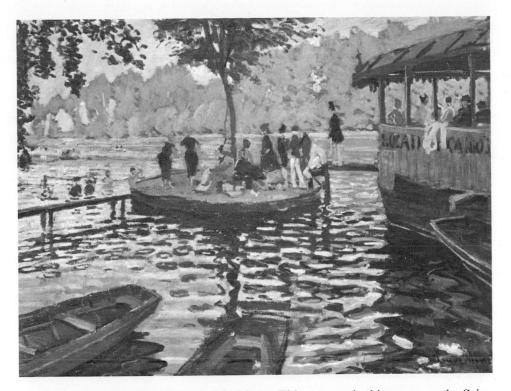

11-4A. LA GRENOUILLERE. Claude Monet. This scene, a bathing area on the Seine, was painted by both Monet and Renoir. Both artists were fascinated by the flowing freedom of a new technique. (Courtesy of The Metropolitan Museum of Art. H. O. Havemeyer Collection.)

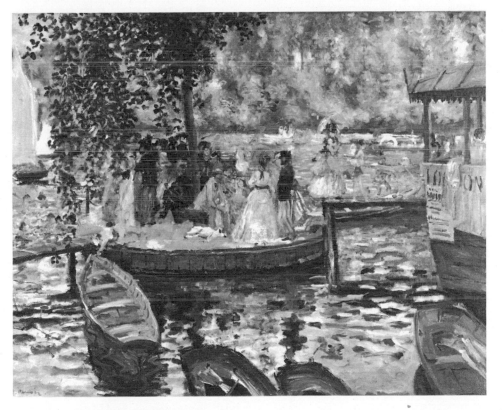

11-4B. LA GRENOUILLERE. Pierre Auguste Renoir. Here is the same bathing spot as that shown in Illustration 11-4A, interpreted by Renoir. (Courtesy of National Museum, Stockholm.)

would have considered 'sketchiness' — the execution of an entire canvas without a single definite line, the use of the brushstroke as a graphic means, the manner of composing surfaces entirely through small particles of pigment in different shades — all this became now for Monet and Renoir not merely a practical method of realizing their intentions, it became a necessity if they were to retain the vibrations of light and water, the impression of action and life. Their technique was the logical result of their work out-of-doors and their efforts to see in subjects not the details they recognized but the whole they perceived. While Monet's execution was broader than Renoir's, his colors were still opaque, whereas the other was using brighter colors and a more delicate touch.

It would be only partly true to say that the now familiar style of Impressionism — spots, strokes, and lines of colors, as distinct from solid, flat areas — came naturally to men like Monet and Renoir. It would be completely true to state that the technique was guided and inspired by the scientific inquiry of the day. And to one man in particular — Michel Eugène Chevreul — goes major credit. Neo-Impressionism had Ogden Nicholas Rood, an American, as one of its foremost scientific tutors. This will be taken up in the next chapter.

Michel Eugène Chevreul (1786-1889)

As far as art and painting are concerned, there is little doubt that one of the greatest books on color ever written was that of Michel Eugène Chevreul, *The Principles of Harmony and Contrast of Colors*. This book and a work by Ogden Rood were dominant influences in Impressionism and Neo-Impressionism. They became handbooks that were diligently studied by the artists of the late nineteenth century.

Chevreul was an unusual and talented man; among other unusual accomplishments, he became a centenarian, reaching the age of 103 years. He was the son of a physician in Angers, France. When he was 17 years old he went to Paris and, being a prodigy with an encyclopedic mind and great powers of concentration, by the time he was 20 years old he was not only teaching and working in a laboratory but had started to write scientific papers.

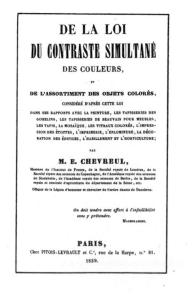

11-5. TITLE PAGE. *The Principles of Harmony and Contrast of Colors* by M. E. Chevreul. First edition.

In 1810, he was appointed assistant naturalist at what was known as the Garden of Plants, later taking the Chair of Chemistry. Six years later, he was appointed Professor of Chemistry and director of the dye houses at the famous Gobelin tapestry works.

Chevreul was not an artist, but he became fascinated with color and visual illusions centering around color perception. Like other men before and after him such as Goethe and Ostwald, he did not summarize his views or publish books on color until late in life. He continued as a chemist, investigated organic substances and the coloring materials for dyed wool, edited scientific journals and contributed to encyclopedias and dictionaries. In 1826, at the age of 40, he became a member of the French Academy of Sciences and foreign honorary member of the Royal Society of London. One of his biographers wrote, "It is safe to say that, if the man had died in his fortieth year, his name and fame would still be familiar to us."

During his 40's Chevreul went about the organization and writing of his masterpiece on color. This work was first published about 10 years later and it immediately attracted international attention. The book remained in print for 50 years, with editions published at regular intervals.

To continue with his life before estimating the importance of his work, Chevreul maintained his interest in color as long as he lived, even though his faculties began to decline when he reached 70 years. Nevertheless, 30 years later, on his 100th birthday, the following event was reported in a French chemical journal, "There came marching with banners into the great hall of the Museum (Gobelin), to do him honor, 2000 or more delegates from the learned societies, the schools, the museums, and the workshops in whose behoof he had labored so faithfully during many useful years." The National Printing House of the French Government did him the further honor of publishing a handsome, memorial edition of his book on color, with an introduction written by his son.

Chevreul's principles became the guiding laws of the technique of Impressionism. Delacroix had been intrigued by them and had passed the interest on to Monet and others. Pissarro and Seu-

rat methodically carried the principles out in detail, putting in practice Chevreul's Law of Simultaneous Contrast.

What was meant by the Law of Simultaneous Contrast? Chevreul begins his book with words that clearly involve the "divisionism" of the Impressionists:

> If we look simultaneously upon two stripes of different tones of the same color, or upon two stripes of the same tone of different colors placed side by side, if the stripes are not too wide, the eye perceives certain modifications which in the first place influence the intensity of color, and in the second, the optical composition of the two juxtaposed colors respectively. All the phenomena I have observed seem to me to depend upon a very simple law, which, taken in its most general significance, may be expressed in these terms: *In the case where the eye sees at the same time two contiguous colors, they will appear as dissimilar as possible, both in their optical composition and in the height of their tone.*

In other words, colors of different *hue* will tend to "spread" still farther apart from each other; colors of different *value* (brightness) will tend to appear still lighter and darker by contrast.

Chevreul then proceeded to give long lists and examples of such contrast. Surprising effects were due both to the influence of afterimages and to the singular results of different colors being confused or blended on the retina of the eye. Much of this is academic today but in Chevreul's time the facts were startling.

In case the reader is not too well versed in matters of simultaneous color contrast, here are examples. When an area of red is seen next to an area of yellow, the afterimage of red (blue-green) will tend to make the yellow appear greenish. The blue afterimage of the yellow will similarly make the red appear purplish. Complements, however, enhance and lend brilliance to each other. If red and green are juxtaposed, both will have heightened power because of their afterimages. As Chevreul wrote, "Red, the complementary of green, added to red, increases its intensity. Green, the complementary of red, added to green, augments its intensity."

On the problem of optical mixtures (fine lines or small dots of a color mixed on the retina of the eye) Chevreul was able to draw upon a wealth of color experience gained in the making of Gobelin and Beauvais tapestries and Savonnerie carpets,

11-6. DIAGRAMS. From *The Principles of Harmony and Contrast of Colors* by M. E. Chevreul. Contrast effects were demonstrated in actual color. The whole approach was scientific and academic.

French textiles of world eminence. His conclusions were that, "there is a *mixture of colors* whenever materials of various colors are so divided and then combined that the eye cannot distinguish these materials from each other; in which case the eye receives a single impression." This impression differed from that of colors seen in large areas side by side. However, the American Ogden Rood would later prove to be more perceptive in the matter of visual color mixtures.

Other comments on Impressionist styles, effects, palettes, and techniques were given in Chapter 3. Notes on the founders of the Impressionist movement will follow here.

All of the 10 artists that will be covered knew each other intimately, fought together, suffered together, dwelt and ate together, painted together, exhibited together, and stood together against the Philistines of the French Academy. Seven of the 10 were born within seven years of each other. Manet and Pissarro were the oldest.

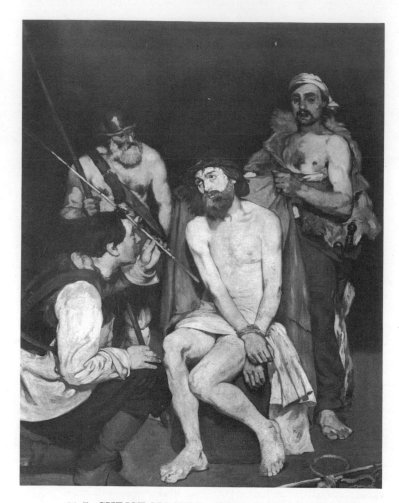

11-7. CHRIST MOCKED. Edouard Manet. His style was once looked upon as crude and unfinished. The colors are earthy to express the mood of the composition. (Courtesy of The Art Institute of Chicago. Gift of James Deering.)

Edouard Manet (1832-1883)

Manet was the most famous member of the group at the time, a dubious distinction in view of the low esteem in which he and his confreres were held during the formative years of the Impressionist movement. He came from an upper middle-class family and never forgot the privileges of his snug heritage. Having a natural bent for art and an independent spirit, he gave up the idea of a naval career, enrolled in a studio, frequented the Louvre, and diligently emulated the Old Masters.

Fortunately, he was financially able to study in Holland, Germany, Italy, and Spain, and by 1861 became competent enough to have his work exhibited at the French Salon.

Manet was a man of firm intentions and stubborn ideals. Although in one sense he could be called the first of the Impressionists, he remained on the edge of the movement. Boldness of design and color appealed to him and he gave himself to them regardless of French traditions. In a time of classical pretensions and academic mannerisms, Manet trampled confidently over the fussy conventions of his day. "There are no lines in nature," he declared, and his canvases became alive with bold, flat areas keyed to bright

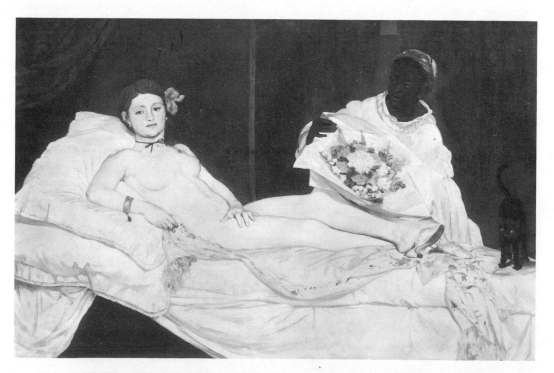

11-8. OLYMPIA. Edouard Manet. Like so many vital painters, Manet was fascinated by the courtesan. The colors here are flesh tones, pink, white, and brown, and a bouquet of muted hues. Most of Paris was shocked. (Courtesy of Louvre, Paris.)

212

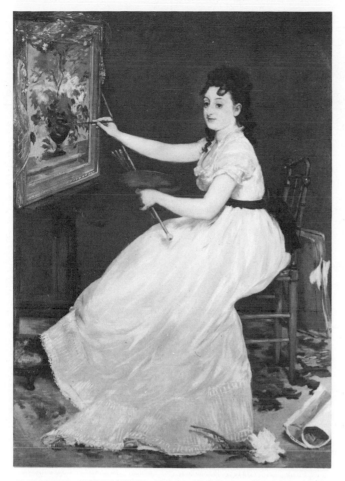

11-9. EVA GONZALES. Edouard Manet. Portrait of the attractive daughter of a French author who became Manet's pupil. The boldness of the composition is typical; the colors are subdued in hue but strong in contrast of brightness. (Courtesy of Trustees, National Gallery, London.)

colors and offset by solid patches of black, painted without modeling or chiaroscuro, all of which upset the academicians.

To his contemporaries, Manet was an extremely able though astonishing and bewildering man. Artists of his day painted naked women by the score, always set in allegorical surroundings. Manet's nudes, however, were thought indecent, perhaps because he took them out of mythology, made them look human, and put them in the midst of reality. A celebrity himself, he painted many celebrities.

Manet's great importance to the Impressionist movement was in his rejection of convention, his honesty, outwardness, and directness, which, while it confused the older artists, sent the younger painters into rhapsodies of praise and envy. Above all, he gave Impressionism its first big push. He did this not by creating styles of painting but by pulling apart old edifices and opening a road into the future.

He was loved and admired by the younger rebels who considered him patriarch of their cause. A *Dictionary of Modern Painting* states, "Manet deserves the position of leader that is usually granted him in the history of Impressionism, for he was the first, and for years the only, painter to fight for a new art that sought a renewal of inspiration and technique in direct observation of Nature and contemporary life."

Edgar Degas (1834-1917)

In point of time, Camille Pissarro would be the logical man to follow Manet. However, in point of art, Pissarro's style is typical of what most persons associate with Impressionism. Thus his story follows Degas in this book for reasons that will be made clear.

Like Manet, Edgar Degas belonged more to the *spirit* of Impressionism than to its techniques. He was a painter of "fleeting movements" which, in itself, is Impressionistic. Again like Manet, he came from well-moneyed parents. In his early years, he took formal lessons in art, deferred to the Classicism of the times and, respecting the masters of old, trained himself to expert craftsmanship.

Above all, however, Degas was a realist. Yet there are several ways in which he differed from the contemporaries he so admired and with whom he regularly and faithfully exhibited. He was not an outdoor painter and was far from a

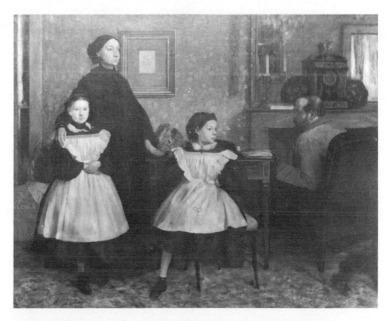

11-10. PORTRAIT OF THE BELLINI FAMILY. Edgar Degas. There is a definite resemblance to the work of Manet, but the colors are lighter and purer in key. (Courtesy of Louvre, Paris.)

213

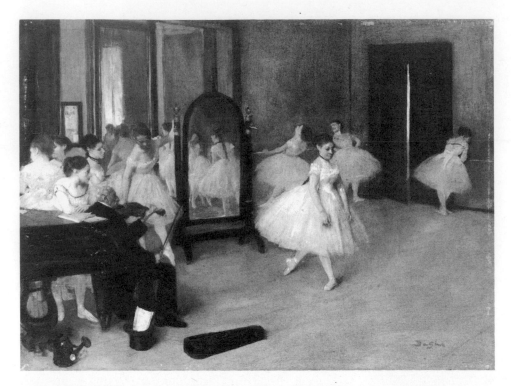

11-11. LE FOYER DE DANCE. Edgar Degas. Lush flesh tones, white, warm tans, and gentle touches of pink and gold were used here, with brown for form and contrast. (Courtesy of The Metropolitan Museum of Art. H. O. Havemeyer Collection.)

"naturalist" in sympathy. He seemed little attracted to the fugitive effects of natural light; his preference was for man-made illuminants, gaslight, limelight, footlights, the pallor of the theater. He was not insulted by being called a photographic painter and indeed worked directly from photographs. He took his subjects seriously, not casually. He was as meticulous as a Classicist like Ingres, yet wholly dissimilar in thought and feeling.

Degas rejected the Beaux-Arts formula completely. He threw off the traditional and presumptuous. Instead of goddesses and nymphs, or even great ladies, there were laundresses, milliners, ballet dancers caught in the only permanence truly individual to life — perpetual change. He innovated new types of compositions, new angles of vision, striking but wholly credible distortions of perspective. Many of his works have the appearance of motion picture "stills"; the viewer feels riveted to a glance and waits for action to proceed.

As a colorist, Degas is as much an Impressionist as anyone of his day. Although he did not work with color divisions, his palette was bright, luminous, and vibrant. "I am a colorist with line," he said. He went beyond local color, accented what he saw, and achieved unusual effects of arti-

ficial light. He cast light up from below as well as down from above. Although there is no rustling of leaves, no shimmering of water, as there is with Monet and Renoir, similar elusive and transient qualities exist in many of Degas' canvases. His dancers have the rustle and the shimmer of the moment. In spirit, therefore, Degas is an Impressionist.

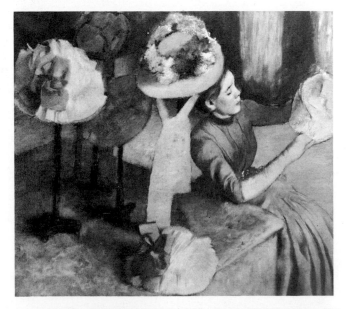

11-12. THE MILLINERY SHOP. Edgar Degas. Here is a charming symphony of colors—the background is blue; the girl wears a moss green dress; the table is tan; the hats are in blue, white, beige, and gold. (Courtesy of The Art Institute of Chicago. Mr. and Mrs. Lewis L. Coburn Memorial Collection.)

Camille Pissarro (1830-1903)

Every movement, every group, needs its staunch and loyal supporter, a man willing to serve in any capacity and to undertake any chore necessary for the benefit of all. Impressionism had such a man in Camille Pissarro, born in the West Indies, the son of a French father and Creole mother.

Pissarro was a sincere but odd person. An atheist and an anarchist on the one hand, on the other he was a devoted parent of six children, gentle and hard working, a poor man most of his life, an humble lover of nature, and an inexorable champion of Impressionism and of all who supported it. In 1865, he joined Manet, Monet, Renoir, and others, exhibiting with the group perhaps longer and more faithfully than anyone else. He took tremendous pride in the success of others, and this attribute won him great admiration, for it was instrumental in holding the group together through thick and thin.

Gauguin wrote of Pissarro, "If we examine Pissarro's art as a whole . . . we find not only a tremendous artistic will which is never belied, but also an essentially intuitive, pure-bred art." Pissarro was a conscientious student of color phenomena, an avid reader of Chevreul and Rood, a man never without the urge for greater knowledge and skill.

Pissarro and Monet went to England in 1870,

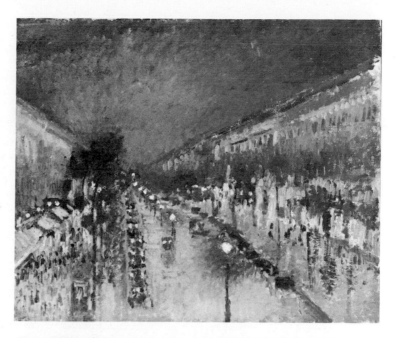

11-14. THE BOULEVARD MONTMARTRE AT NIGHT. Camille Pissarro. The achievement of luminous color in a purely opaque medium has been imitated a thousand times since Pissarro. The large areas are soft greens and blues, with yellow, gold, and orange lights. (Courtesy of Trustees, National Gallery, London.)

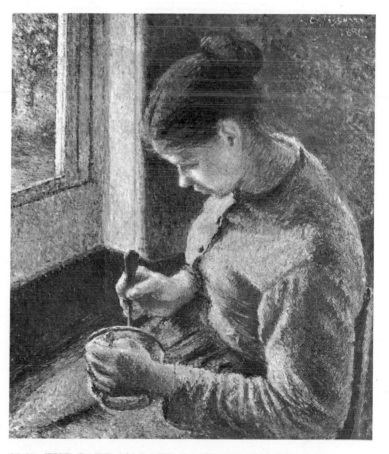

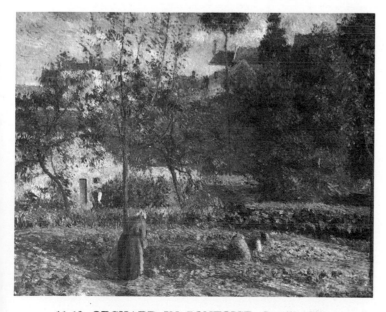

11-13. ORCHARD IN PONTOISE. Camille Pissarro. In this beautifully and firmly set composition there is the glow of summer. The sky is blue. Over the earth is rich terra cotta, blended with equally rich greens, tans, browns, and golden ochers. (Courtesy of Louvre, Paris.)

11-15. THE CAFE AU LAIT. Camille Pissarro. The technique is highly characteristic of Impressionism. The color effect is natural, the colors are pure, the subject is humble. (Courtesy of The Art Institute of Chicago. Potter Palmer Collection.)

11-16. THE ARTIST'S GARDEN AT ARGENTEUIL. Claude Monet. Monet was 32 years old when he painted this. The color effects are as natural as he could make them, with the whole of the spectrum put to use. (Courtesy of The Art Institute of Chicago. Mr. & Mrs. Martin A. Ryerson Collection.)

where they observed the genius of Turner and Constable, as has already been noted. On his return to France, Pissarro began painting under the influence of Corot and Courbet. Gradually his colors grew lighter and showed unusual subtlety. He dropped black and brown from his palette and soon made light itself the dominant feature of his expression. He was attracted to luminous effects, painting with small twists and

11-17 HAYSTACKS, SETTING SUN. Claude Monet. After age 50, Monet sought greater subtlety with color, as in this picture painted in orange and golden tones. He endeavored to portray all the manifestations of natural light. (Courtesy of The Art Institute of Chicago. Potter Palmer Collection.)

dashes, never sacrificing a feeling of form and solidity. If he borrowed here and there from others, a host of followers would borrow from him. He was a teacher at heart and gave instruction to men as famous as Cézanne and Gauguin.

For a while, Pissarro was attracted to a stiff and methodical style of Divisionism like that of Seurat but found this incompatible with his freer and more natural temperament and returned to his former sympathies. In his later years he was surprisingly original, fruitful, sure of himself, and always remained a colorist at heart.

Claude Monet (1840-1926)

Certainly, if Impressionism were to be extolled and exemplified in the work of one man, this man would be Claude Monet; as related earlier, even the word *Impressionism* originated in connection with his work. He symbolized this new movement in his unsophisticated love of nature, his outdoor painting, his concern with moments of life rather than eternities. His adulation of color above all else, and his style and technique were the very fingerprints of the movement.

11-18. SANDVICKEN, NORWAY. Claude Monet. Nearing 60, Monet's style matured. Note the use of different textures for different surfaces. (Courtesy of The Art Institute of Chicago. Gift of Mr. Bruce Borland.)

Monet lived a quiet, full, and long life. He was a friend of Boudin, Pissarro, Renoir, Bazille, Sisley, Degas, and Cézanne, but of them all Monet himself was the most typical Impressionist.

Although Monet did some figure painting in his early years, he devoted himself essentially to landscapes, haystacks, water lilies, cathedrals — to anything that enabled him to convey impressions of light, color, and atmosphere. He wanted the instantaneous, nature arrested in time. He would paint the sun, the wind, mist itself if possible.

Like Turner, he had a keen eye. Any interest he had in scientific inquiry was to make science his servant, not his master. His technique was fluid and graceful, generally conforming to his subjects. Perhaps a sky would be portrayed with little more than dots; but flowers, rocks, buildings, water, clouds, often revealed swirls and flourishes which were tactile in quality like the forms he took as motifs. Monet was superb in all this, often imitated but never equalled. Observe the illustrations on these pages.

Turner painted with supreme imagination; Monet succeeded with a kind of super-realism.

Oscar Wilde was said to have commented that nature, indeed, imitated the art of Monet, for after seeing one of the French artist's paintings done along the Thames, no Englishman could look at fog without seeing iridescence in it.

Monet lived to be 86 years old. His life was by no means without success. He was accepted off and on by the French Salon for some 60 years, beginning in 1865. Considerable fame as well as wealth rewarded his declining years. An innovator himself, he lived to see a younger generation attack him and seek new innovations.

Pierre Auguste Renoir (1841-1919)

Renoir, the son of a tailor, had natural talent as an artist and began his art career by painting flowers on porcelain dishes and fans. He met Monet, Bazille, and Sisley at Gleyre's school in 1862, joined the new movement and remained a dedicated Impressionist for the rest of his long life. Renoir and Monet had much in common. Both practiced the divided color technique and saw color as one of the chief glories of painting. Both were innovators, both keen students of life and nature, both frank and unassuming in viewpoint.

Monet took joy in nature; Renoir's love was for people, group studies, portraits, human ameni-

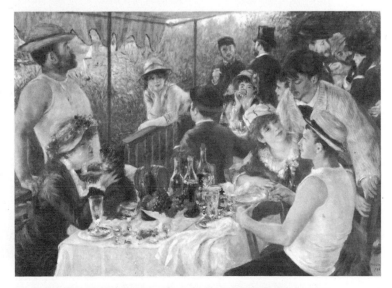

11-19. THE LUNCHEON OF THE BOATING PARTY. Pierre Auguste Renoir. Here is Impressionism in spirit, style, and color. Sunlight and shadow play up the whole of the spectrum. There is spontaneity and "instantaneity." (Courtesy of The Phillips Collection, Washington, D. C.)

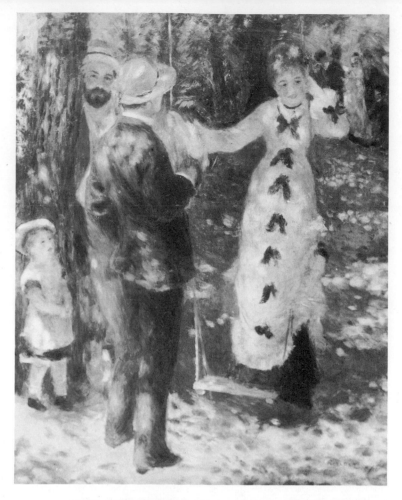

11-20. THE SWING. Pierre Auguste Renoir. Spots of warm yellow sunlight filtering through cool greens and blues opened up a wholly new world of color expression. A simple painting like this separated an old from a new tradition in art. (Courtesy of Louvre, Paris.)

ties. No other painter glorified woman more sympathetically and magnificently. It is said that while Cézanne looked and reasoned, Renoir perceived and felt. Note the simple beauty and dignity of Renoir paintings included in the subjects on these pages.

There are three stages in Renoir's art. First he became a painter of manners, of cafés, music, dancing, boating. Here his colors glistened, sparkled, vibrated, fell lightly through trees in dazzling luminous patches, which some detractors said looked like mold.

At 40, although not financially successful, he was already eminent as an Impressionist. But he felt blocked, so he journeyed to Italy and attempted to develop a new style. He studied the Old Masters, particularly Raphael. After this, he reacted against scattered and juxtaposed colored areas and became more formal and precise, his second stage.

Perhaps this discipline led to a certain matu-

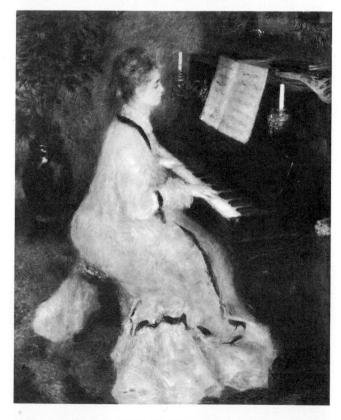

11-21. LADY AT THE PIANO. Pierre Auguste Renoir. Here the color effect is almost monochromatic in tones of white, pale blue, gray blue, and black. There are incidental touches of mustard tan, brown, and gold. (Courtesy of The Art Institute of Chicago. Mr. and Mrs. Martin A. Ryerson Collection.)

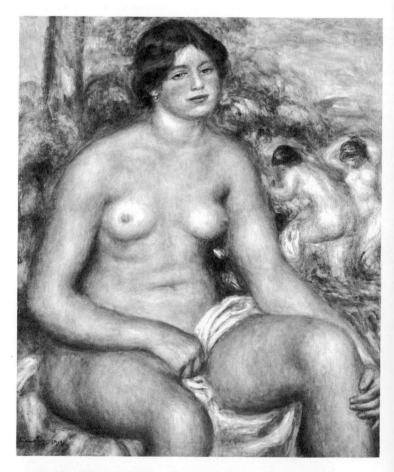

11-22. SEATED NUDE. Pierre Auguste Renoir. The painter was 75 years old when he did this picture. He had abandoned the "spotty" technique for greater form, structure, and plasticity, but his color effects were still delicate and luminous. (Courtesy of The Art Institute of Chicago. Gift of Annie Swan Coburn Memorial Collection.)

218

rity, but it ran contrary to his nature and he soon reverted to the multicolor textures so typical of his art. These paintings, the third stage, devoted mainly to bathing women and other female nudes, were slow to win recognition and even today are not highly valued by some critics and collectors. Less spontaneous than his early work, there is more attention to line and form but color is still dominant.

Renoir was not afraid to change; he did not hesitate to give up styles and subjects that had brought him considerable reputation; he even tried sculpture. He was a man remarkably free of bitterness or jealousy, a man without complexity. He stated his personal philosophy of art and life simply, "For me, a picture must be a pleasant thing, joyous and pretty — yes, pretty. There are too many unpleasant things in life for us to fabricate still more." The palette of colors he used was also unassuming and is described in Chapter 3.

11-24. A TURN IN THE ROAD. Alfred Sisley. There is boldness and self-confidence in the style. The colors are natural—the chalky white and blue of an overcast sky, soft greens and pinks reflected in whites. (Courtesy of The Art Institute of Chicago. Charles H. and Mary F. S. Worcester Collection.)

Alfred Sisley (1839-1899)

Alfred Sisley ranks as one of the great Impressionists. His connection with the Gleyre studio and Monet, Renoir, and Bazille was noted earlier. Middle-class, with a comfortable early life, he later experienced financial privation. Monet and Renoir lived to gain modest returns on their art, but Sisley died a poor man. After he was dead, however, canvases which in dire times he had sold for 10 or 12 dollars began to fetch many thousands.

Sisley painted landscapes almost exclusively. He was a great colorist, worked with a luminous palette, but preserved the apparent structure of his subjects. There is a bit of color divisionism, but Sisley relied mostly on pure hues and bold contrasts. He did not permit style to dominate his compositions.

11-23. SNOW AT LOUVECIENNES. Alfred Sisley. Here the absorption of the artist is with winter. The color effect is colder, grayer, and bleaker. This is an outdoor, not a studio painting. (Courtesy of The Phillips Collection, Washington, D. C.)

Other Impressionists

Armand Guillaumin (1841-1927) is important as an Impressionist and as a teacher of Paul Signac, the Neo-Impressionist. He painted somewhat in the manner of Sisley but with more ruggedness. His impulsive use of vivid hues anticipated the Fauves and brought violent criticism when first exhibited. In his use of sweeps and

dashes of vibrant colors he was apparently influenced by his contemporaries and by the teachings of Chevreul on the phenomena of simultaneous contrast.

Frédéric Bazille (1841-1870) who died in action during the Franco-Prussian war at the age of 29, was one of the original Impressionist group. Middle-class and with a small allowance, he gave up medicine for painting and was one of the first to convert to a lively palette. His subjects are remindful of Courbet and Manet: out-of-door scenes, family groups, bucolic landscapes, and benign portraits, all in keeping with the spirit of impressionism. Perhaps he would have become as great or greater than many of his contemporaries, for he had exceptional talent. His style was firm, sure of itself, mature in spite of the artist's youth. Above all, it was colorful in the extreme. Bazille was forgotten for a while after his untimely death, but his quality was rediscovered and his paintings — less than a hundred in number — are today justly revered.

Berthe Morisot (1841-1895), one of the two women included here, knew Manet and had several portraits done by him. By good sense or intuition she put her faith in Impressionism and was an early member of the group. Indeed, she probably had some influence, even if slight, in encouraging Manet, nine years her senior, to brighten his palette and consider outdoor painting. Like Bazille, Berthe Morisot was middle-class and favored everyday scenes that reflected

11-26. PORTRAIT OF FREDERIC BAZILLE. Pierre Auguste Renoir. Both artists were born in the same year, but Renoir outlived Bazille by almost 50 years. (Courtesy of Louvre, Paris. Photograph by Giraudon.)

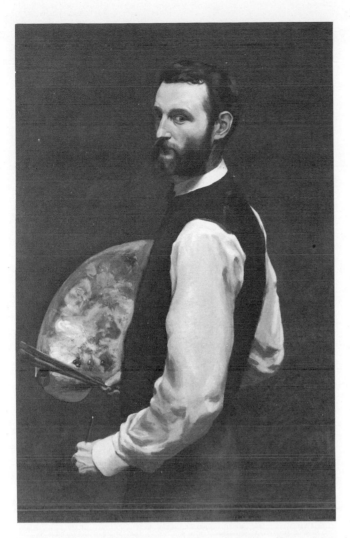

11-27. SELF-PORTRAIT. Frédéric Bazille. Everything here is magnificent. Clearly indicated on the palette (top to bottom) are black, vermilion, yellow ocher, yellow, white, deep blue, deep green, and deep blue-green. (Courtesy of The Art Institute of Chicago. Gift of Mr. & Mrs. Frank H. Woods in Memory of Mrs. Edward Harrison Brewer.)

11-28. THE ARTIST'S FAMILY ON A TERRACE NEAR MONTPELLIER. Frédéric Bazille. Second version. The color effect is as natural, gracious, and unassuming as the composition. (Courtesy of Louvre, Paris.)

11-29. LADY AT HER TOILET. Berthe Morisot. The colors are feminine and pastel in quality. The technique is that of Impressionism. (Courtesy of The Art Institute of Chicago. The Stickney Fund.)

11-30. THE BATH. Mary Cassatt. A harmony of color that is dramatic and unusual is achieved here. The background is green; the mother's dress is striped with white, gray, and soft green; there are golds and reds in the rug—all planned to set off the pink flesh of the child. (Courtesy of The Art Institute of Chicago. Robert A. Waller Fund.)

the good and civilized life. She did not point or divide her colors, preferring extended and graceful strokes that preserved shape and form, yet bathed everything in radiant light.

The friendship of Edouard Manet and Berthe Morisot was a rewarding one, and a similar friendship existed between Edgar Degas and Mary Cassatt. A great part of Impressionism was feminine in spirit.

Mary Cassatt (1844-1926) was born in Pittsburgh, the daughter of a banker. She was wealthy, intelligent and devoted to art both as a patron and painter. Introduced to Degas, she came under his influence and in middle life gave up her social affairs for esthetic pursuits. She joined the Impressionists, exhibited with them, and was duly admired for her work. When Durand-Ruel needed money, Mary Cassatt lent it to him. She prevailed upon her rich American friends to buy Impressionist works and did much to bring prominence to French artists, before they had much recognition in their own country.

Paul Cézanne (1839-1906)

Cézanne was one of the first of the Impressionist group, one of the most loyal and critical, faithful and obstinate. He eventually broke with Monet and the others for temperamental reasons and irascibility perhaps brought on by diabetes. For a time Cézanne painted with a division of colors and tones. But he rejected this for firmness, mass, solidity, plasticity. Thus to the world of art he is less associated with Impressionism than with Post-Impressionism. One thinks of Cézanne in the company of Monet, Renoir, and Pissarro, and also as vividly identified with van Gogh and Gauguin. He knew them all.

Impressionism led to Neo-Impressionism and then soon succumbed to attack. But Cézanne's genius, his acuteness of perception, his discoveries and inventions, were to proceed to continued victories. "All of modern art starts with Cézanne," it has been said, "he is the ancestor, the father." Because of this, a proper account of him belongs in the next chapter of this book.

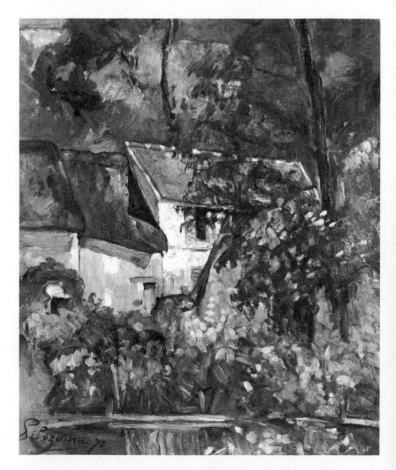

11-31. HOUSE OF PERE LACROIX. Paul Cézanne. The roofs are red and tan; the sides of the house are buff. In the background, soft tones of green scale from gold, to yellow-green, to blue-green. (Courtesy of National Gallery of Art, Washington, D. C. Chester Dale Collection.)

Chapter 12
Neo-Impressionism and Post-Impressionism

Although the Impressionist movement was to continue for some years, in 1880 its exponents began to disperse. What harmony there had been turned into dissonance when Monet, Renoir, Sisley, and Cézanne decided not to participate in the exhibit of 1880, the fifth group exhibit. These defections and the introduction of new names and new paintings left the show wanting so far as Impressionism was concerned. The movement had already lost much of its rebellious excitement and glamor. Indeed, by now the French Salon itself had changed its views and had softened its prejudices to the remarkable extent of welcoming the new art.

When the artists were together — and such meetings became rare — disagreements seemed to arise on all sides. Perhaps the men were becoming old and crotchety, grown set in their ways. Degas even proposed that the term *Impressionists* be dropped for that of *Independents*.

The story at this point is one of age and decline for the artists and of modest success for their heroic ventures. The rebels of a past generation grew conservative and in turn were attacked by other rebels. Impressionism would soon pass into art history, no longer imperious and contemporary. Before discussing its final year, 1886, here are a few notes on individual destinies.

Monet retired to Giverny, painted his famous "Haystacks," "Poplars," "Water Lilies," and "Rouen Cathedral" series, each subject repeated over and over at different hours of the day to attain what he called instantaneity. Even though critics evaluated these experiments as superficial, they sold readily. The aging painter became prosperous, his canvases selling for as much as 800 dollars. He reached the venerable age of 86 years.

Renoir traveled widely, including the Orient, and then spent active days at Paris and Provence. Like Monet, he became prosperous and painted to the end of his life, finally with his brush tied to his wrist, dying at his easel at the age of 78.

Degas became a hermit in the center of Paris. Because of weakening eyesight, he limited much of his work to delicate pastels; when his eyesight failed, he set aside his crayons and brushes and modeled with wax and clay. An irascible and bitter man, he cut himself apart from his friends, remaining loyal only to the saintly and steadfast Pissarro. He lived to be 83 years old.

Cézanne did not have the success that came to Monet and Renoir. As late as 1895, he was still rejected. In this year, thanks to the incredible Pissarro, a young art dealer, Ambrose Vollard, exhibited a number of Cézanne's works and then the "refined savage" began to attract admiring followers to his studio in Aix. By 1889, he started to sell paintings at fair prices. Eventually he was acclaimed as the independent leader of a new generation.

Cézanne had once identified himself as "Pupil

of Pissarro," his "humble and colossal" friend, and indeed Camille Pissarro was an extraordinary man. Coming at the very beginning of the Impressionist movement, he gave it direction and cohesion, carried it directly into Neo-Impressionism, then moved squarely into the midst of Post-Impressionism itself. Pissarro was a part of the "new painting" from the beginning, and he knew everyone concerned with it until he died at the age of 73.

Other Impressionist painters went their different ways and many continued to produce excellent works, but the impact of Impressionism as an advanced art movement ended in 1886. In this important year, several noteworthy events took place.

First of all, it was the year of the eighth and last joint Impressionist exhibit, also a divided one. The generous Pissarro, having met and admired the youthful Neo-Impressionists, Seurat and Signac, wanted both represented. Pissarro succeeded in this and the canvases of Seurat and Signac were shown, and also those of another promising artist, Paul Gauguin. But the exhibit was avoided by Monet, Renoir, and Sisley, and so the ranks of Impressionism were permanently broken.

Secondly, in 1886 the loyal dealer, Durand-Ruel, having been asked by the American Art Association to arrange an exhibition of Impressionism in New York, crossed the Atlantic with canvases of all the patriarchs, and in addition the Pointillist works of Seurat and Signac. As a result of the American exhibition, the great French movement was recognized and acknowledged. Henceforth, America superceded France as the most enthusiastic and lucrative market for art.

Thirdly, in the same year, Félix Fénéon, a well-known writer and critic, issued a pamphlet, *The Impressionists in 1886*, which tolled the bell on the passing of what was now old, and heralded what was now new — the art of Seurat and Signac. He was critical of Monet, Renoir, Degas, Gauguin, was mild toward Pissarro, and declared Neo-Impressionism, as based on the teachings of Chevreul, Rood, Henry, and Sutter, to be the truly great art of the day. His views were respected, and he subsequently went on to eulogize such men as Vuillard, Bonnard, and Lautrec

who were known as Nabis and who declared themselves to be rebels against Impressionism. To quote John Rewald:

> Fénéon's . . . entire admiration being centered on Seurat, he made no secret of his conviction that Impressionism had been supplanted by Seurat's new style. He showed clearly that whatever joined Seurat and Signac to their predecessors was too indefinite a link for the young painters to be regarded as Impressionists, even though they had participated in the eighth exhibition of the group. It was at this moment that the term Neo-Impressionism first appeared. As Signac later explained, this name was adopted not to curry favor (since the Impressionists had still not won their own battle) but to pay homage to the efforts of the older generation and to emphasize that while procedures varied, the ends were the same: light and color.

Then, also in 1886, Vincent van Gogh came to Paris to live with his brother, Theo, an art dealer who handled the works of some of the Impressionists. Pissarro met van Gogh in Paris and considered taking him into his own home, but this plan was not approved by Madame Pissarro.

Pissarro was influential throughout the entire Impressionist movement — as an Impressionist, a Neo-Impressionist, and as the man who, with his life-long friend Cézanne, initiated the Post-Impressionists, Gauguin and van Gogh.

The Neo-Impressionists

Appropriately, the story of Neo-Impressionism begins and ends with Camille Pissarro. He met Seurat in 1885 and was converted to the new technique in 1886. Rewald quotes a letter written by Pissarro to Durand-Ruel in which the painter explained that he wanted:

> . . . to seek a modern synthesis by methods based on science, that is, based on the theory of colors developed by Chevreul, on the experiments of Maxwell, and the measurements of O. N. Rood; to substitute optical mixture for the mixture of pigments, which means to decompose tones into their constituent elements; for this type of optical mixture stirs up luminosities more intense than those created by mixed pigments. It is M. Seurat, an artist of great merit, who was the first to conceive the idea and to apply the scientific theory after having made thorough studies. I have merely followed his lead . . .

There is considerable evidence that Monet and Renoir resented the intrusion of the young Seu-

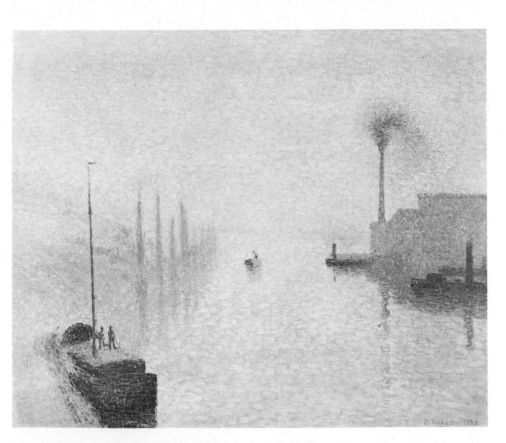

12-1. RIVER, EARLY MORNING. Camille Pissarro. This painting was done under the influence of Seurat. The atmospheric effect is achieved with dotted pastel tints. (Courtesy of John G. Johnson Collection, Philadelphia.)

rat and did not take part in the 1886 Impressionist show because of him. Yet openhearted Pissarro, at age 56, deferred to the style of Seurat, a youngster 27 years old.

Neo-Impressionism, which did not last very long, can be credited to and explained in terms of two men, aside from Pissarro — Georges Seurat and Paul Signac. However, before presenting biographical notes on these two artists, let me again as with Impressionism delve into the scientific background of the new movement. Impressionism was greatly influenced by the writings of Chevreul but Neo-Impressionism was based largely on the technical findings of Ogden N. Rood, Hermann von Helmholtz, David Sutter, and Charles Henry. The Neo-Impressionist period was marked by an absorbing interest in the science that pervaded the new art. This science was eagerly accepted by the painters. Art journals published essays on the science of color, and the artist was advised to devote himself to such inquiry. It was generally assumed by men who were to become the greatest painters of their generation that ignorance in matters of color was unforgivable and that regardless of individual talent, genius, or feeling, a man needed to be versed in the phenomenon of vision and physiological optics.

Ogden Nicholas Rood (1831-1902)

Ogden Nicholas Rood was born in Danbury, Connecticut of Scottish descent. He graduated from Princeton College in 1852 and became a graduate student at Yale. Rood was an amateur painter, had a keen interest in all art, and was one of the very few color scientists who could not resist including the problems of painting while discoursing on highly scientific and technical matters. Hence Rood's writings which were prolific, attracted artists who recognized a kindred soul. Other scientists of Rood's bent were Wilhelm Ostwald and David Katz.

Preparing for life as a scientist, Rood lived in Munich from 1854 to 1858, dividing his time between sober scientific study and painting. In those days, a scientist was supposed to know about everything. Although initially trained as a physicist, Rood returned to America and became professor of chemistry at the short-lived University of Troy in New York State. Here he

225

became interested in physiological optics, a field of endeavor that was to bring him world-wide fame.

In 1863, at the age of 32, he became chairman of physics at Columbia College, a position he held for 38 years. However, the year 1879 was the vital one for Rood and for Neo-Impressionism, for this was the year his *Modern Chromatics* was published. The work became a masterpiece, unique for its inquiries into the human perception of color rather than the mere physics of color — a novelty in technical literature on color. It remained in print, both in America and abroad, until 1902. A life of 29 years for a book on color is a notable record, exceeded however by Chevreul's book.

Rood studied everything that had to do with color and human vision. He reviewed the efforts of others and did remarkably original and abundant labors on his own. He became one of the foremost authorities of his time on physiological optics. And all the while he continued to practice painting, travel abroad, and take the problems of the artist to heart.

In his preface to *Modern Chromatics* he wrote:

> Turning now from the purely scientific to the esthetic side of the subject, I will add that it has been my endeavor also, to present in simple and comprehensive manner the underlying facts upon which the artistic use of color necessarily depends. The possession of these facts will not enable people to become artists; but it may to some extent prevent ordinary persons, critics, and even painters, from talking and writing about color in a loose, inaccurate, and not always rational manner. More than this is true: a real knowledge of elementary facts often serves to warn students of the presence of difficulties that are almost insurmountable, or, when they are already in trouble, points out to them its probable nature; in short, a certain amount of rudimentary information tends to save useless labor.

Rood undertook discussions of reflected and transmitted light, color dispersion, and the constants of color, which he looked upon as purity, luminosity, and hue. There were notes on the production of color by interference, fluorescence, absorption, including a list of pigments that would stand long exposure to light. Color perception, the phenomena of afterimages, colored shadows, color mixtures, theories of color vision, were all taken up. He explained how tinted light affected the appearance of surface colors, talked

12-2. OGDEN ROOD. Detail from an unsigned portrait. His *Modern Chromatics* became one of the gospels of Neo-Impressionism. (Courtesy of Columbia University Club.)

of complements, simultaneous contrast, color harmony, and the duration of color impressions on the retina. He devised a color solid in the shape of a double cone in which everything seen by the eye could be charted, saying, "In this double cone, then, we are at last able to include all the colors which under any circumstances we are able to perceive."

Of direct interest to the Neo-Impressionist, and indeed a statement of the Divisionist or Pointillist technique, were these words:

> We refer to the custom of placing a quantity of small dots of two colors very near each other, and allowing them to be blended by the eye at the proper distance.... The results obtained in this way are true mixtures of colored light...This method is almost the only practical one at the disposal of the artist whereby he can actually mix, not pigments, but masses of colored light.

He went far beyond this mere observation. There were tabulations comparing visual mixtures with pigment mixtures, effects of colored light falling on colored surfaces, plus a wealth of analytic comments on color in nature. Because Rood was artist as well as scientist, what he set forth could be given quick and intelligent appli-

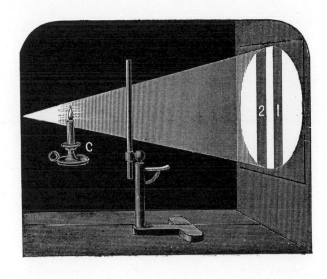

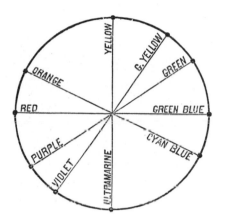

12-3. ROOD DIAGRAMS. He used such illustrative material to explain visual phenomena. (From *Modern Chromatics*.)

12-4A. WATERCOLOR. Ogden Rood. Though Rood more or less wrote the prescription for the Pointillist technique, he did not favor it himself. (Courtesy of Columbia University.)

12-4B. WATERCOLOR. Ogden Rood. Both the Rood paintings shown are drab in color. He preferred the conservative approach in his own work. (Courtesy of Columbia University.)

cation. There is little wonder that the Neo-Impressionists accepted *Modern Chromatics* as one of the basic texts of their art.

Rood was well aware of developments in France at the time; he greatly admired Turner and recommended study of Turner's work. Radical principles were derived from his research. But Rood's own amateur paintings were traditional and conservative. However, here is an amusing tale reported by his own son, Roland, in an article for *The Scrip* magazine, April 1906:

That Professor Rood in his *Modern Chromatics* endorses Impressionism is an assertion frequently enough made; but what he himself thought about the matter is not so generally known. I once had the opportunity of finding out. I had been abroad studying painting in the Paris art schools, and had also tasted Impressionism in Giverny; my head was filled with violent violets and chrome yellows, and the forms of solid bodies seemed *à la* Giverny, as illusory as dreams. In this state of mind, with his book "under my arm," I went to call on my father to tell him that all the excellence of my pictures was due to his recipes. My enthusiasm was instantly cooled, however, when I saw him. He seemed ill and mentally much depressed.

"Are you ill?" I asked.

"No," he replied, "I am very well, but I have just been to see an exhibition of paintings at the galleries of Durand-Ruel," and he groaned.

"What are they?"

"They are by a lot of Frenchmen who call themselves 'Impressionists;' some are by a fellow called Monet, others by a fellow called Pissarro, and a lot of others."

"What do you think of them?" I ventured.

"Awful! Awful!" he gasped.

Then I told him what these painters said of his theories. This was too much for his composure. He threw up his hands in horror and indignation, and cried—

"If that is all I have done for art, I wish I had never written that book!"

Some years later, I had the opportunity thoroughly to discuss the question with him. It was in the country, and together we tried many experiments in landscape painting, always referring to his book for the rules. At times, he seemed doubtful if in fact he had not endorsed Impressionism; he seemed to feel that possibly while searching for truth in one direction he had also uncovered it elsewhere. Turner he understood and considered logical. The conclusion, however, to which he finally came is summed up in the last statement he made to me regarding the matter:

"My son, I always knew that a painter could see anything he wanted to in nature, but I never before knew that he could see anything he chose in a book."

Helmholtz, Sutter, Henry

These three scientists also contributed important color research during this period. From the great and celebrated Hermann Ludwig von Helmholtz, a genius of first rank, came highly regarded data on theories of color vision, on color-blindness, and the spectrum. Helmholtz wrote an accurate description of color fundamentals, enlarged the science of physiological optics, pointed out the difference between mixtures of light and pigment, and determined the true nature of complementary color relationships. He had only a secondary interest in esthetics, but others borrowed freely from him in an endeavor to turn his factual findings to more artistic ends.

One such disciple was David Sutter who in 1880 published an important series of articles on

the "Phenomena of Vision" in *L'Art*. In these days of the twentieth century when art is meant to be creatively free, and when expression must be without restrictions, it is interesting to read these words of Sutter written in 1880 and to appreciate that what he said was highly respected and accepted:

> Despite their absolute character, rules do not hamper the spontaneity of inventor or executor. Science delivers us from every form of uncertainty and enables us to move freely within a wide circle; it would be an injury both to art and science to believe that one necessarily excludes the other. Since all rules are derived from the laws of nature, nothing is easier to learn or more necessary to know. In art everything should be willed.

Lastly, there was the young scientist, Charles Henry, who sought to embrace all of art — painting, poetry, literature, music, philosophy — under the wing of science. Henry, Seurat, and Signac became friends. Seurat, in fact, followed Henry's theories religiously and applied them directly to his canvases, while Signac drew charts for Henry's books.

His *Theory of Directions* and his treatise on *The Scientific Esthetic*, 1885, and later his *Education of the Spirit of Colors*, 1888, had broad success and were followed by many other writings. The Neo-Impressionists and Post-Impressionists avidly studied Henry. Signac wrote to van Gogh about one of Henry's publications:

> It is a book on the esthetic of forms, with an instrument — the esthetic table of C. Henry — that permits the study of measures and angles. One can thus see whether a form is harmonious or not. This will have a great social importance, especially from the point of view of industrial art. We teach the workers, apprentices, etc., whose esthetic education until now has been based on empirical formulas of dishonest or stupid advice, how to see correctly and well. I shall send you one of these pamphlets as soon as it is printed.

What did Henry teach? According to Rewald in his outstanding book, *Post-Impressionism:*

> The course of his researches had permitted Charles Henry to establish a close relationship between esthetic and physiological problems, after he had set out to discover which spatial *directions* are expressive of pleasure or dynamogeny, and which of pain or inhibition. His findings were that pleasure is associated with an upward direction and with movement from left to right, while the oppo-

site effect is achieved by moving downward or from right to left; intermediary excitations being occasioned by intermediary directions. The scientist also found that certain colors, such as red and yellow (*warm* colors), are more or less agreeable (dynamogenous), whereas others — green, violet, and blue (*cold* colors) — are relatively inhibiting. Henry consequently established a chromatic circle on which agreeable (dynamogenous) colors correspond to agreeable (dynamogenous) directions, and inhibiting colors to inhibiting directions, also taking into consideration the theory of contrast, the wave length of the various colors, etc. Exploring rhythm and measure, Henry arrived at definitions which apply to color as well as to forms. Fénéon hailed his publications as a "flowering mathematical work of art which re-animates all sciences."

Gauguin, like Seurat, was taken by such ideas. It was Seurat, however, who earnestly attempted to put them into action and to formulate principles of color, form, and line, some of which were discussed in Chapter 4.

Georges Seurat (1859-1891)

Seurat was born of well-to-do parents, in Paris. He died at the untimely age of 32. During his short life he showed prodigious energy, patience, and concentration; he was that rare artist who could analyze and think. Very early in life he showed exceptional skill as a draftsman, technician, and colorist. A master work, "Une Baignade," completed when Seurat was 25 years old — the canvas measures over 6½ by 9½ feet — was rejected by the *Salon* in 1884 (Ill. 12-5). However, the same year it was included in the first exhibition of a newly formed *Society of Independent Artists*.

"Une Baignade," painted in a new and methodically neat order, exhibited many dull and brownish tones. But Seurat's friendship with Signac and probably Pissarro soon converted him to a more brilliant palette and to the writings of Chevreul, Rood, Sutter, and Henry.

Seurat had admired Monet. Now he came under new influences and labored feverishly. Pure colors alone were employed, and these were applied in myriads of dots that he expected would attain heightened brilliance through optical mixtures. In his opinion, color variations should be achieved in this manner, rather than through mixtures on the palette.

Working against time — perhaps with prescience of his fate — Seurat ignored the heated

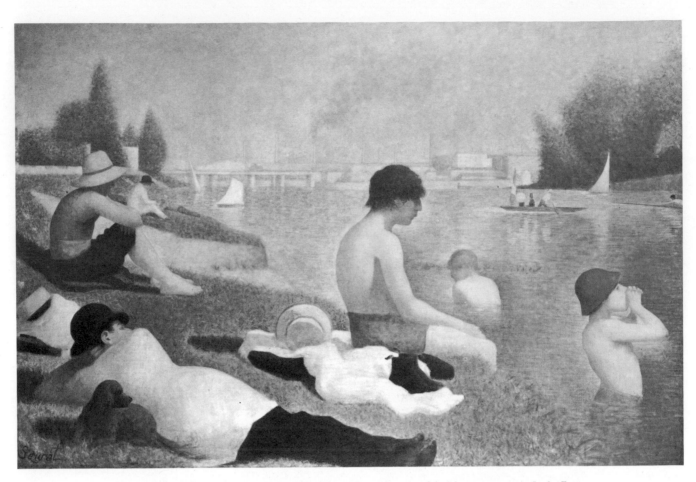

12-5. UNE BAIGNADE. Georges Seurat. The colors in this big canvas are drab. Later his palette brightened. (Courtesy of Trustees, National Gallery, London.)

polemics that greeted his art and busied himself with his ambitions. He became the center of a close circle of friends and was sensitive and jealous of his individuality in founding a new "school." Although he died very young indeed, he left a considerable body of work that was neglected at first and then bought, preserved, and cataloged as among the most unusual esthetic achievements of the late nineteenth century.

Paul Signac (1863-1935)

Paul Signac, friend, champion, and confrere of Seurat, was also from a middle-class family and able to paint without family resistance. He was a man of passionate enthusiasms, with an intelligent and knowledgeable interest in science, literature, and politics as well as painting.

Starting as an admirer of Monet, he later became one of the chief Neo-Impressionists. His methods were less exacting than those of his close associate, Seurat. However, his style of painting,

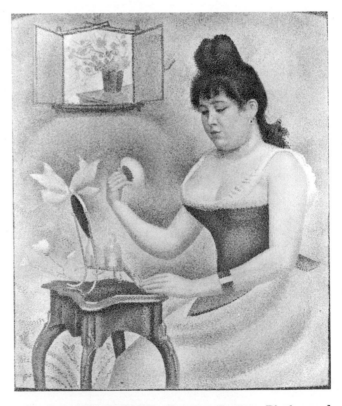

12-6. LA POUDREUSE. Georges Seurat. Blacks and browns were avoided for pure spectral hues. This composition, in over-all effect, has a blue and lilac ground, gold table, yellow dress, brown bodice, and flesh tones. (Courtesy of Courtauld Institute of Art, London.)

230

as described by Félix Fénéon, the most ardent spokesman of the movement, sets forth the whole spirit and technique of Neo-Impressionism:

His colorings spread out in spacious waves, tone down, meet, fuse, and form a polychromatic design similar to a linear arabesque. To express these harmonies and oppositions, he uses only pure colors. Arranging these on his palette in the order of the spectrum, the painter mixes only contiguous colors, thus as far as possible obtaining the colors of the prism, adding white to graduate their tone scale. He juxtaposes these dabs of paint on the canvas, their interplay corresponding to local color, light, and varying shadows. The eye will perceive them mixed optically. The variation of coloring is assured by this juxtaposition of elements, its freshness by their purity and a brilliant luster by the optical blending, because unlike a mixture of pigments, optical mixing tends to brightness.

Signac lived to the age of 72, spending much of his life in loyalty to his chosen fashion of painting and in defense of his friend, Seurat. He wrote, "And for Seurat: oblivion, silence. Yet he is a greater painter than van Gogh, who is interesting merely as an insane phenomenon."

How can Impressionism and Neo-Impressionism be evaluated? Camille Pissarro who had christened himself a Neo-Impressionist in 1886, wrote its epitaph a few years later in a com-munication to a friend, related in Rewald's *Post-Impressionism:*

I believe it is my duty to write you frankly and tell you how I regard the experiment I made with systematic divisionism by following our friend, Seurat. Having tried this theory for four years and having then abandoned it, not without painful and obstinate efforts to regain what I had lost and not to lose what I had learned, I can no longer consider myself one of the Neo-Impressionists who abandon movement and life for a diametrically opposed esthetic which, perhaps, is the right thing for the man who has the temperament for it, but which is not for me, anxious as I am to avoid all narrow and so-called scientific theories. Having found after many attempts (I speak for myself) that it was impossible to be true to my sensations and consequently to render life and movement, impossible to be faithful to the effects, so random and so admirable, of nature, impossible to give an individual character to my drawing, I had to give up. And none too soon! Fortunately, it appears that I was not made for this art which gives me the impression of the monotony of death!

As a commentary on the two schools of Impressionism, the following items may be of interest:

Impressionism: When a wealthy patron of the Impressionists, Gustave Caillebotte, died in 1893 leaving 65 paintings to the French State, with

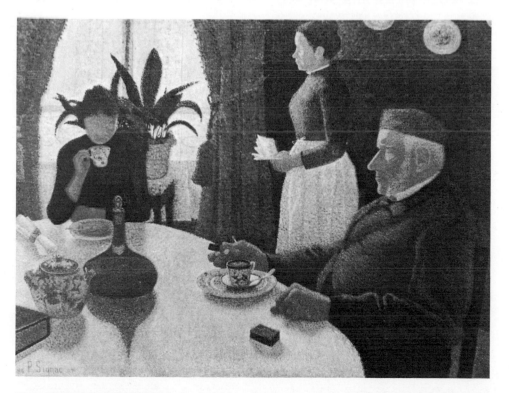

12-7. THE DINING ROOM. Paul Signac. His style was somewhat freer and even more vivid in color than that of Seurat. There are only spectral hues here, and red dots are found in all dark areas. (Courtesy of Rijksmuseum Kröller-Müller, Otterlo, Holland.)

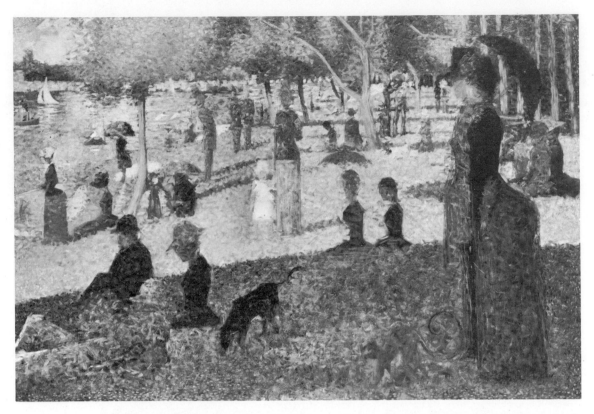

12-8. LA GRANDE JATTE. Preliminary Study. Georges Seurat. His habit was to do numerous sketches and studies of details for his few major works. This is a completely charming preliminary study. (Courtesy of The Metropolitan Museum of Art.)

←

12-9. LA GRANDE JATTE. Detail. This shows the Pointillist technique clearly. Myriad dots, applied with patience, create a unique but rigid embroidery. (Courtesy of The Art Institute of Chicago.)

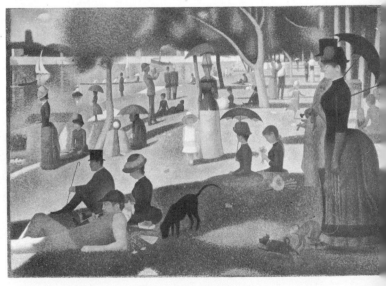

12-10. LA GRANDE JATTE. Georges Seurat. Here is the masterwork itself. The colors applied in tiny dots were mostly pure and arranged in accordance with Seurat's ideas of scientific law. (Courtesy of The Art Institute of Chicago. Helen Birch Bartlett Memorial Collection.)

232

Renoir named as executor, the protest aroused among academicians and politicians was so great that the State considered refusing the entire bequest. As it was, eight out of 16 Monets were rejected, 11 out of 18 Pissarros, two of six Renoirs, three of nine Sisleys, one of three Manets, and two of four Cézannes. In Durand-Ruel's American exhibition of Impressionism in 1886, several paintings were sold. Americans were more responsive than the French, but the great Metropolitan Museum did not buy Impressionist works until 1907. Its representation of Impressionism was aquired principally through gifts by Mrs. H.O. Havemeyer, in 1929.

Neo-Impressionism: For some time after Seurat's death, very few of his paintings were sold. His most familiar masterpiece, "La Grande Jatte," was sold by Seurat's family in 1900 for 800 francs. This is an American value of about 160 dollars and is a pittance indeed for a large and truly magnificent work of art. Illustration 12-10 and 12-8 show preliminary sketches and final paintings of this classical work.

An Evaluation

In the art of color, Impressionism is far more important than Neo-Impressionism. It is far more likely to influence the art of the future. Impressionism, with its freedom of action, its loose style, its clean palette, its bright juxtaposition of color tones will probably survive. At least it is difficult to imagine a return to the "brown gravy" schools of the more distant past.

Neo-Impressionism, on the other hand, is too formal and stiff. The style and viewpoints are not likely to be repeated. Neo-Impressionism is thus a curious incident, a passing phase in the history of color which, like Cubism, will perhaps always stand apart. In its painstaking application of dots, it is drudgery rather than discipline. It has, as Pissarro felt, "the monotony of death." Virtually anyone capable of holding a brush — and with plenty of time on his hands — can achieve the style of Neo-Impressionism. There is really nothing about it that differs very much from needlepoint, or embroidery, or tapestry weaving, or any of the meticulous arts. It is too slow to allow for spontaneity, for the dynamic and fluid, or for personality and individuality.

In Neo-Impressionism it is assumed but is only partly true that Divisionism and Pointillism result in the optical mixture of colored light, a phenomenon directly related to physics. There were said to be primary colors and binary colors, all of them pure. As such colors were juxtaposed in a composition, so would the eye mix them in the manner of corresponding light rays. Spots of contiguous colors would build up, enhance each other, and become brilliant and luminous. Complementary colors would neutralize each other and produce grays. With only spectrum hues and white on the palette, anything could be achieved — from pure hues to pastels, shades, muted tones, browns, grays, even black.

As this book has already endeavored to make clear in Chapter 6, color phenomena of vital concern to art are less likely to be found in the physiology of vision than in the psychology of the whole process of seeing. In other words, the brain serves far more significant functions in perception than does the eye.

Further, optical mixtures do not react as the Impressionists and Neo-Impressionists believed. They are not truly *additive* like the mixture of light. For example, 50 units of red light thrown over 50 units of green light will produce 100 units of *yellow* light. No such thing can possibly happen with adjacent dots of red and green pigment on a white or other ground. Optical mixtures are *medial*. That is, 50 units of one placed side by side with 50 units of another will average off to 50 units of a muddy tan — not a pure yellow.

The luminous effects expected by the Neo-Impressionists did not occur. Seurat's canvases are not brilliant and atmospheric. Turner achieved this with far greater success, and with the brain rather than the eye being responsible. Divisionism may employ gaudy pigments, but the blending at a distance tends to produce tones that fall down into dullness rather than rise up into brightness. And when colored dots form exceedingly small images on the retina of the eye, certain hues may turn completely colorless. This surprising fact was mentioned in Chapter 6.

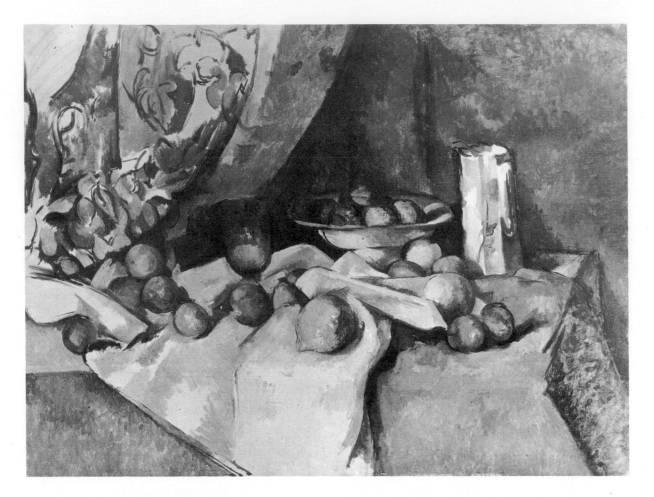

12-11. STILL LIFE WITH APPLES. Paul Cézanne. In compositions like this, Cézanne was less concerned with still life than with ideas of structure, solidity, dimension. (Collection of The Museum of Modern Art, New York. Lillie P. Bliss Collection.)

The Post-Impressionists

Neo-Impressionism lasted only a short time. Fortunately, it did not prove to be a wall from which later artists would have to retreat, but instead it was a broad, sturdy stepping stone that enabled Impressionism to advance into Post-Impressionism and to new and magnificent art forms. The familiar names now became Cézanne, Gauguin, van Gogh, and Lautrec, with the omnipresent Pissarro responsible for many innovations.

Cézanne was an Impressionist during most of his life. He ignored Neo-Impressionism. But the theories of Seurat were extensively practiced by Gauguin in 1886, Lautrec in 1887, and van Gogh from 1886 to 1888. Pissarro was friendly to them all, recognized the genius of van Gogh and lectured to him on Impressionism and Seurat's Neo-Impressionism, saying, "Originality depends only on the character of the drawing and the vision peculiar to each artist."

Paul Cézanne (1839-1906)

Post-Impressionism began with Paul Cézanne. Though an Impressionist in conviction and loyalty, he never entirely adopted the Impressionist style of painting nor its ideas of "instantaneity." On the contrary, he declared, "I wish to make of Impressionism something solid and durable, like the art of the Old Masters." Rather than paint what was flimsy and vaporous, he was convinced that "nature must be treated through the cylinder, the sphere, the cone." Art must have soundness, structure, dimension.

It would be unfair if not futile to conclude from this that the Impressionists were wrong and that Cézanne was right. Although it is generally considered true that Cézanne was exceedingly influential in guiding the course of painting during the early twentieth century, today his works are by no means any more significant than those of Monet and Renoir. In truth, the presumption of Cézanne's eminence as

the father of modern painting seems to rest largely on the overzealous evaluations of enthralled critics and historians. In the field of color, for example, his notion that structure and three-dimensional form were to be achieved through certain restricted color relationships has been all but abandoned — at least in the particular terms set forth by Cézanne. Most of all, he looked to nature for the secrets of art, but the painter of today understands art as being wholly independent of nature and dependent entirely on the personal content of human perception. Secrets, if any, lie within man, not in the world outside.

Nevertheless, Cézanne is important to the story of art and color and is perhaps the most distinguished leader of the Post-Impressionist movement.

He was born of well-to-do parents who wanted him to become a lawyer and banker. He was not a precocious youth, but he was hard-working and intelligent, and interested in athletics and music. His first studio was set up in his father's country house, and one of the first artists he knew was Camille Pissarro.

Cézanne and Pissarro became life-long friends and often spent lengthy periods together even though they were so entirely different in temperament. Pissarro was the radical and unbeliever; Cézanne, the scrupulous church-goer and conventional bourgeois. Pissarro was the poor man with an outgoing manner; Cézanne, the sober citizen of means, reserved and level-headed.

He associated himself with the Impressionists, Degas, Monet, and Renoir, but was never completely converted to their views or styles of painting. After the war of 1870, he settled in Paris where he engaged in a somber and theatrical sort of painting. Two years later, and with the encouragement of Pissarro, his palette became brighter and lighter and he painted with divided strokes. He also met van Gogh through a Dr. Paul Gachet, champion of several of the Impressionists.

Losing patience with finical brush-strokes, Cézanne soon painted in masses. This was more to his liking, and he presently gained firmness, plasticity, and strength in his work. He began to develop the intellectual qualities that would one day add measurably to his fame.

12-12. AUVERS: VILLAGE PANORAMA. Paul Cézanne. Even in the landscape, Cézanne sought a world of real and tangible things, not mere atmosphere. His colors were rich and earthy. (Courtesy of The Art Institute of Chicago. Mr. & Mrs. Lewis L. Coburn Memorial Collection.)

Upon the death of his father in 1886, he became independently wealthy and could now accept or reject the world as his spirit moved. He painted feverishly, quarrelled with his friends, but his character was formed by his dogged persistence and concentration. There was always hostility from the public and from academic circles. Fame was slow in coming, but it did come in fair measure before he died.

Pissarro once advised Cézanne, "Never paint except with the three primary colors and their immediate derivatives." Pissarro did much to encourage Cézanne in matters of color, color understanding, and color inventions. But Cézanne wanted more than color; he felt that there must be form, construction, and permanence; that if there was any use for color, it was to shape and express form. He stated his point of view in the famous saying, "Where color has its richness, form has its plentitude." The colors used in his palette are given in Chapter 3.

To Cézanne, light and shadow meant little in themselves. One modeled with color. Each area of paint became a colored plane, definite, thick, guided by reason as much as by intuition. In the relationship and proximity of colors, warm or cool, the artist could build dimension, make a picture "a concrete and complete world, a reality which is an end in itself." There must be an architecture of colors and shapes. Art must not be merely Impressionistic but indestructible and eternal.

Though Cézanne had at one time determined to paint out-of-doors, he became essentially a studio master; many of his lighting effects are weird and unnatural. Before he died, Fauvism was born, and it drew heavily from Cézanne.

Cézanne was the painter's painter, all work and no presumption, facts and not fancies. He explained, "Painters must devote themselves entirely to the study of nature and try to produce pictures which are an instruction. Talks on art are almost useless." Cézanne needed to say nothing; his works were to speak for themselves. Note the bold and sturdy quality of "Still Life with Apples," Illus. 12–11.

Vincent van Gogh (1853-1890)

With the possible exception of Paul Gauguin, no artist's personal life is better known than that of Vincent van Gogh, thanks to a host of biographies, novels, syndicated articles, and motion

12-13. THE DRINKERS. Vincent van Gogh. In admiration of Daumier, he painted this version of Daumier's "The Drinkers" from an engraving. The color effect is unique —a chalky blue atmosphere (the very opposite of van Gogh's usual fancy for yellow and yellow-green), with gray-green, gray-blue, dull red, and brown. (Courtesy of The Art Institute of Chicago. Joseph Winterbotham Collection.)

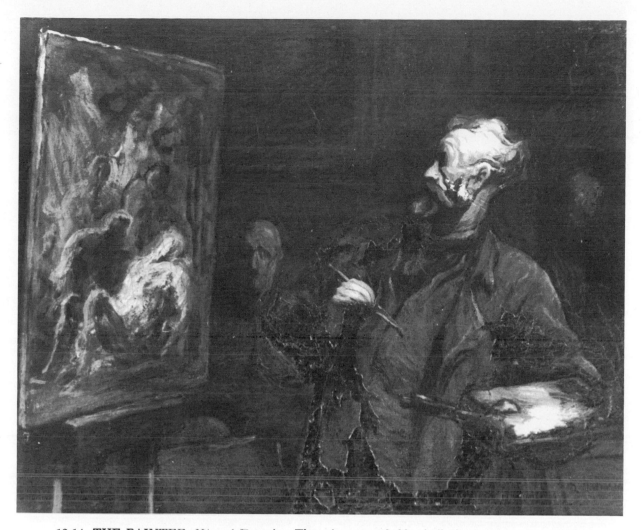

12-14. THE PAINTER. Honoré Daumier. There is a remarkable similarity between the technique and brush-handling of Daumier and that of van Gogh. Both have spirit and flair. (Courtesy of Museum of Art, Rheims.)

pictures. He led a short but incredibly active life and came to know many of the great painters of his time: Pissarro, Degas, Guillaumin, Cézanne, Seurat, Signac, Gauguin, and Toulouse-Lautrec.

Born in Holland, son of a clergyman, van Gogh was absorbed by religious convictions at an early age and became an evangelist, dedicating himself to an ascetic life among the poor and destitute. After this phase, he studied painting and made his decision to devote his life to art. Unstable by temperament, he eventually became insane, spent some time at the Saint-Rémy-de-Provence Asylum, and finally ended his life by firing a bullet into his heart. He was then 37 years old. Yet in this brief and fervid span of time, he developed into one of the first and greatest of the Expressionists.

His early paintings of cottages, weavers, and peasants were done in a dark, gloomy, and heavy manner. Then after exposure to Impressionism, and a number of psychic experiences, his palette took wings. He completed over two hundred pictures in Arles in a period of 15 months during 1888 and 1889, and 150 more at the asylum and in Paris. Only a few of the works of Vincent van Gogh were sold during his lifetime, even though his beloved brother, Theo, was an art dealer.

In the Foreword, there is a discussion of the primacy of color in art and in human sensation, and the heightened color perception of gifted persons. All this was true of van Gogh. Aldous Huxley wrote, "The mind is its own place, and the places inhabited by the insane and the exceptionally gifted are so different from the places where ordinary men and women live, that there is little common ground of memory to serve as a basis for understanding or fellow feelings."

Human imagination and fancy — sane or insane — take delight in color. "Bright, pure colors are characteristic of the Other World," said Huxley. In his vision of the New Jerusalem, St. John the Divine saw color glisten in twelve foundations garnished with twelve precious stones, twelve pearly gates, a wall of jasper, and streets of gold.

There is little doubt that Vincent van Gogh

12-15. THE OLIVE TREES. Vincent van Gogh. He did not hesitate to paint the sun itself in a cloudless sky. The sky is vivid yellow, the mountains are violet; the earth and trees are streaked with rich green, gold, and brown. (Courtesy of The Minneapolis Institute of Arts.)

12-16A, 16-B. CYPRESSES and Detail. Vincent van Gogh. A striking demonstration of van Gogh's vigorous style. The coupling of firm brush strokes with vivid colors was later emulated by the Fauvists. (Courtesy of The Metropolitan Museum of Art. Rogers Fund, 1949.)

ranks as one of the greatest of all colorists in the history of art — greater than Monet and as great perhaps as Turner. This author believes, however, that in the case of van Gogh, color expression may have had some psychic or neurotic origin, that what he "saw" and recorded on his canvases was far beyond mere audacity or impulsiveness, as with the Fauvists. Undoubtedly, van Gogh's vision was abnormal. Sensitive brain activity within him probably caused colors — those of nature included — to appear not only blazingly intense but twisting and turning with violent movement. All this is remarkably expressed in many of his paintings such as "The Olive Trees," Ill. 12–15 and "Cypresses," Ill. 12–16 A and B. Note the vigor and intensity of his style.

In the last creative years of van Gogh's life, from 1888 to 1890, he used dazzling colors. His canvases are brilliant with vermilion, emerald, golden yellow, and penetrating blue. His visions were those of a god, but he was tormented by a dreadful sense of failure. The divided stroke of Impressionism had now become too cumbersome. He needed to work with clean-cut sweeps of shadowless hue, with precise and incisive strokes and swirls. There were "delirious landscapes, surging mountains, whirling suns, cypresses and olive trees twisted by heat whirling arabesques, dismantled forms, perspective fleeing toward the horizon in a desperate riot of lines and colors The fire lit by his hand was communicated to his brain," as described in *A Dictionary of Modern Painting*.

Yet none of this was the abandoned impulse of a madman. Van Gogh never forgot balance, order, and reason in his paintings; he was always conscious, dedicated, and real; he understood the need for harmony. There might be violence, but never chaos. Few artists in any century have had so sure a hand, so little need for change or alteration. He may have painted quickly at his easel, but only after patient deliberation. These qualities are revealed in most of his art. John Rewald tells of the kind of life the painter often led:

As far as one can judge from his letters, it would seem that van Gogh, despite his exaltation, did not exactly work under the pressure of an overpowering first impression. Long daily walks took him across the lovely countryside, and whenever he saw a tempting motif or one that offered elements which challenged his imagination, he would decide to return and work there. Thus each time he set out with a canvas and his box of paints, he knew where he was going . . .

It is a delight to write of van Gogh and his love of color. Quotations from a few of his letters were given in Chapters 3 and 4. In his Arles period, his palette was as candent as the rainbow itself. Later, at the asylum and shortly before his death, his colors would at times deepen and become more subdued: muddy browns, ochres, dull purples, soft tonalities that would be without accent. But while his spirit surged, color was everything. His friend Milliet wrote, "He painted too broadly, paid no attention to details, did not draw first. . . . He replaced drawings by colors."

In his effort to paint the "diamonds" that glistened in the night sky, Rewald relates that "he stuck a number of burning candles into his hatband and painted by the light of this strange and flickering crown, a circumstance which prompted the citizens of Arles who watched him to consider Vincent more than a little crazy."

12-17. THE CHURCH OF AUVERS. Vincent van Gogh. This was painted shortly before van Gogh's death. The sky is deep blue; the church is white with an orange roof; the ground is yellow, yellow-green, and brown ocher. (Courtesy of Louvre, Paris.)

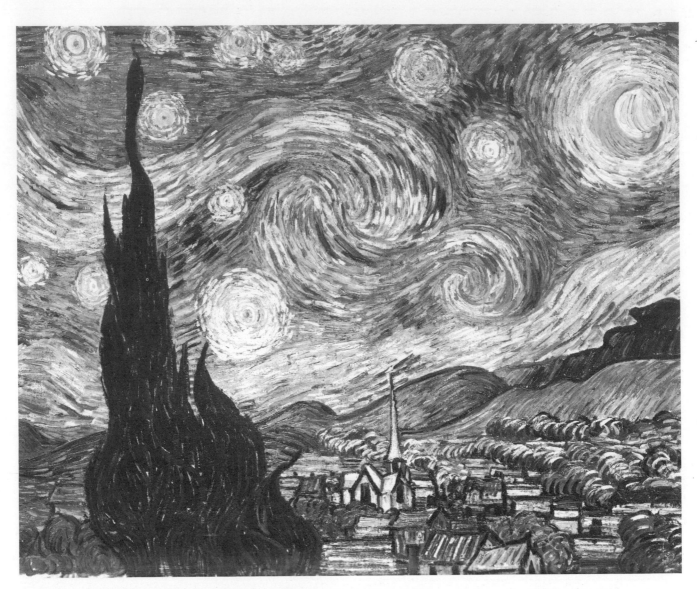

12-18. THE STARRY NIGHT. Vincent van Gogh. This singular and dynamic painting is one of the most remarkable of modern times. There is a passionate effort to express light, motion, the mystery of nature. (Collection of The Museum of Modern Art, New York. Lillie P. Bliss Bequest.)

This resulted in his famous painting "The Starry Night" (Ill. 12-18). To his brother, van Gogh admitted that the fascination of night "haunts

12-19. BEDROOM AT ARLES. Vincent van Gogh. The only spot of white is in the mirror. (Courtesy of The Art Institute of Chicago. Helen Birch Bartlett Memorial Collection.)

me always." He wrote, "The problem of painting night scenes . . . on the spot and actually by night interests me enormously."

Done in anticipation of Gauguin's visit in 1888, he described the painting of his bedroom in Arles (Ill. 12-19):

And it gave me tremendous pleasure to paint this interior without artifice, of a simplicity á la Seurat: flat surfaces, though coarsely brushed with heavy pigment; the walls pale lilac, the floor of a broken and faded red, the chairs and the bed chrome yellow, the pillows and the sheet very pale lemon green, the blanket blood red, the dressing table orange, the washbasin blue, the window green. I should have liked to express absolute peacefulness through all these various colors, you see, where the only white note is given by the small spot of the mirror with its black frame (so as to cram yet the fourth pair of complementaries into the painting). Well, you will see it with the others and we shall talk about it, for I often don't know what I am doing, working almost like a somnambulist.

Paul Gauguin (1848-1903)

Among artists, Paul Gauguin was one of van Gogh's closest friends. There is much that is human, touching, and tragic about the lives of both men — van Gogh who committed suicide, Gauguin who renounced social duty for artistic freedom and who brought misery to his family and himself. Here is a thumbnail biography of Gauguin: He was born in Paris and had a substantial background, enlisted in the Navy when he was 17 years old, became a broker shortly after his discharge, worked methodically for 12 years, made money, and married a Danish girl. When he was about 35 years old, Gauguin was introduced to the art of painting and discovered that he had unusual talents. He thereupon gave up his job — much to the disgust of his family and family acquaintances — and devoted the rest of his life to painting. Early in his painting career, he settled in the South Sea Islands where he spent the rest of his life except for occasional visits back to France and Denmark. His life in the islands included a number of lurid incidents such as his imprisonment by the local government and an attempt at suicide. He died of syphilis, in one of the Marquesas.

Gauguin is outstanding for beauty of composition; Cézanne for form and space; van Gogh for color. Gauguin had been schooled in Impressionism and Neo-Impressionism; the genial Pissarro had been one of his teachers and mentors. However, Gauguin broke with these styles about 1887 and gave himself to massive and simplified

12-21. THE MOON AND THE EARTH. Paul Gauguin. Here the colors are mostly rich and somber, with strong accents of red. The result is beauty of composition in simple mass and exotic hue. (Collection of The Museum of Modern Art, New York. Lillie P. Bliss Collection.)

forms and planes, and to flat exotic colors. He seemed interested essentially in design, paid little attention to light and shade, and showed exquisite taste throughout, becoming the idol, years later, of a new school of Non-Representational artists. Gauguin declared, "Painting is an abstraction." His canvases are sumptuous, powerful, mysterious, human. The colors are lush and sensuous, with a special beauty in the pinks. Note these merits as readily perceived in "The Moon and the Earth," Ill. 12–21.

On occasion, Gauguin taught at Pont-Aven in France where he attracted many artists. He knew van Gogh and lived with him at Arles in 1888 — but not for long. "On Christmas night,

12-20. WHY ARE YOU ANGRY? Paul Gauguin. The atmosphere is clear, but as if the sun were behind a cloud. The colors are in patterns of rich green, terra cotta red, gold, blue, light tan. (Courtesy of The Art Institute of Chicago. Mr. & Mrs. Martin A. Ryerson Collection.)

during a futile quarrel, van Gogh threw his glove in Gauguin's face. The next day, Gauguin, walking in the street, heard hurried steps behind him. He turned and saw van Gogh with razor in hand." This episode is reported in *A Dictionary of Modern Painting.*

Gauguin gave Post-Impressionism increased stature. Nevertheless, the art of color soon went into decline, for the concentration of interest, the admiration of science and "natural law" went out of fashion much more abruptly than it had come in.

The Nabis

There were many other worthy painters in France during the period covered in this chapter. There were the Symbolists — Gustave Moreau (1826-1898), Odilon Redon (1840-1916) — opposed to naturalism and taken by dreams and symbolic allusions. There were the Nabis — Pierre Bonnard, Edouard Vuillard, Maurice

12-23. THE MUSES. Maurice Denis. The colors in this painting are mostly browns, black, rusty reds, and muted golds. (Courtesy of Museum of Modern Art, Paris.)

12-22. EVOCATION. Odilon Redon. This artist was a Symbolist who turned from realism to dreams. Here the ground is a deep blue, with deep brown and muted red below. The halo of the woman is in vivid yellow-green, the oval form is light gold. (Courtesy of The Art Institute of Chicago. Joseph Winterbotham Collection.)

Denis — admirers of Cézanne and van Gogh, influenced by Gauguin in part, and dedicated to "a plane surface covered with colors brought together in a certain order," all neatly expressed in poster-like compositions. And there was Henri de Toulouse-Lautrec. Though not completely a Nabi, Lautrec knew this group and the Symbolists well, and his attention to and fascination by color deserves a special note to bring the story of Post-Impressionism to an end.

But first, here is a brief account of the Nabis. Their views constituted the final artistic movement of the nineteenth century, the last exhibition of their work being held in 1897 under the sponsorship of the famous Durand-Ruel. Maurice Denis (1870-1943) expressed the Nabi doctrine in these words, "The Objective Distortion, based upon a purely esthetic and decorative concept, upon technical principles of color and composition, and the Subjective Distortion, which brought into play the artist's own perception." The Nabis were distinguished by dramatic works of art, often poster-like in design; these were seen throughout Paris in lithographic prints, books, illustrations, theater settings. Here were

new experiments, simple in concept, plain in color, the opposite of Neo-Impressionism.

Most talented in the group, perhaps, were Pierre Bonnard (1867-1947) and Edouard Vuillard (1886-1940). Bonnard had a splendid eye for color, and his works have gained in value and recognition over the years. He was a sensitive man with a delightful sense of humor and very little interest in the material comforts of life. At first, he worked in the applied arts — furniture, screens, ceramics, theater decoration and posters.

As a Nabi, many of his early achievements were bold and precise, yet Bonnard at heart had a romantic attitude toward nature. He saw it as luminous, transparent, shimmering with color. He painted washerwomen, children, errand boys, dogs, still life, landscapes — and nudes. *A Dictionary of Modern Painting* gives this description:

> Sometimes we see a glossy interior There, nude bodies appear so integrated with the room that it is difficult to say whether they color the surrounding space or take their existence from it. The pearly flesh of a thigh seems to be composed of the same substance as the furniture against which it stands out miraculously; but at the same time the back of this bathing woman, like an idol, seems part of the golden atmosphere of the room.

The palette he used was described in Chapter 3.

Edouard Vuillard, who for a time shared a studio with Bonnard, found life less a fairy tale than a simple and fully acceptable business of people working, eating, reading, sewing, resting. Although influenced by Gauguin, his art is often remindful of Degas. He was a man without vanity or pretensions who spent most of his life in Paris and, like Utrillo, immortalized some of its byways. Vuillard's sense of color was quite magical. Aldous Huxley in his *Heaven and Hell* describes it:

> In Vuillard's interiors every detail however trivial, however hideous — the pattern of the late Victorian wallpaper, the *art nouveau* bibelot, the Brussels carpet — is seen and rendered as a living jewel And when the upper and middle-class inhabitants of Vuillard's New Jerusalem go for a walk, they find themselves not, as they had supposed, in the department of Seine-et-Oise, but in the Garden of Eden, in an Outer World which is yet essentially the same as this world, but transfigured and therefore transporting.

12-24. THE BREAKFAST ROOM. Pierre Bonnard. There are a great many colors in this picture, and all of them are handled as if they were transitory, shimmering, elusive. (Collection of The Museum of Modern Art, New York.)

12-25. INTERIOR WITH SEATED WOMAN. Edouard Vuillard. The lighting effect is natural. The woman wears a black dress; the table and cloth are white; the carpet is bright red and blue. (Courtesy of The Art Institute of Chicago. Charles H. and Mary F. S. Worcester Collection.)

Henri de Toulouse-Lautrec (1864-1901)

Lautrec was born of wealthy and aristocratic parents who lived a life of hunting, horses, and high society, with all the carefree luxuries of their class. In two tragic accidents at the age of about 15, his legs were broken, leaving him stunted and deformed for the rest of his life. He died when he was 37 years old.

However, Lautrec was a superior person in intellect and never bewailed his fate. Perhaps by way of compensation, he grew fond of the sophisticated world of the café, theater, bordello, actresses, dancers, and prostitutes. Color was vital to him. In the manner of the Nabis, he often worked in simple areas, his colors flat and unmodeled. Everything not essential to his subject was rejected. Most of his paintings, lithographs, and program covers were magnificent caricatures that neither flattered nor vulgarized what he saw — he always portrayed the essential quality, characteristic, or mood.

Although Lautrec did at times paint with divergent strokes, among the Impressionists he preferred Manet and Degas to Monet and Renoir. Manet and Degas, like himself, preferred the broad, direct plane. Lautrec's colors were few, as a rule. Highly individual with him was the strange quality of illumination he so often featured — a pale greenish and unearthly pallor that looked as dissipated as the night-beings with whom he so liked to associate.

Toulouse-Lautrec was a man of complete independence. He renounced all artistic theory and participated in no artistic movement. He was emulated by the Fauves, and admired by a young man from Spain, Pablo Picasso.

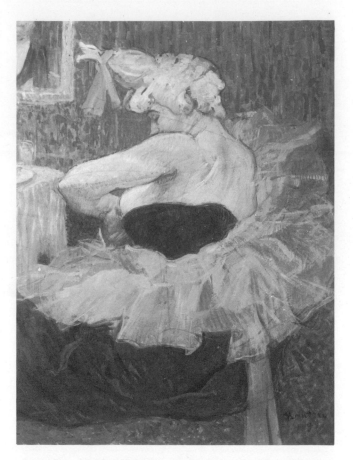

12-26. LA CLOWNESSE. Henri de Toulouse-Lautrec. The effect is almost opalescent. The colors are deep blue, brilliant golden yellow, terra cotta red, blue-green, and flesh tones. (Courtesy of Louvre, Paris.)

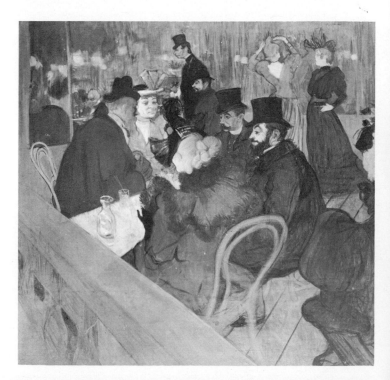

12-27. AT THE MOULIN ROUGE. Henri de Toulouse-Lautrec. Here is the pallor of gaslight—whitened faces, brown and green colors touched with incandescent yellow. (Courtesy of The Art Institute of Chicago. Helen Birch Bartlett Memorial Collection.)

Chapter 13

The Artists of America

This chapter is a unit in itself. If the reader wishes to continue chronologically with the history of painting into the twentieth century, he may omit it and proceed to the following chapters where the directions of art from Impressionism, Neo-Impressionism, and Post-Impressionism are traced through Fauvism, Expressionism, Cubism, Dadaism, Surrealism, Suprematism, Neo-Plasticism, Abstract Expressionism, and minor isms.

The history of color in the art of America has been a short one, and none too distinguished in its early years. When a nation is built out of a wilderness, there is little time for cultural amenities. No wealthy states or churches offer commissions. No princes, cardinals, or landed aristocrats lend patronage. And those who finally achieve prosperity are often unprepared to appreciate the esthetic.

In Colonial and early Federal America, most painters were of English birth, training, or interest. A truly original and indigenous art, other than primitive Indian art forms, did not come into existence until the nineteenth century. Art that adorned American edifices was usually imported. And the art of Europe — particulary that of France — continued to dominate America even in the late nineteenth and early twentieth centuries. The wellsprings and the inspirations all too often came from abroad. In truth, some of America's native-born artists chose to become expatriates, such as James McNeill Whistler and Mary Cassatt. The eminent and popular John Singer Sargent was born in Florence and trained in France.

But now, even though American art followed the leads and incentives of Britain, France, and Germany in the past, there are a number of modern art historians and critics who claim that it has finally taken leadership in what today is known as Abstract Expressionism. Apparently American art has at least earned respect abroad, and modern American abstract art forms are now being emulated in other countries.

The Colonial Painters

Before the days of the great Colonial artists, Copley, West, and Stuart, virtually all American art came from Europe. Paintings came by sailing vessel, and so did painters. In the seventeenth century, medieval and Elizabethan influences were strong, particulary in the decorative arts.

Presently, however, the burghers of New Amsterdam introduced and supported an active band of Dutch artists who devoted themselves not only to still life, landscapes, figures, and portraits, and biblical, historical, and allegorical fancies, but to stencilled designs on walls, to signs, to decorations on furniture and carriages, and to just about anything that needed the elegant touch. The feeling was in the sound tradition of the Dutch Masters

— dark grounds to give bold and dimensional relief to faces, figures, folded drapery, fruits, and flowers.

In Boston and New England, however, art had a more difficult time. The Dutch of New York were agreeable to the good and sensuous life; the Puritans were not — they did not like artists and they did not like paintings. A portrait would be accepted now and then if it was suitably modest and executed in dirty browns, but not much more.

However, in the eighteenth century, as a result of new wealth and prosperity, Georgian architecture was introduced, art gained status, and America saw the rise of a number of capable portrait painters. In New England, John Smibert (1688-1751), born in Scotland and trained in Italy, became Boston's leading portrait artist and did much to influence an emerging American school. He used comparatively pure colors, but his style was rigid and academic. As one service to culture, he introduced copies of Italian masters and hence gave Massachusetts a taste of the Renaissance.

13-1. PORTRAIT OF A WOMAN. Unknown Dutch painter. Seventeenth century. At this time no man or woman was properly established socially until immortalized in an oil portrait. (Courtesy of The Metropolitan Museum of Art. Gift of J. Pierpont Morgan, 1916.)

13-2. THE ARK. Jacob Hogers (Dutch, 1614-1641). In America, the subjects of art had to be simple and moral. (Courtesy of The Metropolitan Museum of Art. Gift of James DeLancey Verplanck and John Bayard Rodgers Verplanck, 1939.)

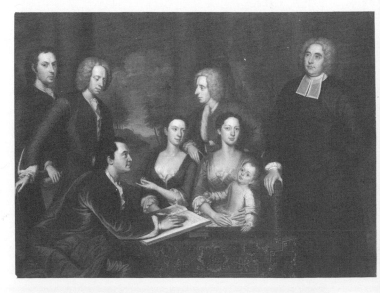

13-3. DEAN GEORGE BERKELEY AND HIS FAMILY. John Smibert. In this group portrait done in academic style, Smibert used comparatively pure colors. (Courtesy of Yale University Art Gallery. Gift of Isaac Lothrop.)

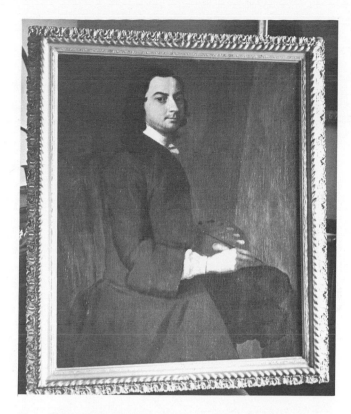

13-4. SELF-PORTRAIT. Robert Feke. Before the American Revolution, he painted the great and near-great of his day. On his palette, shown in the picture, are hints of black, brown, dark green, vermilion, yellow, and white. (Collection of The Rhode Island Historical Society, Providence.)

13-5. PORTRAIT OF MARY MACKINTOSH (Mrs. Thomas Palmer). Robert Feke. Before 1750. (Courtesy of The Metropolitan Museum of Art. The Chester Dale Collection, 1955.)

Robert Feke (ca. 1705-1752), also of Boston, followed Smibert's example, although his portraits were more stylized and less realistic in treatment. Then came John Singleton Copley (1737-1815), the greatest American portrait painter of his day. There is a racy, original, and American quality in Copley's work. He painted with exceptional skill, used colors boldly, and put remarkable spirit and animation into his compositions. Nothing he did seemed stiff or strained.

But in 1774, America lost Copley to England where, at the age of 37, he set up permanent residence. Eight years before, he had sent a portrait, "Boy with a Squirrel," to an exhibition in London and had asked the mighty Sir Joshua Reynolds for his opinion. Encouraged by Sir Joshua, Copley left Boston for England, labored diligently, and before the end of his life attained well-deserved wealth and fame.

13-6. PORTRAIT OF MRS. SYLVANUS BOURNE. John Singleton Copley. Skill, craftsmanship, and sensitivity to human character are revealed here. (Courtesy of The Metropolitan Museum of Art. Morris K. Jessup Fund, 1924.)

247

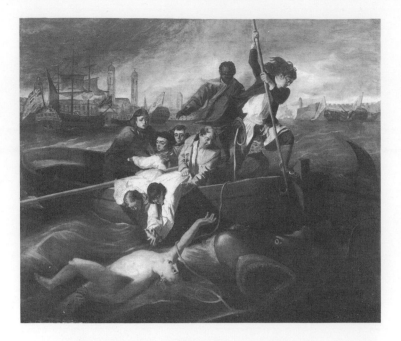

13-7A. WATSON AND THE SHARK. John Singleton Copley. Here is one version of this famous subject. Illustration 13-7B shows another. In both pictures there is realism with color, even to the sea stained with red blood, in the lower left corner. (Courtesy of The Metropolitan Museum of Art. Gift of Mrs. Gordon Dexter, 1942.)

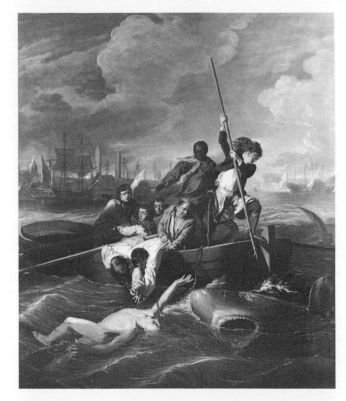

13-7B. WATSON AND THE SHARK. John Singleton Copley. (Courtesy of The Detroit Institute of Arts.)

One of his most dramatic works, "Watson and the Shark," is an unquestioned masterpiece and one of the very best of early American historical paintings. Because of its great popularity, Copley did several versions. Two are shown in Illustrations 13-7A and 13-7B. A third version is in the Museum of Fine Arts, Boston. The story goes

that Brook Watson as a boy had one of his legs bitten off by a shark while swimming in Havana Harbor. He was rescued by his shipmates — as shown in the pictures — and lived to become a rich and prosperous merchant and Lord Mayor of London.

England proved irresistible to many American artists. Only there, it seemed, could the artist find the excellence in art needed to become sophisticated and facile. Benjamin West, Charles Willson Peale, Gilbert Stuart, John Trumbull, William Dunlap, and Samuel Lovett Waldo all went to England for various lengths of time. Unfortunately, the historical or mythological theme — which told a story of some dramatic import and which Great Britain would accept — was not marketable in America, where portraits were insisted upon. Apparently such restrictions discouraged ambitious painters and made them eager to try London, if not to remain there, at least to develop their skills.

In this way, America lost Benjamin West (1738-1820). This remarkable painter was born in Philadelphia. At the age of 22, with funds collected by Philadelphia patrons, he set off for Italy where he studied for three years and then continued on to London.

West could well be considered an English painter except for the American heritage that always remained in his memory. While America

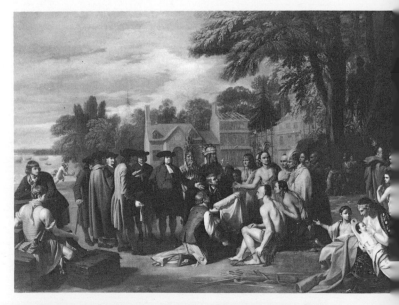

13-8. PENN'S TREATY WITH THE INDIANS. Benjamin West. This great historical panorama is a treasured American heritage. (Courtesy of The Pennsylvania Academy of the Fine Arts, Philadelphia.)

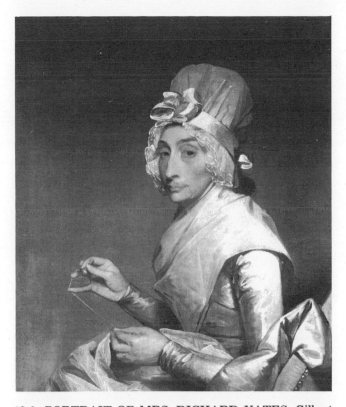

13-9. PORTRAIT OF MRS. RICHARD YATES. Gilbert Stuart. Able portraits like this brought Stuart a good living. His most notable patron was George Washington. (Courtesy of National Gallery of Art, Washington, D. C. Mellon Collection.)

was shaking its fist at George III, the king was conferring favors on Benjamin West, and West was appointed historical painter at his court. He became popular and wealthy, followed Sir Joshua Reynolds as president of the Royal Academy, and in an histrionic gesture rejected British knighthood.

West's style was classical, his colors bright and clear. His "Penn's Treaty with the Indians" (Ill. 13-8), his "Death of Wolfe," and his portrait of Robert Fulton, all reflect his interest in America. Almost every important American painter of the time visited him in London for advice and counsel. Comments about some of them follow.

Gilbert Stuart (1755-1828) is famous for his portraits of George Washington that remain the eternal image of America's Revolutionary hero. Another fine portrait by Stuart, "Mrs. Richard Yates," is shown in Illustration 13-9.

Charles Willson Peale (1741-1827) did excellent portraits and genre studies and organized the first museum in the United States, in Philadelphia.

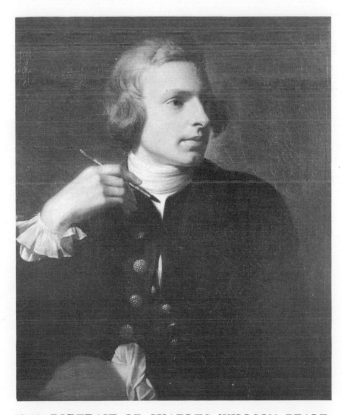

13-10. PORTRAIT OF CHARLES WILLSON PEALE. Benjamin West. This was done when Peale was quite young. (Courtesy of The New-York Historical Society, New York City.)

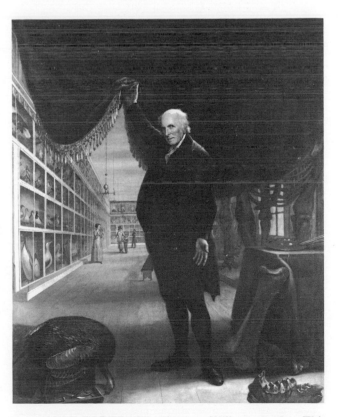

13-11. SELF-PORTRAIT. Charles Willson Peale. This portrait was done when Peale was quite old. Here he proudly shows his museum. Note the palette on the table. (Courtesy of The Pennsylvania Academy of the Fine Arts, Philadelphia.)

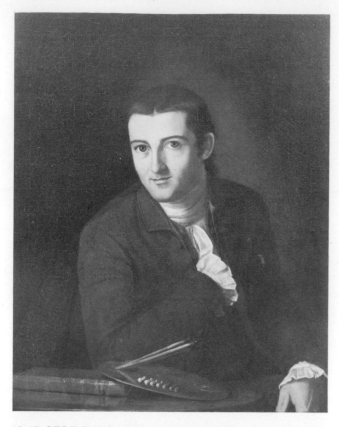

13-12. SELF-PORTRAIT. John Trumbull. A patriot whose historic canvases are an intimate part of the American heritage. (Courtesy of Museum of Fine Arts, Boston.)

John Trumbull (1756-1843) painted the "Battle of Bunker's Hill" (Ill. 13-13), the "Battle of Yorktown," and the famous "Signing of the Declaration of Independence."

These painters venerated Benjamin West. They all knew each other and painted portraits of each other, many of which are reproduced in this chapter, and in Chapter 2. Together, these artists constituted the American School, no matter where they lived, England or America.

There was also William Dunlap (1766-1839), painter and dramatist. His work, "The Artist Showing a Picture from 'Hamlet' to His Parents," is a remarkably good example of genre painting (Ill. 13-14). Dunlap holds a palette in his hand containing vermilion, bright orange, yellow, a flesh tone, black, and deep blue. His book, *History of the Rise and Progress of the Arts of Design in the United States* (1834), gave American painters one of the first literary accounts of themselves. Dunlap was reasonably successful as a playwright and theatrical manager and only painted occasionally.

Samuel Lovett Waldo (1783-1863), another American painter befriended by West, became one of the most successful and prolific of the portrait painters in the thriving city of New York. A self-portrait and a portrait of the patriotic John Trumbull, both with palette, are shown in Illustrations 13-15 and 13-16.

In the same formal classical tradition, Thomas Sully (1783-1872) did numerous portraits in a simple, rhythmic style, in addition to his heroic "Passage of the Delaware" (Ill. 13-17).

Samuel F. B. Morse (1791-1872), who dreamed of a Renaissance in America, did magnificent portraits, but he gave up art after his invention of the telegraph.

13-13. BATTLE OF BUNKER'S HILL. John Trumbull. This is an unusually stirring painting of a great American historical event. (Courtesy of Yale University Art Gallery.)

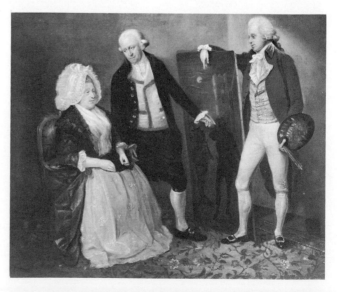

13-14. THE ARTIST SHOWING A PICTURE FROM HAMLET TO HIS PARENTS. William Dunlap. On his palette, as with other American painters, green was omitted as a pigment. (Courtesy of The New-York Historical Society, New York City.)

13-15. PORTRAIT OF THE ARTIST. Samuel Lovett Waldo. Although the colors on the palette are indistinct, there are glints of white, clear red, brownish red, and black. (Courtesy of The Metropolitan Museum of Art. Lazarus Fund, 1922.)

13-17. THE PASSAGE OF THE DELAWARE. Thomas Sully. A vivid portrayal of a significant moment in American history. (Courtesy of Museum of Fine Arts, Boston.)

13-16. PORTRAIT OF JOHN TRUMBULL. Samuel Lovett Waldo. Note the sword, and palette on which are daubs of white, yellow ocher, red, black, and mixtures. (Courtesy of Yale University Art Gallery. Gift of Mrs. Benjamin Silliman III.)

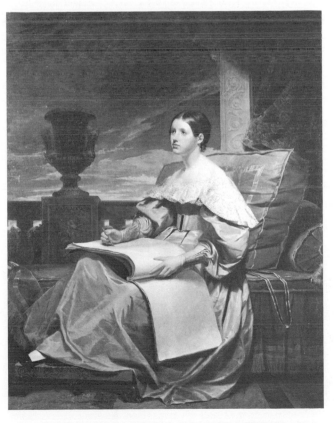

13-18. THE MUSE—SUSAN WALKER MORSE. Samuel F. B. Morse. This portrait clearly demonstrates that Morse was extremely able as a craftsman, with a perceptive eye for form, color, and texture. (Courtesy of The Metropolitan Museum of Art. Bequest of Herbert L. Pratt, 1945.)

13-19. SEA CAPTAINS CAROUSING IN SURINAM. John Greenwood. The character is American, the color effects ambitious. (Courtesy of City Art Museum of St. Louis.)

One of the earliest so-called genre paintings depicting the life of average Americans was done about 1758 by John Greenwood (1727-1792), a young Boston painter. Titled "Sea Captains Carousing in Surinam," it depicted a lusty group of Colonials drinking and gambling at an inn (Ill. 13-19). Although the colors are mostly dark and somber, there is a good attempt at conveying an impression of luminous candlelight.

There is nothing particularly individual as to color in the paintings of these men, at least nothing that did not derive from England. The Colonial School of America followed the ways of the London School of Great Britain and so they were much the same. Color effects were the same, and so were the palettes employed. In the nineteenth century however, there was increasingly less dependence on foreign example and foreign dictates.

The Outdoor American Scene

British and French painters gave attention to the landscape in the early years of the nineteenth century, and in America, too, the glory of nature led the artist beyond his studio to woods and valleys, rivers, lakes, and seas. Portrait painting and historical painting were given less attention.

Early in the century, Washington Allston (1779-1843), born in South Carolina, educated at Harvard, and an art student in London, Paris, and Rome, created a series of dream-like landscapes full of light and atmosphere, subtle in color and tone.

This was apparently a beginning. Soon came Thomas Cole (1801-1848) and the Hudson River School. America was finding the beauty of its land, though still painting in the tradition of England and Europe. Cole was a typical American, even though born in England. At an early age he came to America with his parents who settled in Ohio. He was self-taught, awed by the wilderness around him, diligent, and religious. Eventually, he made enough money from his art to travel abroad, and on his return he settled near the Hudson River valley.

Cole painted landscapes as he saw them. He liked the idea of allegory, for he was a moral man. America was "to be the abode of virtue," and he painted such subjects as "The Course of Empire," "The Voyage of Life," and "Expulsion from the Garden of Eden," titles that speak for themselves (Ill. 13-22). He achieved excellent effects of di-

13-20. MOONLIT LANDSCAPE. Washington Allston. He was one of the earliest of American landscape painters. Note how well this luminous scene translates into black and white. (Courtesy of Museum of Fine Arts, Boston.)

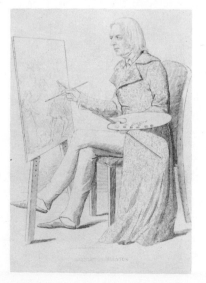

13-21. ENGRAVING OF WASHINGTON ALLSTON, with his palette. Like so many early painters, color selection was limited, consisting mostly of white, red, and brown. (Picture Collection, New York Public Library.)

13-22. EXPULSION FROM THE GARDEN OF EDEN. Thomas Cole. Like the British of his day, Cole used the landscape for purposes of allegory. Colors were mostly subdued, with major emphasis on light and dark. (Courtesy of Museum of Fine Arts, Boston. M. and M. Karolik Collection.)

13-23. THE PEACEABLE KINGDOM. Edward Hicks. One of the greatest of early folk painters, Hicks was a fundamentalist in religion like so many Americans of the time. (Courtesy of The Brooklyn Museum.)

mension, atmosphere, and luminosity, though his palette was limited and "timid" for the most part.

Also religious was the fondly remembered Edward Hicks (1780-1849), sign painter extraordinary from Bucks County, Pennsylvania, and a peace-loving Quaker. His "The Peaceable Kingdom" is one of the best known and most widely reproduced examples of American folk painting (Ill. 13-23). In his day, Hicks was hardly considered an artist, but today, his works are the prized possessions of museums and collectors everywhere. Had he foreseen this, Hicks probably would have credited all to the Lord.

William S. Mount (1807-1868) was yet another American artist devoted to outdoor folk scenes. Illustration 11-24 depicts his delight in the reaction of a simple farmer to one of his paintings.

Wholly American in thought and spirit were George Catlin (1796-1872), John James Audubon (1785-1851), and George Caleb Bingham (1811-1879). All loved and painted the American scene. Bingham was a highly skilled painter and one of the greatest of American artists. In spite of the fact that his pictorial subjects irritate some modern critics, there is little doubt that what he produced will have its place in history and be long remembered, admired, and valued.

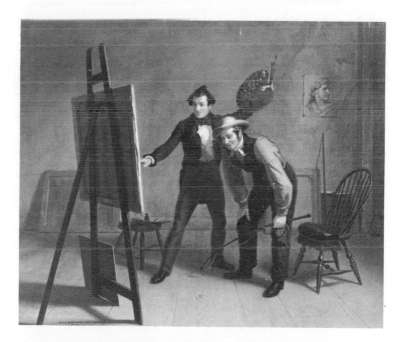

13-24. THE PAINTER'S TRIUMPH. William S. Mount. This artist's interests were all purely American with no sentiment for tradition and no craving to live anywhere but in America. He used a well-balanced palette. (Courtesy of The Pennsylvania Academy of the Fine Arts, Philadelphia.)

Bingham was born in Virginia and trained as an artist at the Pennsylvania Academy in Philadelphia. He knew the work of West, Sully, and Allston. A master draftsman with a remarkable flair for good composition, he also had a keen sense of color. There is something clean and

13-25. RAFTSMEN PLAYING CARDS. George Caleb Bingham. His color effects often suggested the glow of the American Indian Summer. (Courtesy of City Art Museum of St. Louis.)

13-27. PORTRAIT OF GEORGE CATLIN. William Fisk. 1849. The palette is partly concealed but shows glints of white, red, blue, and black. (Courtesy of The Smithsonian Institution, Washington, D. C.)

13-26. A BIRD'S-EYE VIEW OF THE MANDAN VILLAGE. George Catlin. By living beyond the frontier and recording the customs and habits of the American Indian, Catlin produced authentic pictures of the American West that are of great historical value. (Courtesy of The Smithsonian Institution, Washington, D. C.)

liquid about his color effects, the hues are fresh in quality, the air seemingly drenched with tinted light; there is depth, solidity, transparency, and atmosphere, all under capable control.

Bingham loved the out-of-doors and knew America well as a traveler. So, too, did George Catlin, remembered for his early Indian paintings, and John James Audubon, renowned for his skill, patience, and genius as a naturalist. A special exhibit of Catlin and Audubon paintings recently sent to Europe brought added prestige to American art.

13-28. IVORY-BILLED WOODPECKERS. John James Audubon. This unusual painter won international fame as an American naturalist and as a definitive depictor of birds. (Courtesy of The Metropolitan Museum of Art. Rogers Fund, 1941.)

The American landscape was further glorified by Albert Bierstadt, Thomas Moran, and George Innes, among others.

It is the sad fate of art and the artist to see fame rise, shine brightly, grow dim, and, at times, disappear completely. The work of no creative man — including the Old Masters themselves — is forever secure. An artist may seem to be a demi-god to one generation and a clown to the next. The museums may feature his canvases at full-dress receptions and then, later, hide them in the basement.

In our time, the latter part of the twentieth century, advanced art is Abstract and Non-Representational. The realist, the romanticist, and the naturalist are often frowned upon as dowdy old limners in moth-eaten frock coats. At a party for an Abstract Expressionist, a statement that Thomas Moran once painted the Grand Canyon would probably be greeted with a howl of derision even though the work of the Abstract Expressionist may have offered little more to see than a few lines or blobs of paint.

It may be that naturalistic painting is old-fashioned. Yet, for how long? Aside from ephemeral vogues and fashions, there are and must be eternal values in art. The landscapes of the following painters are striking and moving, and for this author, they are worthy contributions to the art of color.

Albert Bierstadt (1830-1902), of German parents, delighted in the scenic wonders of the far West. He was trained in Germany and his technique betrays foreign influence, but when he roamed America in an overland wagon he caught the majesty of what he saw. Perhaps Bierstadt was a better illustrator than artist. His canvases were spectacularly successful during his day and sold for unprecedented prices, and even if lately they have been consigned to remote spaces in American museums who knows how soon they may be brought to the fore again. And if they do come back, it is safe to guess that there will be a new day of revived interest in sound craftsmanship, for Bierstadt was a craftsman of first rank. It could well happen that early American landscapes may one day pass action paintings on the stairs of museums — the landscapes on their way up, of course, and the Abstractions on their way down.

Thomas Moran (1837-1926) painted the Grand Canyon, the Teton Range, and other American natural wonders. These canvases are large and come close to covering the observer's field of view. Such panoramic quality gives a feeling of three dimensions. The colors are bright, luminous, clean, and expertly blended and applied. Perhaps it does not take a great mind to paint such glories as the Grand Canyon but, at least, it does take nerve, brawn, and skill.

13-29. ISLAND IN PRINCESS LOUISA INLET, BRITISH COLUMBIA. Albert Bierstadt. Old-world craftsmanship is brought to the American scene. (Courtesy of The Art Institute of Chicago. Charles H. and Mary F. S. Worcester Collection.)

13-30. THE TETON RANGE. Thomas Moran. Like Constable of England, Moran painted nature with courage and passion. He remains evaluated as one of America's most eloquent landscape painters. (Courtesy of The Metropolitan Museum of Art. Bequest of Moses Tanenbaum, 1939.)

13-31. PORTRAIT OF THOMAS MORAN. Howard Russell Butler. On the palette are white, cobalt blue, brown, vermilion, deep green, and mixtures. (Courtesy of The Smithsonian Institution, Washington, D. C.)

13-33. A SILVERY MORNING. George Innes. A master colorist, Innes was able to endow his canvases with haunting appeal. (Courtesy of The Art Institute of Chicago. Edward B. Butler Collection.)

13-32. PORTRAIT OF GEORGE INNES. Franklin C. Courter. Visible on the palette are vermilion, red ocher, dark brown, yellow, and soft green. There are other colors on the section of the palette that is not shown. (Courtesy of The Smithsonian Institution, Washington, D. C.)

13-34. THE HOME OF THE HERON. George Innes. Rich browns and olive greens with a glow of orange light over all give this painting a strange and melancholy beauty. (Courtesy of The Art Institute of Chicago. Edward B. Butler Collection.)

George Innes (1825-1894), considered one of America's most perceptive colorists, called himself a *luminist* and devoted great attention to color phenomena. Born and raised in New Jersey, he refused a career there as merchant, preferring to become an artist. When he went abroad to study, he was soon inspired by the English and French landscape painters.

Innes felt that "the true artistic impulse is divine." He had a fondness for hills and valleys, woods and meadows. His palette was rich and his eye for color was exceptionally keen — he was an Impressionist, at least in spirit for he believed that "the aim of art is not to instruct, not to edify, but to awaken an emotion." With remarkable skill, surpassed neither in England nor

France except by rare painters like Constable and Corot, Innes coud handle his hues and tones to convert paint into convincing illusions of atmospheric tinted illumination. In this ability, he quite directly exploited the mysteries of human perception. A subject like "Home of the Heron," in tones of orange, brown, and olive greens, is put together for an overall effect that is Indian summer in full but elusive reality (Ill. 13-34). One must look hard and long for a more remarkable example of color illusion.

American Standards for America

America had long judged itself by European standards, for only the artist who painted like an Englishman or a Frenchman could get recognition. This could not go on. The child would have to mature. Whistler, for example, who was born an American, became an English citizen. He is therefore discussed elsewhere in this book. John Singer Sargent (1850-1925), however, born of wealthy Philadelphia parents, in Florence, became the most distinguished American painter

13-36. MRS. GEORGE SWINTON (Elsie Ebsworth). John Singer Sargent. Here is the work of a virtuoso, brilliantly and quickly done, but perhaps too self-conscious. (Courtesy of The Art Institute of Chicago. Wirt D. Walker Fund.)

of his day, although wholly in the British tradition of striving for the facility of a Reynolds or a Gainsborough. Sargent was a particularly able colorist. He had a brilliant eye and a deft hand and could, in a few short strokes, evoke magnificent effects of texture, highlight, shadow, and form.

Sargent may have been more sophisticated than perceptive. Daniel M. Mendelowitz writes of him, "He could so easily catch the external characteristics that he ceased to explore beyond the momentary impression. . . . Many portraits of his later years, distinguished only by vivacious execution, seem to be mere records of beautiful clothes and elegant postures which bore us despite their brilliance."

Perhaps this is a little unfair to Sargent. Or perhaps Sargent, laden with commissions, fell

13-35. THE FOUNTAIN, VILLA TORLONIA. John Singer Sargent. A fine example of Sargent's sophisticated style. (Courtesy of The Art Institute of Chicago. Friends of American Art Collection.)

13-37. THE HERMIT. John Singer Sargent. Here Courbet's influence seems evident. The theme is an engaging one, with surprises in the old man and the deer, the interplay of light and shade. (Courtesy of The Metropolitan Museum of Art. Rogers Fund, 1911.)

13-38. DAUGHTERS OF EDWARD BOIT John Singer Sargent. This painting recalls Manet, and it is Sargent at his very best. The lighting effect is striking. The colors are a dark brown offset by rich blue greens, a streak of vermilion red (to the right), and white. (Courtesy of Museum of Fine Arts, Boston.)

into superficial habits. At times he created true masterpieces, such as his "Daughters of Edward Boit" (Ill. 13-38). And his amazing facility in the painting of landscapes, a little known facet of his great versatility, should be remembered.

With the advent of Winslow Homer (1836-

1910), Thomas Eakins (1844-1915), and Albert Pinkham Ryder (1847-1917) truly American art was born. These men were indifferent to current notions of style and taste, of conventions borrowed from abroad. Homer was born in Boston and worked during his early years as a litho-

13-39. THE LOOKOUT—"ALL'S WELL." Winslow Homer. An effect of coldness, and blue moonlight, and the clear sound of a bell is brilliantly realized. (Courtesy of Museum of Fine Arts, Boston.)

13-40. THE HERRING NET. Winslow Homer. Love and awe for man's struggles with nature moved and inspired Homer. (Courtesy of The Art Institute of Chicago. Mr. and Mrs. Martin A. Ryerson Collection.)

grapher and illustrator, associating with people in all walks of life. He covered the Civil War as a sketching reporter for *Harper's Weekly*, and further enlarged his knowledge of humanity.

Homer did a number of "story title" pictures, such as "Home, Sweet Home" and "Prisoners from the Front," which raise the eyebrows of some modern critics. His art was purely American, with virtually no influence from abroad. In the last half of his life, he settled on the coast of Maine, gave up his narrative style, and seemed enrapt by the awesome power of the sea and those who sailed upon it. He was expert with oil, and few could surpass him with watercolor. Color, light, and shade were used dramatically in all his pictures. He could catch illumination effects and put them on canvas and paper as though painting with a beam of light.

Thomas Eakins was a realist and an exceptional man among average men. The most American of poets, Walt Whitman wrote, "I never knew of but one artist, and that's Tom Eakins, who could resist the temptation to see what they ought to be rather than what is." Philadelphia-born Eakins was imbued with the vitality of American life and devoted himself to depicting its straightforward aspects. At a time when art was self-conscious of style, of fine manners and lofty sentiments, Eakins painted just what he saw about him, not with deliberation but because he had a frank and unassuming mind.

Although he did some portraits, his true love was for the out-of-doors. Like Degas, he caught impressions of things familiar and dear to him, scenes of fishing, rowing, and sailing. The light in his pictures seems intense, being sunny and warm. Light and color control all his forms and reveal his world in blazing reality rather than in some mystic aura.

Albert Pinkham Ryder was a recluse and a mystic. He is rated close to Innes as one of the greatest of all American colorists. Born in New Bedford, Massachusetts, he moved to New York when he was 21 years old and there he lived a solitary existence, taught himself to paint and employed a technique known only to himself. Although his canvases — thick, overladen with pigment and layer upon layer of overpainting — have cracked like dry mud, they have strangely retained an eerie beauty.

13-41. LADY WITH A SETTER DOG (Mrs. Eakins). Thomas Eakins. Indoors or outdoors, Eakins devoted himself to painting simple, familiar scenes. (Courtesy of The Metropolitan Museum of Art. Fletcher Fund, 1923.)

13-42. SIEGFRIED AND THE RHINE MAIDENS. Albert Pinkham Ryder. This painting shows the imaginative and unearthly qualities that pervade all Ryder's work. (Courtesy of National Gallery of Art, Washington, D.C.)

13-43. THE RACE TRACK OR DEATH ON A PALE HORSE. Albert Pinkham Ryder. The sky is a strange golden yellow that casts its pallor over everything, forming deep browns and ghoulish grays. (Courtesy of The Cleveland Museum of Art. Purchase from J. H. Wade Fund.)

Ryder limited his compositions almost entirely to views of land and sea in moonlight. His paintings are small, but each one is a gem. There is no doubt that his melancholy and brooding life, his treks through the streets at night, his cramped and unkempt one-room studio, all stirred his imagination. Few painters in any century have achieved more weird and luminous effects with color. In his pictures, the moon becomes lemon yellow (van Gogh was also so haunted). Its light floods the sky and reveals vague silhouettes. The palette is almost monochromatic — a ghostly and greenish yellow, shades of brown, muted olive greens. Ryder blended this limited range of colors to reveal another and ghoulish world, as if seen through the porthole of an ancient ship.

The American Impressionists

America also had its Impressionists in painters like Theodore Robinson (1852-1896), John H. Twachtman (1852-1902), Childe Hassam (1859-1935), and Maurice B. Prendergast (1859-1924). The American Impressionistic revolt was frankly derived from France and had the same objectives — to break with Classicism and with all that was dour and academic. Mary Cassatt (covered in

13-44. STREET SCENE IN WINTER. Childe Hassam. Although Hassam was one of few Americans who took up Impressionism, he did not adopt this style until after the turn of the century. Note the similarity to Monet, Pissarro, and Renoir. (Courtesy of The Metropolitan Museum of Art. Bequest of George D. Pratt, 1935.)

13-45. WEAVINGS OF SPRINGTIME. Joseph P. Birren. Calling his art "tactilism," Birren sought to convey the textures of nature. Here is early spring, a soft, cool light, and tones of yellow, pink, green, and blue set against the fading darks of winter.

260

Chapter 11), was perhaps the greatest of the American Impressionists, but she settled in Paris and became identified with the French movement.

Though the works of the French Impressionists had been exhibited in the United States by Durand-Ruel in 1886, American painters were not immediately enthralled and over a decade passed before American artists scraped their palettes and squeezed out tubes of pure pigment. Then Robinson, Twachtman, Hassam, and the others began to display much competence with all that was bold, vivid, and striking.

The work of Joseph P. Birren (1864-1933), father of the author, was also in the mood of Impressionism. Born in Chicago before the days of art schools there, Joseph Birren began as a painter of cycloramas, then journeyed around the world and studied art for several years both in Munich and Paris. He eventually developed a tactile style that caught the textures of nature in a fresh and spontaneous way. Like the Impressionists, he painted out-of-doors in all seasons, and in many climates and countries.

The Famous Eight

Impressionism in America had not been very original on the whole. Maurice B. Prendergast was one of the more creative adherents of the movement. He developed a curiously interesting style that had a tapestry-like quality. Textured planes of bright colors seem to be woven on a dark ground, the outlines of the warp helping to emphasize the richness of the hues. Like the Impressionists, Prendergast featured yellow, orange, and red, discarding browns and earth tones, and filled his shadows with blue and violet.

Prendergast was one of "The Eight," dubbed The Ashcan School, a group of vigorous young American artists who finally broke with all precedent and dared to venture in art — as Theodore Dreiser, Sherwood Anderson, and Sinclair Lewis ventured in literature — and depict the dingy side of American life, up and down the streets and alleys of American towns and cities. The Eight were angry men weary of rejection and determined to have their voices heard and have their works seen in a world of art dominated at the time by academicians and timid or stubborn reactionaries.

13-46. ACADIA. Maurice Prendergast. The colors here are slightly muted pastels—pink, rose, gold, turquoise, lilac, green—presumably laid in opaque areas over a deeper tan or brown ground. (Collection of The Museum of Modern Art, New York. Mrs. John D. Rockefeller, Jr. Fund.)

13-47. PROMENADE, GLOUCESTER. Maurice Prendergast. The painting here was done with a refined touch, like that of Pierre Bonnard, the Nabi. The colors are all delicate, choicely harmonized, and built up as in a tapestry. (Collection of Whitney Museum of American Art, New York.)

Leader of the group was Robert Henri (1865-1929), a teacher at the Pennsylvania Academy of Fine Arts, Philadelphia. A man of engaging personality, Henri spoke eloquently for a vigorous art that would put fire into painting and destroy revered institutions of the day. Arthur B. Davies (1862-1928), George B. Luks (1867-1933), William J. Glackens (1870-1938), Ernest

Lawson (1873-1939), Everett Shinn (1876-1953), and John Sloan (1871-1955), in addition to Henri and Prendergast, completed the original group.

There was group unity only in rebellion.

13-48. HAMMERSTEIN'S ROOF GARDEN. William J. Glackens. The use of sharp colors, influenced by Renoir and Degas, produced color effects that are clean and realistic. (Collection of Whitney Museum of American Art, New York.)

Hardly any two of the eight men painted alike. While they all declared themselves champions of truth and realism, not one of them honestly remained faithful to that credo. What they wanted was to be seen and heard, and not passed aside by esthetic conservatives.

In 1908, The Eight were granted an exhibition at the Macbeth Galleries in New York, one of the first dealers to favor American painters. Surprisingly, the group show aroused a certain amount of favorable comment. Perhaps Americans were now tired of the stodgy Victorian past. Perhaps the nation had had its fill of artificial and histrionic art and wanted simpler fare. Nevertheless, soon afterward the notorious Armory Show of 1913 caused riots in the street and indignant artists issued furious manifestos.

Although The Eight had different styles, the most typical style was that of John Sloan. The "ashcan" label of derision was directed largely at him — "How could an artist want to paint dirty back yards and the rooftops of tenements" was a familiar reaction to his pictures. Sloan's expression with colors was simple and direct, with little that was either effusive or crude. Having been a newspaper artist, he painted what he saw and worked with broad masses of light and dark that had few subtle tonalities or sequences. Later in life, Sloan gave up his bold approach to color for some of the more refined innovations of French Post-Impressionism. He also gave up

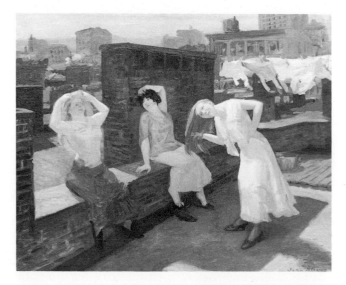

13-49. SUNDAY, WOMEN DRYING THEIR HAIR. John Sloan. This artist was prominently identified with the Ashcan School because he picked subjects such as this one. The color effect is as true to life as the scene depicted. (Courtesy of Addison Gallery of American Art, Phillips Academy, Andover, Massachusetts.)

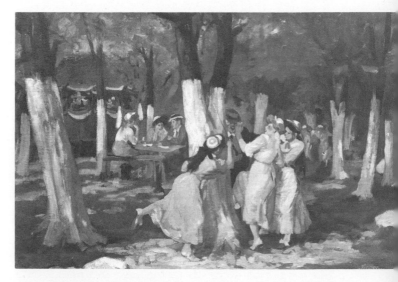

13-50. THE PICNIC GROUNDS. John Sloan. Here Sloan expresses a lighter mood with colors of frank and honest realism. (Collection of Whitney Museum of American Art, New York.)

13-52. BOTH MEMBERS OF THIS CLUB. George Bellows. The power, drama, and action in Bellow's prize ring paintings have rarely if ever been surpassed. His mastery of color, lighting, and detail is obvious here. (Courtesy of National Gallery of Art, Washington, D. C. Chester Dale Collection.)

13—51. ARMISTICE NIGHT. George Luks. Note how dark masses are used to set off brighter accents. (Collection of Whitney Museum of American Art, New York. Anonymous Gift.)

painting in the streets and settled down to painting in his studio.

His confrere, George Luks, recorded a world similar to that of Sloan. His interest, however, was centered in the individual humble mortal set apart in an everyday environment. He painted like Manet in broad, flat masses, but his color effects admitted dark tonalities. Robert Henri, too, painted direct, boldly executed portraits and figure studies, chiefly of unimportant but distinctive personalities.

Then came George Bellows (1882-1925) who painted with the vigor and candor of John Sloan. He did not need to protest, as did The Eight, for his talent quickly made him acceptable to the conservatives and won him admittance to the National Academy.

Bellows was a painter of action, a superb draftsman with a psychologist's eye for human character. His sense of color was exceptional. He favored the rough and ready life as material for his pictures — the prizefighter, swarming humanity in noisy streets, portraits of the stolid American. He knew the force of severe contrast, of stark hue, of illuminating effects that suggested artificial lights and cigarette-smoke.

The Famous Armory Show

The most momentous and publicized event in the history of art in America occurred in 1913. This event was the famous exhibition known as the Armory Show of New York; most of the paintings shown were gathered for a repeat exhibition in 1963, half a century later. A large part of the original revolutionary exhibit was arranged by members of The Eight. Good citizens looked upon the Ashcan School as something shocking and degrading in America. However, they were even more violently outraged by the contemporary French works brought over for the exhibition. Many reacted as though themselves — Like Marcel Duchamp's "Nude Descending a Staircase" — had been pushed down a flight of stairs all split up like a cascade of brown wood shingles (Ill. 13-53).

Americans had seen the works of the Impressionists before, through Durand-Ruel and in the New York galleries of Alfred Stieglitz, the noted photographer. But it was this 1913 exhibition of modern art, held at the Sixty-ninth Regiment Armory in New York, that shook the world of art and artists of that time. Displayed here were some 1600 works of art — paintings and sculp-

13-53. NUDE DESCENDING A STAIRCASE, No. 2. Marcel Duchamp. 1912. This composition was painted entirely in tans and browns. (Courtesy of Philadelphia Museum of Art. Louise and Walter Arensberg Collection.)

ture — gathered chiefly from France but including other European art and some American works. No other art show in America ever created more furore. On view were examples of Fauvism, Cubism, and German Expressionism. The revolt of the Dada movement was anticipated in the astonishing "Nude" of Marcel Duchamp (1887–1968). Duchamp came to New York two years after the controversial show and actively led the new radicalism.

Shortly after the Armory Show of 1913, World War I was fought, and art was temporarily set aside. Then two things happened: the American spirit of Homer, Eakins, Sloan, and Bellows was carried on by such painters as Hopper, Burchfield, Wood, Benton, Wyeth, and others, to be discussed later, and so-called *modernism* planted its roots abroad.

At about this time, Paris developed a large American art colony. American artists of the late 1800s and early 1900s had gone to London to study with men like Benjamin West, and now American artists gathered in Paris to be near such giants as Matisse and Picasso.

Abstract and Non-Representational painting was first developed in Europe, but after it was introduced in America, what is known as Abstract Expressionism was taken up by American artists from coast to coast. Part of this story will be told in the next two chapters.

13-54. MANCHESTER VALLEY. Joseph Pickett. Ca. 1914. Modern folk art painted by a man once devoted to boat building, carpentry, and storekeeping. Its naive realism, like pure abstraction, helped to change the course of art in America. (Collection of The Museum of Modern Art, New York. Gift of Mrs. John D. Rockefeller, Jr.)

Chapter 14

The Road Down from the
Mountain

In the early part of the twentieth century the art of color turned from inquiry to intuition, from an outward search for principles (which an artist might then use creatively) to an abandonment to "creative impulses" and "inner necessities." This change came as a surprise to many art critics and historians.

A few decades before it had been assumed that art would shift from the fugitive and ephemeral to the more structural and substantial. The hero then was Cézanne who spoke of turning Impressionism into that which was solid and durable like the art of the Old Masters. Indeed, Cézanne's work was hailed by one critic as "a contribution so rich and weighty that it has influenced the whole of modern painting, nourished all the movements that seek renewal, and inspired all the talent and genius of our century." Essays on art are given to such hyperboles, but the ideals of Cézanne — genius though he was — failed to materialize.

True, Cézanne attracted many followers. However, the works of van Gogh and Gauguin became equally important influences for the future. At this point, instead of a new epoch of form, there came a passion for color without form. Instead of color as a structural element in painting, color became a thing in itself, a pure fantasy, an invention — and even nothingness.

All of Impressionism, and all of Cézanne, had been concerned with an esthetic expression of natural phenomena. What had not been foreseen was that much mid-twentieth century art would abandon any semblance to nature and turn radically from the mysteries of the outer world

to the inner mysteries of the human psyche. Instead of realizing art that was solid and durable, art became obscure and elusive.

Classical art is notable for its fidelity and for its excellence of form, highlight, and shadow; Impressionism is notable as an age of color. Recent art is notable for its experimental diversity — anything and everything at one and the same time. There has never been a period with so much activity in art. Most of all, however, this is the age of the manifesto. Any reviewer of "modern" art must necessarily jump about as if at a side show where each one of a multitude of wonders must be described as the most singular the world has ever seen. And if there is any consistency at all, it is to be found in the strange consistency of each one of hundreds of painters trying to be completely different not only from artists of the past but from each other.

As will be seen in this and the following chapter, there are modern schools of art that stand in direct opposition to each other, some "tight" and orthodox in view, others "loose" and nihilistic. Art critics find it almost impossible to write coherently and to avoid contradiction in discussing movements that are in themselves contradictory. The course of this author is an easier one, for with only one viewpoint before him — color — he can proceed without a multitude of other distractions.

The very sight and sound of the word *manifesto* has become trite and ineffective. There is little wonder that so many intellectuals, impatient with semantic absurdities, have lost interest in art. Too much recent art sounds better

265

than it looks. In the old days, eulogy and evaluation followed a man's work; today they tend to precede it. The manifesto is written, published, and distributed first, sometimes before the artist has done much painting at all. In other words, the artist may demand a favorable verdict before his trial is held or his evidence presented.

To pursue my subject of color, in recent years art has taken many directions, some of them blind alleys. The history of Impressionism shows that one thing tended to lead to another, but there has been little such continuity in the recent past. There are cross-purposes to be observed rather than connecting links. To some painters color is everything; to others it is not important and sometimes not even used.

The recent course of events regarding color is confusing and disconcerting. The conservative painter who was once the butt of the Impressionists has done more to further the cause of progress in color than his contemporary who claims descent from Impressionism. What happened is this: those who followed the Impressionist tradition crushed the movement in a wave of reaction, and the movement died. In effect, the son and the grandson of the Impressionist said, "There will be no more scientific discipline. From now on, all feeling shall come from within."

Thus if Impressionism led directly or indirectly to Fauvism, Cubism, Dadaism, Suprematism, Abstract Expressionism, and other such isms, it cannot be said that disciplined use of color (which dominated Impressionism) maintained its fascination. On the contrary, the disciplined approach sputtered and then went into a state of atrophy.

This is regrettable, of course, for as art went from the naturalistic to the Non-Objective, it had its first chance in all history to do anything with color it wished, for it had freed itself completely from nature. But the opportunity was not seized, and it still is not. As art movements went "modern," the discriminating use of color went downhill. What little dignity color retained was in the hands of conservative painters.

The author may be prejudiced, but what troubles him is that he has every reason to favor Abstract Art because it offers unqualified freedom to the painter; but nevertheless, the conservative has done better with color than the modern, for with color, or anything else, there can be no freedom in ignorance. The author contends that most modern abstract painters are ignorant on the subject of color. With a few exceptions, there seems to be no effort on the part of abstract painters to learn from modern scientific research. The quest for knowledge that enthralled a multitude of artists during Impressionism seems to be lacking; today, with new knowledge waiting to be interpreted and applied, the abstract painter keeps himself isolated from the wonders of modern color research.

It will be of interest in this connection to review the major schools, movements, conquests, and revolts of the twentieth century and explore their significance to the art of color.

Fauvism

The first art movement, or revolution, of the twentieth century was known as Fauvism. The term was anything but flattering, being devised by a French critic who in 1905 greeted an exhibition of furiously painted canvases as the work of "les fauves," or wild beasts.

Henry Matisse (1869-1954), one of the greatest and most original painters of modern times, was the leader of this group. The revolt of Fauvism was directed against Impressionism and Neo-Impressionism. Regarding Neo-Impressionism Matisse said:

> Neo-Impressionism, or rather that part of it which is called divisionism, was the first organization of the method of Impressionism, but this organization was purely physical and often mechanical. The splitting up of color brought the splitting up of form and contour. The result: a jerky surface. Everything is reduced to a mere sensation of the retina, but one which destroys all tranquillity of surface and contour. Objects are differentiated only by the luminosity that is given them. Everything is treated in the same way.

Matisse wanted to change all this. Color would be used to construct space and form rather than destroy them. There would be purity and simplification, complete freedom from the dreary and mechanical application of spots, dabs, and dashes. Most of all, Matisse held that the feelings of the artist should be expressed, rather than visual illusion depicted. The painter, in a word, should not submit to theory as did men like Seurat, but should force color to serve high-

14-1. WOMAN BEFORE AN AQUARIUM. Henri Matisse. The composition here is somewhat restrained in color, with soft blue, green, gold, and brown dominant. (Courtesy of The Art Institute of Chicago. Helen Birch Bartlett Memorial Collection.)

er and more dynamic ends. Wrote Matisse, "What I am after, above all, is expression." Impressionism was considered too static — a mere recording of passing and superficial sensations. Note the simplicity of "Woman Before an Aquarium," Ill. 14-1.

In all fairness, however, although Impressionism had its shortcomings and faults, it did constitute one of the greatest and most eloquent periods in the history of color. Obviously, its principles could not be carried on indefinitely; change is inevitable. Fauvism as a revolt in art had a short life, less than three years (1905-1907), and led to Cubism. But while it lasted, it gave the world a number of exciting experiments in color.

Matisse attempted to reduce the whole art of painting to color and a few other fundamental elements, chiefly line and rhythm. In his Fauve period' he painted boldly and feverishly; colors were laid on fully and openly, often in severe contrast, with black lines interposed. His pictures were executed in the purest hues always applied with respect to structure, a conviction Matisse accepted from Cézanne. Color always dominated. One of his palettes is mentioned in Chapter 3.

Later Matisse abandoned the "broken" color for the plain color, working in large, flat areas remindful of Oriental and early Romanesque painting. Insisting that nothing superfluous could be tolerated, he attempted to imply space and light in amazingly simple terms. He wrote, "A moment comes when every part has found its definite relationship and from then on it will be impossible for me to add a stroke to any picture without having to paint it all over again." During his long and varied career Matisse exerted considerable authority over a group of friends and admirers who flocked about him and shared his enthusiasm. Although he painted a series of landscapes, his interest was primarily in the human figure.

Matisse played a leading role in Fauvism, but there were other masters of the style, notably André Derain (1880-1954) and Maurice de Vlaminck (1876-1958). These artists knew each other, worked and dwelt with each other, and exhibited together, along with other kindred spirits. A critic of the day said their paintings were executed "with sticks of dynamite," that palettes of brilliant hues were "hurled into the faces of the public."

André Derain painted with Matisse and also

14-2. THE POOL OF LONDON. André Derain. Pure spectral red, yellow, green, and blue are used with rich gold and warm brown. (Courtesy of Director, Tate Gallery, London. Rights reserved by A. D. A. G. P.)

in art. Always a sober and reasonable student, he returned to the Old Masters, to chiaroscuro, modeling, and discipline. Regarded by some critics as one of the greatest of recent French painters, Derain was a curious combination of creator and compiler, innovator and copier. "No other painter has shown, at one and the same time, so much doubt and so much mastery. No other painter has so conveyed the feeling of wanting to dominate his century and, at the same time, reject it," states *A Dictionary of Modern Painting*.

Maurice de Vlaminck was a very different personality. Having little education and plebian tastes, he seemed quite happy to lead a simple and natural life, playing the violin, farming, bicycle racing, and painting. He shared Derain's passion for the primitive and Derain wrote, "We were always intoxicated with color, with words that speak of color, and with the sun that makes color live!"

shared a studio with Vlaminck. He was a man of considerable intelligence, with a particular liking for the primitive in art. As a leading Fauvist he insisted upon garish colors, the bold segmented touch, the swift curve, but he was less "brutal" than Vlaminck. His color arrangements show greater order, thought, and reflection. The palette he used is described in Chapter 3.

Unlike Matisse, however, in his later years Derain did little to advance the cause of color

Perhaps no one deserves the name Fauvist more than Vlaminck. His vitality animates his canvases of this period. Sensing an emotional kinship with another vigorous colorist, he declared "Van Gogh means more to me than my own father!" He had van Gogh's obsession for yellow. Vermilion, ultramarine, emerald green, and white were his next favored hues. He laid

14-3. LONDON BRIDGE. André Derain. A brilliant use of spectral hues. (Collection of The Museum of Modern Art, New York. Gift of Mr. and Mrs. Charles Zadok.)

14-4. THE RED TREES. Maurice de Vlaminck. The tree trunks are a bright red with ultramarine blue shadows; other areas show luminous gold and vivid emerald green. (Courtesy of Museum of Modern Art, Paris. Photograph, National Archives of France.)

color down in thick layers, with driving twists and daubs, using hard impulsive strokes. No man before him had indulged in a more abandoned method.

Then suddenly, in 1907, Vlaminck's furies came to an end. He wrote, "I suffered from not being able to hit harder, from having arrived at the maximum intensity." Matisse went on to become a giant in art. Derain returned to cautiousness, virtuosity, and sustained eminence. Vlaminck, however, as though in a rage, broke with Cézanne, van Gogh, Matisse, Derain, and Fauvism itself, to become a painter of realism. His palette went somber. "As a modern painter, he rejects modern painting and to express himself finds only means borrowed from the Old Masters of museums," according to *A Dictionary of Modern Painting*.

14-5. HOUSE WITH LEAN-TO. Maurice de Vlaminck. Here the colors are bold—blue, green, red, and golden ocher, with the shack in white. Everything is in full daylight. (Courtesy of Museum of Modern Art, Paris. Photograph, National Archives of France.)

Color Knowledge vs. Color Sense

Fauvism burnt itself out in its own fires. It created nothing new except a blazing moment of audacity. Its service, perhaps, was in writing the last chapter and turning the final page on the majestic styles of Impressionism and Neo-Impressionism. Blatant color does not make good art any more than large type makes good printing or loud noise good music. Yet in bringing an old era to an end, Fauvism introduced the best of Post-Impressionism (Cézanne, van Gogh, Gauguin, Matisse) into the twentieth century. It became the advance agent of many strange road shows and circuses to follow.

In the art of color, intuition took over where reason, knowledge, and respect for natural phenomena had prevailed. This shift of emphasis was inspired by Matisse and others who followed him. Now the artist was told to disregard the academic, disclaim laws of optics and physics, and the psychology of perception, and force colors to express his own inner feelings. A man like Matisse who understood color thoroughly could do this, but to the uninitiated the complexities of color were too awesome and bewildering, and some artists gave up entirely.

After Fauvism the art of color rapidly declined. Men no longer cared to reflect on the mysteries of the subject or engage in inquiries that might qualify them to enter new and wondrous realms of the spectrum; they seemed to prefer their own devices.

Later in this and in the next chapter, it will be seen that all hope was not lost. But for the most part, discourse and expression in the art of color degenerated; methods became highly personal. Every man was his own teacher and in most cases his own judge. Chiaroscuro and Pointillism are obvious to the beholder, but modern color needs to be explained, for what the eye sees is not in itself apparent.

The average person in viewing a painting by Rembrandt or Renoir will be impressed by what he acknowledges to be great virtuosity and skill. Yet in viewing a great deal of recent art, the average person may not only be confused but may indignantly state that he could paint as well if not better. No explanation is needed for Rembrandt; much Abstract Expressionism is helpless without explanation.

In the experience of the author, an artist today may be accused of bad drawing, poor composition, amateurish technique, and he will not blink an eye. But tell him that he has a weak sense of color and he will be insulted. Color sense has supplemented color knowledge in most recent art. The situation is unsound. Color expression, like music expression, demands a certain amount of basic understanding. Perhaps a folk tune can be conceived without any formal musical training, but symphonies cannot be written by the untrained. Neither chiaroscuro nor Impressionism — monuments in the art of color — were attained by insight and inspiration alone, nor by wishful thinking. They were the result of mental brilliance and hard work. With so rich a heritage, color expression is puerile when it expects a viewer to "see" or "feel" profound significance in mere areas, twists, or turnings of color.

Matisse had a magnificent sense of color — but so too did the Post-Impressionists he knew so well and admired. After Matisse, however, the color sense — having discarded the stout support of tradition — found itself involved in many strange resolutions.

Expressionism

Before going too far down the mountain from Impressionism, let me offer praise to another twentieth century art movement that had its origin at the same time as Fauvism, but lasted much longer and, in fact, still endures.

Expressionism represents a more or less permanent tendency in art. Like Fauvism, it resisted the objective attitude of the Impressionists and Neo-Impressionists — men concerned with outside reactions. The Expressionists reversed the process; to them, life was not an armchair or hammock mode of life as so often depicted by the Impressionists. Man dwelt in a bitter world, not a serene and pastoral one; he felt lost in the presence of nature fundamentally hostile and unknown. His only recourse was to seek isolation within himself and give release to subjective and introspective feelings. Like the Fauvists, and at about the same time (1905 and after), the Expressionists were influenced by the Post-Impressionists (Cézanne) and by primitive art. Both groups exploited color and distorted form. Both sought a sharp break with the past, being con-

scious that life in the twentieth century would bring crises and chaos not foreseen in earlier times.

Fauvism had its origin in France but Expressionism came mostly from the Nordic countries. One of the great heroes of the movement was van Gogh who in passion and obsession symbolized the anguish and ferment of the times. And van Gogh, of course, was a master colorist both by training and insight.

The Expressionist movement was broad and varied, knew many countries and had many facets; as far as the art of color is concerned, it far surpassed Fauvism in invention and creativity. But like Fauvism, its proponents also abandoned objective color knowledge for subjective color sense.

Identified with Expressionism are such great painters as van Gogh, already mentioned, James Ensor (Belgian), Edvard Munch (Norwegian), Emil Nolde (German), Georges Rouault (French), Ernst Kirchner (German), Oskar Kokoschka (Austrian). Also included are Wassily Kandinsky (who will be discussed in the next chapter under Abstract Art), and great Mexican painters such as Diego Rivera and José Orozco, and some others.

Color was of tremendous significance to Expressionism. Its intensity, violence and emotional impact enabled the artist to release the furies within him.

Expressionism, though worldwide, had two federated German groups, *Die Brücke* (The Bridge) in Dresden and *Der Blaue Reiter* (The Blue Rider) in Munich. Exhibitions were arranged, meetings held, manifestos, books, tracts published. To describe the Brücke group, according to *A Dictionary of Modern Painting*, "All these artists were restless creatures, over-sensitive, haunted by religious, sexual, political, or moral obsessions. Dramatic landscapes and nudes, mystical and visionary compositions, scenes of the countryside, the streets, the circus, the cafés-dansants and the demi-monde were their principal themes. Their pure colors blaze in acid stridency."

With *Der Blaue Reiter* group (to be mentioned again), the whole course of Abstract and Non-Objective Art began, largely through the leadership and inspiration of Kandinsky. The two groups merged into one, and freely exchanged interests with the French.

Today the term *Expressionism* is usually applied to the more naturalistic painters, while *Abstract Expressionism* includes the Non-Objective group. Let me offer a few notes on the artists listed earlier.

14-6. SELF-PORTRAIT. James Ensor. Pure hues and white as used by Ensor show a sound knowledge of the art of color. (Courtesy of Uffizi, Florence. Alinari-Art Reference Bureau.)

James Ensor (1860-1949), one of the earliest of the Expressionists, painted the human figure and had a taste for farce and caricature. His colors were strident—often a riot of reds, greens, blues, and yellows was employed to dramatize the grimacing faces of his models. Familiarity with the Impressionists and Post-Impressionists gave him a thorough grounding in color techniques, which he practically abandoned in favor of his own personal devices. Lack of such back-

14-7. STRANGE MASKS. James Ensor. The ground is a dull white with color concentrated at the right—pure red, yellow, blue-violet, orange, and black. (Courtesy of Musées Royaux des Beaux Arts, Brussels.)

14-9A. GIRLS ON THE BRIDGE. Edvard Munch. Version One. This shows four girls. The version in 14-9B shows three girls. Observe the differences in the two paintings. (Courtesy of Wallraf-Richarts Museum, Cologne.)

14-8. SELF-PORTRAIT. Edvard Munch. This great Norwegian painter preferred deep, rich colors, and the luminous effects of twilight and moonlight. (Private Collection. O. Varing, photographer. Oslo, Norway.)

14-9B. GIRLS ON THE BRIDGE. Edvard Munch. Version Two. (Courtesy of The National Gallery, Oslo, Norway. O. Varing, photographer.)

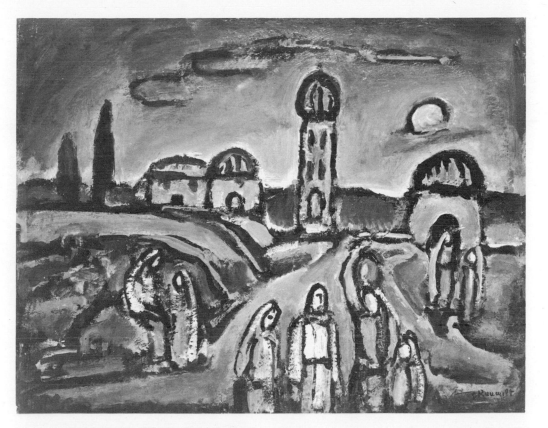

14-10. LANDSCAPE WITH FIGURES. Georges Rouault. The use of heavy black outlines with color effects varying from the subdued to the brilliant creates his highly individual style. (Collection of The Museum of Modern Art, New York. Gift of Sam Salz.)

ground and knowledge makes many recent Abstract Impressionists seem amateurs by comparison.

Edvard Munch (1863-1944) was fascinated by loneliness and death. His simple, primitive use of color was remarkably powerful in creating moods and effects of light and illumination. Occasionally he used vibrant colors in the manner of the Fauvists, but usually he showed far greater taste, insight, and control of the spectrum.

Shown in Illustration 14-8 is a self-portrait of Munch. Two versions of one of his most famous subjects, "Girls on the Bridge," are shown in illustrations 14-9A and 9B; the lighting effect is strange in both pictures, with the sun (or is it the moon?) seen at the left. In the Cologne composition, the dresses worn by the girls are white, bright red, light green, and intense blue. In the Oslo picture, the girls have turned their backs and the one in blue seems to have departed. There is a yellowish pallor over all, a gray-blue sky, deep green trees, and a brown road. The mood conveyed is a melancholy one, though without apparent reason.

Nolde (1867-1956), also schooled in Impres-

sionism, was even more dramatic an expert than Munch in the art of color. Unlike the Fauvists, Derain and Vlaminck, who tended to indulge themselves in an orgy of spectral light, Nolde modified his hues for more consistent, overall effects involving heightened luminosity and brilliance. In other words, Derain and Vlaminck painted bright light — white, natural light; Nolde painted illumination that is strange, mystical, and as though from another world — the world of Nolde's inner fervor.

Georges Rouault (1871-1958), in his early years a stained-glass painter, worked powerfully with color, using heavy concentrations of black to give impact to his hues. The result was a curiously earthy and human profundity. Although Rouault was fascinated by clowns and harlots, bestiality and stupidity, he had tremendous religious feeling and painted many religious works. To him, color was true Expressionism and he employed it not merely for outward visual effect but in deep sympathetic relationship to his inner passions.

Ill. 14-10 shows a typical example of his style.

14-11. CHRISTIAN NOCTURNE. Georges Rouault. Here the colors seem iridescent, with gold, green, violet, and red lighted by a blazing sun. (Courtesy of The Museum of Modern Art, Paris. Photograph by Giraudon.)

14-12. DUNES AT FEHMARN. Ernst Kirchner. This is Expressionism. The colors are rich and bold; the sky is red and purple; the dunes are yellow, gold, and brown; the trees are in dark contrast. (Collection of The Museum of Modern Art, New York.)

14-13. DODO AND HER BROTHER. Ernst Kirchner. This painting demonstrates Kirchner's inclination toward simple forms and bright pure color like the Fauvists. (Courtesy of Smith College Museum of Art, Northampton, Massachusetts.)

to his color sense and to his style of painting, in which pigments are seemingly "dragged" or "flooded" over a deep ground and made to shine from within somewhat like a film of oil on water. The contrast of black outlines greatly heightens the power of the painting.

Ernst Kirchner (1880-1938), was one of the dominant personalities of *Die Brücke*. He wrote, "My goal was always to express emotion and experience with large and simple forms and clear colors." Like other Expressionists, he was always in the very midst of life. But at the peak of his career, he committed suicide. He sought clarity and plastic structure in his woodcuts and paint-

ings, whether they were concerned with nudes, houses, landscapes, or mountains. His palette was similar to that of the Fauvists, but it embodied more black and shades of color, in keeping with the introspective Nordic temperament. Color was always related to design and shaped by it.

The work of Austrian-born Oskar Kokoschka (1886–1953) has found growing admiration with the years. His colors are gloomier than those of most Expressionists. Typical effects were achieved with muted tones shot with touches of brighter blue and red. However, Kokoschka went through periods of brilliant coloring and feverish brush strokes. He was a painter of portraits, figures, landscapes, panoramic views of entire cities. At one time, according to the strange incident described by Herbert Read, he ordered a full-size mannequin to be delivered to a mountain studio. About this incident Read says:

> The point I wish to make is that in his disgust with humanity, the direct result of his war experiences, he decided that he would himself create an ideal figure, devoid of human passions and failings, with whom he could live in unearthly solitude; but when he came to depict this lifeless doll, to pay his tribute to her unearthly stillness, the result was a projection of colors of such vital intensity that one might say that though the subject was inanimate, the painting had life.

14-14. PORT OF HAMBURG. Oskar Kokoschka. The colors here are as sketchy as the drawing itself, but heightened as to intensity and realism. (Collection of The Museum of Modern Art, New York. Rose Gershwin Fund.)

Expressionism has been of great importance to the art of color. Its leaders, such as those commented on, understood, supported, and respected the best of Impressionism, Neo-Impressionism, and Post-Impressionism. Their revolt, or mutiny, was like that of a trained army against smug and decorated generals who had themselves revolted in their time.

However, while Expressionism was spreading in the art world, a new and wild group of other rebels suddenly appeared. They were younger, with little or no training in color. The path down the mountain now became a steep one, with a new generation scrambling to get to the bottom as quickly as possible and then perhaps climb another mountain entirely.

Cubism, Dadaism, Surrealism

Cubism followed in the wake of Fauvism in France (1907-1914). Men like Matisse and Derain contributed to the formation of the movement, but leadership was quickly taken over by

14-15. SELF-PORTRAIT. Pablo Picasso. 1906. The colors on Picasso's palette, left to right, are red, gray, orange, black, and white. (Courtesy of Philadelphia Museum of Art. A. E. Gallatin Collection.)

Pablo Picasso, Georges Braque (1882-1963), Juan Gris (1881-1955), and Fernand Léger (1881-1955).

Cubism did not last long. Originally, its ambition was to destroy what in Impressionism could be termed visual spontaneity and permit no casual or accidental effects. Through Cubism the permanent properties of things were to be

14-16. MA JOLIE (Woman with a Zither or Guitar). Pablo Picasso. Much of Picasso's Cubism was drab, the colors usually dull grays and browns. His emphasis was on geometry. (Collection of The Museum of Modern Art, New York. Lillie P. Bliss Bequest.)

14-17. THREE MUSICIANS. Pablo Picasso. This is one of Picasso's greater works, large in size (about 6½ by 7 feet), and a culmination of the Cubist style. The colors are black, brown, deep blue, red, yellow, and cream. (Collection of The Museum of Modern Art, New York. Mrs. Simon Guggenheim Fund.)

stabilized. Early Cubism was largely monochromatic in color and done in sculptural form. Later, color took on greater significance. In essence, however, Cubism was less concerned with color than with form. Cubist painters strove to represent the essences, not the mere appearances of things, and to accomplish this they became absorbed with geometrical, plastic, and material aspects.

For example, Picasso, the most original and inventive painter of modern times, is not classed as a great colorist. This is not to his discredit as an artist, for his genius and versatility transcend means and methods. He is prolific, restless, creative, and inconsistent. To quote from *A Dictionary of Modern Painting*, "Picasso has never been concerned with producing eternal masterpieces. . . . He draws and paints on anything: a paper tablecloth, cardboard, wood or plywood, fibrocement. He does not concern himself with the preparation of his canvases, the quality of his colors, the improvement of his tools."

14-18. STILL LIFE. Georges Braque. The colors are all muted—dull grays, black, brown, and ocher, offset by a chalky white. (Courtesy of The Art Institute of Chicago. Joseph Winterbotham Collection.)

Braque, who was probably the greatest of all Cubists, gave more attention to color. About Braque, *A Dictionary of Modern Painting* says, "On the whole, his painting. . . . is distinguished by its unity, its coherence, the sobriety and, at the same time, precious beauty of its tones: blacks, grays, beiges, greens, whites, which, despite their lack of brilliance, have a mysterious vibrancy." His palette is given in Chapter 3.

Little comes to the art of color from Cubism, there is even less from Dadaism, and nothing at all from Neo-Plasticism and Constructivism, as

14-19. THE CHECKERBOARD. Juan Gris. Here there is more color—bright green, yellow, white, and blue, with brown and black in the background. (Courtesy of The Art Institute of Chicago. Gift of Mrs. Leigh B. Block with a contribution from the Ada Turnbull Hertle Fund.)

14-20. THREE MUSICIANS. Fernand Léger. His colors are as clear as his forms. Here there are bright yellow and red in the background, blue in the men's suits, touches of bright red, yellow, and white in details. (Collection of The Museum of Modern Art, New York. Mrs. Simon Guggenheim Fund.)

will be seen. Yet to the author, Dadaism offers one of the most amusing and refreshing of all moments in the long history of art.

The Dada movement dates from 1915 to 1922 and lies between Cubism and Surrealism. The true precursor of the Dada spirit was Marcel Duchamp whose notorious painting. "Nude Descending a Staircase" (see Chapter 13), more than any other single work, typifies the whole so-called modern movement in art. Dada (which means hobby horse) represented a completely nihilistic assault on all esthetic, political, social, and moral standards. In fact, it was not an art movement at all. To those who look at Duchamp's "Nude" and say, "Is this art?" the answer is, "Certainly not." If pressed for an explanation of what the "Nude" might mean, the response would be, "Nothing — or whatever you care to think!" Illustration 14-21 shows another painting by Duchamp, "Le Passage de la Vierge à la Mariée."

14-21. LE PASSAGE DE LA VIERGE A LA MARIEE. Marcel Duchamp. This striking composition is all in tones of soft yellow, gold, tan, and brown. (Collection of The Museum of Modern Art, New York.)

14-22. EDTAONISL. Francis Picabia. This large painting (about 10 by 10 feet), is an interesting example of Dadaism. The color scheme is pleasing, with its tones of golden ocher, ultramarine blue, orange-tans, brown, purple, and black. (Courtesy of The Art Institute of Chicago. Gift of Mr. and Mrs. Armand Phillip Bartos.)

14-24. COMPOSITION. Joan Miró. 1933. Here is Surrealism with a sense of humor. The ground is composed of soft gray, dull green, dull brown, and taupe. Superimposed are black figures and touches of red and white. (Collection of The Museum of Modern Art, New York. Gift of the Advisory Committee.)

14-23. MOUNTAIN, TABLE, ANCHORS, NAVEL. Hans Arp. 1925. Dadaism led to Surrealism. In this composition, the title of which is significant, there are flat tones of red, blue, and white. (Collection of The Museum of Modern Art, New York.)

John Canaday defines the Dadaists as "a disruptive band of esthetic stuntsmen, at once clowning and despairing, the only artists in the history of art to declare themselves anti-art and to devote their energies to the annihilation of all art values." Behind Dada was the specious logic that if government, religion, art, science, education, and culture had failed to regenerate man, then all of civilization should be junked.

Dadaism was viciousness, pathos, and humor, all in one. Beside Duchamp was Francis Picabia (1879-1953), friend and companion and equal in the cause of anarchy and libertarianism. Through him, the contemptuous spirit of Dadaism spread throughout Europe and across the Atlantic to America. Color meant little. Duchamp, in fact, used browns and tans for his "Nude" to avoid the issue of color completely. In absolute negation, the Dadaist produced collages made of emptyings from ash cans and waste baskets, bits of paper, wood, cloth, and dirt. These were meant

14-25. PERSONAGES WITH STAR. Joan Miró. 1933. The background is in subdued tones of rose, tan, rust, and blue-violet. The figures are in black, yellow, and white, with a few touches of red. (Courtesy of The Art Institute of Chicago Gift of Mr. and Mrs. Maurice E. Culberg.)

to be insulting to men of good will, but often turned out to exhibit considerable charm.

Dadaism attempted to break down established values; Surrealism picked up the loose and broken pieces and with them endeavored to construct a new school of art devoted to the unconscious, to human neuroses, and hallucinations. And color, which had been almost forgotten, was restored to the painter's palette.

New manifestos were written (1924) announcing that rational vision was to be replaced by psychic ventures into strange depths. A number of Dadaists became Surrealists, among them Max Ernst (1891-1976), Hans Arp (1881-1966), and Joan Miró (1893-). André Masson (1896-) wrote this about the movement: "The Surrealists drew from darkest abysses of their instincts those forces which had been ignored by tacit consent, and gave form to the painful, disquieting, exciting metamorphoses of the subconscious life."

The author has observed that whenever the

artist goes to great pains in his creative effort — and does not react simply on spontaneous impulse — the quality of his color expression usually rises. (This statement does not apply to men like Mondrian who, as will be seen in the next chapter, have deliberately considered, weighed, and rejected color.)

The Surrealists mentioned, others such as Masson, just quoted, and Salvador Dali (1904-) were all good colorists. Ernst, being German, was very familiar with the Expressionist movement; he was attracted to both simple and complex coloring techniques. On occasion he sought startling effects of luminosity.

Arp and Miró are more primitive. In Arp there is a love of clarity of line and purity of form complemented by a choice and perceptive use of color. In Miró there is humor, lyricism, and a dream-world of whimsical shapes in elementary red, yellow, green, blue, and black.

André Masson displays particular awareness of color nuances. Quite unlike the Fauvists who were obvious and extroverted with color, Masson

14-26. MEDITATION ON AN OAK LEAF. André Masson. 1942. Here is the dream world of Surrealism. The color effect is jewel-like. Black outlines and deep contrasts give brilliance to red, yellow, blue, and white. (Collection of The Museum of Modern Art, New York.)

14-27. THE PERSISTENCE OF MEMORY. Salvador Dali. 1931. The technique is superb but the dream world portrayed is in full, normal daylight, with a realistic use of blue, yellow, brown, and gold. (Collection of The Museum of Modern Art, New York.)

shows what can be accomplished with patience, care, and a probing of inner subtleties. He uses dull colors as a foil for candent accents. His effects cannot be taken in at a glance. On study, they assume a metaphysical quality, glimpses of a world half-real, half-fanciful, in spirit not unlike that of the Expressionists.

Dali is regarded as perhaps the finest craftsman of the day. He uses the full palette; color is classically treated in a manner remindful of color in the great paintings of the past. Curiously, although his compositions may be concerned with the deepest mysticism, his choice and arrangement of color seem prosaic. In his recent "Sacrament of the Last Supper" and the "Crucifixion," one is amazed by his facility as a painter, yet these tragic scenes, most certainly meant to convey a profound religious mood, are without mood in color. The figures appear as though painted on an average day, or perhaps lighted by a commercial photographer.

Futurism, Rayonism

Before going on to the final phases of the art of color in this century — the substance of the last chapter, which follows — let me cover a few more isms that were the occasion for a few more manifestos.

14-28. STREET LIGHT. Giacomo Balla. 1909. Here is Futurism and a successful effort to convey the action of light. The colors scintillate from a white center to yellow, to red, to purple. (Collection of The Museum of Modern Art, New York. Hillman Periodicals Fund.)

In 1909, a movement called Futurism burst upon Paris following a manifesto written by one Filippo Tommaso Marinetti, an Italian poet. Extolling the beauty of speed and aggression, it vowed the destruction of all museums, libraries, and academies throughout the world. While such obviously calculated mania produced very little stir among sophisticated painters and an indifferent world, it did inspire a few artists of considerable note, among them Giacomo Balla (1871–1958), Gino Severini (1883–1966), and Umberto Boccioni (1882–1916), all Italian. Balla will be remembered as the man who painted "Dog on a Leash" in which the mechanics of moving legs and paws were portrayed with a succession of lines. Nevertheless, Balla had a passion for light and color and had studied the divisionism of Seurat. He took up abstract painting and became a master.

Severini also studied Seurat and had a love for pure colors. Concerned with what Futurism called "the dynamism of life," he devised a variation of divisionism which juxtaposed brilliant hues in compositions that appeared Cubistic, Abstract, and Non-Objective at the same time. His "sense" of color was good and his style expert. Boccioni, the theoretician of the movement, admired Picasso and Cubism. He wrote, "While

14-32A. DOMINATION OF RED, Rayonist composition. Michael Larionov. 1911. (Collection of The Museum of Modern Art, New York.)

the Impressionists create a picture in order to render a particular moment, and subordinate the life of the picture to this moment, we synthesize all moments (time, place, form, color-tone) and so construct a picture." Boccioni tried to glorify "line-force," to express energy, tension, and pressure, with color and vague semblances of natural things. His handling of color resembled that of van Gogh, not through direct imitation, perhaps, but because his search for movement automatically led to van Gogh's techniques.

In 1911-1912, Russia had its own brand of Futurism. Launched with an appropriate manifesto and series of lectures by Michael Larionov (1881–1964), the term given it was Rayonism. Like Futurism, it borrowed from the spectral palette of Fauvism and changed it only in style of application, using bold streams of parallel color or crossed beams of color. Rayonism produced some of the first true abstract works of this century and was moderately successful in conveying impressions of time and space on flat canvas.

14-32B. DOMINATION OF BLUE, Rayonist composition. Michael Larionov. 1912. (Collection of The Museum of Modern Art, New York.)

Chapter 15

The Camps in the Forest

To continue the metaphor of the mountain: the art of color has now come down from the mountain of Impressionism, Neo-Impressionism, and Post-Impressionism. At the foot of the mountain is a great forest.

However, the artists who trekked through Fauvism, Expressionism, Cubism, Dadaism, Surrealism, and other isms have not all settled in the same part of the forest. There are many camps; some are hostile to each other, some are ignorant of each other, some are divided. For the most part, however, profound interest in the mysteries of color has been forsaken. This is not because the artist no longer recognizes the importance of color; it is because he has been told to seek it out of the depths of his subconscious and to take neither advice nor guidance from any other source. He may consider himself professional as an artist, but in the realm of color, his standing has become that of an amateur, who is defined by Webster as "one who follows a pursuit without proficiency."

Again, this may be an exaggeration on my part. But it is curious — as this chapter will bear out — that neglect of color has been deliberate in some instances and the result of indifference in others. And through it all, the realistic or traditional painters have been the most loyal to color and have maintained the greatest respect for it. They have not condemned or rejected the chiaroscuro of the Old Masters or the divisionism of the Impressionists. They have been willing to submit to a certain measure of training and discipline; and therefore the art of color has

found sustenance in their camp. Temporary sustenance, it is hoped, in anticipation of a great, new, creative epoch of color.

Suprematism, Neo-Plasticism

As the twentieth century progresses, much that is new in art can be described liberally as Abstract or Non-Objective Art. And under this banner, too, there are divided camps. On one side there is tightness, precision, and geometric formality; on the other, there is looseness spontaneity, and seeming formlessness. Both sides started out in harmony, took contrary directions and then came together in the Abstract Expressionism of recent years.

An anti-naturalistic view is common to these camps. In this view, art must not recall, reflect, or evoke reality; art must come entirely from within the artist. Never mind about nature is the credo; man is the greatest of all unexplored territories.

One of the first precursors of what is known as Abstract Art is Russian-born Wassily Kandinsky, of whom much has been said in Chapter 4. It may be that the Slavic temperament, more than the Gallic, is fascinated and haunted by thoughts of death and nonexistence. In any case, the beginnings of Abstract Art did come out of Russia — followed by Holland and Germany — and it was several years before the French had important Abstractionists of their own, although Fauvism and Cubism, both French in origin, had tremendous influence in the development of Abstract Art — Fauvism for its

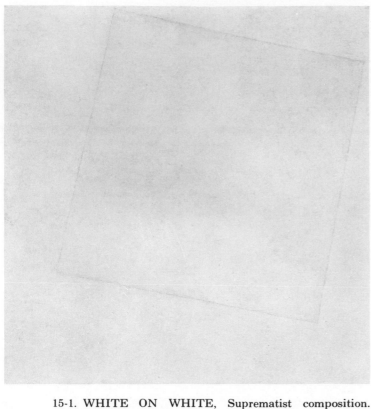

15-1. WHITE ON WHITE, Suprematist composition. Kasimir Malevich. Ca. 1918. This is the controversial painting that was meant to convey "the sensibility of the absence of any object." It is about 31 inches square. (Collection of The Museum of Modern Art, New York.)

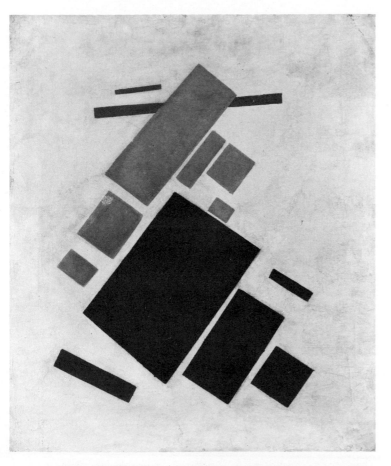

15-2. AIRPLANE FLYING, Suprematist composition. Kasimir Malevich. 1914. The ground is dull white, the geometric forms are black, deep blue, and warm yellow, with bars in red. (Collection of The Museum of Modern Art, New York.)

glorification of color, and Cubism for its dissection of form and structure.

Suprematism dates to about 1913 and was given the name by its chief exponent, Casimir Malevitch (1878-1935). It had its manifesto (1915) and endured until about 1919 when its principles were blended with those of Neo-Plasticism and Constructivism. In Malevitch's words, "By 'Suprematism' I mean the supremacy of pure sensibility in art. From the point of view of the Suprematists, the external appearances of nature are of no interest whatever; the essential thing is the artist's sensibility as such, regardless of the surroundings which brought it into being."

What kind of art could accomplish this? To the Russian, Malevitch, it could all be simply done with a square, circle, cross, and triangle, and with clear, primary hues. The essence of such art, however, is less in the composition than in the eyes or spirit of the artist or beholder. Says Malevitch, "Art is no longer content to be the servant of Church and State, it is no longer content to be the illustrator of customs and costumes, it is no longer willing to have anything to do with objects as such, and it believes that it is capable of existing of itself and for itself independently of the object."

In the history of the art of color, Malevitch will be remembered as the man who brought everything to a full stop up against a dead end, in the following way: in 1913, in Moscow, he exhibited a *black* square on a white background; in 1918, he exhibited his ultimate composition, "White on White" which, as its title states, shows only a white square on a white ground (Ill. 15-1).

In a philosophical sense, Malevitch was not perpetrating a hoax. He could argue that virtuosity was superficial, that true art was more than "concretization." Art, he felt, would forever be impure if people continued to look only for the obvious. Malevitch declared, "It is thus not surprising that my square seemed empty to such a society The square that I had exhibited was not an empty square — it was the sensibility of the absence of any object."

A little Suprematism like a little Dadaism is good for the soul of art — even if it leads to nowhere at all. Once absolutes are reached, however, (they were also reached by Mondrian) any repetition becomes tiresome and one has a

good reason to suspect either opportunism or outright charlatanry.

Malevitch's "White on White" is an intellectual oddity, so one would hardly expect to see, 40 years later, a composition 8 by 10 feet in size consisting of a white line bisecting a flat area of deep blue — this and nothing more. Yet such a painting, privately owned, has been shown in Europe and America under the sponsorship of an eminent museum. The suspicion of either egomania or deliberate nonsense enters when the painter, who had been challenged by a critic to explain the significance of his art to the world, said, "My answer was that if he and others could read it properly, it would mean the end of all state capitalism and totalitarianism."

Neo-Plasticism and its creator, Piet Mondrian of Holland (1872-1944), brought the art of color to another full stop and dead end. Neo-Plasticism also grew out of Cubism, and its beginning can be dated as 1917. And again, like Suprematism, the movement was more concerned with polemics than with graphic expression.

According to Mondrian, the whole language of painting — indeed, the whole language of life itself — could be conveyed with straight lines set in horizontal and vertical relationship. Mondrian stated:

> Art has to attain an exact equilibrium through the creation of pure plastic means composed in absolute oppositions. In this way, the two oppositions (vertical and horizontal) are in equivalence, that is to say, of the same value: a prime necessity for equilibrium. By means of abstraction, art has interiorized form and color and brought the curved line to its maximum tension: the straight line. Using the rectangular opposition — the constant relationship — establishes the universal, individual duality: unity.

A statement like this must be digested slowly. And it needs a Mondrian composition for visual reference. The art itself is probably not as important as the philosophy it diagrams. In color expression, Mondrian adhered to primary red, yellow, and blue — and this is the dead end for color. The new plastic approach to art, according to Mondrian, was "to find its expression in the abstraction of all form and color, in other words, in the straight line and clearly defined primary colors."

Mondrian is almost as famous for his writings as for his paintings, and he continued to write

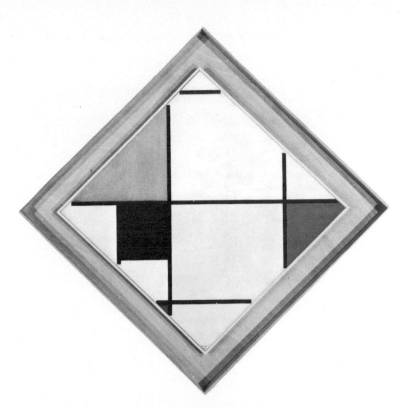

15-3. DIAGONAL COMPOSITION. Piet Mondrian. 1921. By insisting on primary colors, the Neo-Plasticism of Mondrian brought the art of color to a dead end. (Courtesy of The Art Institute of Chicago. Gift of Edgar Kaufmann, Jr.)

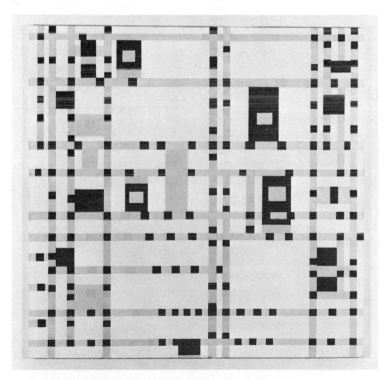

15-4. BROADWAY BOOGIE-WOOGIE. Piet Mondrian. 1942. The colors are red, yellow, blue, and light gray on a white ground. (Collection of The Museum of Modern Art, New York.)

up to his death, at age 74. His thoughts and his style are impressive. For example, he wrote, "Whatever its method of expression, each art tends to become, through the cultivation of the

human mind, an exact representation of balanced relationships. For the balanced relationship is, in fact, the purest representation of that universality, that harmony, and that unity which are the essential qualities of the mind."

The difficulty with Neo-Plasticism, however, lies in its idealism and inherent perfection. Its conclusions begin to sound like platitudes — such as "beauty is truth, truth is beauty." It is too rational, too right. It is equivalent, in intellectual thought, to the unreasoning acceptance of the Golden Rule as the key to a good and happy life. Yet life is never so neat or so well ordered. Knowing the muddle that is man's lot on earth, one thinks of Dostoevsky's low opinion of man's reason: "One may say anything about the history of the world — anything that might enter the most disordered imagination. The one thing that cannot be said of it is that it's rational. The very words stick in one's throat."

Straight lines, circles, and squares are symbols of abstract principles; life itself is full of twists and dents, and hardly anything is regular. If man ever were to achieve complete harmony and unity, either within himself or with the world, he would probably die of ennui.

Kandinsky, Klee, the Bauhaus

The name of Wassily Kandinsky (1866-1944), holds a dominant place in the history of Non-Representational Art; he dedicated a lifetime to

15-5. Composition No. 2. Wassily Kandinsky. 1910. The colors are clear and pleasing in hue—red, orange, yellow and gold, blue, purple, and violet. (Courtesy of The Solomon R. Guggenheim Museum, New York.)

the cause of abstraction and was at once its creator, prophet and master. He was born in Moscow, where he studied and practiced law and led an exceedingly active life; but at the age of 30 he gave up his other pursuits to devote himself entirely to painting. For several years he studied and painted in Munich, working furiously. Then he traveled, taught, wrote, and laid the foundation of a new form of art. The spirit of Non-Figurative painting was expressed by Kandinsky as follows, "I felt more and more strongly that it is the inner desire of the subject which determines its form.... The separation between the domain of art and the domain of Nature grew wider for me, until I could consider them as absolutely distinct, one from the other." He would copy nothing. Rather, he would attempt to express and release cosmic forces that transcend the powers of the artist himself. Whether he ever succeeded in this would be difficult to say.

Kandinsky was greatly inspired by one of Claude Monet's "Haystacks" shown at an exhibition in Munich in 1898. Four years later, he opened a school in Munich. At intervals he traveled to Africa, Holland, Italy, and France. In France he became interested in Impressionism and later in Fauvism, which brought him new courage and understanding in the use of color.

In 1909, he founded the New Association of Munich Artists and wrote his famous treatise, *Concerning the Spiritual in Art,* published in 1912 (reviewed in Chapter 4). His first abstract painting, a water-color, was done in 1910. A year later, he helped to form *Der Blaue Reiter* (The Blue Rider) group, which took its name from one of Kandinsky's paintings and became extremely important to the progress of German and European art.

During World War I, Kandinsky retired to Switzerland. After the Revolution, he returned to Moscow where he occupied several official posts at the Commissariat for Popular Culture and at the Academy of Fine Arts. He organized a score or more museums, directed the Museum of Pictorial Culture, and then founded an Academy of Arts and Sciences.

Authoritarian governments, however, are unlikely to be friendly to the creative artist. Years later, Communism banished "modern movements" in painting as degenerate, and before

15-6. COMPOSITION 8, NO. 260. Wassily Kandinsky. 1923. Note the sharpness and angularity of details—as though done by a draftsman. The colors are mostly red, yellow, green, blue, and violet, with some brown and yellow ocher. (Courtesy of The Solomon R. Guggenheim Museum, New York.)

that the Nazis had confiscated and sold a number of Kandinsky's canvases.

At the invitation of Walter Gropius in 1922, Kandinsky joined the Bauhaus in Germany and remained there as a teacher until 1932, when Hitler closed the institution. Here he associated with Paul Klee and others, and taught general theory and abstract composition. The influence of the Bauhaus was tremendous. According to one of its manifestos, "We must desire, devise, and work together to prepare the new edifice of the future, which will harmoniously unite architecture, sculpture, and painting." This became the doctrine of Constructivism and it brought great changes not only to painting and sculpture, but to architecture, typography, and the graphic arts, and to industrial, product and advertising design.

How can Kandinsky's contribution to the art of color be evaluated. He himself wrote. "The artist must train not only his eye but also his soul, so that it can weigh colors in its own scale and thus become a determinant in artistic creation." And he goes on to say that care must be used lest "we shall produce works that are mere geometric decoration, resembling something like a necktie or a carpet." In Kandinsky's philosophy there must be "vibrations of the spirit," for unless art evokes a deep response, it is superficial and sensuous.

The author has been a staunch admirer of Kandinsky for many years. Of all modern artists, he above anyone else has glorified the importance of color in art. Therefore, it may seem unappreciative on my part to say that in my opinion Kandinsky wrote far better than he painted. What he gave to color was enthusiasm, momentum, and the force of his vital personality. Despite all this, however, if one separates form from color in Kandinsky's work, the color is neither original nor compelling.

Kandinsky's great book was *Concerning the Spiritual in Art*, but he also wrote numerous tracts and articles, and a second book, *Point and Line to Surface*, published in 1926. A theorist on color, Kandinsky gave little attention to natural phenomena or the science of human vision and perception — differing in this from the Impressionists and Fauvists. His viewpoint was directed to "vibrations of the spirit," and this meant to Kandinsky's own psyche. However, this does not mean much, for there is little that is intrinsic in color itself, Even though red may be more stimulating than blue, physically and optically, "spiritual qualities" do not and cannot exist in the spectrum — such qualities exist solely in man's psychological interpretation. Kandinsky, probing his own inner feelings, could not possibly speak for the inner feelings of all men. These feelings differ as men differ.

Perhaps it is unfortunate that Kandinsky, living in Germany, did not rewrite his *Concerning the Spiritual in Art*, for shortly after the book was published, the science of Gestalt psychology, with its amazing revelations on the wonders of human vision, originated in Germany. Articles about the remarkable findings of such scientists as Max Wertheimer, Wolfgang Köhler, Kurt Koffka, and David Katz began to appear in 1920. This new body of knowledge, so much concerned with the perception of form, space, and color, had great impact on scientific thought. Kandinsky, however, either ignored or resisted Gestalt psychology, probably because it was his nature to be subjective as an artist rather than objective as a scientist. In any event, his writings do not reflect the great wealth of new discoveries and insights that the Gestalt psychologists brought forth during Kandinsky's life.

Nevertheless, Kandinsky's color expression

15-7. THE DANCER. Paul Klee. 1940. This delightful and whimsical composition is done on a grayish and blackish ground, with luminous areas of red-orange, gold, green, and pink. The effect is outstanding. (Courtesy of The Art Institute of Chicago. Gift of George B. Young.)

shows ingenuity and good taste, and his compositions are most remarkable. Study his "The Dancer," Ill. 15-7. Klee in most of his art used the "full palette" and painted virtually everything as though seen under natural lighting conditions. The "spiritual qualities" of his colors are certainly not obvious. His sense of color is much like that of the Orphist, Delaunay, his French contemporary. Both reflect the bold but shallow exploitation of spectral painting which entranced the Fauvists.

Paul Klee (1879-1940), his close friend, companion, and fellow-teacher at the Bauhaus, was more subtle and perceptive with color than Kandinsky. The two men saw each other constantly for a period of 10 or more years. Although both were Abstractionists, Kandinsky would have nothing to do with anything figurative, while Klee often borrowed themes from nature.

Klee, of Swiss birth, began his career and spent most of his life in Germany. He admired and studied the Neo-Impressionists and Post-Impressionists. Kandinsky strove to pull forth expression from the subconscious depths of man, and so did Klee, but in Klee's work there was mysticism, symbolism, and the strange things of which dreams and fancies are made.

Klee loved color. He said, "Color and I are one; I am a painter." His subjects were exceedingly varied and primitive but they had recognizable forms, a kind of hieroglyphic writing — arrows, houses, animals, fish, plants, and figures never clearly defined but seen as in fantasy. Note the humor and eerie color quality of his "Dance of the Red Skirts" shown in Color Plate XXVI.

15-8. TWITTERING MACHINE. Paul Klee. 1922. Few modern painters have shown greater variety of color effects. Here soft tones of orchid-pink and lavender are harmoniously blended. (Collection of The Museum of Modern Art, New York.)

Unlike Kandinsky, the color expression of Paul Klee is filled with atmosphere and a wide range of nuances in perception. In an exhibition of Kandinsky's work, it is noticeable that the palette of colors is always the same, despite different color combinations and arrangements. Klee, however, reveals a dozen different palettes. Some of his color effects may be bold and spectral; others may have the subtlety of moonlight. There is a significant sense of mood that ranges from brilliant hues to "a tender radiance" of muted grays. Often the two — color suppression and color accent — are combined to produce remarkably luminous and iridescent beauty. Klee wrote, "Color has taken hold of me; no longer do I have to chase after it. I know that it has hold of me forever. That is the significance of this blessed moment."

Orphism

Klee was a true scholar. His lectures at the Bauhaus comprise an outstanding treatise on principles of design. His conviction was that an artist had to know much and yet be guided by intuition. Nothing could be superficial. He put it this way, "Things must grow, they must grow upward . . . we must go on searching."

Because of his interest in color, Klee translated an essay, *On Light*, by Robert Delaunay who fostered a French branch of Abstract Art called Orphism. Robert Delaunay — in the author's opinion — is given more credit than he deserves as an innovator in the field of color. In principle, Orphism, introduced about 1912, proclaimed the primacy of pure colors in pictorial construction; this was supposed to be the full essence of art. The Orphists claimed that by exalting the dynamic qualities of color, pure expression could be achieved and an entirely new art form realized.

The truth of the matter is, however, that Orphism was nothing more than Fauvism, with non-representational compositions replacing naturalistic ones. Yet Delaunay and Orphism created a stir at the time.

Paris-born Robert Delaunay (1885-1941), devoted an entire life to color. According to his biographers, he began to study Chevreul in 1908 — this was nearly 70 years after Chevreul's famous book was first published. Excited by Seurat and the Fauves, he became strongly attracted to color and soon began to evolve methods of applying spectral hues in large, flat patches. Unfortunately, Delaunay's color constructions, although quite unusual in design, are unoriginal in color effect.

What did Delaunay attempt? Michel Seuphor writes in a flattering way, "His main undertaking was in breaking down the prism and reassembling its elements on the canvas by a discreet though thorough division of surfaces. . . . Like a child with its favorite toy, he took the rainbow to pieces and improvised with the separate parts. . . . He turned it into the very song of light, both airy and powerful."

In the author's opinion, however, these words are empty ones. Delaunay's "Compositions," "Disks," "Unending Rhythms," "Colored Rhythms," "Windows," and "Eiffel Towers" are

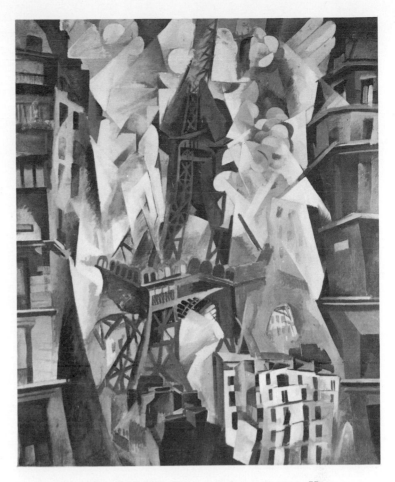

15-9. THE RED TOWER. Robert Delaunay. 1911. Here Delaunay uses black, white, gray, bluish greens, pale blues, golden ochers, and reddish browns in the Orphist manner. (Courtesy of The Art Institute of Chicago. Joseph Winterbotham Collection.)

15-10. SUN DISKS. Robert Delaunay. 1912. The colors are those of the spectrum—pure red, orange, yellow, green, blue, and violet. (Collection of The Museum of Modern Art, New York. Mrs. Simon Guggenheim Fund.)

all obvious in color, all derivative. They are as the eye sees them, bold, even vibrant, but demanding nothing that is subtle or profound from the perception of the viewer. The manipulation of color is clever but aside from style one sees nothing that has not been achieved before.

Delaunay was soon surpassed by other French abstractionists. One of them was Jacques Villon (1875–1963), brother of Marcel Duchamp the Dadaist. Villon, like so many others, was influenced by the Post-Impressionists and Fauvists. Using geometric forms in a free and informal way, he refined Cubism and used abstract devices to glorify color.

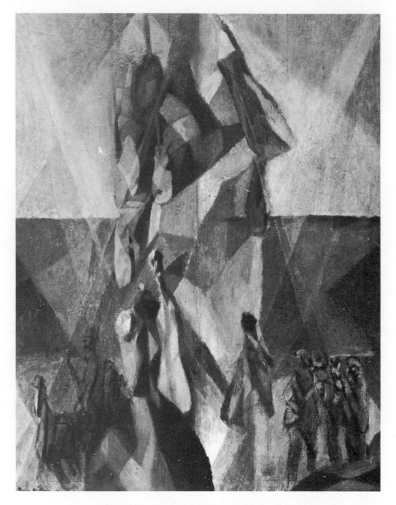

15-11. MUSICAL INSTRUMENTS. Jacques Villon. 1912. The color effect is subtle and almost monochromatic, with grayish browns, reddish browns, and some orange. (Courtesy of The Art Institute of Chicago. Gift of Mr. and Mrs. Francis Steegmuller.)

Villon's paintings show evidence of a superior knowledge of color. He studied candent sequences and wrote, "I am . . . greatly concerned with research in color and color values." Unlike Delaunay, he did not think academically or insist upon using nothing but pure hues. He is more skillful and imaginative, employing yellow-greens, pinks, lilac, and bluish grays with rare

skill. In a sense, he blended Cubism with Impressionism and developed a new approach to non-figurative painting which was highly urbane, civilized, and removed from the primitive or pedantic.

Kandinsky and Delaunay are still being emulated by the Abstract Expressionists. However, as far as color is concerned, their art lacks illusion. One is not struck by magic, as in the plasticity of the Old Masters, the luminous visions of Turner, and the scintillating moods of nature caught by the Impressionists. Orphism, Suprematism, and Neo-Plasticism are hard, cold, and factual; they ask nothing of human perception beyond reaction to exactly what is before it, without contributing anything of its own.

This may seem contradictory, but I am trying to differentiate in color expression between an artist's assumptions and a viewer's ability to react to them. Recent art, in the tradition of Kandinsky and Delaunay, presupposes that the colors of the spectrum themselves have strange, psychological endowments. They do not. It is man who is responsible for interpretation — and all men differ.

Let me use the color "orange' as an example. This color may be liked by a Spaniard and loathed by an Irishman; it may appear cheerful and ebullient to an extrovert and revoltingly gaudy to an introvert. Color as a thing in itself, as a certain wave length, is without much meaning. Set aside matters of culture (where all men differ) for matters of perception (where all men are very much alike) and universal qualities in color become more apparent. Orange, to Titian, could be warm, luminous flesh. To Rembrandt, it could suggest the eerie light of another age. To Americans like Albert Ryder and George Innes, it could be mystery or the equanimity of Indian summer.

To put this more directly: orange, or any other color, is without significance in itself if it consists merely of a daub, patch, or line in an abstract composition. The painter asks too much if the viewer is expected to find anything deep or psychic in the color alone. But let the painter build illusion with color, let him show uncommon skill, let the color appear to be other than it is through the magic of perception, and virtually any mood or reaction can be stimulated.

Abstract Expressionism

Artists from Russia, Holland, Germany, Switzerland stole laurel from the holy wreath of French art during the course of the twentieth century, but one giant stood firm — Pablo Picasso, of Spanish birth (1881–1973). Any comprehensive review of his art will reveal an impressive series of styles which in themselves became art movements of great variety. His Cubism was a forerunner of much Geometric Abstraction. Although he did not engage in complete abandonment to impulse as did men like Pollack of America, at one time or another he undertook works that seem to have directed the eyes, hands, and creativity of virtually all artists of his day. To put this another way: it is most difficult today to look upon art in *any form*, without somehow feeling that "Picasso has been here."

Picasso has always been essentially concerned with form rather than color, and if any recent art movement has failed to engage his attention, it is the movement that is called "Abstract Expressionism."

15-13. HARLEQUIN. Pablo Picasso. 1915. Warm brown, golden yellow, blue, orange, green, and violet are used against a black ground. The Cubism is representational, not wholly abstract. (Collection of The Museum of Modern Art, New York. Lillie P. Bliss Bequest.)

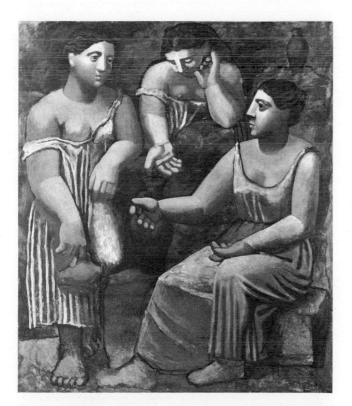

15-12. THREE WOMEN AT THE SPRING. Pablo Picasso. 1921. Here is a demonstration of Picasso's outstanding versatility. This painting was done in the same year as "Three Musicians" shown in the previous chapter. A pleasing flesh tone is combined with muted grays and tans. (Collection of The Museum of Modern Art, New York. Gift of Mr. and Mrs. Allan D. Emil.)

Let me approach this art form as follows: color is more primitive than form; it arouses feelings that are wholly spontaneous, requiring no reasoning. A person merely looks at color and reacts automatically. Like music, it is rich with stimulation and motivation. One would suppose that a medium, a sensation, and phenomenon so powerful would send an abstract painter into ecstacies and give him a driving hunger for greater knowledge.

It would be unfair and untrue for this writer to state that no modern artist has such initiative. But in spite of the exceptional painter, the whole of Abstract Expressionism can be indicted as far as the art of color is concerned. In Abstract Expressionism, little counts but the artist's ego. He is to be free, uninhibitedly creative, unfet-

tered, and driven solely by the forces of his inner life.

Therefore color knowledge has been neglected in Abstract Expressionism. No artist is to be a student in any way whatsoever. He is to throw off all bonds. Hence, the movement has wandered in various directions — to stark simplicity, to conglomeration, to formality and informality, to an impulsive sort of painting in which color on one hand may not be used at all, or, on the other, literally flung about.

Abstract Expressionism became a world movement but is now in decline. Since Impressionism, it has had a longer reign than any other school or ism mentioned in this and the preceding chapter, excepting Expressionism itself. It would be unwise to judge what time and history may think of it. There is little question, however, that in the art of color it will be recorded as a time of retrogression, naiveté, and nescience. Perhaps in disregarding it, the great Picasso will prove himself a wise genius indeed.

In Europe, the famous champions of the abstract in art were Kandinsky, Malevitch, Mondrian, and others discussed in this chapter. In England, Ben Nicholson (1894–) has won considerable eminence. His style is an exact one, a refined and controlled geometry, usually composed of stylized landscapes or still life. About

his color, one writer speaks of "a range of colors that is best described as chaste. . . . A certain gentleness and discreet lyricism relate him to the English watercolorists, as do the lightness of his touch and the transparency of his color."

15-15. THE COAST OF INLAND SEA. Victor Pasmore. The sub-title is "Special Motif: Green, Violet, Blue, and Gold." (Courtesy of Director, Tate Gallery, London.)

15-14. RELIEF. Ben Nicholson. 1939. The British abstract painter Nicholson found inspiration in the work of Mondrian and sought the same fundamental values. Here is restrained white with a sandy tan and small areas of soft red and brown ocher. (Collection of The Museum of Modern Art, New York. Gift of H. S. Ede and the artist.)

15-16. ENTRANCE TO A LANE. Graham Sutherland. The colors are light and dark green with gold; the whole composition is pervaded by a yellowish-green tonality. There is mysticism, symbolism, and beautiful color. (Courtesy of Director, Tate Gallery, London.)

Victor Pasmore of London (1908–) is another famous English abstract painter. Attracted first by the Impressionists and then the Cubists, Pasmore developed a highly individual abstract style in which lines and planes are interwoven. Loyal to his convictions, he became an undisputed leader of the London abstract group.

Graham Sutherland (1903–) is also a leading English artist but he works in a less abstract mood. Influenced by William Blake and fascinated by whatever is magical, he invented strange forms of life — plants and insects — and tinted them with equally strange hues. Sutherland has undertaken murals and large wall panels, his themes varying from "Christ on the Cross" to "The Origins of the Earth." He has also devoted himself to portraits and landscapes. According to *A Dictionary of Modern Painting,* "In Sutherland's work, art reaches back to its primal nature: it inspires in man a mixture of fear, joy, and ecstasy. At once sign and symbol, the work of art becomes, in the hands of this sorcerer, a vehicle for cosmic forces."

Meanwhile back in America

Nearly all Abstract and Non-Objective Art in the United States came from abroad, from France, Germany, the Netherlands, and Russia. John Marin (1870-1953), for example, having studied at the Pennsylvania Academy in Philadelphia and the Art Students' League in New York, went abroad to polish up his talents. After six years he returned to the United States, participated in the famous Armory Show and exposed Americans to a unique form of expression combining bright colors with simple abstractions of skyscrapers, bridges, and ships executed skillfully in a few expertly placed calligraphic strokes.

15-18. VISA. Stuart Davis. 1951. The colors are as bold as the composition. Yellow, black, brownish red, and orange are used, with the letters of the word "Champion" in brilliant magenta on emerald green. (Collection of The Museum of Modern Art, New York. Gift of Mrs. Gertrud A. Mellon.)

15-17. LOWER MANHATTAN. John Marin. Watercolor. 1920. This painting is direct in its approach to subject matter as well as color. A dramatic impression of city life is conveyed with strong drawing and subdued color. (Collection of The Museum of Modern Art, New York. Philip L. Goodwin Collection.)

Stuart Davis (1894–1964), an early American pioneer in Abstract Art, also studied in Paris and also participated in the Armory Show. Influenced by Cubism, he applies fresh colors to abstract forms which are remindful of jazz music. Stuart's attitude is carefree and witty. He delights in compositions that reveal glimpses of store fronts, billboards, and taxicabs — the very texture and tempo of his native land.

Mark Tobey (1890–1976), from Seattle, Washington, has traveled extensively but seems mostly influenced by oriental culture. Some of his compositions resemble Chinese and Japanese prints, are muted in color, and their maze of swirls may comprise forms of birds, flowers, musical instruments, and sometimes Buddha himself.

More geometric in style — but still abstract — are the paintings of Stanton Macdonald-Wright (1890–1973) and Morgan Russell (1886–1953) whose Synchromism (described in Chapter 6) was a small sensation in Europe and America after World War I.

The list could go on and on. In the abstract and non-representational field, America has lately produced hundreds of painters and perhaps has taken world leadership. Undoubtedly, the most typical of them all and the best known is Jackson Pollock (1912-1956).

15-20. GRAYED RAINBOW. Jackson Pollock. 1953. Here is completely non-objective action painting by this world-renowned American artist. White, black, and gray have been used over most of the area, with glints of orange, lilac, blue-green, and yellow in the lower part. (Courtesy of The Art Institute of Chicago. Gift of the Society for Contemporary American Art.)

15-19. ABOVE THE EARTH. Mark Tobey. 1953. The viewer projects his own imagination into the composition to see real and unreal images. The color effect is mostly gray, with small areas of soft purplish red, gold, yellow ocher, and grayish green. (Courtesy of The Art Institute of Chicago. Gift of Mr. and Mrs. Sigmund Kunstadter.)

Although Pollock is the very opposite of geometric painters like Mondrian in his approach to art, he, too, typifies the spirit of Abstract Expressionism. His color is boldly used but without much knowledge, plan, or preparation. He writes of his methods:

My painting does not come from the easel. I hardly ever stretch my canvas before painting. I prefer to tack the unstretched canvas to the hard wall or the floor. I need the resistence of hard surface. On the floor I am more at ease. I feel nearer, more a part of the painting, since this way I can walk around it, work from the four sides and literally be *in* the painting. This is akin to the method of the Indian sand-painters of the West. I continue to get further away from the usual painter's tools such as easel, palette, brushes, etc. I prefer sticks, trowels, knives, and dripping fluid paint or a heavy impasto with sand, broken glass, other foreign matter added.

Fantasy and Reality

The observation has already been made that whenever the artist is deliberate rather than importunate in his approach to painting, whenever he exhibits patience and technical skill, his color expression is usually outstanding.

This surely applies to three artists often referred to as the Fantasts: Paul Klee, Marc Chagall (1887–) and Giorgio de Chirico (1888–1978). Klee's work has already been touched upon. In the instance of Chagall, one of Russia's greatest painters, color is given tremendous expressive value. Concerned with fantasy and mysticism, with the enigmatic themes of life, birth, marriage, and death, each of Chagall's paintings, unlike those of Dali, for example, seems to have been studied as to an overall color effect. There may be a predominant mood of green, or yellow, or blue, and some of these

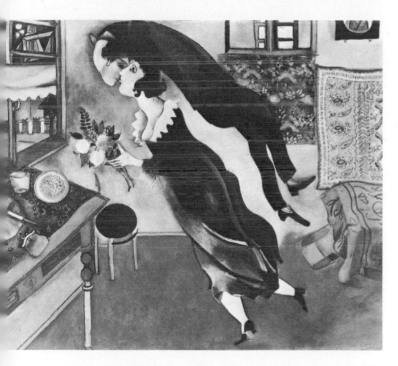

15-21. BIRTHDAY. Marc Chagall. 1915. A delightful demonstration of Chagall's words, "You pour on color. . . . You float away so beautifully." (Collection of The Museum of Modern Art, New York. Lillie P. Bliss Bequest.)

color effects are remarkably similar to those of Klee. In all cases, however, he went far beyond Fauvism and Orphism and did not hesitate to reject the full spectral hue for the modified and therefore more arcane tone.

Chagall, perhaps by intuition, understood that mystery was elusive. He understood that in order to express mystery, color required subtlety.

His paintings are a credit to the art of color and seem to promise a new tradition that may one day lead to a new height.

A most unusual Chagall item is the black-and-

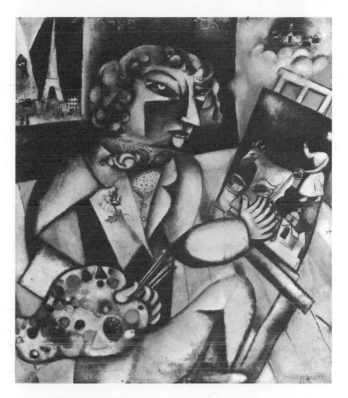

15-22. SELF-PORTRAIT. Marc Chagall. The rich detail in this unusual composition is well worth study. Note the ornate palette. (Courtesy of Stedelijk Museum, Amsterdam.)

white self-portrait shown in Illustration 15-22. Here the artist is seen holding a palette. He is painting a scene of his native Russia, obviously done in a Paris studio to judge from the Eiffel Tower visible through the window.

The brilliant Italian, Giorgio de Chirico, like Chagall, was fascinated by a dreamworld. With great sensitivity he wrote, "Thought must so far detach itself from everything which is called logic and sense, it must draw so far away from human fetters, that things may appear to it under a new aspect, as though illuminated by a constellation now appearing for the first time."

There is architectural majesty in de Chirico's art. His compositions are melancholy, poetic, and strangely disturbing. Perspective is strange. There are forms, figures, buildings, all clearly drawn, but which somehow appear as if in a vision. And there is no question that the mood he wanted was basically keyed to color — usually

15-23. THE DELIGHTS OF THE POET. Giorgio de Chirico. 1913. A strange yellowish-green light dramatically complements this dream world, although the colors are warm and golden. (Collection of The Museum of Modern Art, New York. Lillie P. Bliss Bequest.)

jectivity, a new objectivity; instead of abstraction, a reaffirmation of representation and specific subject matter; instead of internationalism, an art based on the American scene." In these views he firmly disputed Abstract Expressionism and followed in the fine tradition of Ryder, Homer, Eakins, and Sloan. Hopper's subjects are mostly city scenes in which unusual lighting effects are featured, with often two illuminations on the same canvas — for example, the inside and the outside of a restaurant (Ill. 15-24), a movie house with yellow light from wall fixtures and blue light from the movie screen (Ill. 15-25).

15-24. NIGHTHAWKS. Edward Hopper. In this striking composition, an all-night coffee shop in the golden tones of artificial light sails like a ship into the blueness of night. (Courtesy of The Art Institute of Chicago. Friends of American Art Collection.)

an unearthly greenish or yellowish white. One critic, James Thrall Soby, describes this, "The image is especially piercing and memorable in that its thin pigment is astonishingly luminous, almost incandescent, as though lighted from beneath the canvas." Nothing so dramatic as this could possibly have come without training. De Chirico in his earlier years copied Raphael and other Italian Masters in an effort to dissect the chiaroscuro style. He worked with an extensive palette, described in Chapter 3. In 1930, at the age of 42, de Chirico broke with his past and tried his hand at other techniques.

In the realm of realism, there are outstanding modern American painters who have a realistic or traditional approach to painting and excellent colors, such as Edward Hopper (1882–1967), Charles Burchfield (1883–1967), Andrew Wyeth (1889–1975), and the western regionalists, Grant Wood (1892-1942), Thomas Hart Benton (1889–), and John Steuart Curry (1897-1976). Hopper in particular has created some of the most remarkable color effects of any artist to appear on the American scene. Whether or not one likes his photographic style, there is little question that he ranks as one of the great masters of this century in the art of color.

Hopper studied in France, but returned to America to express this credo: "Instead of sub-

15-25. NEW YORK MOVIE. Edward Hopper. 1939. An usher at the right ponders under yellowish artificial light; to the left are cold, bluish reflections from the motion picture screen. (Collection of The Museum of Modern Art, New York.)

15-26. WINTER TWILIGHT. Charles Burchfield. 1930. The mood of the composition is complemented by the mood of the colors—deep shaded reds, browns, ochers, and slate blues, with brightness for the luminous details. (Collection of Whitney Museum of American Art, New York.)

15-27. CHRISTINA'S WORLD. Andrew Wyeth. 1948. The use of color here is realistic but restrained. (Collection of The Museum of Modern Art, New York.)

and precise technique to depict rather melancholy views, usually of New England. Although his style is almost photographic, Wyeth puts a warm and moving spirit into his compositions. His vision is most perceptive and stirring, and his craftsmanship is superb.

Wood, Benton, and Curry picture the midwest. All three, like Wyeth, are able craftsmen, and all handle color with keen vision and competent skill. Benton, a highly successful muralist, manipulates color somewhat in the fashion of El Greco. Some Eastern sophisticates may look upon him, and Wood, and Curry, as academic

15-28. AMERICAN GOTHIC. Grant Wood. 1930. American painting drawn from American tradition. Magnificent in both style and mood, this picture portrays much that is part of the American spirit. (Courtesy of The Art Institute of Chicago. Friends of American Art Collection.)

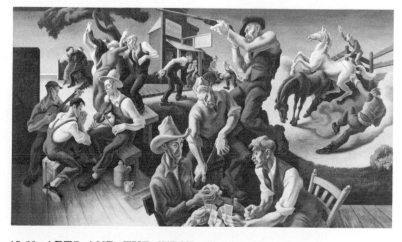

15-29. ARTS AND THE WEST. Thomas Hart Benton. Much American art, in the manner of Wood, Benton, and Curry, stands apart from the sophistication of the big city. Benton used a balanced palette, with chalky white highlights like El Greco. (Courtesy of The New Britain Museum of American Art, Connecticut.)

Burchfield, whose paintings resemble those of Hopper, is perhaps more perceptive and emotional. His preferred subjects are small towns, and they have a haunting air about them. Again, knowledge and facility with color are beautifully apparent. Both Hopper and Burchfield do as well — or better — than many of the foremost American painters of the past.

Wyeth, son of the brilliant American illustrator N. C. Wyeth, is one of the most admired of modern American painters. He uses a tight

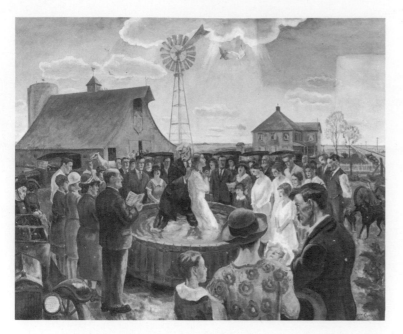

15-30. BAPTISM IN KANSAS. John Steuart Curry. 1928. The colors are somewhat subdued—a pale blue sky, light red barn with gray roof, figures dressed in brown, henna, soft blue, and yellow. (Collection of Whitney Museum of American Art, New York.)

and naive, but the nation at large feels whole-hearted admiration.

Finally, and in the same tradition, are Ben **Shahn** (1898-1969), Jack Levine (1915–), and several others. Shahn, a Lithuanian by birth, came to New York as a child. Perhaps because of parental influences and early memories, he found himself sympathetic to the lot of simple and forlorn people. Earlier Americans had merely commented on life or depicted a few of the seamier aspects, but Shahn and Levine were determined to take a more aggressive stand. Shahn's style is powerful, exposing crude shacks, unemployed men, sadness, and bitterness, so vividly that viewers feel angry as well as compassionate.

In Levine's work, there is visual satire — faces that reveal corruption, gluttony, and dissipation. His technique is much like the best of American craftsmen, and is indebted to Rubens, Hogarth, Goya, and other such painters of mankind.

It seems clear, after this general survey, that the art of color has been championed more by the realist than by the abstractionist; the Abstract Expressionist has contributed little to the progress of effective color usage.

How long will it be to the next great epoch of color? Impressionism went into decline at the turn of the century. It took nourishment from

the sciences of physics and physiological optics. Meanwhile a new science has reached maturity — psychology — a science intimately concerned with the mysteries of human perception and one that can teach the artist how to build anew. Schooled in the new scientific research into color expression, the artist will now be able to understand how he can use the laboratory of his own consciousness and his own human perception to original and creative ends.

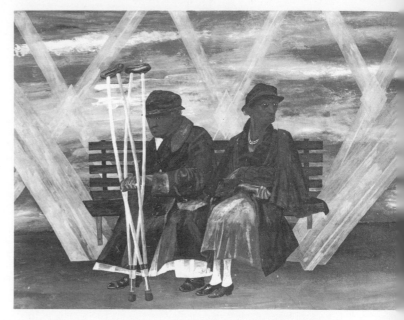

15-31. WILLIS AVENUE BRIDGE. Ben Shahn. 1940. The powerful steel girders of the bridge are a brilliant red-orange, with the figures in dull blue and gray. (Collection of The Museum of Modern Art, New York. Gift of Lincoln Kirstein.)

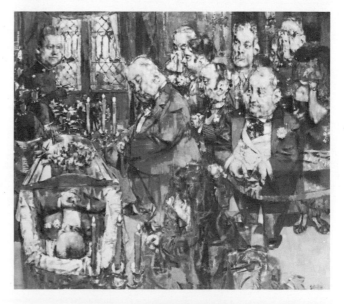

15-32. GANGSTER FUNERAL. Jack Levine. There is fascination in the subject, the composition, design, technique, and handling. The color effect is a harmony of flesh tones, browns, grays, and blacks. (Collection of Whitney Museum of American Art, New York.)

Index